Polymetric Puzzles

Exercises and Short Pieces for Piano and Keyboard

Polymetric Puzzles
Exercises and Short Pieces for Piano and Keyboard

Jeffrey S. Fineberg

Jeffrey S. Fineberg
2014

Copyright © 2014 by Jeffrey S. Fineberg

All rights reserved. This book or any portion thereof may not be reproduced or used in any manner whatsoever without the express written permission of the publisher except for the use of brief quotations in a book review or scholarly journal.

First Printing: 2014

ISBN 978-1-304-17425-3

Jeffrey S. Fineberg
Post Office Box 545
Amherst, N.Y. 14226

Email: bookinfo@polymetricpuzzles.com

Additional information is available at www.polymetricpuzzles.com

Special discounts are available on quantity purchases by corporations, associations, educators, and others. For details, contact the publisher at the above listed address.

Dedication

This book is dedicated to my wonderful wife Kim and my two great sons, Ian and Alex. Thank you for all your help and encouragement which ultimately contributed to my completing this book. Thanks also to my mother and father who have instilled confidence in me and always supported my aspirations as much as possible.

Contents

List of Music Works: puzzles, exercises and pieces .. viii

Acknowledgements .. x

About the Author ... xi

Preface ... xii

Chapter 1: Illustration and Explanation of Polymeters .. 1

Chapter 2: Polymetric Puzzles and Variations ... 7

Chapter 3: Polymetric Puzzle Short Pieces .. 31

Chapter 4: Illustration and Explanation of Polyrhythms ... 44

Chapter 5: Polyrhythmic Exercises and Short Pieces .. 49

Chapter 6: Polyrhythmic Puzzles .. 65

Chapter 7: An Approach Combining Polyrhythms and Polymeters 67

Chapter 8: Out of Phase Puzzles using Asymmetric Phrases .. 80

Chapter 9: Free-Form Polymetric Puzzles .. 95

Chapter 10: Tools for Improvisation and Composition ... 100

Appendix 1 - Selected Puzzle Solutions ... 113

Index ... 186

List of music works: puzzles, exercises and pieces

Puzzles, Exercises and Pieces (in "Puzzle" notation)	Page
2:3 Polymetric Puzzle	9
2:3 Polymetric Puzzle - Variation 1	10
3:4 Polymetric Puzzle	13
3:4 Polymetric Puzzle - Variation 1	15
4:5 Polymetric Puzzle	17
4:5 Polymetric Puzzle – Variation 1	18
5:6 Polymetric Puzzle	19
5:6 Polymeter Puzzle - Variation 1	20
6:7 Polymetric Puzzle	21
6:7 Polymetric Puzzle - Variation 1	22
7:8 Polymetric Puzzle	23
8:9 Polymetric Puzzle	24
9:10 Polymetric Puzzle	25
10:11 Polymetric Puzzle	26
5:2 / 5:3 Polymetric Puzzle	27
Polymetric Variations in 13,11,7,6,4,3,2,1 (a sort of comprehensive exam)	28
11:12 Polymetric "Single Measure" Challenge	29
Deceptively Simple Polymetric Puzzles	30
Polymetric Song - Variations in 11	32
Polymetric Song - Variations in 12,9,5,4,3,2	34
Polymetric Song - Variations in 20,10,5,4,3,2	36
Polymetric Dissonance Variations	37
Polymetric Polytonally Dissonant Variations	39
Polymetric Chordal Distraction	41
Sunrise Comet	43
Polyrhythms of Various Types	47
Polyrhythm 2:3	50
Polyrhythm 2:5	51
Polyrhythm 2:7	52
Polyrhythm 2:9	53
Polyrhythm 3:4	54
Polyrhythm 3:5	56
Polyrhythm 3:5 Variation 1	58
Polyrhythm 3:5 Variation 2	59
Polyrhythm 3:7	60
Polyrhythm 4:5	62
Polyrhythm 5:7	64

Puzzles, Exercises and Pieces (continued)	Page
Combining Polyrhythms and Polymeters	70
2:3 Polyrhythm within Polymetric Melodic Patterns of 5:5, 30:5, 15:5, 8:5	71
3:4 Polyrhythm with Triplets Metrically grouped in 4	73
Key West Tangle	76
Protein Clock Hypothesis	77
Polyrhythmic Melodic Exchange - 4:5	79
Out of Phase Puzzle illustration using C, F and G	82
Out of Phase Additional Puzzle illustration (using C, F, G, B and D, F, G, A)	83
Out of Phase Puzzle 1	89
Out of Phase Puzzle 2	90
Selected Solutions – fully notated pieces	
Out of Phase Puzzle 1 (solution)	91
2:3 Polymetric Puzzle (solution)	114
2:3 Polymetric Puzzle - Variation 1 (solution)	115
3:4 Polymetric Puzzle - Variation 1 (solution)	118
4:5 Polymetric Puzzle - Variation 1 (solution)	121
5:6 Polymeter Puzzle - Variation 1 (solution)	125
6:7 Polymetric Puzzle (solution)	128
6:7 Polymetric Puzzle - Variation 1 (solution)	133
5:2 / 5:3 Polymetric Puzzle (solution)	138
Polymetric Song - Variations in 11 (solution)	141
Polymetric Song - Variations in 12,9,5,4,3,2 (solution)	146
Polymetric Song - Variations in 20,10,5,4,3,2 (solution)	151
Polymetric Song - Variations in 13,11,7,6,5,4,3,2,1: comprehensive exam! (solution)	154
11:12 Polymetric "Single Measure" Challenge (solution)	160
Deceptively Simple Polymetric Puzzles (solution)	161
Polymetric Dissonance Variations (solution)	165
Polymetric Polytonally Dissonant Variations (solution)	169
Polymetric Chordal Distraction (solution)	174
Sunrise Comet (solution)	179

Acknowledgements

Thanks to the many musicians, creative people and friends I have had the pleasure of working and playing with over the years.

Thank you to all the teachers I have studied with, from whom I have learned a great deal about disipline in order to work so many years on this project.

I wish to acknowledge Johann Sebastian Bach (1685-1750) whose keyboard works have inspired me to realize the importance of utilizing both hands equally.

Finally, thank you to my family for their help throughout this project.

Thank you to my son Alex Fineberg for his expertise in developing software to generate polyrhythmic tables and his help using various software which was part of this project.

Thank you to my son Ian Fineberg for his expertise with proofreading and editing the text, his invaluable advice regarding the book cover and various logistics regarding the project for this book.

Thank you to my beautiful wife Kim Fineberg for an unbelievable amount of patience, coffee shop discussions about multistable images and polymeters, as well as helping me with the focus and direction needed to complete this work.

About the Author

Jeff Fineberg is a keyboardist with extensive experience playing synthesizers, piano, harpsichord, organ and computer-based virtual synthesizers *(such as Absynth, Reaktor, FM8, etc.)*. He also utilizes computer programming as a tool for music performance and composition. His music genre interests include progressive rock, classical, jazz-rock fusion, electronica and experimental approaches – among others.

He has played in a number of ensembles, focusing primarily on composition as well as improvisation. He also pursues solo efforts, exploring various interests such as improvisation, composition, recording, and experimenting with temporal aspects of music, such as polymeters and polyrhythms.

Jeff attended the University at Buffalo, in New York - earning a Bachelor of Arts degree in "Music and Media Studies" and a Master of Science degree in "Computer Science".

In addition to his music interests, Jeff is an Information Technology Professional, working as a Programmer Analyst, Database Analyst and an Adjunct Lecturer at the University at Buffalo in New York. He has taught a wide range of Information Technology topics, such as Software Development, Database Systems and Systems Analysis.

Preface

I would like to explain what "Polymetric Puzzles" is about and the motivation for creating it. During much of my music experience, I have had a strong interest in the idea of experimenting with music from a perspective of interesting meters, as well as the use of polyrhythms. Music that contains odd meters and rhythms has always intrigued me. You can find examples of this in many forms of music. Examples include Popular Music, Dance Music, Progressive Rock, as well as Art Music (e.g. Impressionistic / Avant Garde), Jazz and and Jazz/Rock fusion.

I have always been fascinated with keyboard musicians who can play different meters and rhythms between two hands. This seemed like an interesting challenge to conquer. The main focus of the book is to give the reader opportunities to develop independence of the hands using (as I refer to them) "Polymetric Puzzles".

Much of the book contains a variety of puzzles that the keyboardist needs to solve. In addition, there are recommendations on how to play variations. There are also sections of the text with fully written out manuscript consisting of a variety of composed works based upon polymetric patterns.

My intention when developing this book was to illustrate the interesting aspects of both polymeters and polyrhythms so that the reader gains interest with these aspects of music, to increase independence of the hands, as well as experiment further beyond the text. I also hope the reader discovers these techniques to be useful tools for improvisation and composition.

How might you get the most out of this book? Feel free to initially skim the chapters to get an overall understanding of the concepts, as well as to consider where you may want to focus your interests. While some readers may choose to start playing examples, others may want to read some of the theory behind the exercises. To gain the most understanding of the concepts, I recommend that you read the background material in chapter 1. However if you intend to only play the fully notated pieces, this may or may not be necessary.

Throughout the book you will see footnotes with recommendations to perform "web searches". If you come across any term you are not familiar with, please feel free to search the web or refer to a music theory textbook for additional details.

Please refer to the website **www.polymetricpuzzles.com** for additional information and content regarding this book. If you have any questions or comments regarding the material, please direct them to bookinfo@polymetricpuzzles.com.

Chapter 1: Illustration and Explanation of Polymeters

Welcome to Polymetric Puzzles! You may be wondering what the title of this text "Polymetric Puzzles" is all about. Let me explain. I have always being fascinated with the problem of trying to play different parts of music with each hand at the keyboard *(e.g. piano, synthesizer, harpsichord, etc.)*. To me, this is the main difficulty of the keyboard. The type of music that exploits this problem can be seen in the works of various composers, including Johann Sebastian Bach – particularly with his inventions and fugues. The goal of this book is to give the musician more opportunities to accomplish independence of the hands, using techniques that progressively increase in difficulty. To get started, let's discuss the definition of the title "Polymetric Puzzles" as it is intended in the text.

The "Puzzle" Context for "Polymetric Puzzles"
A puzzle is typically a problem in which a set of items are "out of place" or not assembled, with the solution requiring an activity to reassemble or "solve" the puzzle. In most puzzles, there is usually quite a bit of work involved in assembling the items together. The idea of the puzzles in this book is for the keyboardist to work through the difficulty and assemble the left and right hand parts into a completed segment of music.

The "Polymetric" Context for "Polymetric Puzzles"
We can think of Polymeters as a rhythmic structure within a piece of music which contains multiple meters played simultaneously. For example, we may have a piece that has the right hand playing in 2/4 and the left hand playing in 3/4 (figure 1.1). To elaborate, we have two meters playing at the same time which are partially out of synch, however we will see that they always come together at some point to the first beat in both meters. This occurs after 6 beats in our example of 2/4 and 3/4, because $2 \times 3 = 6$. The point at which the two meters come together marks the end of a cycle, therefore the cycle is 6 beats long in our example.

Figure 1.1. Illustrating the count structure of Polymeters (2 cycles of 2/4 against 3/4)

| | \multicolumn{6}{c}{Meters come together at beat 1} | | | | | | |
|---|---|---|---|---|---|---|---|---|---|---|---|
| **a. 2/4** | 1 2 | 1 2 | 1 2 | 1 2 | 1 2 | 1 2 |
| **b. 3/4** | 1 2 3 | 1 2 3 | 1 2 3 | 1 2 3 |
| beats / count | 1 2 3 | 4 5 6 | 1 2 3 | 4 5 6 |
| | ⊢── cycle 1 ──⊣ | ⊢── cycle 2 ──⊣ |

Note the comparison of the two meters (2/4 and 3/4), which exist within a cycle of 6.

 a. 3 sets of 2 beats = 6 total beats.
 b. 2 sets of 3 beats = 6 total beats.

Interesting aspects of Polymeters

Polymeters can create interesting textures using interwoven patterns that function in a sense, very similar to a multistable image (figure 1.2)[1]. Polymeters can be thought of a musical version of an optical illusion. The reason for this is that the mind can generally perceive a limited scope of complexity at any one time. Using our previous example, most people can only focus on either the 2/4 meter or the 3/4 meter, but not usually both at the same time. One possible compromise might be to perceive the piece in 6/4; however it may not be realistic due to the prevalent patterns of 2 and 3 occurring simultaneously.

Figure 1.2. A multistable image (from the front cover). Similar to perceiving a polymeter in one of two ways, this image can be seen as a 'tunnel' going from left-to-right or right-to-left.

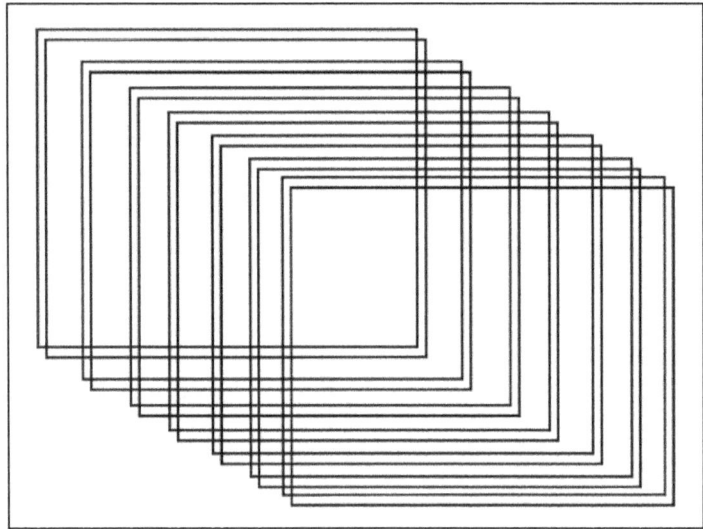

Defining a polymetric pattern

In order to clearly define a polymetric pattern, we need to be able to provide either a pitch pattern, accent pattern or a combination of both. Without either of these elements, any patterns will be perceived as a series of repetitious pulses. Throughout much of this text, the use of pitch-based patterns is illustrated.[2] Note that in figure 1.3 and 1.4 the total beats in a polymetric cycle of 2/4 and 3/4 are 6 (as noted earlier, since 2 x 3 = 6).

Figure 1.3 / 1.4. Examples of polymetric patterns based upon pitch and accents (1 cycle).

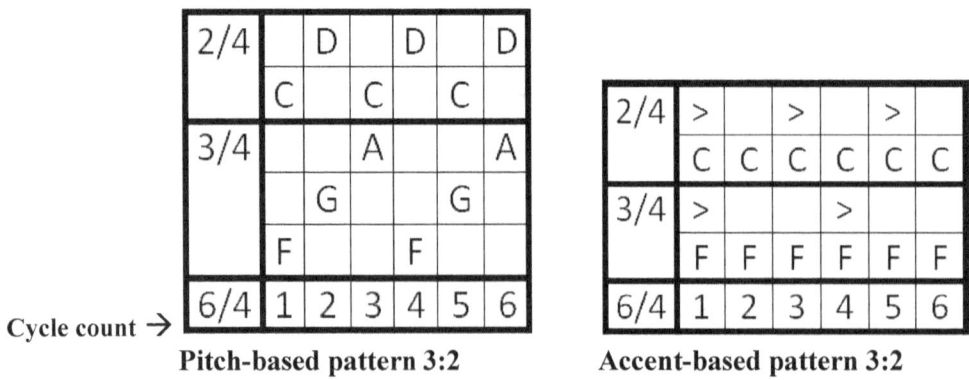

Pitch-based pattern 3:2 Accent-based pattern 3:2

[1] Perform a web search of "multistable image" for more details.
[2] However a more complex usage may consist of the combination of pitch-based and accent-based patterns.

Relatively prime meters for more interesting polymetric patterns

When considering the combinations of meters to use when creating polymetric patterns, the most complex *(and potentially most interesting)* are typically those having meters which are 'relatively prime' to each other. This means that there are no factors which are common between the two numbers, other than 1. Examples of pairs of relatively prime numbers include 2:3, 3:4, 4:5, 3:5, etc. Examples of combinations that are not relatively prime include: 2:4 *(common factor of 2)*, 3:6 *(common factor of 3)*, 4:12 *(common factor of 4)*, 10:15 *(common factor of 5)*, etc.

Notation for polymetric patterns – pitch vs. scale degree based

Notation throughout this text will consist of the following type: **absolute pitch-based**, where the note pitches are explicitly stated or **scale degree based**, where the note pitches are relative to a given scale or mode, such as the Major, Minor, Pentatonic, Lydian modes, etc. Patterns could also utilize chords or arpeggios.

Figure 1.5 / 1.6. Examples of polymetric patterns based upon pitch and scale degrees.

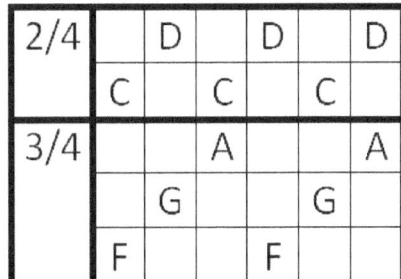
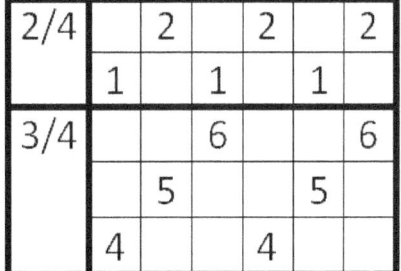

3:2 pattern based on pitches 3:2 pattern based on scale degrees

In order to illustrate the similarities between pitch-based and degree-based notation, if we declare the degree-based example to be in the scale of C, then these two examples are identical in pitches. It is interesting that the degree-based notation allows much flexibility due to the modes that can be utilized during a particular pattern. This is explored later in the text.

Understanding the idea behind the puzzles

My thought about the idea of these puzzles is that by conquering a puzzle, you are achieving independence of your hands, which is an interesting challenge for both of the hands as well as the mind. Throughout this book you will notice that it is relatively easy to play the puzzles, hands separately. That is the intrigue from my perspective – how is it that we can play hands separately, yet when using hands together the task can become nearly impossible!

Recommendations for mastering puzzles

The puzzles consist of patterns which are to be repeated while mastering the challenge of the exercise. They should be repeated in a meditative manner, allowing you to focus intensely on the challenge of the pattern itself.

Steps to follow which can help you to learn how to play any of the exercises in this book
1. Play each hand alone and make sure you are comfortable with a repeating pattern.
2. Using a recording device (on your cell phone, computer, IPad, etc.), record a part with one hand, and then play along with that part using the other hand.
3. With each hand separately, play as slow as you need to in order to play evenly. In other words, don't rush the easy parts and slow down on the difficult parts.
4. Play with both hands together, slowly and evenly.
5. Once you are comfortable with the pattern, try to play without looking at the notation. Think about your actual playing and the sound you are producing. This is a more natural way of playing and allows you to concentrate to a greater degree.
6. Increase the tempo as desired.

Variations on Polymetric Puzzles

So far we have looked at the structures of a various polymetric patterns, adhering strictly to the patterns without variation. Below is a description of several methods for creating variations with the patterns. These variations can be used to create additional patterns entirely or to enhance an existing work. Alternatively, the variations may be used to help create material spontaneously during an improvisation. In any case, they allow for much experimentation which may result in a number of interesting results. The variations are broken down into five categories: tonal, articulation, rhythmic, structural and arrangement.

Tonal variations
- Alter scale degrees or modes which the degrees are based upon. This may include utilization of scales such as whole tone, chromatic, diatonic, pentatonic, or even the degrees of a chord for arpeggiation.
- The use of accidentals (sharps / flats) where deemed appropriate.
- Use chords in place of single note melodies.
- Play the pattern on a different set of keys by moving your hand position to a different set of keys of your choice. This is considered to be modulation and helps to add interest to a piece.

Articulation variations
- Experiment with a variety of accents.
- Ornaments such as trills, mordents, etc.
- Insert silence using rests.
- Experiment with different attacks of the keys, such as a short pressing of a key (also called staccato) or longer pressing of a key (also called legato).
- Use dynamics to bring out a different voice. This is somewhat different than applying accents, which typically apply to selective notes, rather than an entire melody segment.
- If using a piano or keyboard capable of touch sensitivity, experiment with different dynamics (loud, soft, medium, etc.)
- If using a piano or a keyboard with sustain pedal, experiment with using the sustain pedal, along with the dynamics.
- Use passing tones.

Rhythmic variations[3]
- Further subdivide patterns into other n-lets (3-let, 5-let, 7-let), which would likely result in implicit polyrhythms.
- Utilize metric modulation as a variation, This is most easily done by juxtaposing different patterns together, creating a group of patterns (e.g. 3:4 → 5:6 → 2:5 repeating)
- Combine polymetric patterns with any combination of note values (quarter, eighth, sixteenth, triplets, etc.)
- Use a number of species from counterpoint techniques: note against note, two notes against one, in general N notes against one, notes offset against each other, or finally florid counterpoint which consists of any number of these species being used together. (species which contain fractional ratios could be thought of as being polyrhythmic, such as two notes against three, or three notes against 4,etc.).
- Convert a pattern directly to a polyrhythm, such as a 3:4 polymetric pattern into a 3:4 polyrhythmic pattern.
- Combine different polymeters with polyrhythms (e.g. 2:3 polyrhythm with 5:5 polymeter illustrated later in the text).

Structural variations
- Swap (or exchange) the right hand and left hand patterns.
- Shorten or elongate one of the melodic patterns to introduce a different Polymeter during a performance (e.g. a piece beginning as a 3:5 polymeter changes to 3:6 and then 3:7 during the piece).
- Try different combinations of patterns to construct a piece of music.
- Combine patterns with free improvisation, including solos.

Arrangement variations
- If you are using an electronic keyboard or synthesizer, experiment with different sound settings to see which produce interesting results for the pattern.
- Sing one pattern while playing the other on a keyboard.
- Utilize Polymetric Puzzles with ensembles, designating different instruments with each pattern.

[3] Polyrhythms are mentioned early in the book for completeness of the variations. For those unfamiliar with polyrhythms, they are discussed in detail in chapter 4.

Polymetric Puzzles – describing levels of difficulty

One of the major goals of this text is to introduce polymeters and the difficulties that occur when trying to perform them, especially with a single person performing both parts on an instrument, such as a piano or synthesizer[4]. As mentioned earlier, when the level of difficulty increases, even though a musician can play each separate pattern with a single hand, the difficulty of playing them "hands together" is where a significant challenge arises. Next we will see how the levels of difficulty increase, and specifically describe the attributes of the patterns that define how difficult a pattern is to perform, that is: **motion**, **slope** and **proximity of notes**.

Challenge Levels – classification of Polymetric Puzzles

Motion (easiest to most difficult)
a) contrary motion (strict) – notes move in exact opposite directions, including exact intervals.
b) parallel motion – notes move in the same direction, including exact intervals.
c) contrary motion (non-strict) – notes are in opposite directions, but not in exact intervals.
d) similar motion – notes move in the same direction, but not in exact intervals.
e) oblique motion – one note remains at the same pitch while the other changes, in either direction (up or down).
f) free motion – a combination of all methods above (a – e).

Slope / direction of notes (easiest to most difficult)
a) purely ascending or purely descending notes for each pattern.
b) a mixture of ascending and descending notes for each pattern.
c) a mixture of ascending, descending and static notes for each pattern.

Proximity of notes (easiest to most difficult)
a) stepwise sequence of notes (e.g. scale-wise sequence).
b) non-stepwise sequence of notes, including octaves, arpeggios, etc.
c) non-stepwise sequence of notes other than predictable structures such as octaves and arpeggios.

Examples of challenge levels

The **easiest type of puzzle** will generally contain strict contrary motion, purely ascending or descending notes for each pattern, and will consist of a sequence of stepwise notes (e. g. motion=a, slope=a and proximity=a).

The **most difficult type of puzzle** will generally contain free motion, a mixture of ascending, descending and static notes with each pattern, and contain non-stepwise sequences of notes other than octaves and arpeggios (e. g. motion=f, slope=c and proximity=c).

A shorthand notation could be used which utilizes the parameters (**M)otion**, **(S)lope** and **(P)roximity**. We could then say that a puzzle is defined with values for each parameter of M, S, and P. Therefore the easiest puzzle would be categorized as AAA, and the most difficult type would be categorized as FCC.

[4] However these patterns can be performed with nearly any instrument, including percussion and voice.

Chapter 2: Polymetric Puzzles and Variations

In chapter 1 we discussed what a polymetric puzzle is, and how it is constructed. In this chapter we describe how a polymetric puzzle is performed, which of course, solves the puzzle.

Working out a Puzzle
Readers may decide to go through the book by attempting to "solve the puzzles" - playing pieces using the shorthand notation or they may prefer to play the sample solutions in Appendix 1. Either approach is fine and up to the individual. It is certainly recommended that you try the shorthand method and seek the adventure of working out the problem of coordinating different time signatures before trying the solutions.

Understanding the Notation
Looking at the various puzzles, you will notice that the left hand and right hand have different time signatures. This is why the puzzles are "polymetric" – meaning "many" meters played at once (see chapter 1 for details).[5] Review Figures 2.1 and 2.2, which is an example puzzle and its solution. Notice that in order to complete a single cycle, we need to play the 3/4 measure 2 times and the 2/4 measure 3 times. This results in a solution with a cycle of 6/4.

Figure 2.1. Solving a Polymetric Puzzle

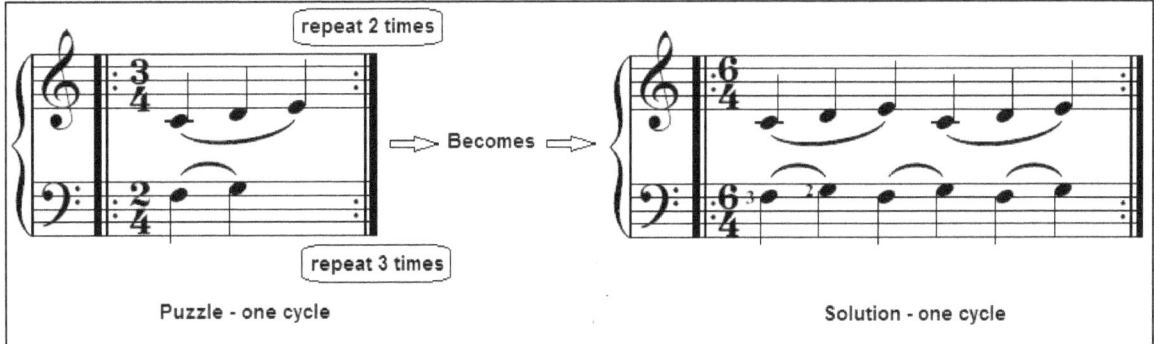

Figure 2.2. Illustrating the transformation from puzzle to solution

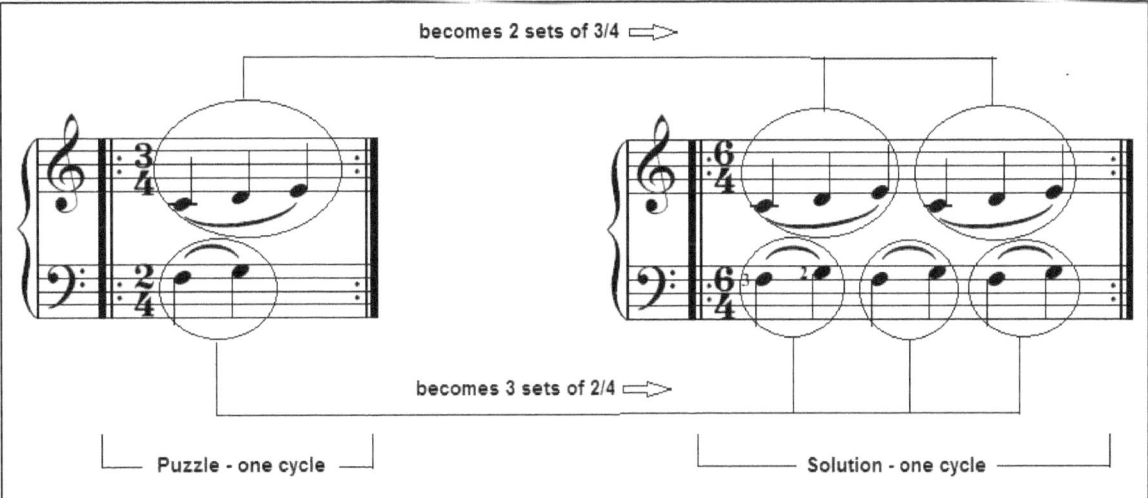

[5] The focus of this book uses 2 meters, however more are certainly possible.

Observations of the notation
For simplicity of readability and clear understanding, we use quarter notes in many of the puzzles; therefore the quarter note is assigned to the beat. In some cases other note values are used, especially where this helps to clarify a possible approach to playing the puzzle.

Structure of measures and the freedom of playing the puzzles
The first thing you will notice looking at puzzles on the pages that follow is that there are several measures on a page, each with repeat bars. Each of these bars is actually a single puzzle – a complete cycle which needs to be understood how to play. The goal is to learn each of the cycles and repeat them as desired; in some cases you may decide to play each cycle only once, which typically increases the difficulty. In addition to deciding on repetition, feel free to play these cycles in any order you like, omit certain cycles, or even create variations as you desire.

Freedom is an important aspect of playing these puzzles, to allow one to create their own version of a puzzle. Lastly, feel free to play the puzzles at any speed you desire, keeping in mind that this can drastically change the spirit of the piece. This may include playing a piece at multiple tempos.

Solving the puzzle
This involves playing at least one cycle of the polymetric puzzle. Preferably you should be able to execute several cycles to show mastery of playing the different meters simultaneously. Refer to the section "Recommendations for mastering puzzles" in chapter 1 for more detail.

Variations – customizing a pattern
Once you have accomplished playing cycles of the puzzle, you are ready to try variations. This may include any number of music elements, such as different dynamics, articulation, tempo, etc. Refer to the section "Variations on Polymetric Puzzles" in chapter 1 for a detailed list of variations.

2:3 Polymetric Puzzle

Note: in order to complete a cycle of 2:3 polymeter, the 2/4 measures are repeated 3 times and 3/4 measures are repeated 2 times. Cycles may also be repeated as desired (typically twice throughout the piece). Feel free to play the measures in the order shown or experiment with alternatives.

Jeff Fineberg

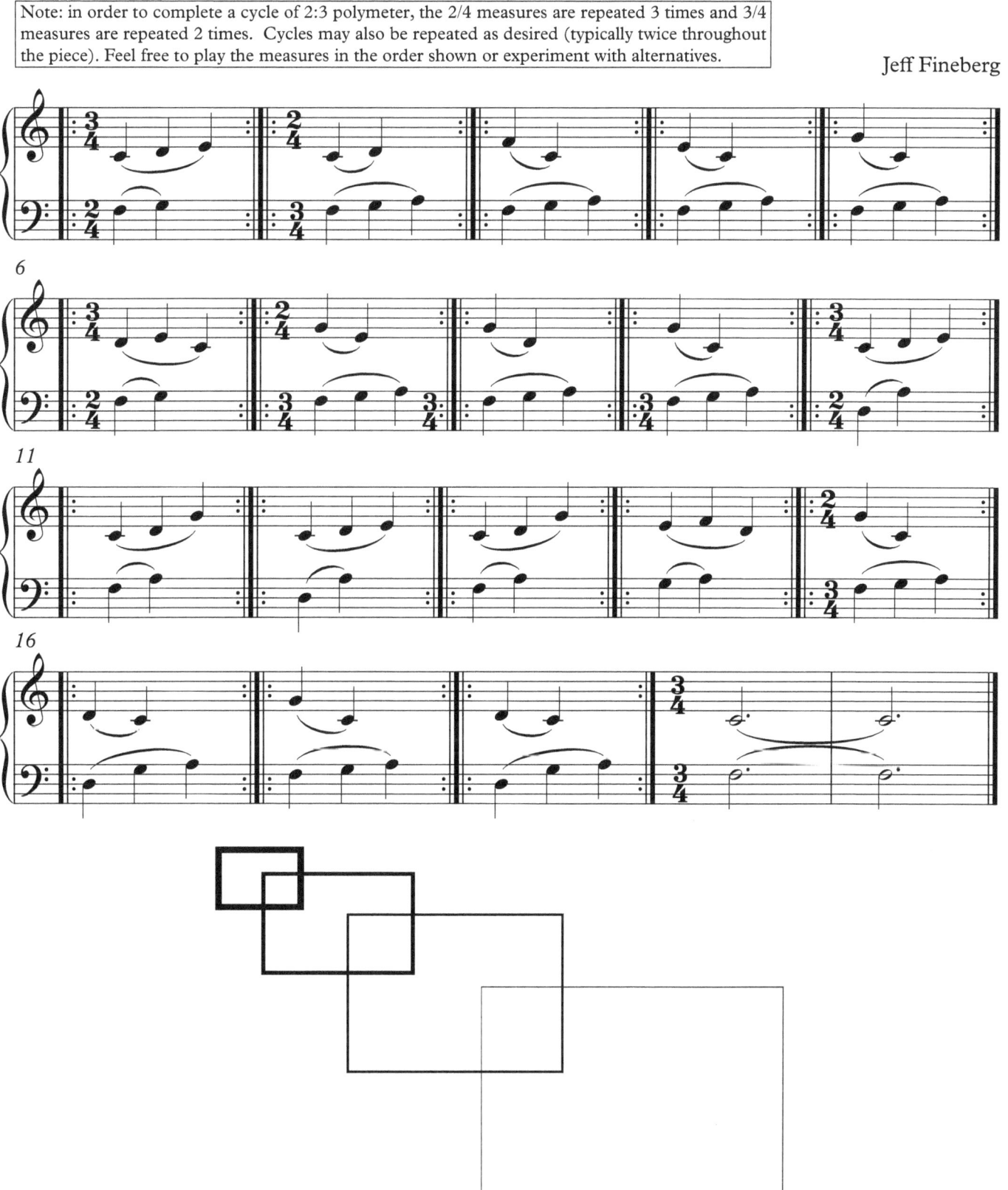

Which square is closest and which is furthest? Similarly, which meter is in the forefront and which is secondary?

© 2014 Jeff Fineberg

2:3 Polymetric Puzzle - Variation 1

Performance Note: in order to complete a cycle of 2:3 polymeter, the 2/4 measures are repeated 3 times and 3/4 measures are repeated 2 times. Cycles may also be repeated as desired (typically twice throughout the piece).

Jeff Fineberg

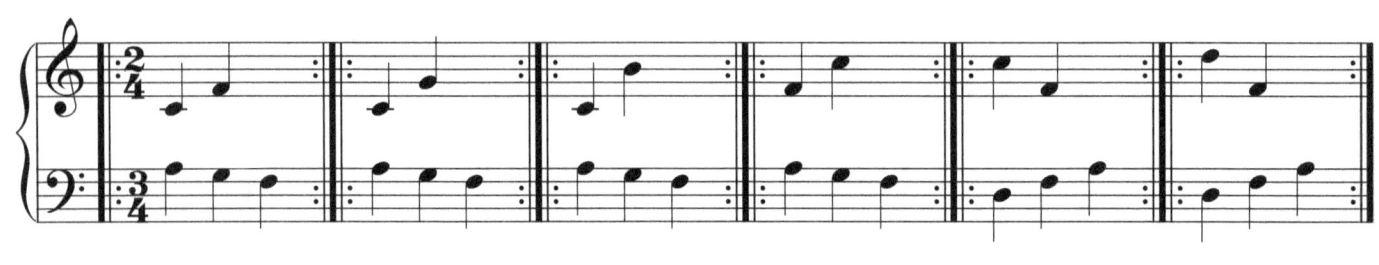

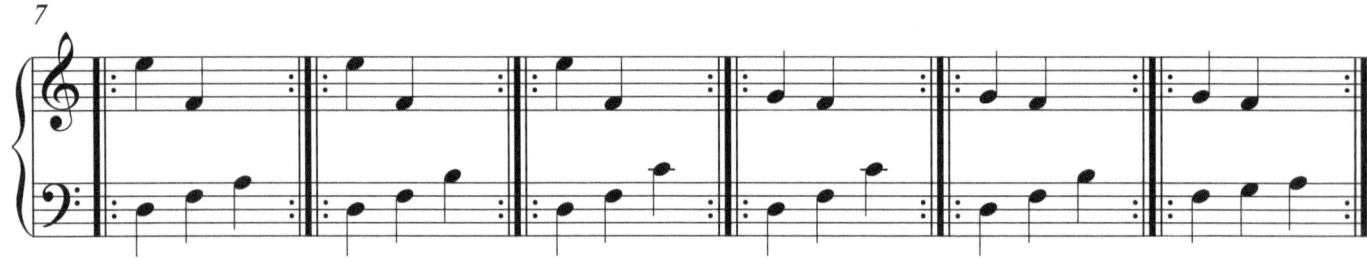

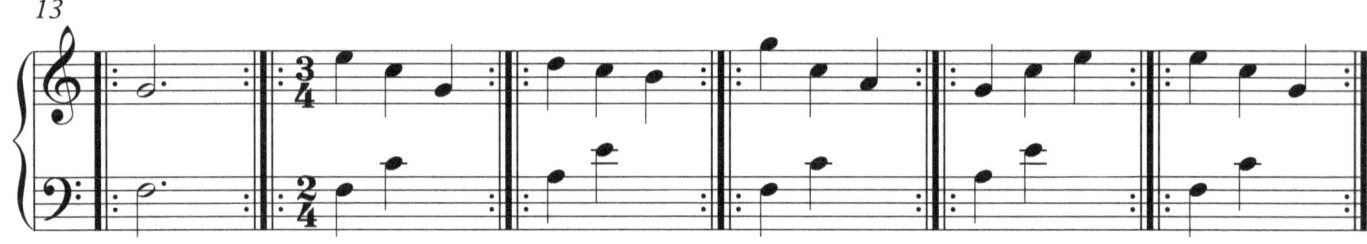

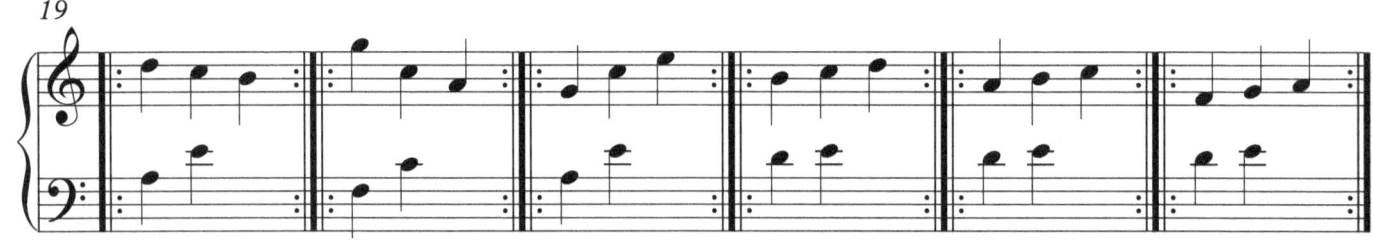

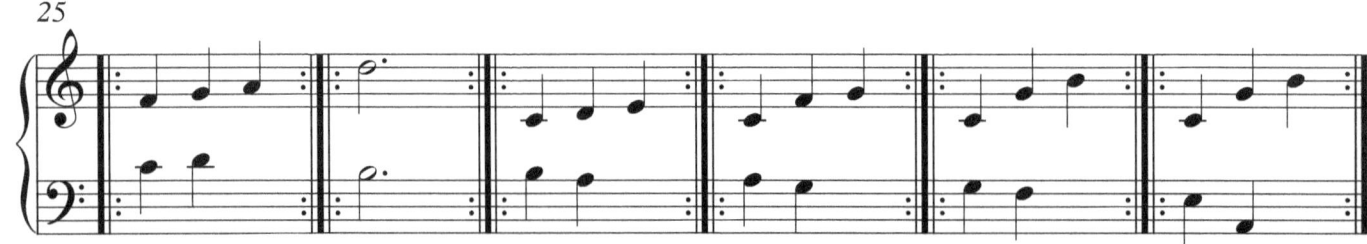

© 2014 Jeff Fineberg

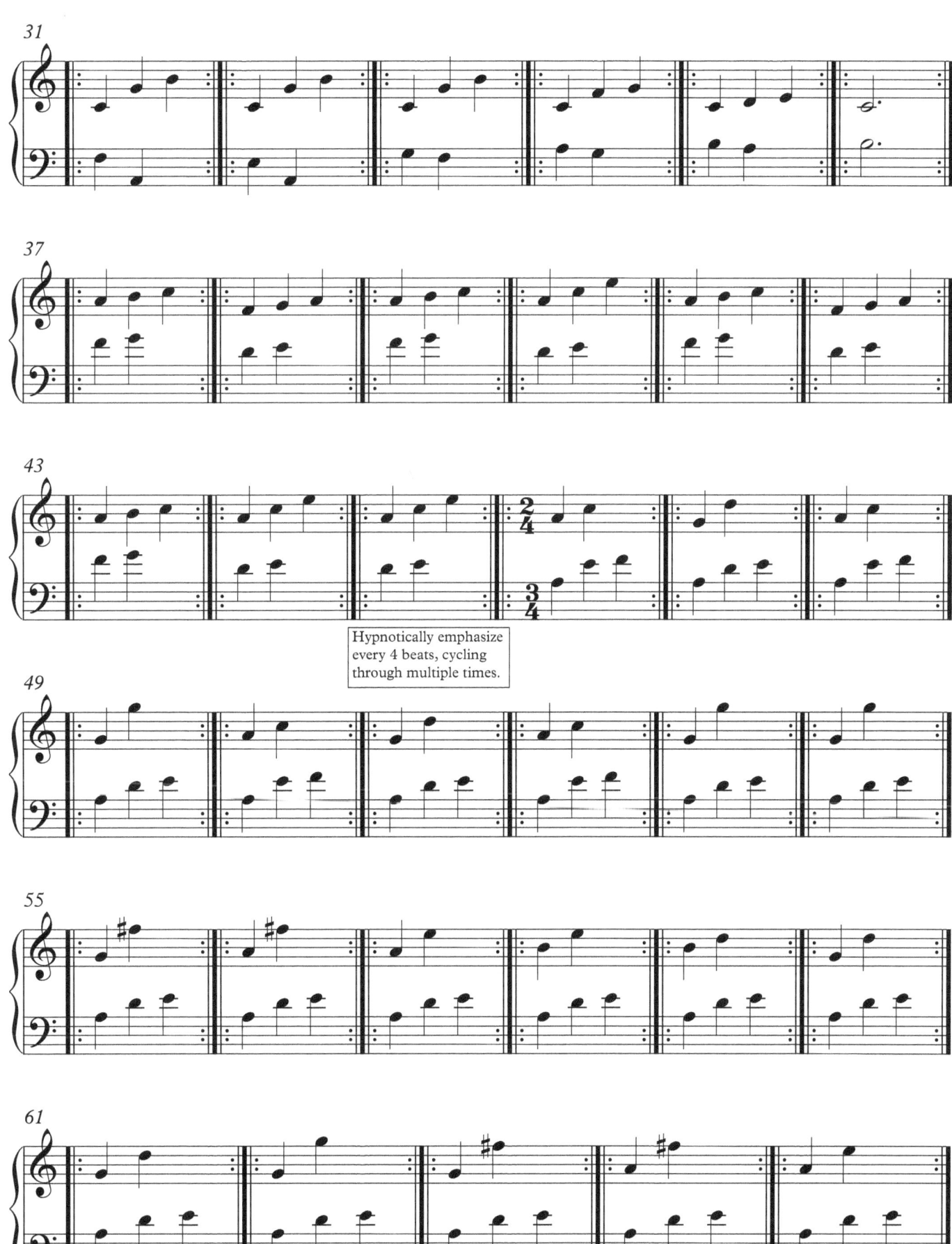

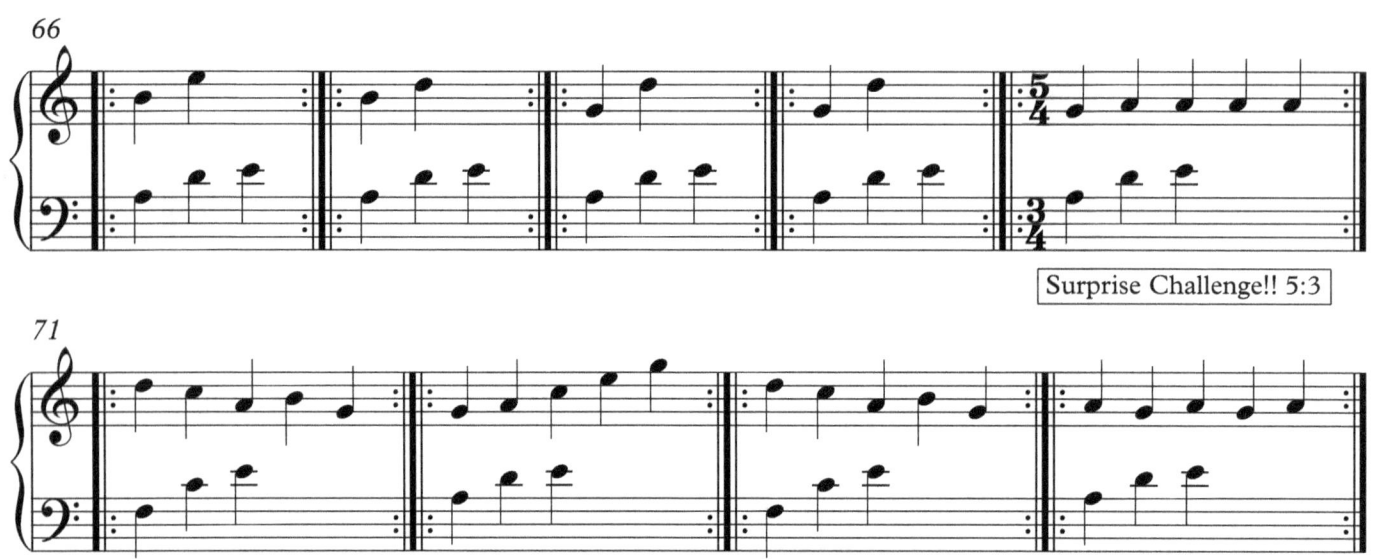

Surprise Challenge!! 5:3

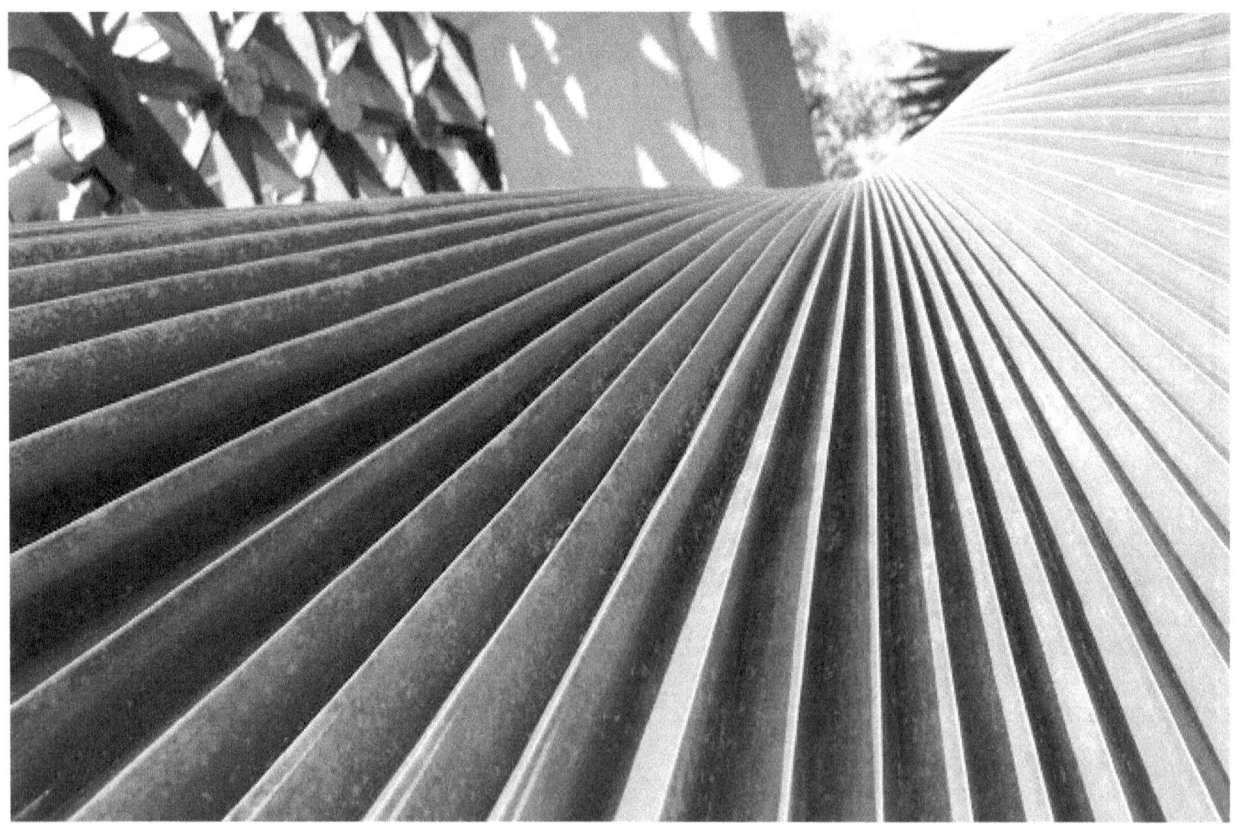

© 2014 Jeff Fineberg

3:4 Polymetric Puzzle

Jeff Fineberg

Performance Note: in order to complete a cycle of 3:4 polymeter, the 3/4 measures are repeated 4 times and 4/4 measures are repeated 3 times. Cycles may also be repeated as desired (typically twice throughout the piece).

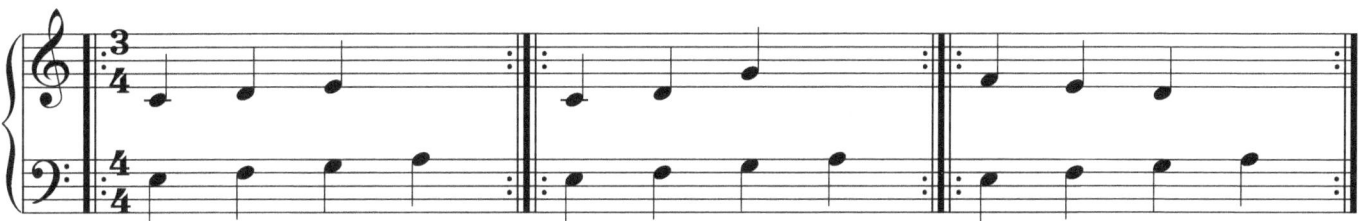

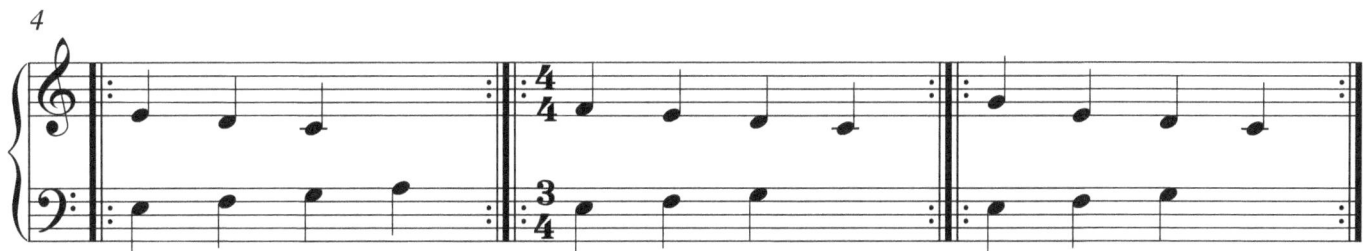

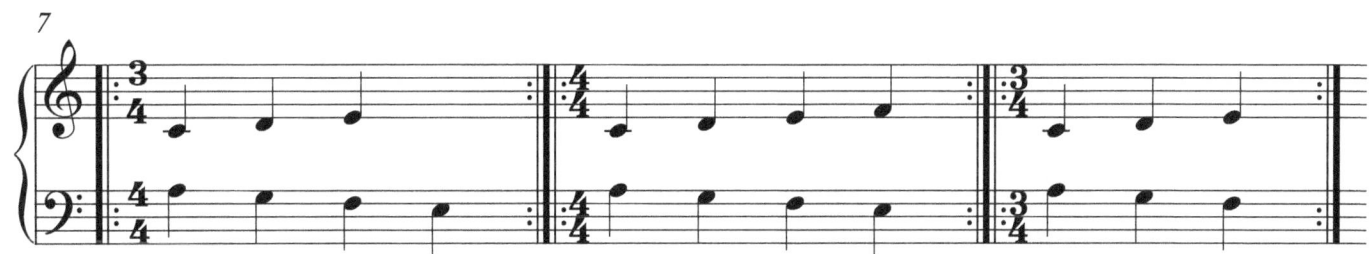

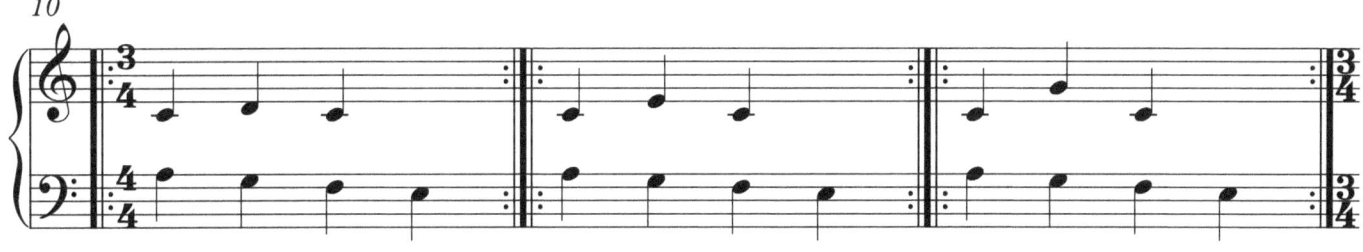

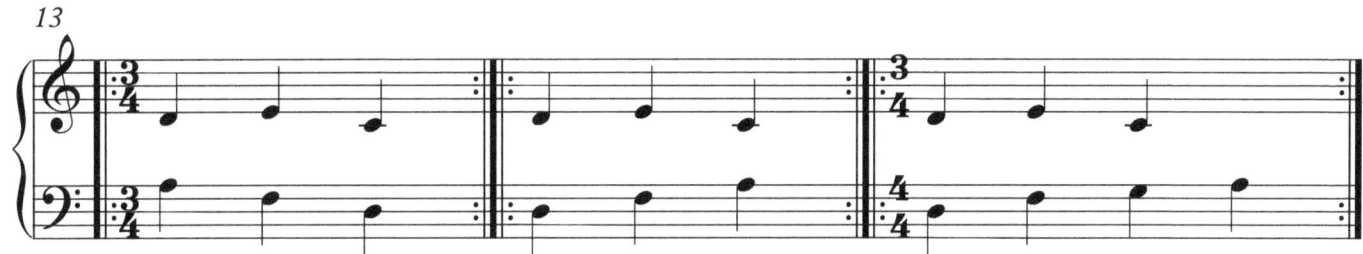

Copyright 2013

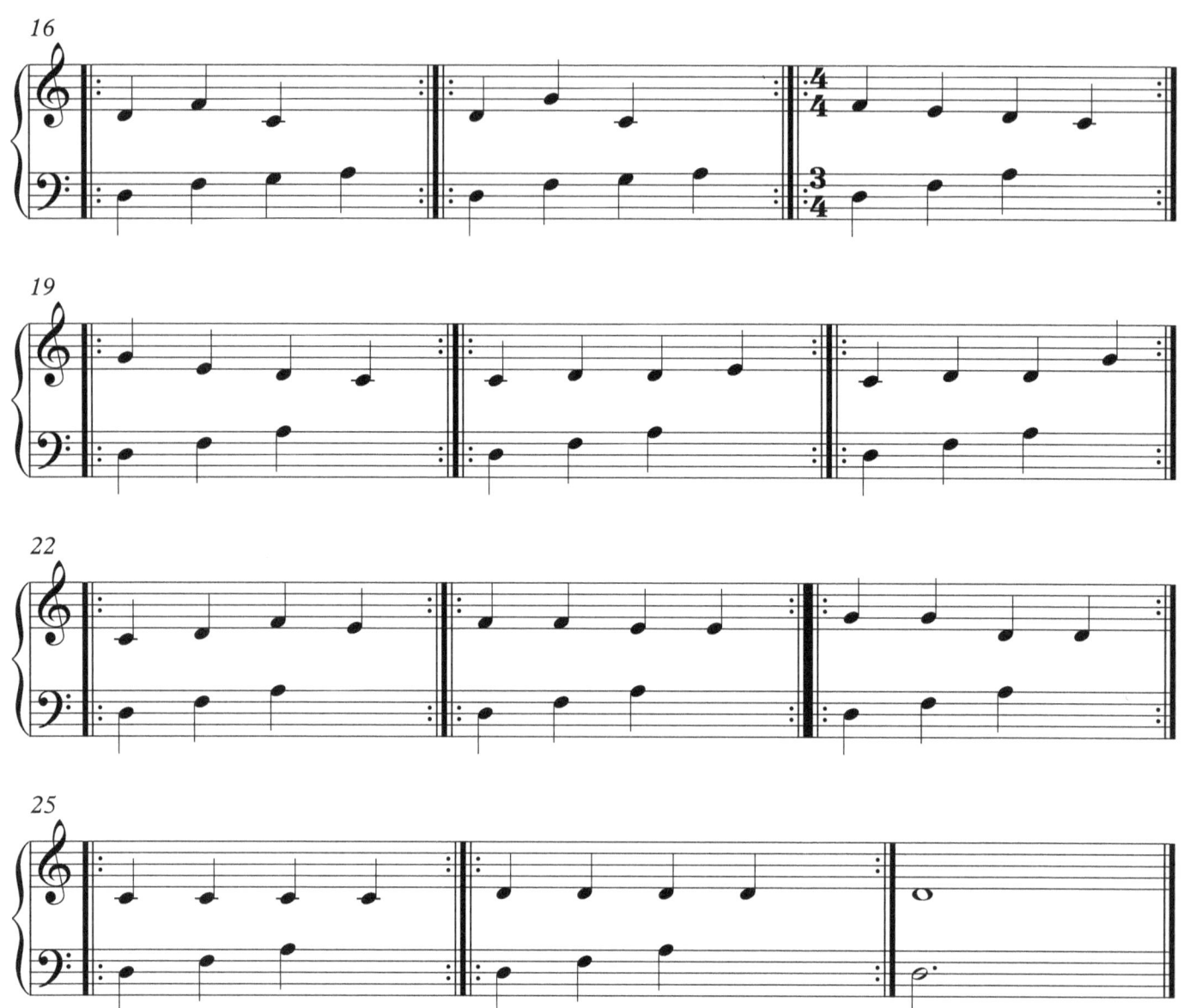

3:4 Polymetric Puzzle - Variation 1

Performance Note: in order to complete a cycle of 3:4 polymeter, the 3/4 measures are repeated 4 times and 4/4 measures are repeated 3 times. Cycles may also be repeated as desired (typically twice throughout the piece).

Jeff Fineberg

© 2014 Jeff Fineberg

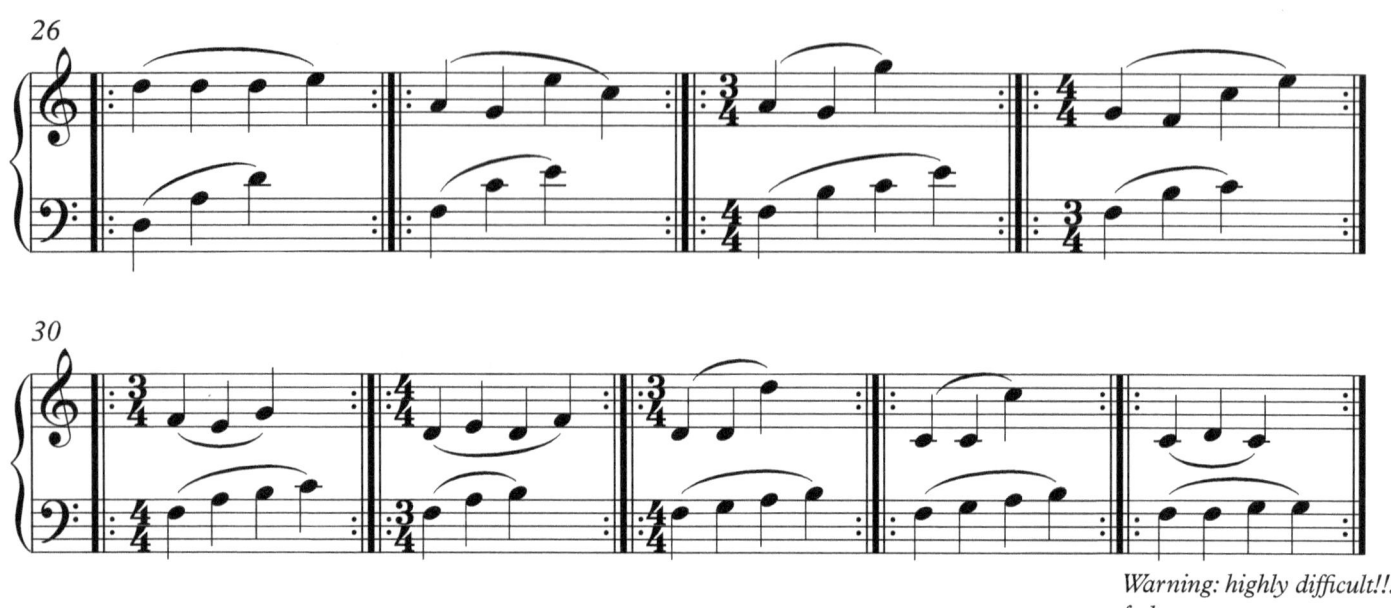

Warning: highly difficult!!!
fade away...

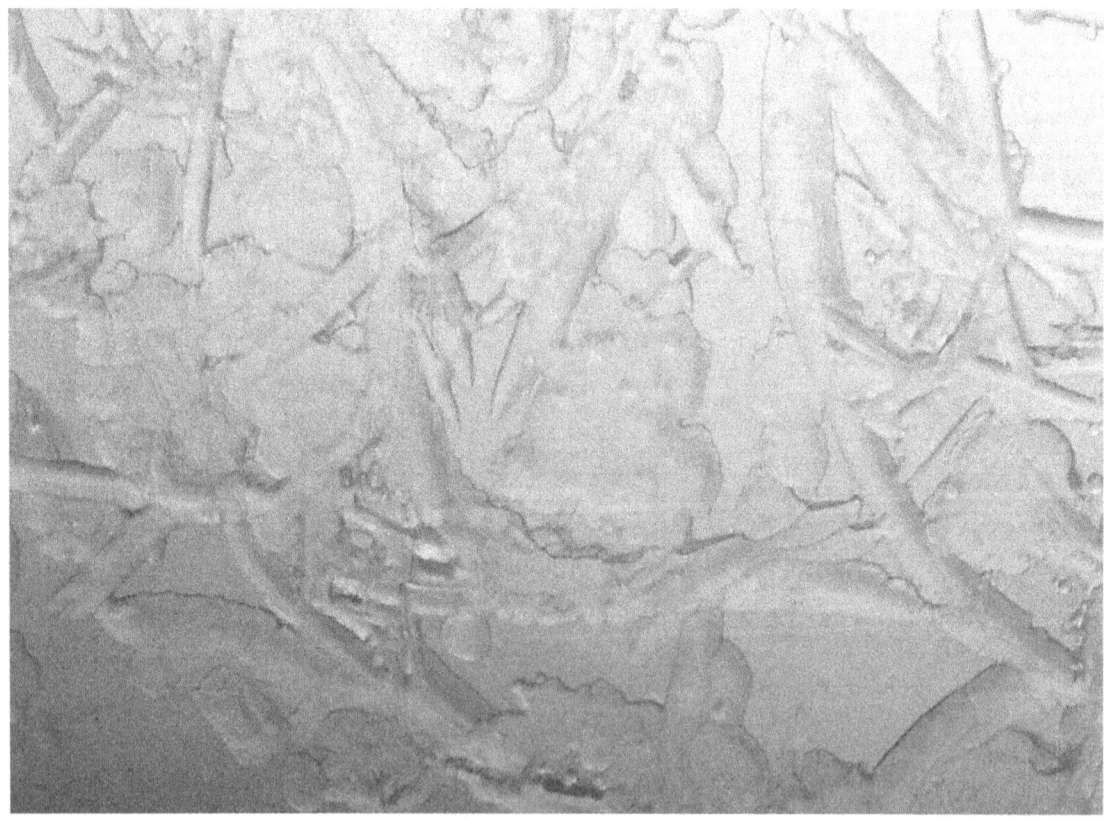

© 2014 Jeff Fineberg

4:5 Polymetric Puzzle

Jeff Fineberg

Performance Note: in order to complete a cycle of 4:5 polymeter, the 4/4 measures are repeated 5 times and 5/4 measures are repeated 4 times. Cycles may also be repeated as desired (typically twice throughout the piece).

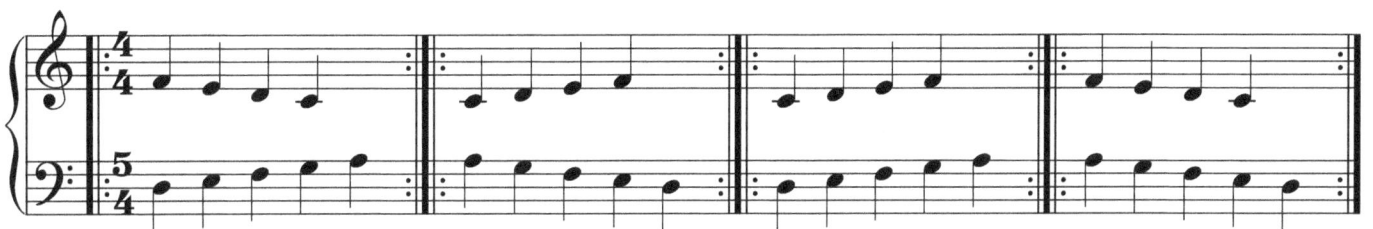

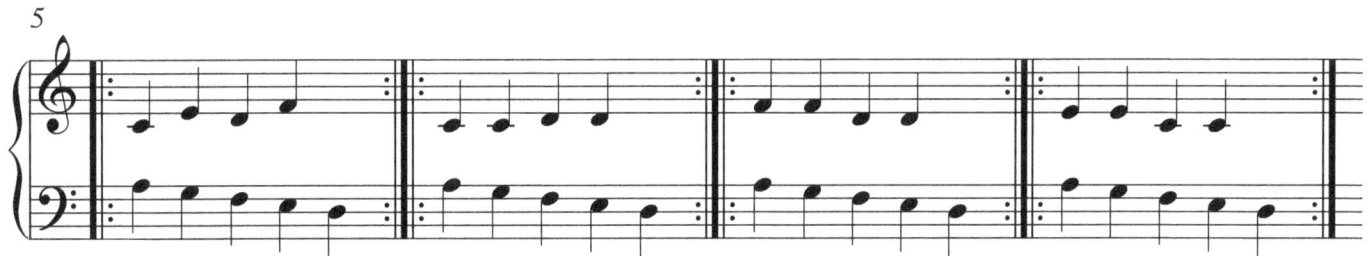

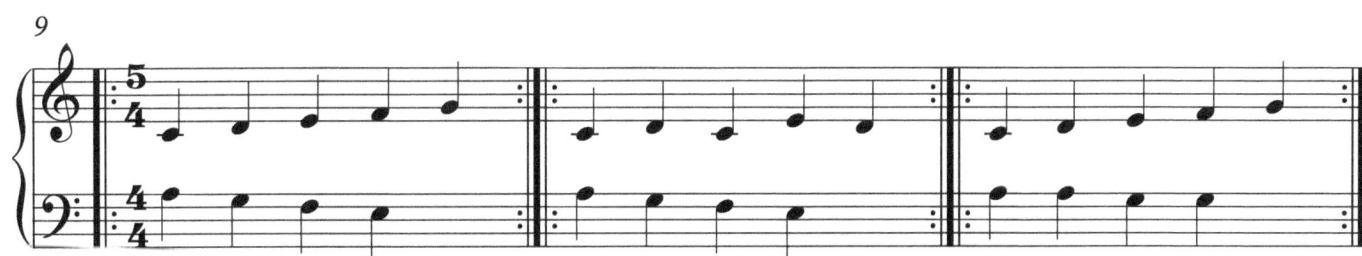

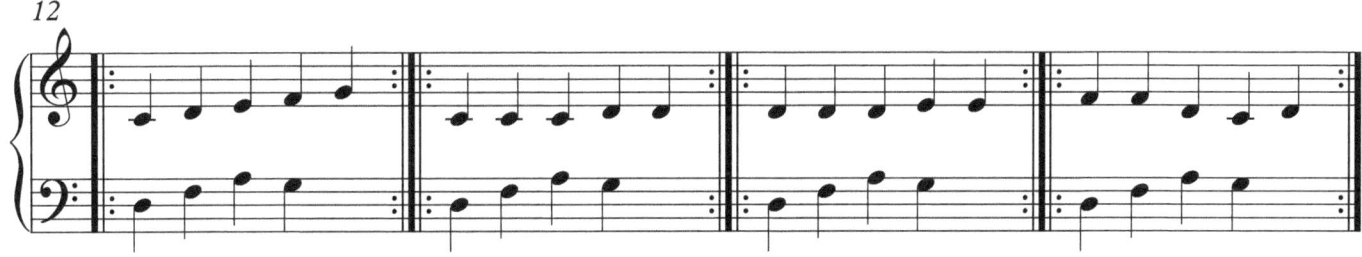

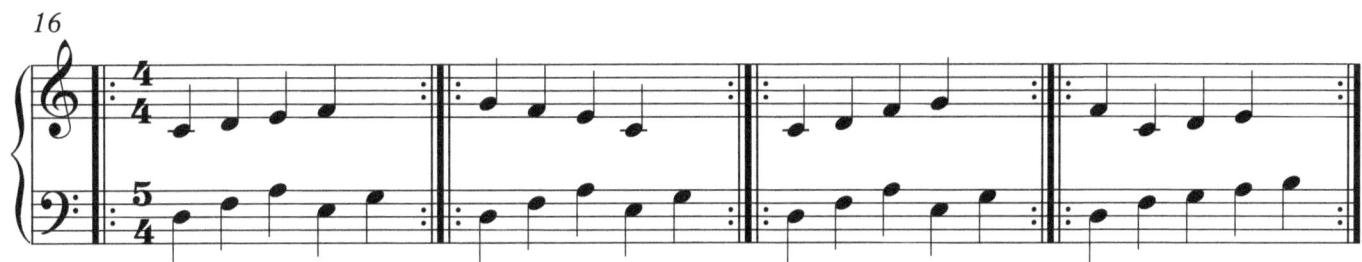

4:5 Polymetric Puzzle - Variation 1

Performance Note: in order to complete a cycle of 4:5 polymeter, the 4/4 measures are repeated 5 times and 5/4 measures are repeated 4 times. Cycles may also be repeated as desired (typically twice throughout the piece).

Jeff Fineberg

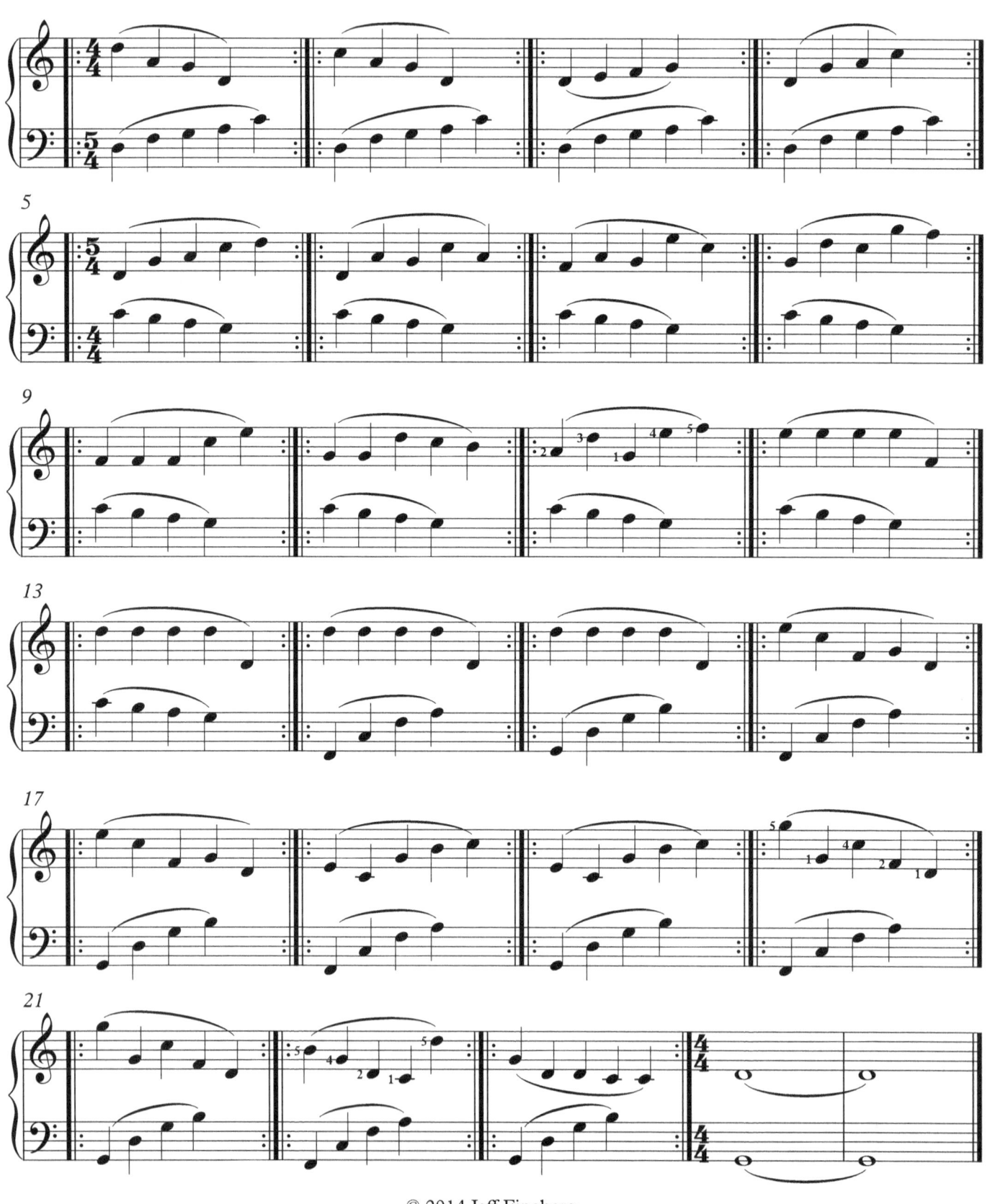

© 2014 Jeff Fineberg

5:6 Polymetric Puzzle

Performance Note: in order to complete a cycle of 5:6 polymeter, the 5/4 measures are repeated 6 times and 6/4 measures are repeated 5 times. Cycles may also be repeated as desired (typically twice throughout the piece).

Jeff Fineberg

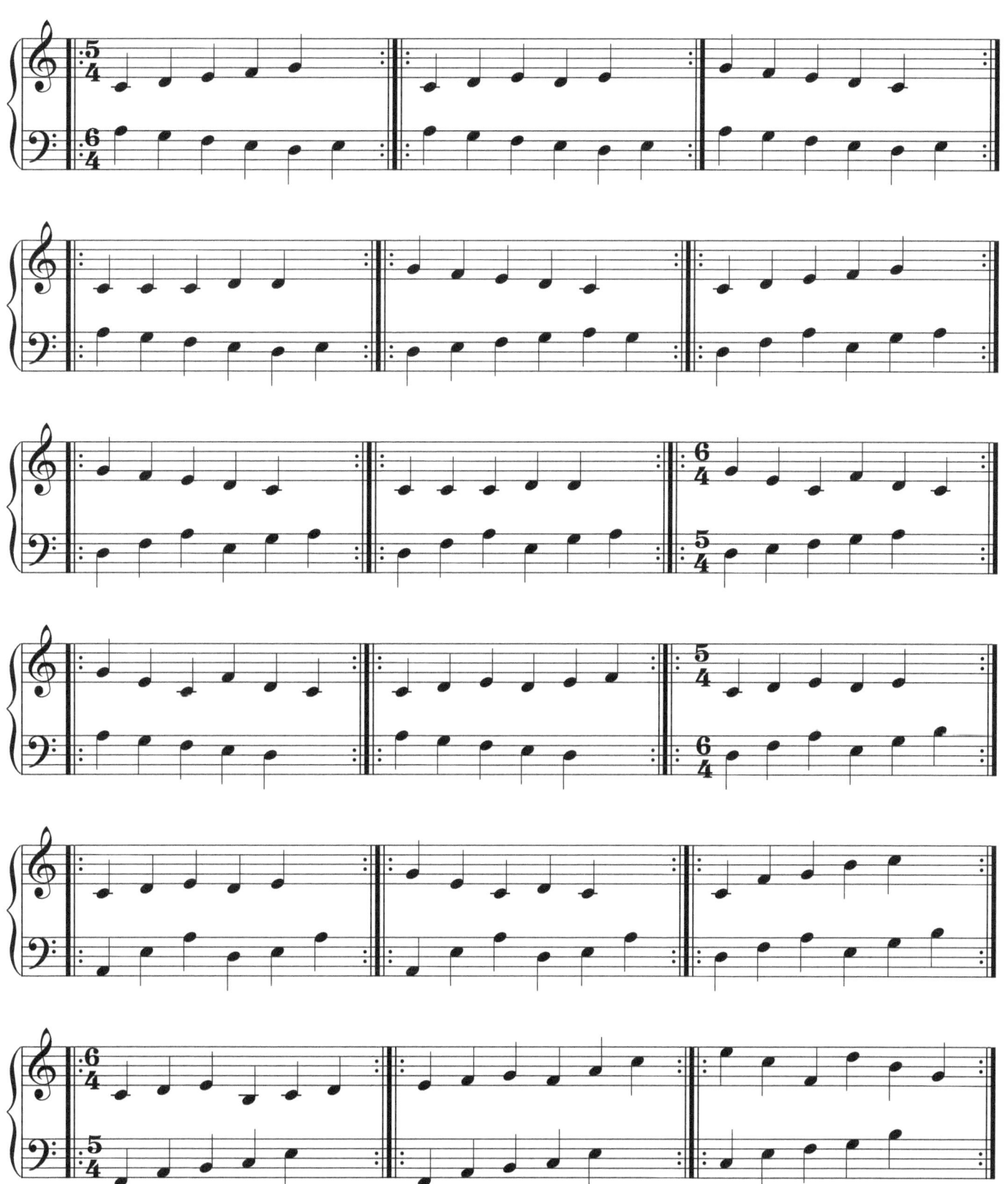

Copyright 2013

5:6 Polymeter Puzzle - Variation 1

Performance Note: in order to complete a cycle of 5:6 polymeter, the 5/4 measures are repeated 6 times and 6/4 measures are repeated 5 times. Cycles may also be repeated as desired (typically twice throughout the piece).

Jeff Fineberg

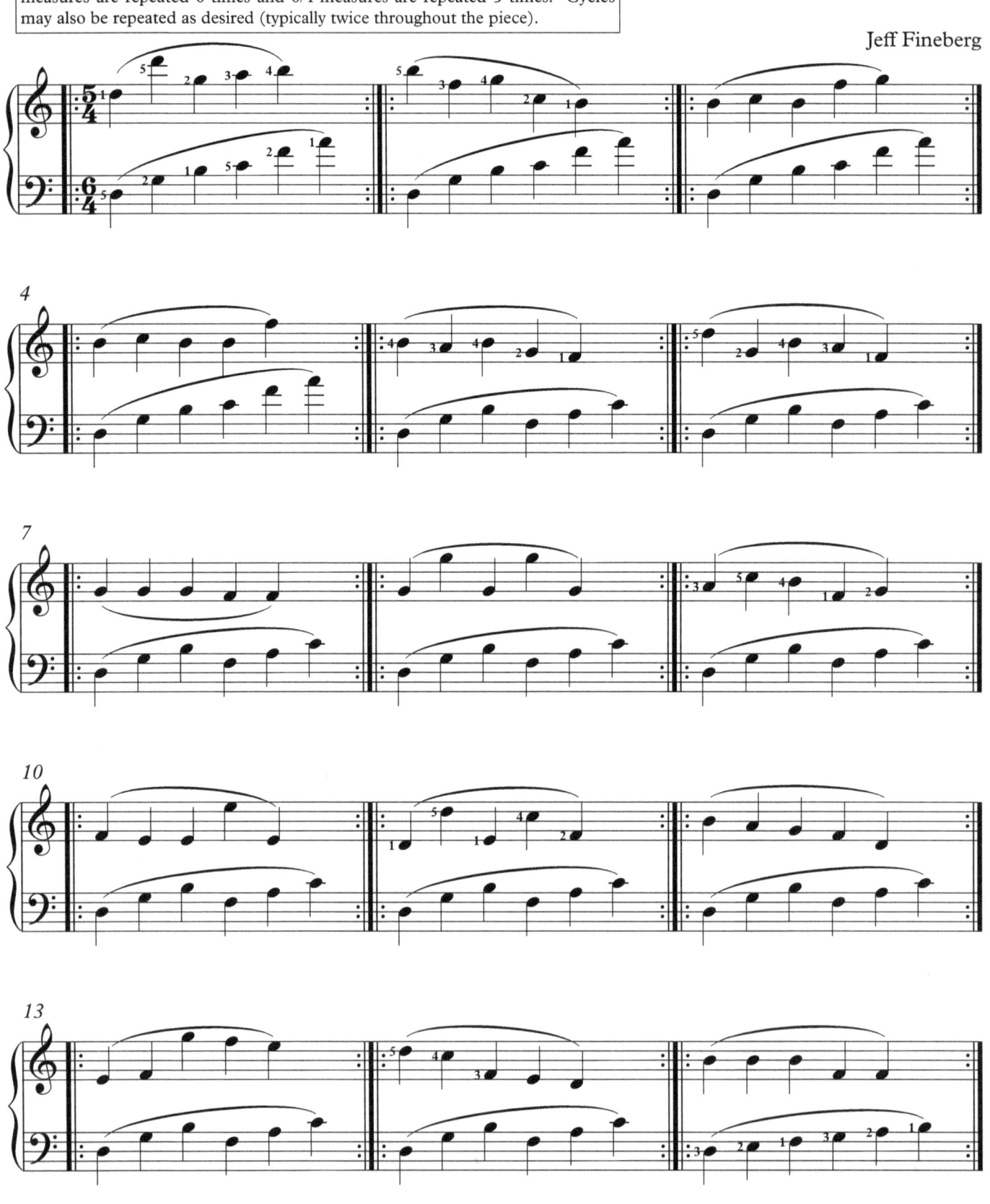

© 2014 Jeff Fineberg

6:7 Polymetric Puzzle

Performance Note: in order to complete a cycle of 6:7 polymeter, the 6/4 measures are repeated 7 times and 7/4 measures are repeated 6 times. Cycles may also be repeated as desired (typically twice throughout the piece).

Jeff Fineberg

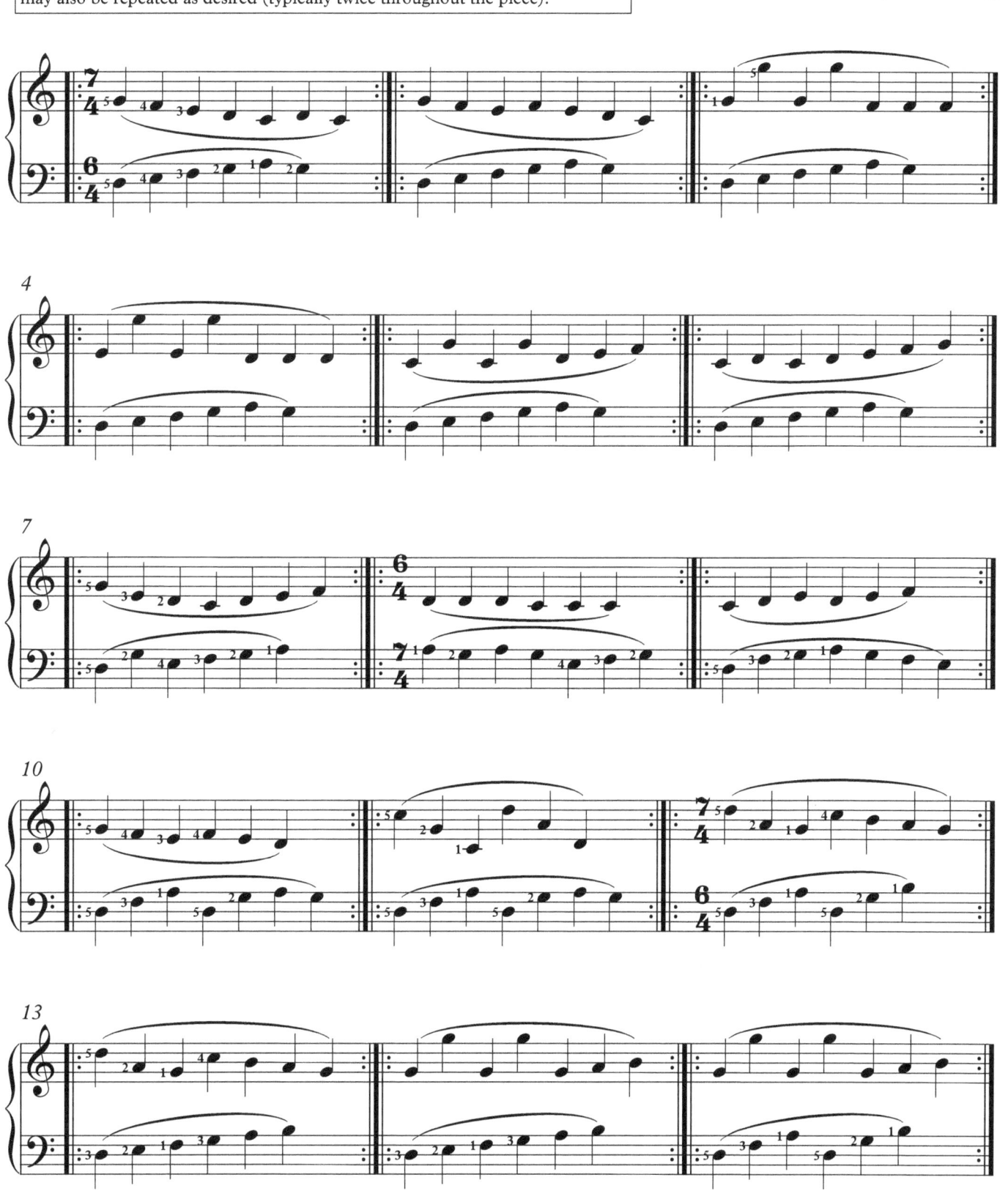

© 2014 - Jeff Fineberg

6:7 Polymetric Puzzle - variation 1

Performance Note: in order to complete a cycle of 6:7 polymeter, the 6/4 measures are repeated 7 times and 7/4 measures are repeated 6 times. Cycles may also be repeated as desired (typically twice throughout the piece).

Jeff Fineberg

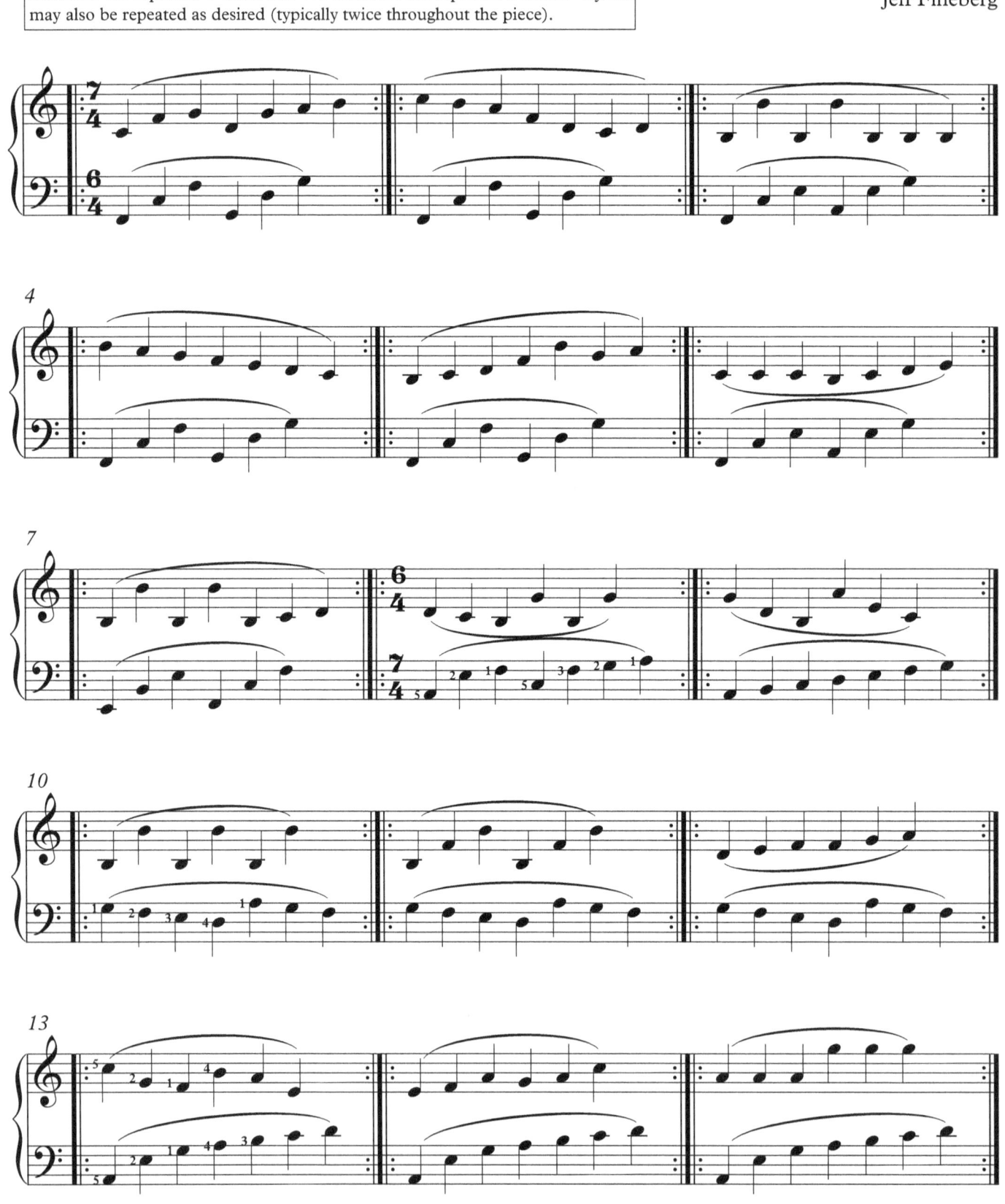

© 2014 - Jeff Fineberg

7:8 Polymetric Puzzle

Jeff Fineberg

Performance Note: in order to complete a cycle of 7:8 polymeter, the 7/4 measures are repeated 8 times and 8/4 measures are repeated 7 times. Cycles may also be repeated as desired (typically twice throughout the piece).

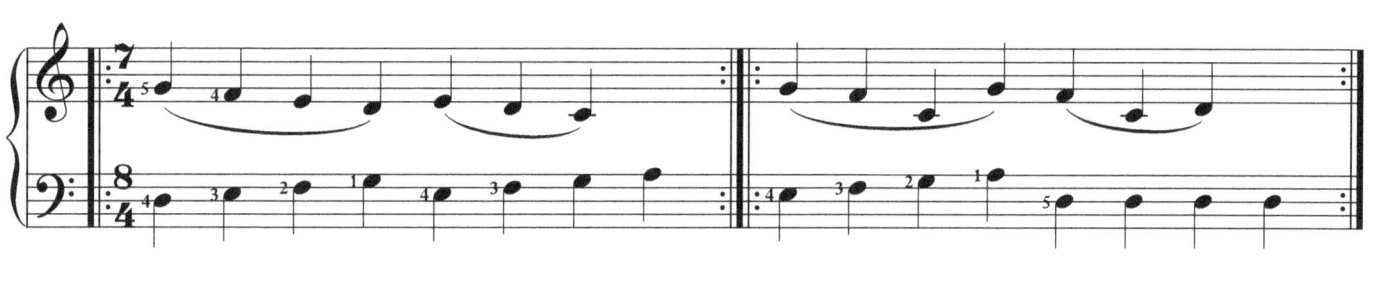

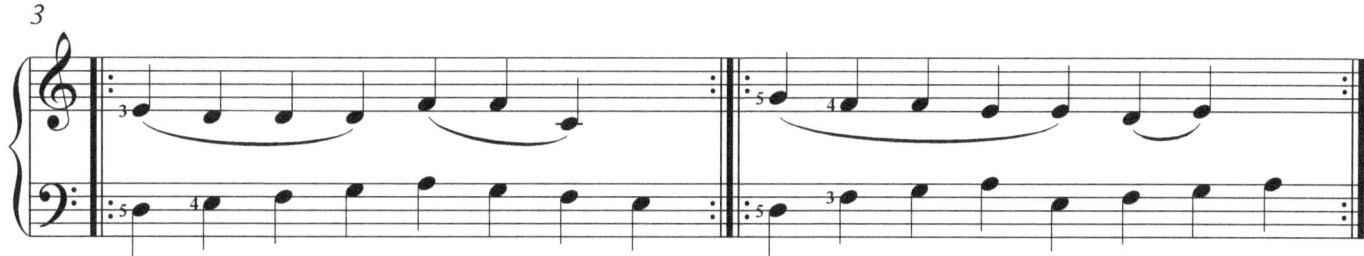

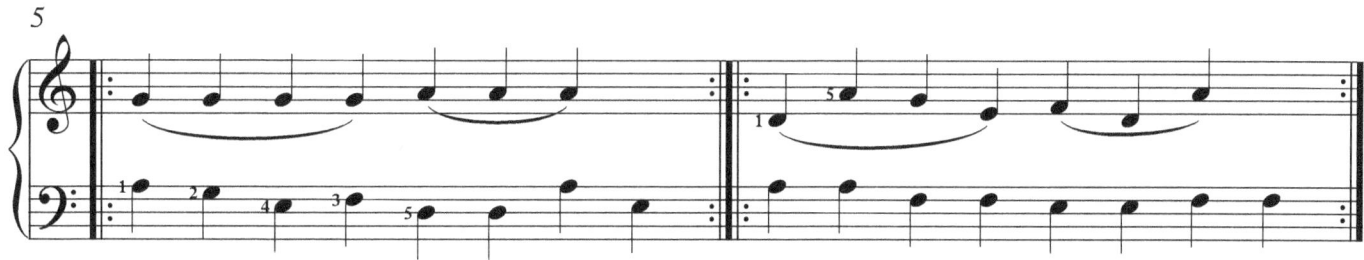

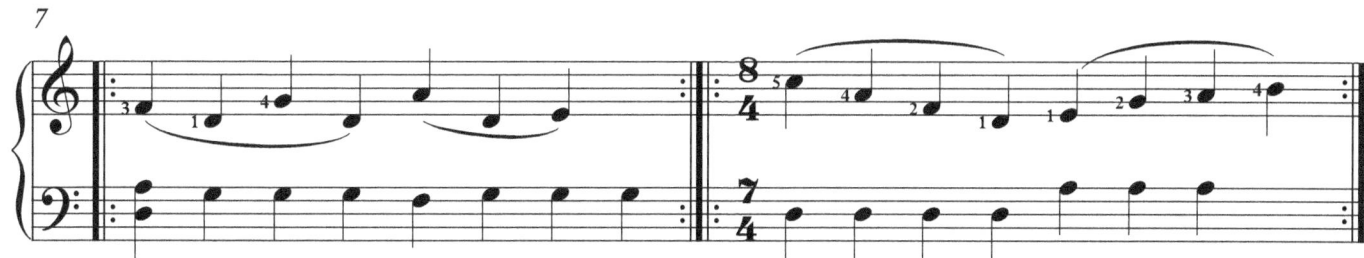

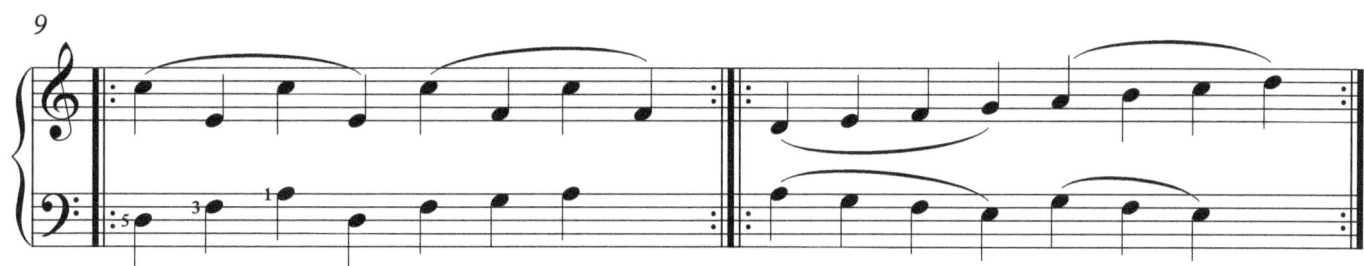

© 2013 - Jeff Fineberg

8:9 Polymetric Puzzle

Performance Note: in order to complete a cycle of 8:9 polymeter, the 8/4 measures are repeated 9 times and 9/4 measures are repeated 8 times. Cycles may also be repeated as desired (typically twice throughout the piece).

Jeff Fineberg

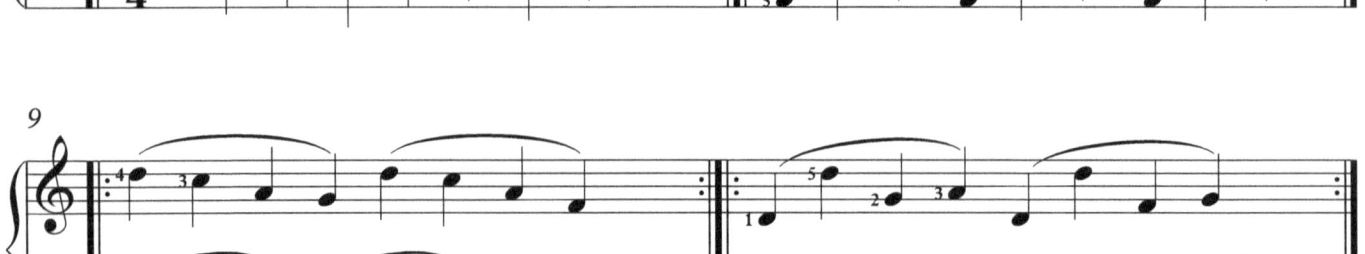

© 2013 - Jeff Fineberg

9:10 Polymetric Puzzle

Performance Note: in order to complete a cycle of 9:10 polymeter, the 9/4 measures are repeated 10 times and 10/4 measures are repeated 9 times. Cycles may also be repeated as desired (typically twice throughout the piece).

Jeff Fineberg

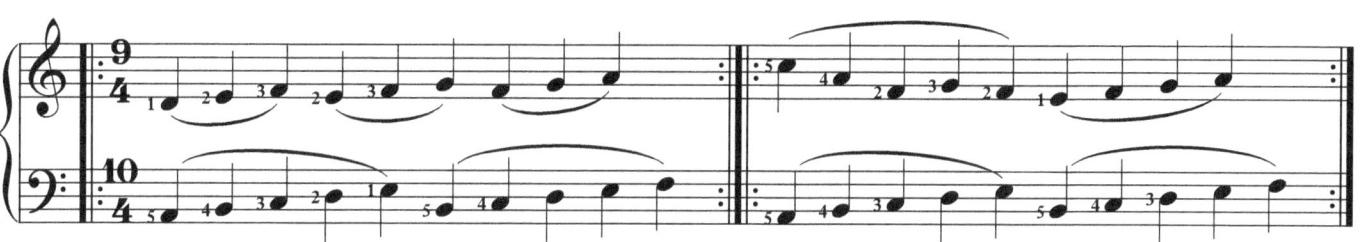

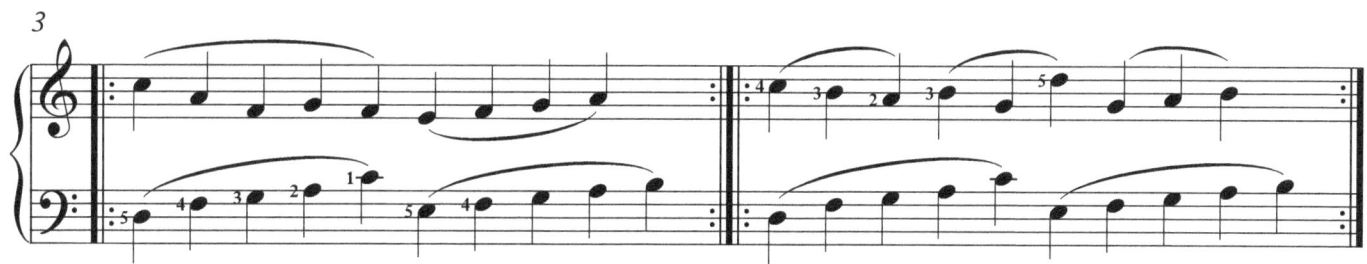

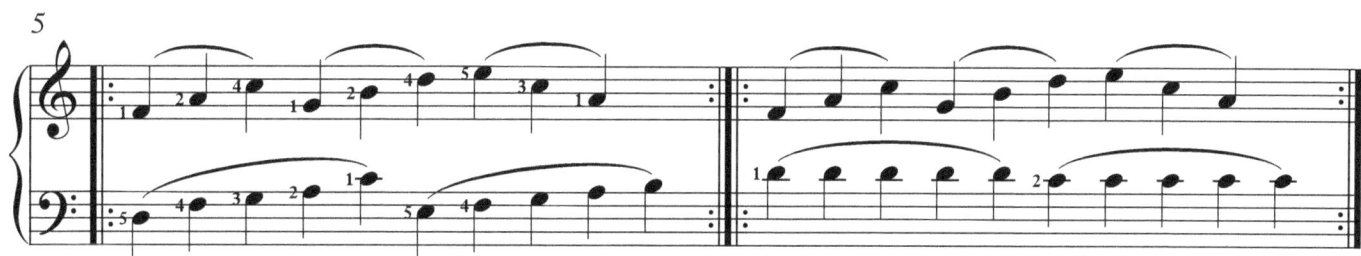

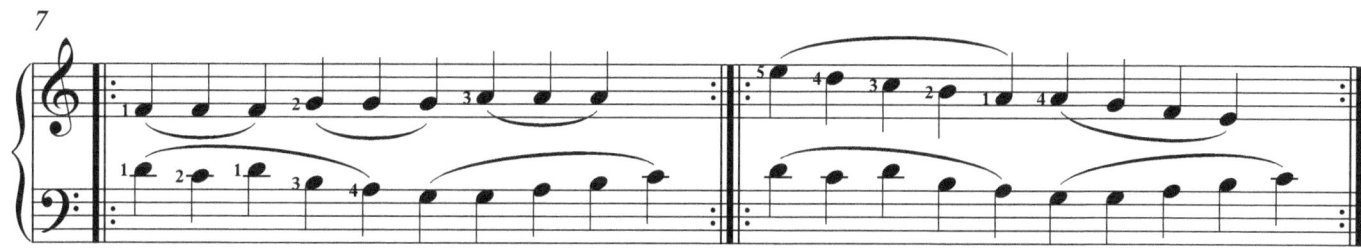

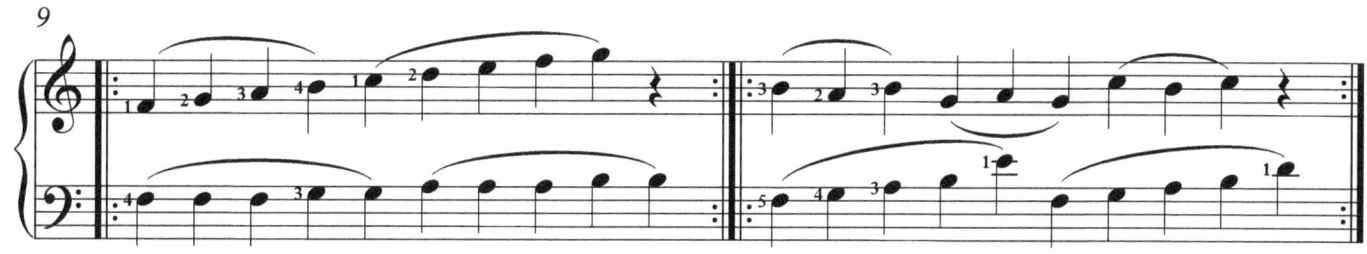

© 2013 - Jeff Fineberg

10:11 Polymetric Puzzle

Performance Note: in order to complete a cycle of 10:11 polymeter, the 10/4 measures are repeated 11 times and 11/4 measures are repeated 10 times. Cycles may also be repeated as desired (typically twice throughout the piece).

Jeff Fineberg

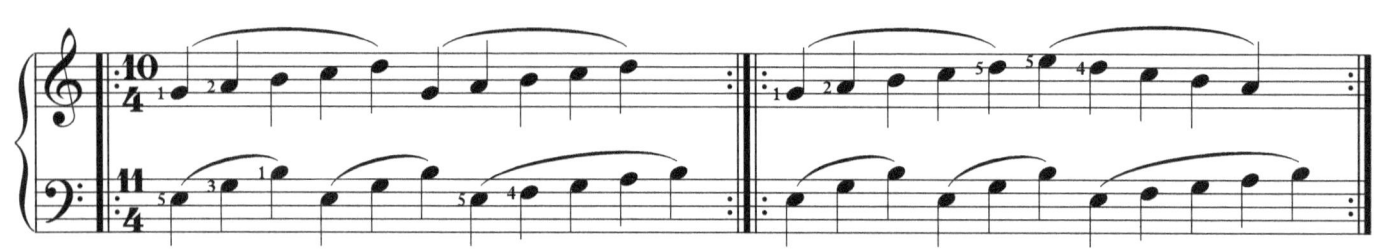

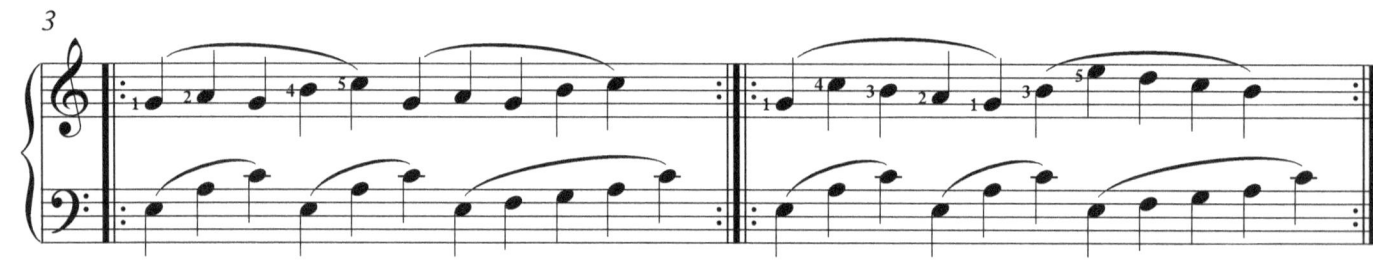

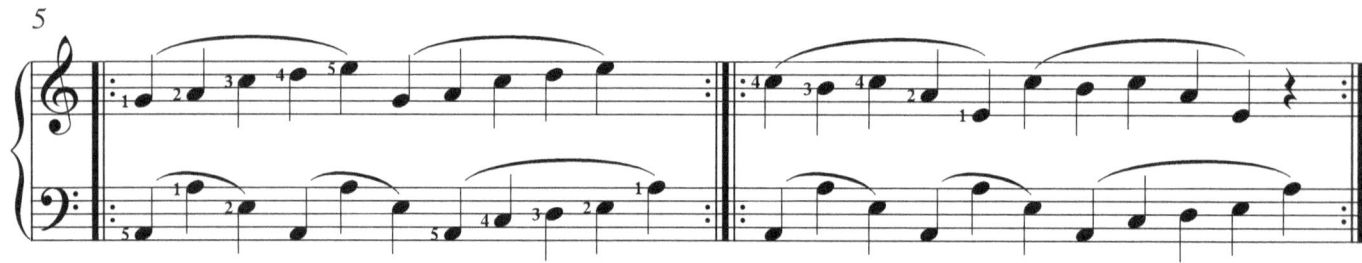

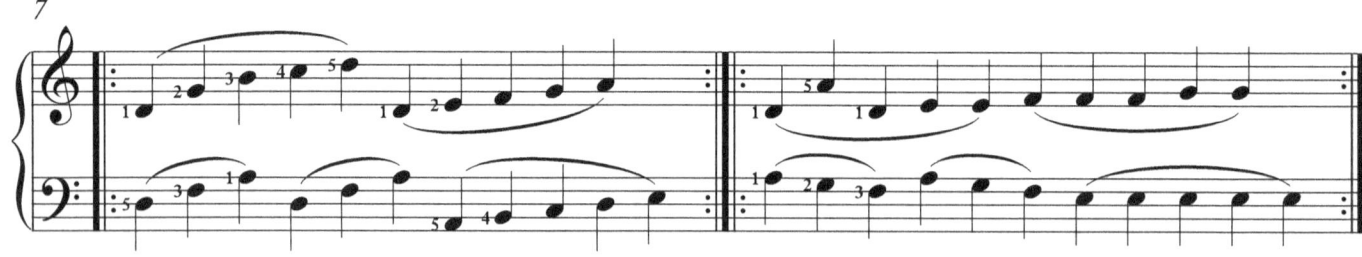

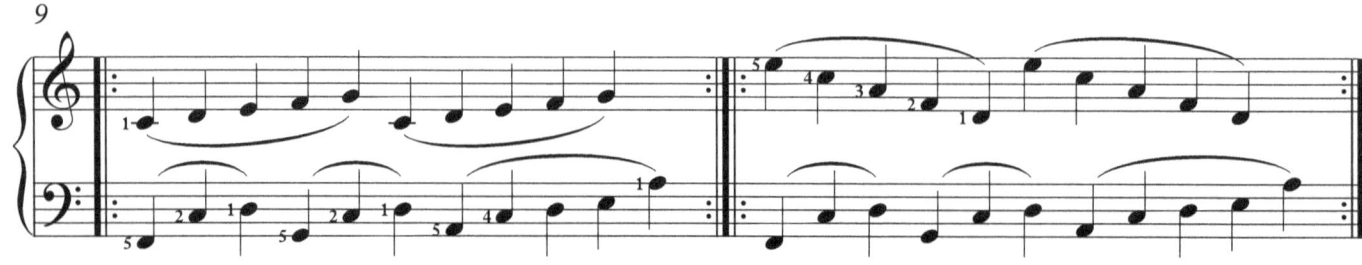

© 2013 - Jeff Fineberg

5:2 / 5:3 Polymetric Puzzle

Performance Note: each measure represents a cycle for 2 hands, such as 2:5, 3:5, etc. In order to complete a cycle of these polymeters, play each hand's measure by the number of beats for the other hand's measure. **For example, in 2:5, play the 2 beat measure 5 times and the 5 beat measure 2 times, equaling a total of 10 beats. Cycles may also be repeated as desired (typically twice throughout the piece).

Jeff Fineberg

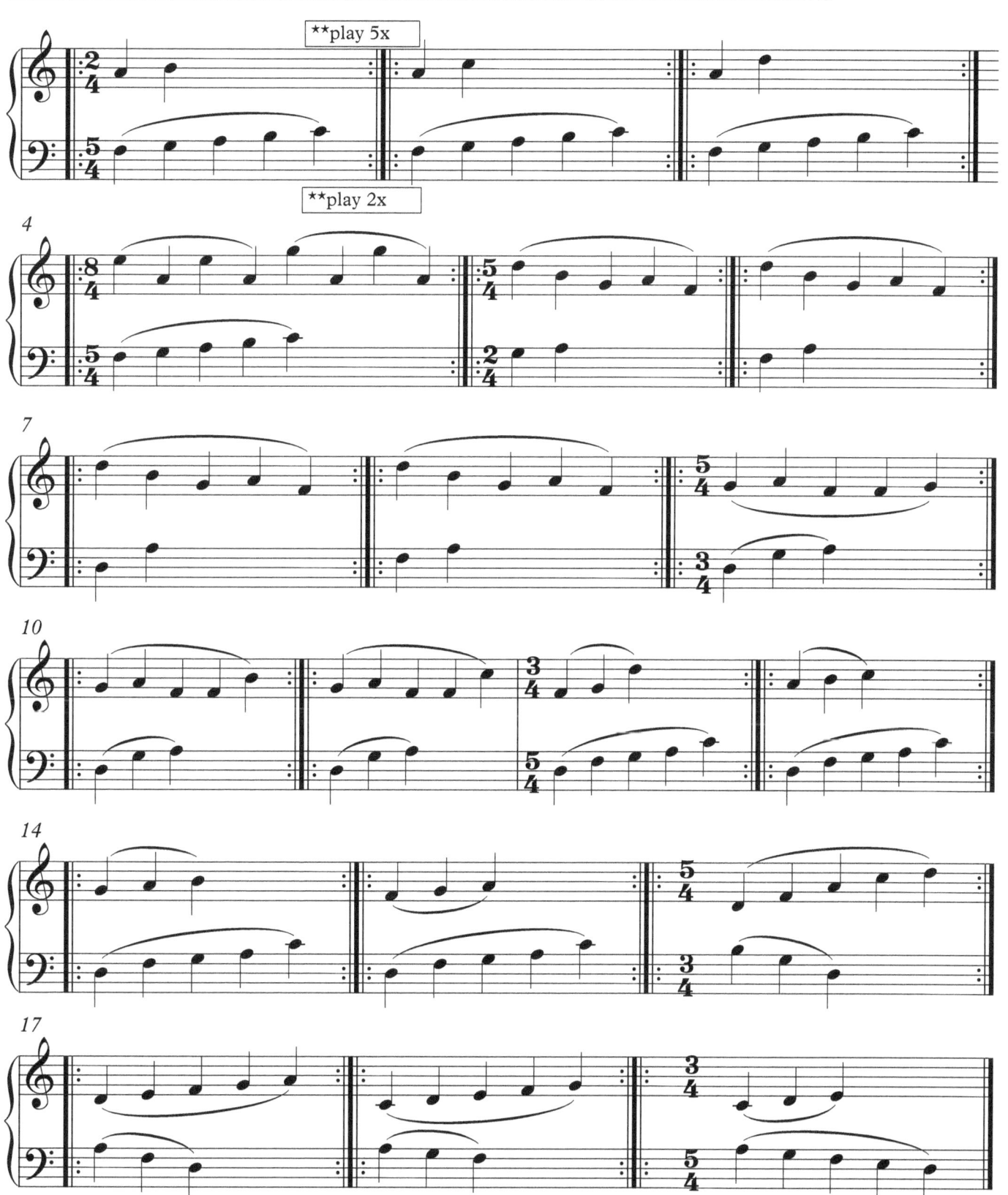

© 2013 - Jeff Fineberg

Polymetric Variations in 13,11,7,6,4,3,2,1
(a sort of comprehensive exam!)

Jeff Fineberg

Note: the number of times for a repeat is denoted as **'number x times'**, where 'number' is the number of times to repeat, such as 8x. Where a polymeter section exists, note that there are different number of repeats due to the different meters, such as repeating 2/4 8x and 1/4 16x.

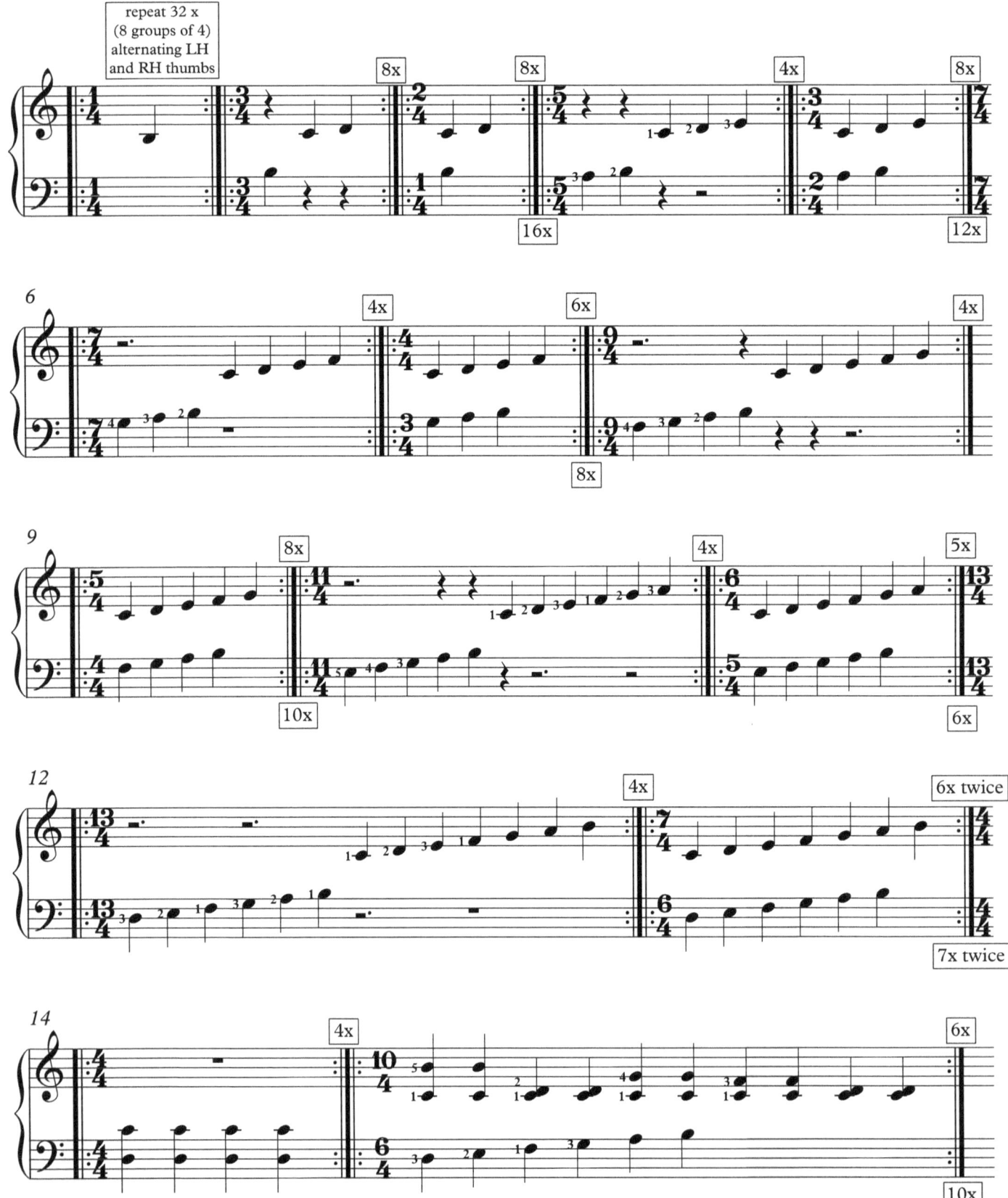

11:12 Polymetric Single Measure Challenge

Performance Note: in order to complete a cycle of 11:12 polymeter, the 11/4 measures are repeated 12 times and 12/4 measures are repeated 11 times. Cycles may also be repeated as desired.

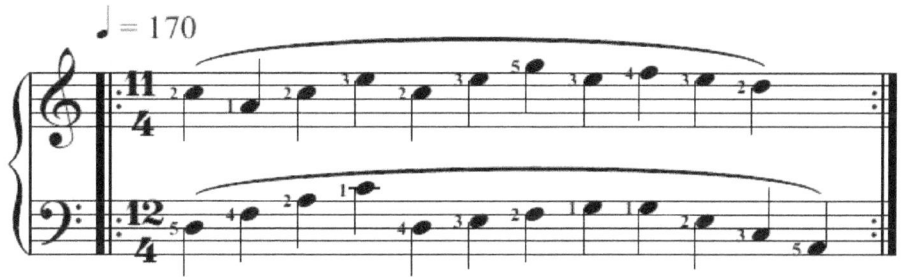

© 2013 - Jeff Fineberg

Deceptively Simple Polymetric Puzzles

Jeff Fineberg

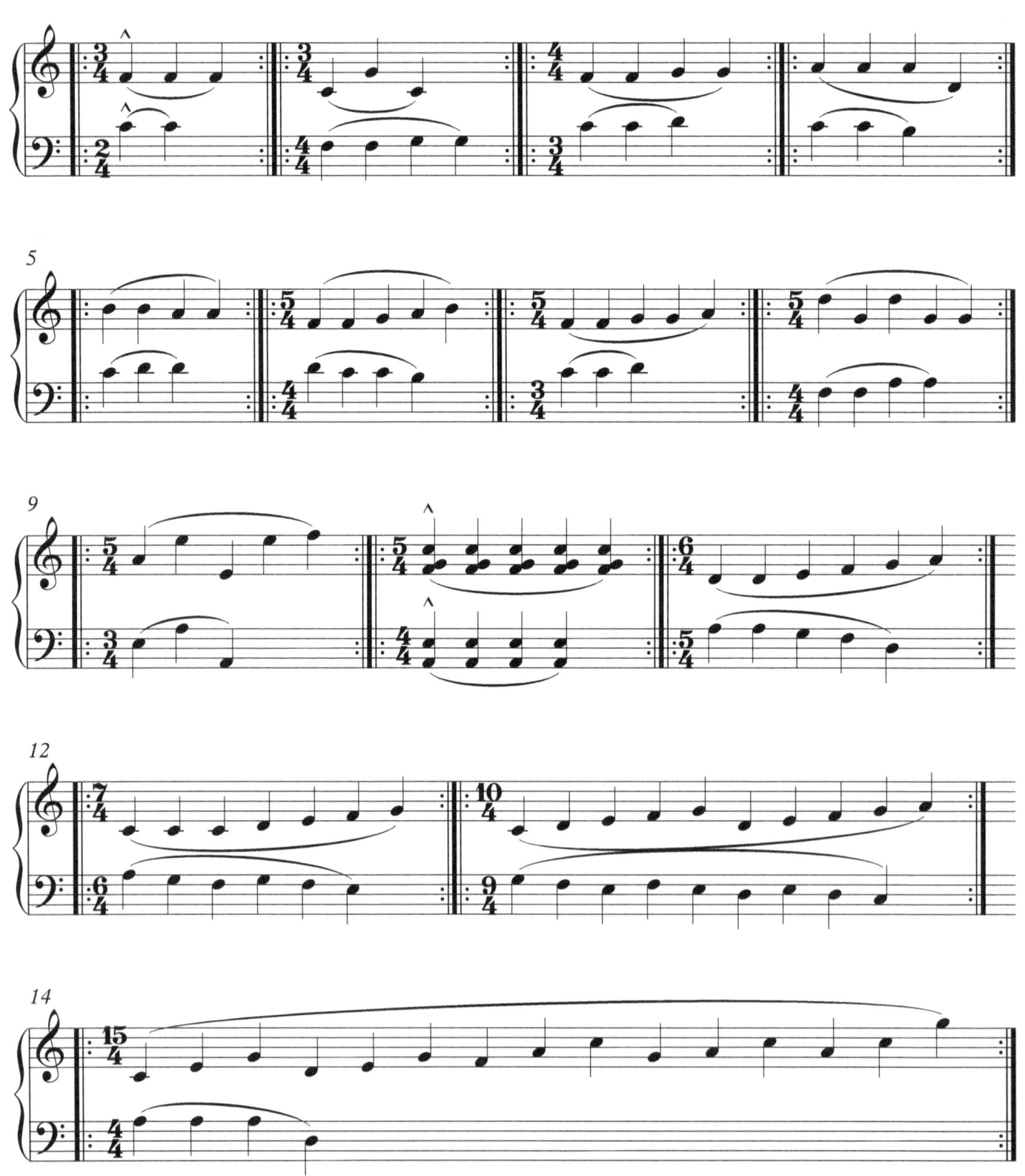

© 2014 - Jeff Fineberg

Chapter 3: Polymetric Puzzle Short Pieces

The following pieces are focused for performance differing from the exercises in chapter 2, which are designed to help you understand the fundamentals of playing polymeters. For example, the Polymetric Puzzle exercises may contain either a single polymeter or a small set of related polymeters, presented in order of gradual increasing difficulty. The pieces in this chapter may contain any number of polymeters, allowing for more freedom of musical expression.

Depending upon your level of comfort with the various polymetric patterns throughout a piece, you may need to spend time working out each separate measure before combining them into a single piece. The goal is to be able to play all of the sections with continuous flow as a single piece of work, once the difficulties are mastered.

Once comfortable with the various segments of a piece, feel free to choose a tempo and repeat each section as you feel allows the piece to flow. Also, remember that you may utilize any of the variations discussed in Chapter 1 (or any of your own).

Polymetric Song - Variations in 11

Performance Note: each measure represents a cycle for 2 hands, such as 4:11, 2:11, etc. In order to complete a cycle of these polymeters, play each hand's measure by the number of beats for the other hand's measure. **For example, in 4:11, play the 4 beat measure 11 times and the 11 beat measure 4 times, equaling a total of 44 beats. Cycles may also be repeated as desired (typically 2 or 4 times throughout the

Jeff Fineberg

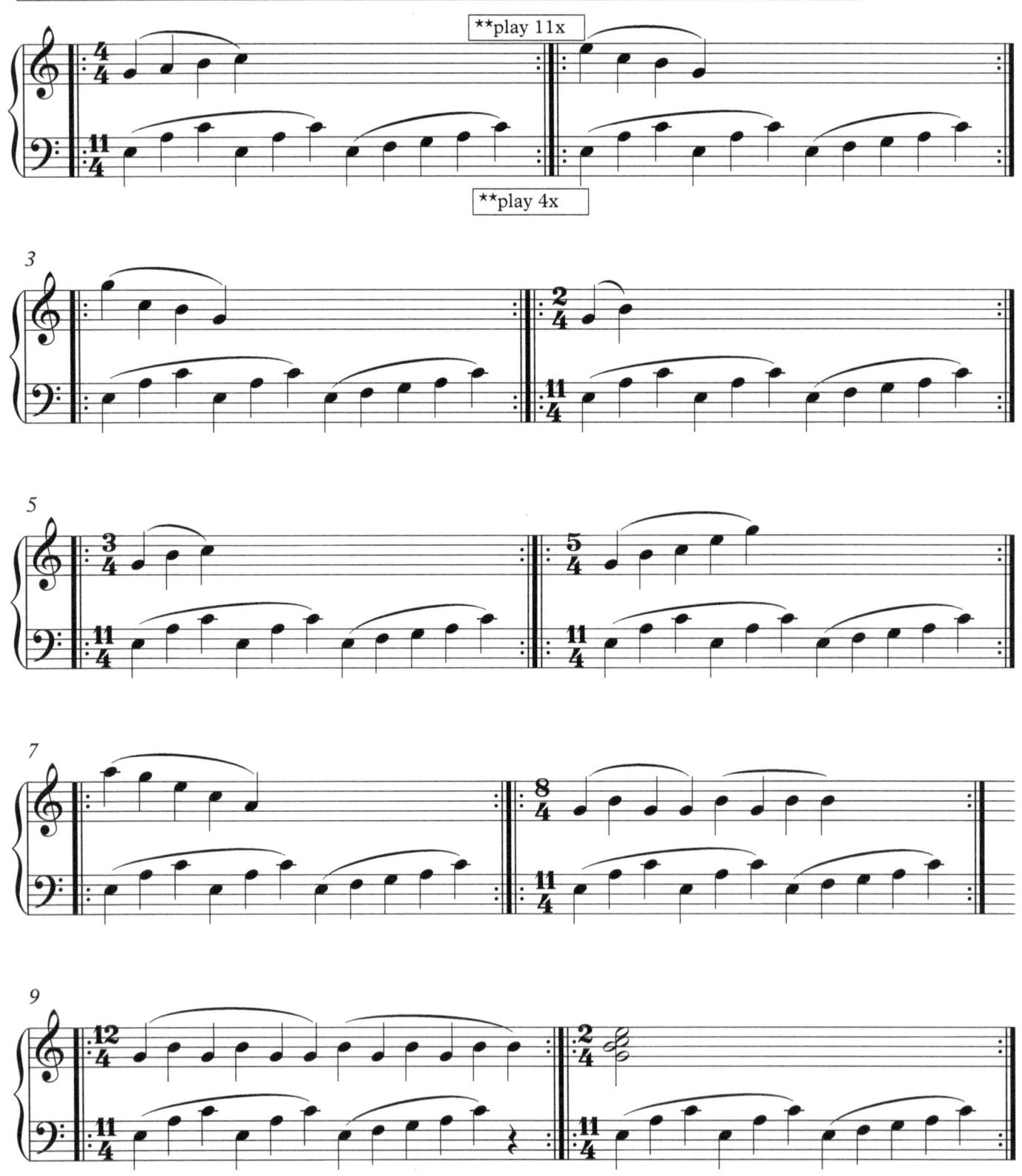

© 2013 - Jeff Fineberg

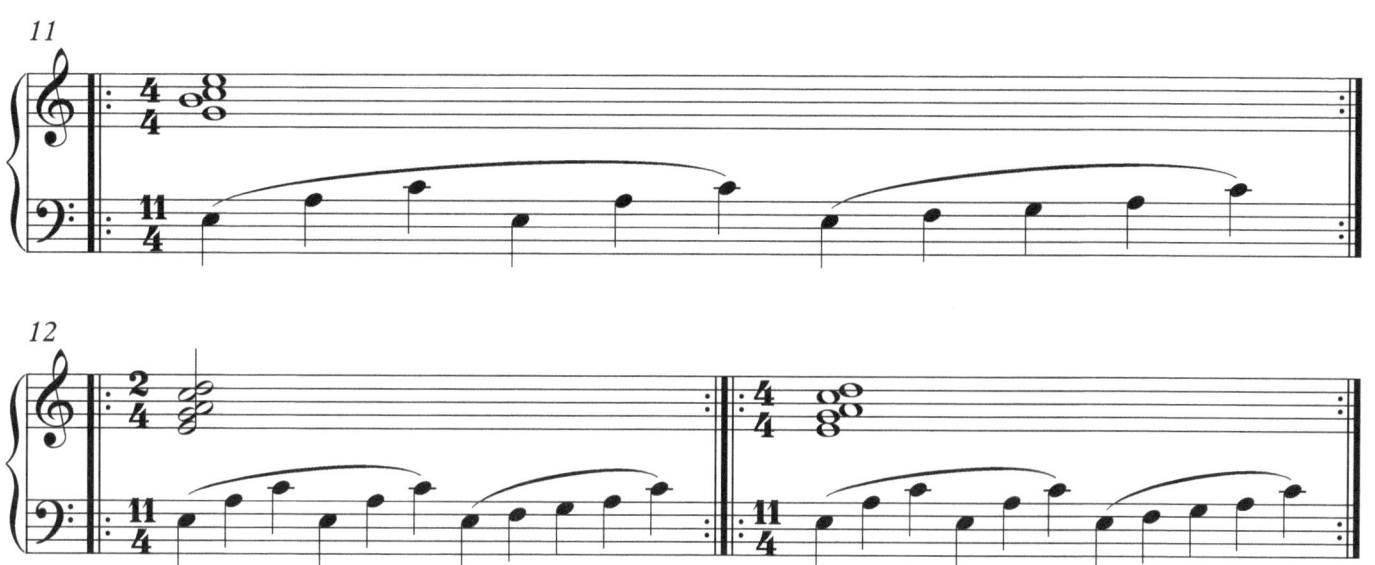

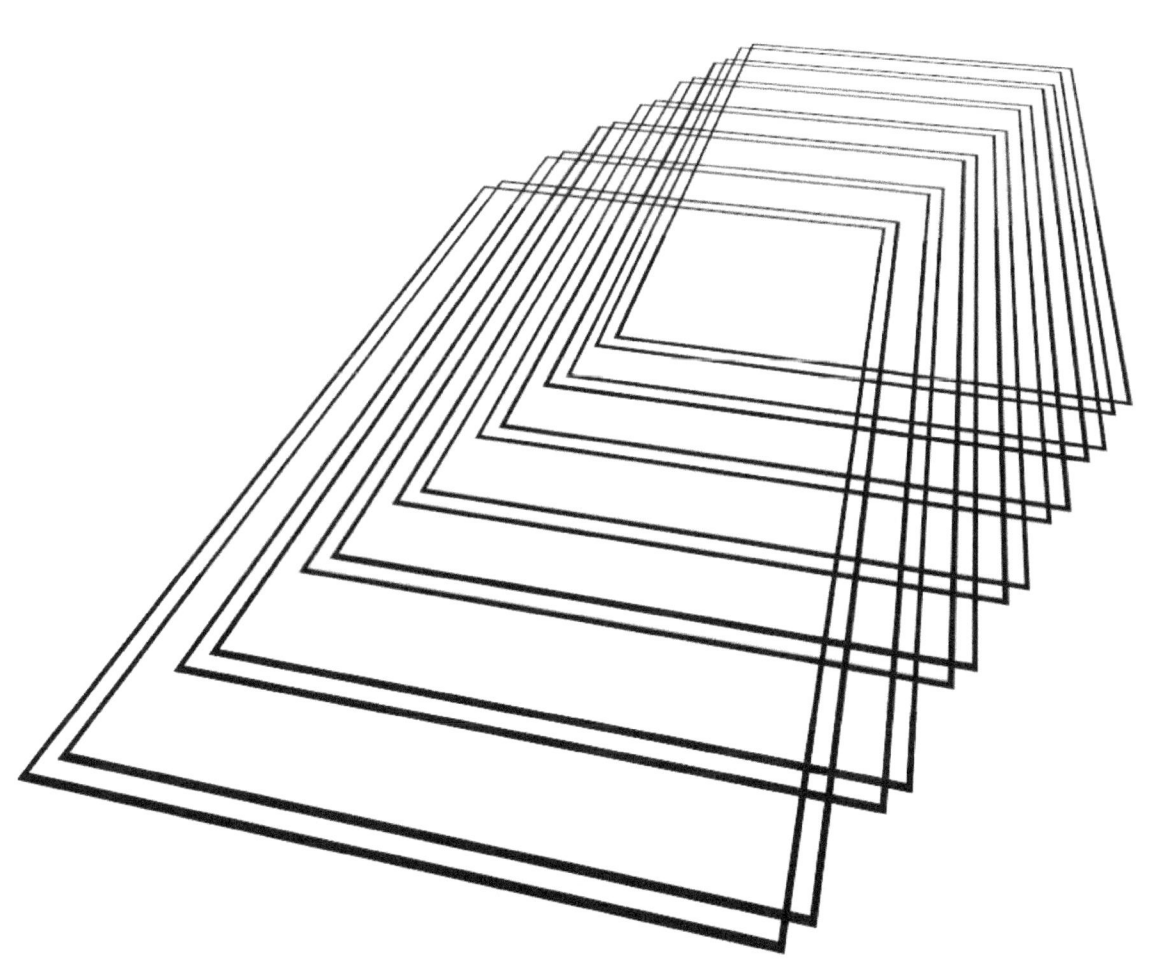

Polymetric Song - Variations in 12,9,5,4,3,2

Performance Note: each measure represents a cycle for 2 hands, such as 9:4, 9:5, etc. In order to complete a cycle of these polymeters, play each hand's measure by the number of beats for the other hand's measure. **For example, in 9:4, play the 9 beat measure 4 times and the 4 beat measure 9 times, equaling a total of 36 beats. Cycles may also be repeated as desired (typically 2 or 4 times throughout the piece).

Jeff Fineberg

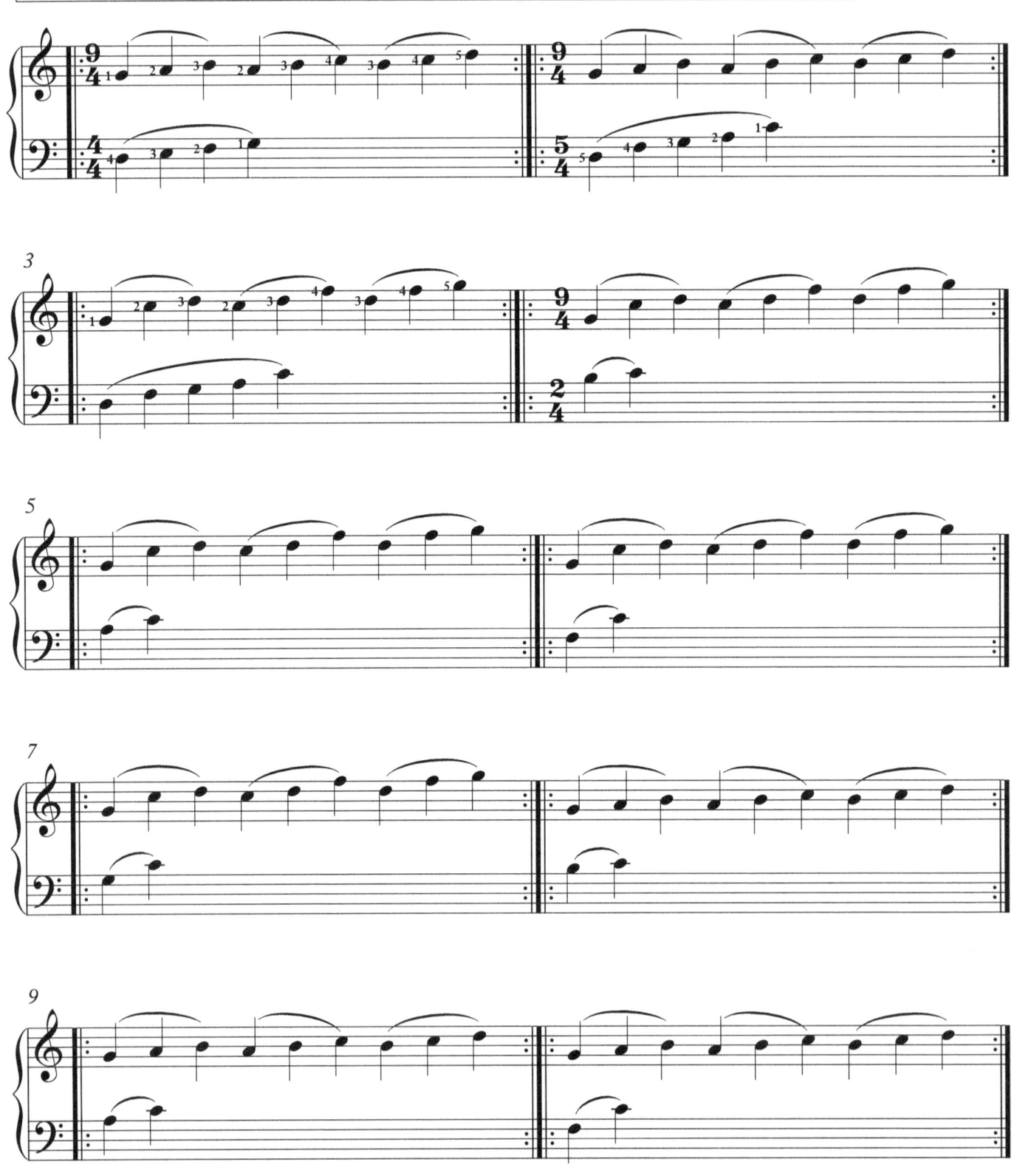

© 2013 - Jeff Fineberg

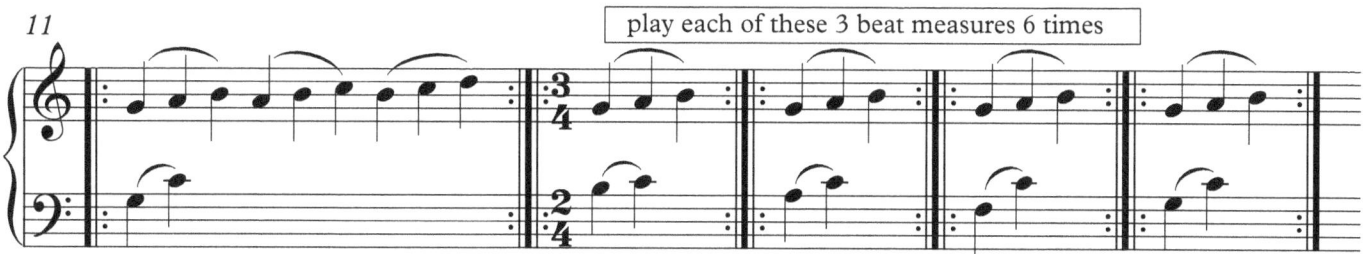

play each of these 3 beat measures 6 times

play the 12 beat measures 2 times and 2 beat measure 12 times

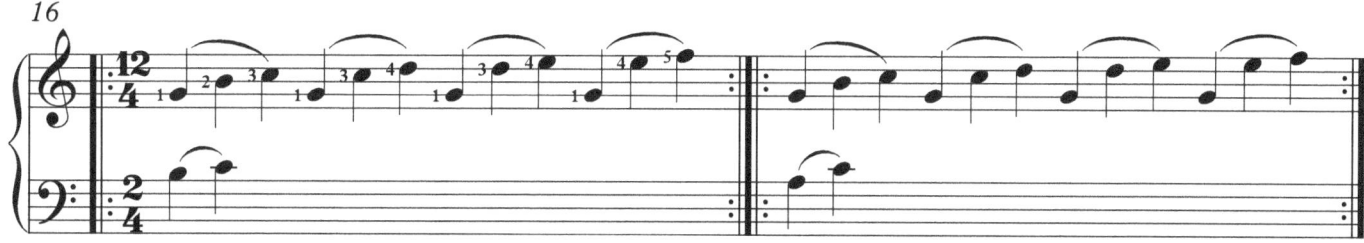

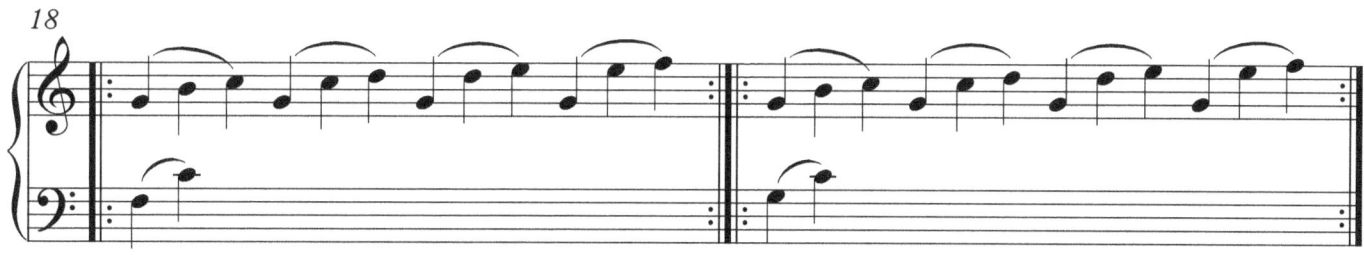

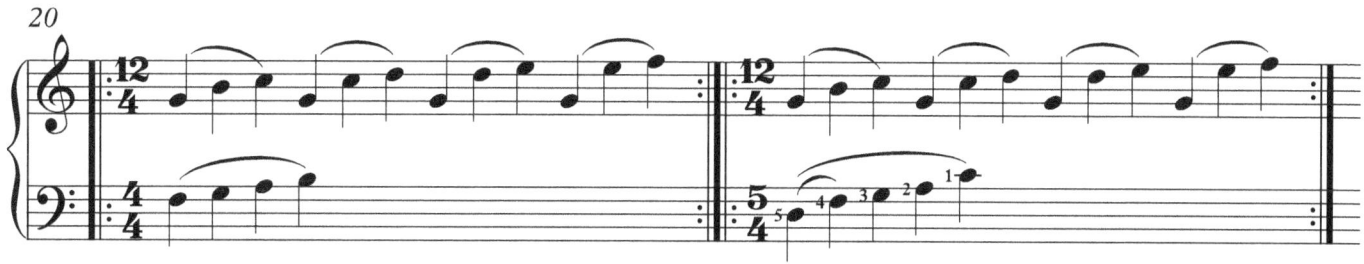

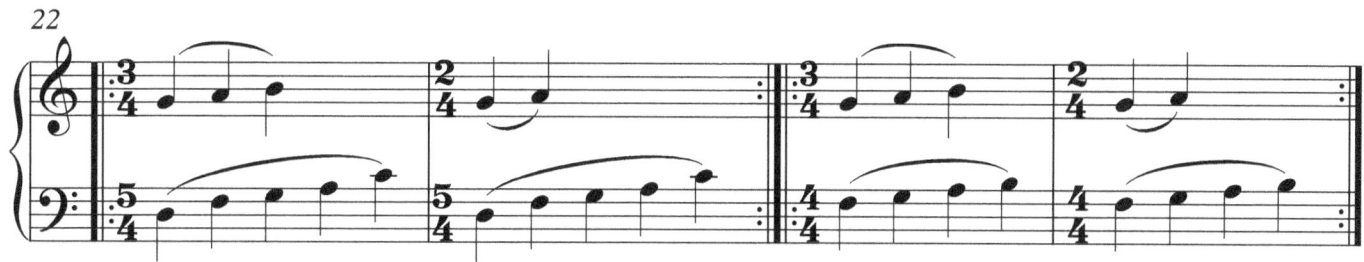

Polymetric Song - Variations in 20,10,5,4,3,2

Performance Note: each measure represents a cycle for 2 hands, such as 10:4, 3:4, etc. In order to complete a cycle of these polymeters, play each hand's measure by the number of beats for the other hand's measure. **For example, in 10:4, play the 10 beat measure 4 times and the 4 beat measure 10 times, equaling a total of 40 beats. Cycles may also be repeated as desired (typically 2 or 4 times throughout the piece), or as recommended in the piece.

Jeff Fineberg

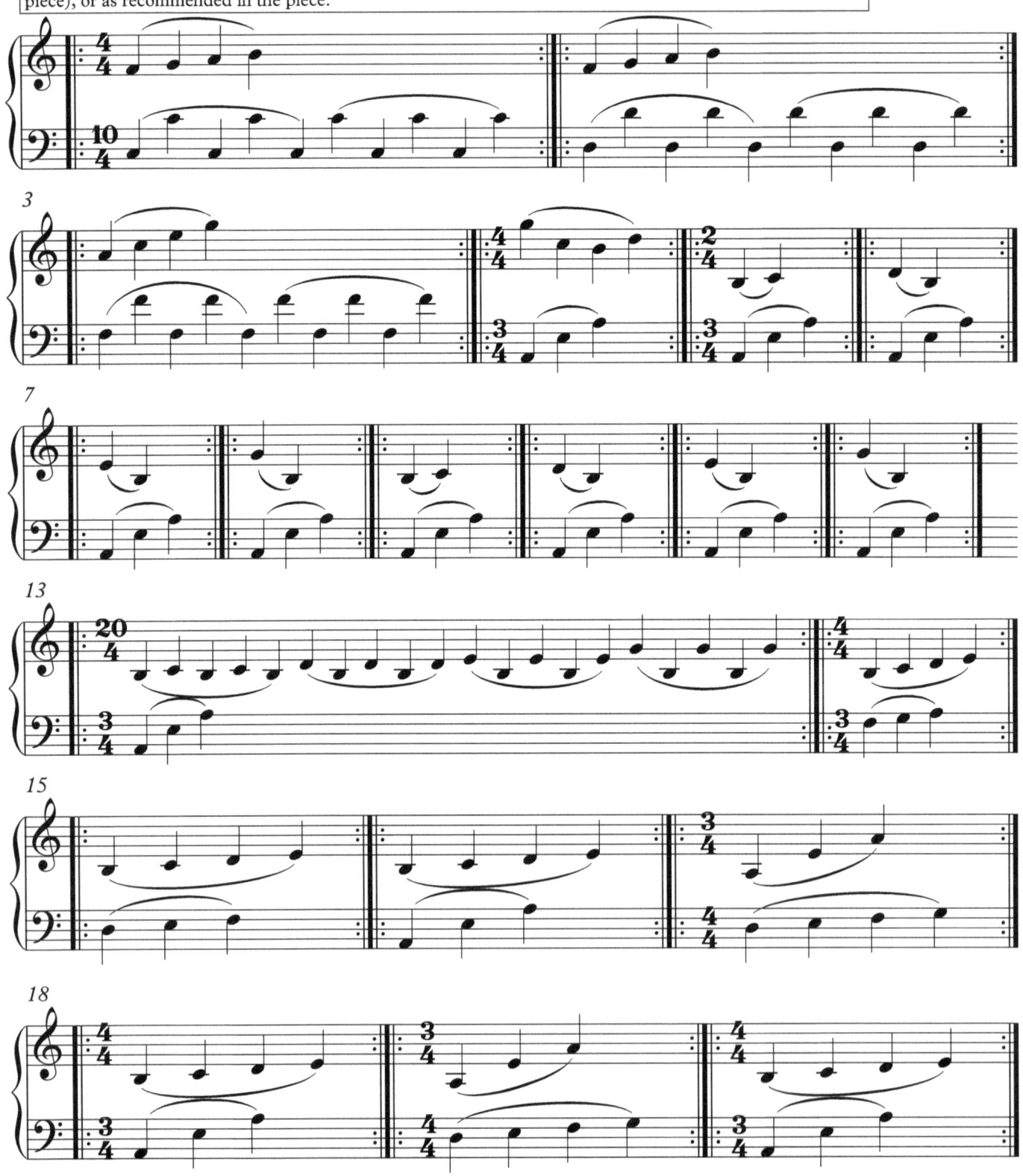

© 2013 - Jeff Fineberg

Polymetric Dissonance Variations

Jeff Fineberg

Performance Note: each measure represents a cycle for 2 hands, such as 5:4, 5:3, etc. In order to complete a cycle of these polymeters, play each hand's measure by the number of beats for the other hand's measure. **For example, in 5:4, play the 5 beat measure 4 times and the 4 beat measure 5 times, equaling a total of 20 beats. Cycles may also be repeated as desired (typically 2 or 4 times throughout the piece).

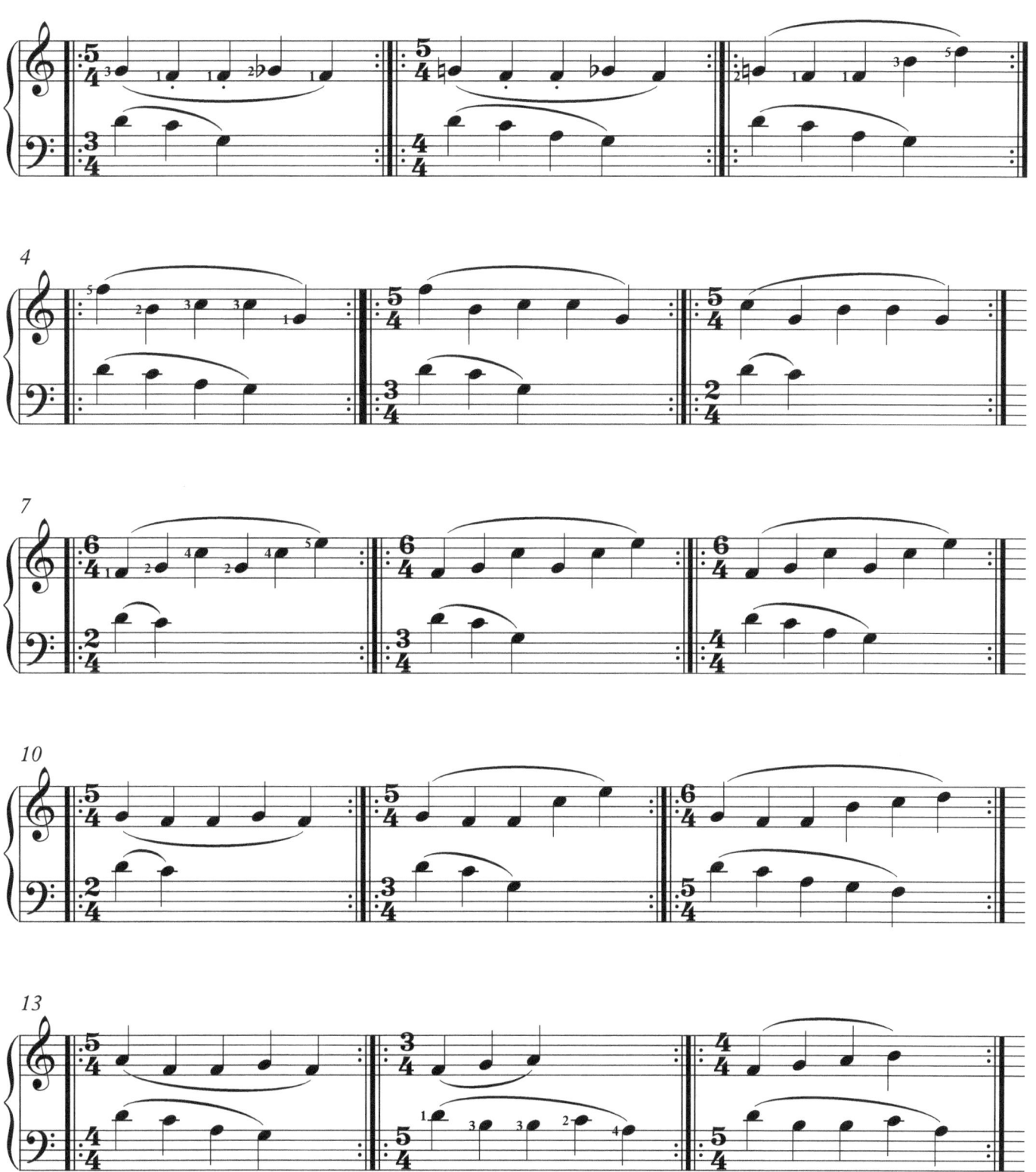

© 2013 - Jeff Fineberg

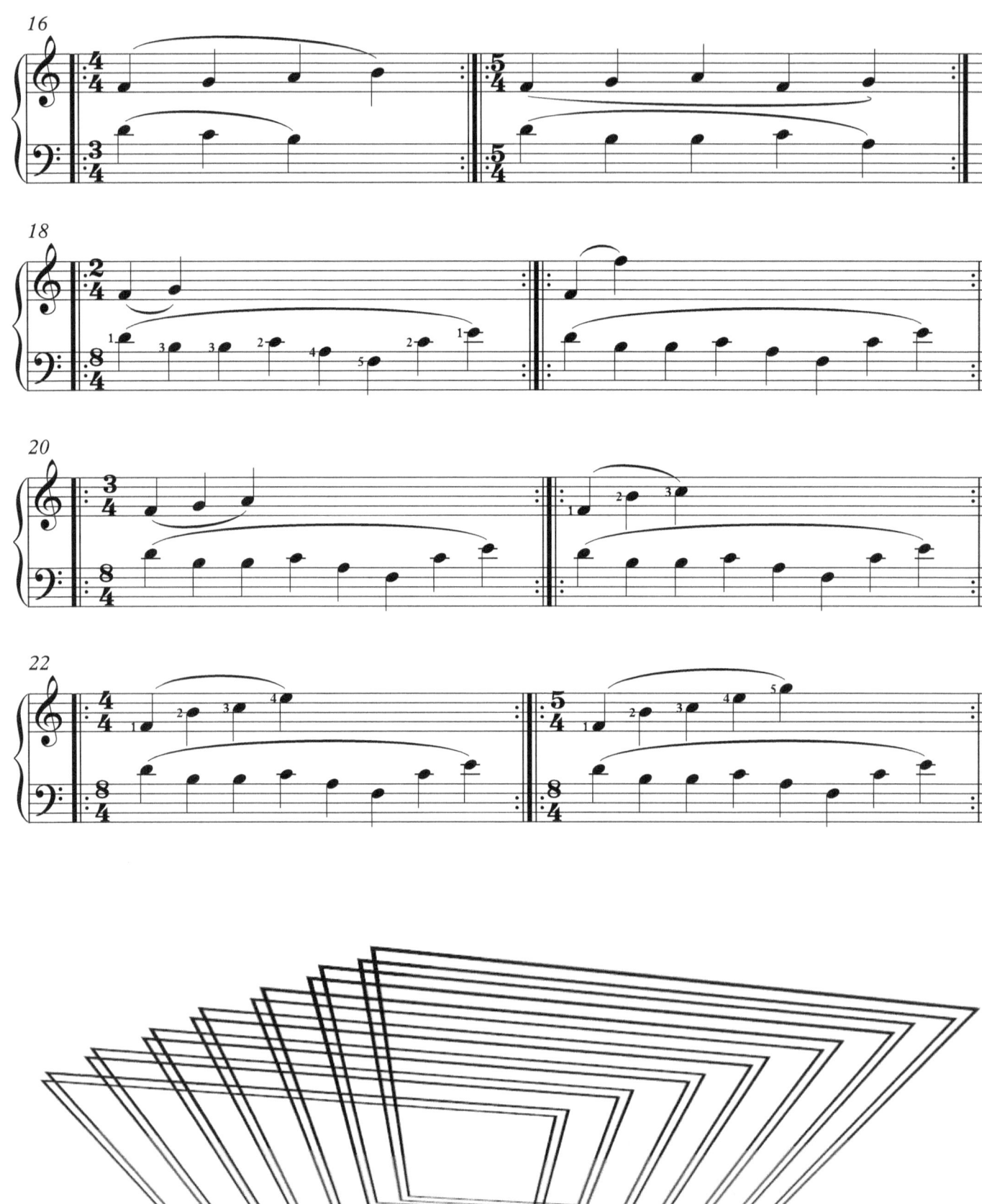

Polymetric Polytonally Dissonant Variations

Performance Note: each measure represents a cycle for 2 hands, such as 3:4, 5:7, etc. In order to complete a cycle of these polymeters, play each hand's measure by the number of beats for the other hand's measure. **For example, in 5:7, play the 5 beat measure 7 times and the 7 beat measure 5 times, equaling a total of 35 beats. Cycles may also be repeated as desired (typically 2 or 4 times throughout the piece).

Jeff Fineberg

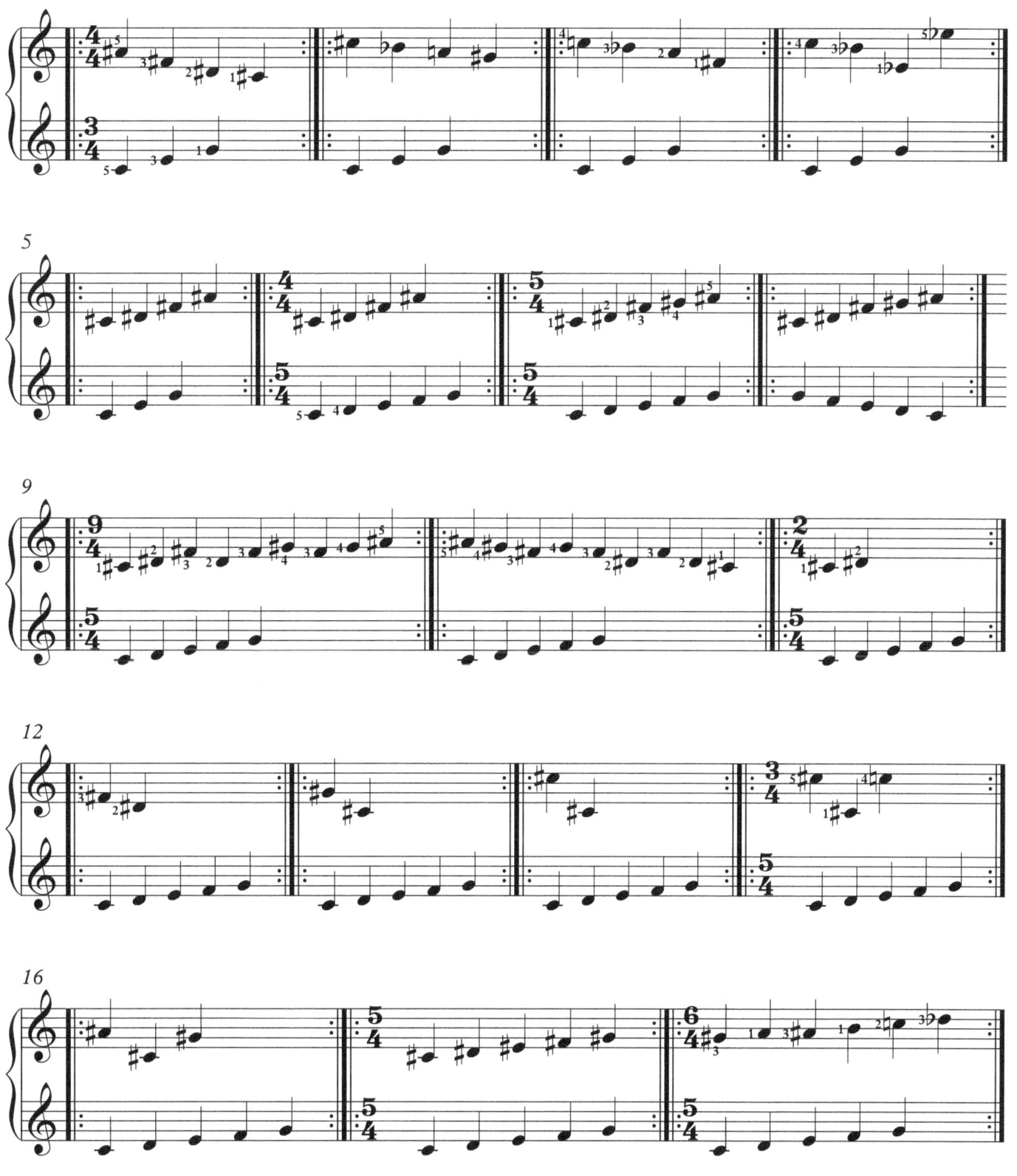

© 2013 - Jeff Fineberg

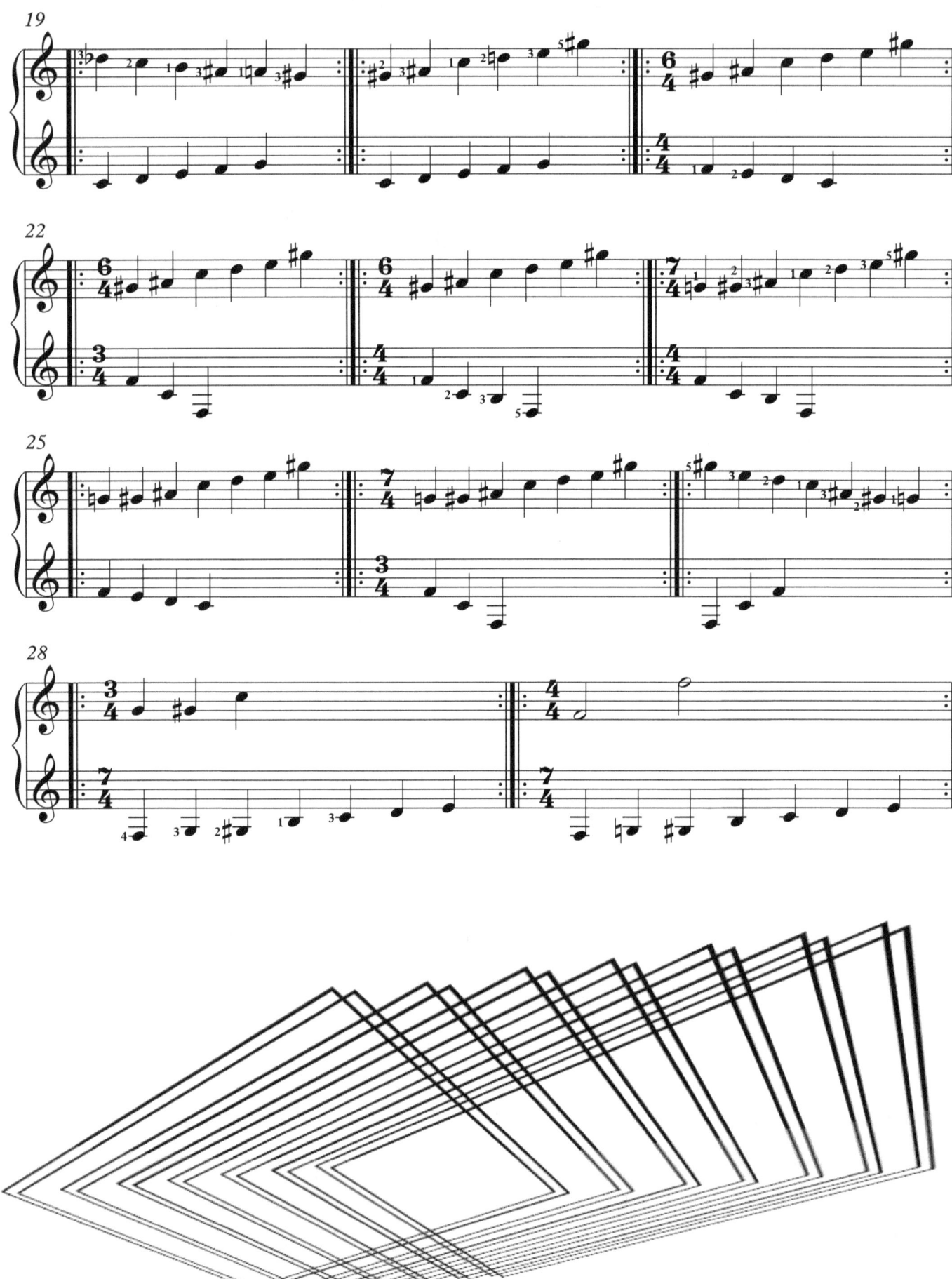

Polymetric Chordal Distraction

Performance Note: each measure represents a cycle for 2 hands, such as 3:4, 4:9, etc. In order to complete a cycle of these polymeters, play each hand's measure by the number of beats for the other hand's measure. **For example, in 3:4, play the 3 beat measure 4 times and the 4 beat measure 3 times, equaling a total of 12 beats. Cycles may also be repeated as desired (typically 2 or 4 times throughout the piece).

Jeff Fineberg

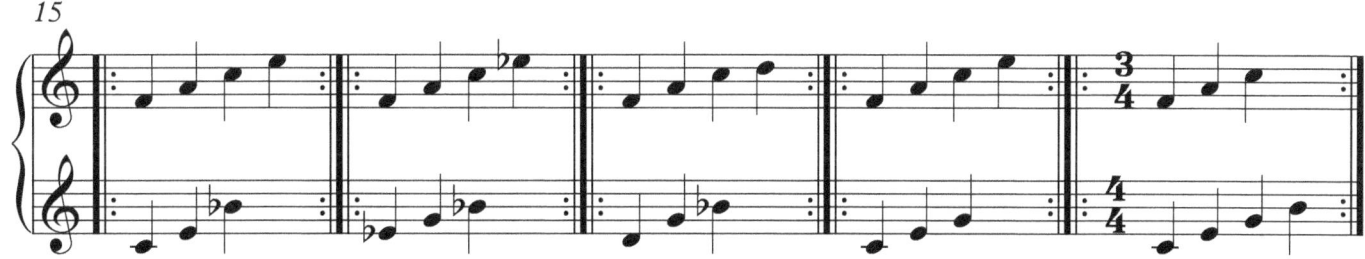
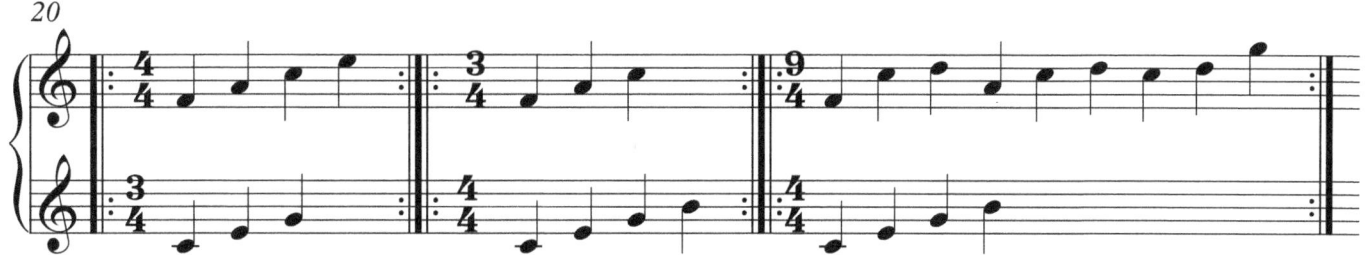

© 2013 - Jeff Fineberg

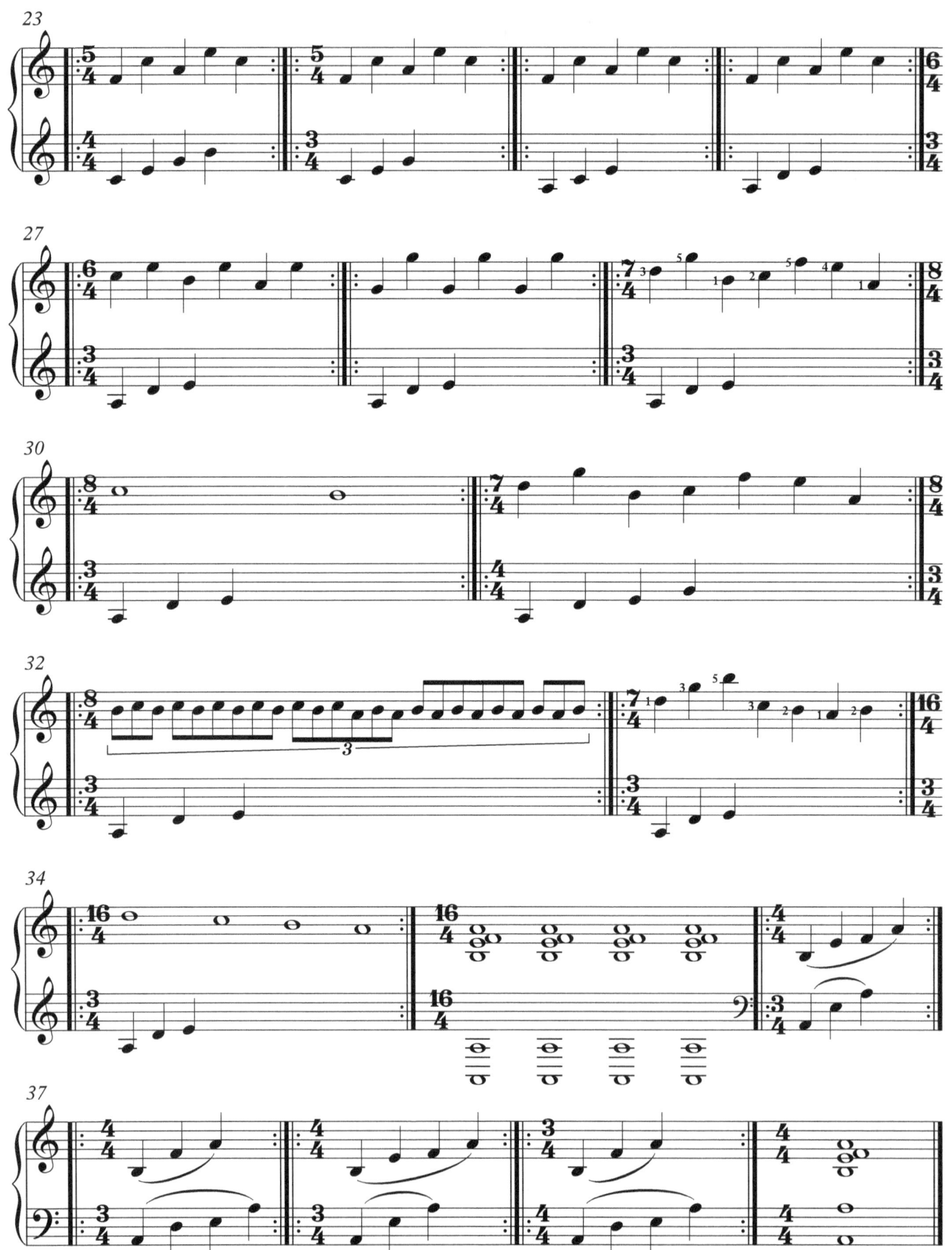

Sunrise Comet

Based on the title from the Crystal Radio CD "Decategorized Sound" 2006

Jeff Fineberg

Performance Notes:

1. measures containing polymeters represents a cycle for 2 hands, such as 2/4 against 3/4, 4/4 against 5/4 etc. In order to complete a cycle of these polymeters, play each hand's measure by the number of beats for the other hand's measure. **For example, in 4/4 : 5/4, play the 4 beat measure 5 times and the 5 beat measure 4 times, equaling a total of 20 beats. Cycles may also be repeated as desired (typically 2, 4 or 8 times throughout the piece).
2. Accent challenge 1: for each polymetric measure, play 2 cycles unaccented, followed by an additional N cycles, accenting (for each cycle) through each of the beats of the larger time signatures. For example, in a polymer of (3/4 against 4/4), play 2 cycles unaccented, then 4 more cycles, accenting on the first beat, then second, third and finally the forth beat. (see solution version for additional hints).
3. Accent challenge 2: in addition to accenting the notes, play the accented note in the left hand simultaneously with a lower octave note.

Fun Fact: Comet Fineberg *(right)* played a couple notes on the Crystal Radio recording "Decategorized Sound" - "Sunrise Comet".

© 2008 / 2013 - Jeff Fineberg

Chapter 4: Illustration and Explanation of Polyrhythms

In chapter 1 we discussed Polymeters, and in chapter 2 and 3 we played example exercises and pieces based upon them. In this chapter and chapter 5 we will cover polyrhythms in enough detail so that you will gain a good understanding of both the theory and application of them.

So what exactly is a polyrhythm? The term 'poly' means many; therefore a polyrhythm contains more than a single rhythm occurring simultaneously, within a single meter[1] or polymeter. A simple definition is when two simultaneously occurring sets of notes have the same total duration, but a different number of equal[2] valued notes within that duration. The cardinality[3] of these sets is typically "relatively prime", where sets A and B have no common divisor other than one (e.g. 2:3, 4:5, 5:6, 7:13, etc.). For example, figure 4-1 has a 2:3 polyrhythm, where one set contains 2 notes, and the other set contains 3 notes to be played simultaneously. Note that the duration of both sets is one beat.

Figure 4.1. Example of a 2:3 polyrhythm with synch points, in a single 4/4 meter.

This is quite different from a polymeter (Figure 4-2), which involves multiple meters (e.g. 2/4 and 3/4) occurring simultaneously. Refer to chapter 1 for more details on polymeters.

Figure 4.2. Example of a 2:3 polymeter with synch points

Note that both polyrhythms and polymeters contain "synch points", which is where each cycle begins, and any mismatches between the metric differences are resolved, or come together. As you can see in figures 4-1 and 4-2, a polyrhythm can exist without the use of a polymeter, and a

[1] It is certainly possible to have a polyrhythm within a polymeter (discussed later).
[2] For simplicity, let's assume that each note within a set has the same duration, such as all eighth notes or triplets. While this may be somewhat common, it is certainly not mandatory.
[3] Cardinality is the number of elements in a set, or in our case the number of notes in a set.

polymeter can exist without a polyrhythm. In chapter 7, we will see a more advanced technique utilizing both polymeters and polyrhythms together.

Executing polyrhythms correctly and with accuracy – creating notation

The difficulty in playing polyrhythms is how to determine the exact timing between the 2 sets. How can we be certain that we're playing them precisely? Regardless of the type of polyrhythm, we can be sure we are playing them correctly using the following method. Suppose we want to play a 2:3 polyrhythm, this can be accomplished by the following procedure to sketch out the timing:

1. To calculate the total length of the polyrhythmic cycle, multiply both portions of the polyrhythm and obtain the result. In this case, 2 x 3 = 6.
2. Create the cycle (of 2:3) using 2 rows of boxes (one for each set of the polyrhythm), each 6 cells long, as follows:

3. Sketch the count for each cell of a set, counting sequentially, starting at one and increasing to the number value for that set. So for 3 (of 2:3), we would count (1, 2, 3) and repeat until all the boxes would be accounted for. For 2 (of 2:3), we count (1,2) and repeat similarly.
4. Fill the table in with X's to determine exactly when to play each set's notes by placing an 'X' for every count of '1' (examples of 2:3 and 3:4 are below).

Important note: the sequential counting of one set represents the 'other' set's actual polymetric count. For example, a count of 1,2,3 denotes the '2' of the 2:3 polyrhythm, and the count of 1,2 denotes the '3' of 2:3.

2:3 polyrhythm (note: 2 x 3 = 6 boxes, counting 1, 2 and 1, 2, 3 repeatedly)

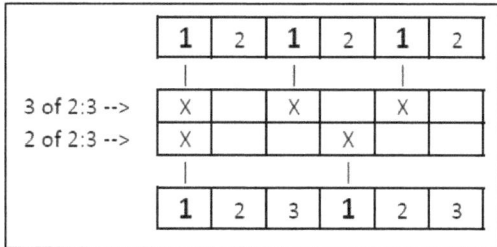

3:4 polyrhythm (note: 3 x 4 = 12 boxes, counting 1, 2, 3 and 1, 2, 3, 4 repeatedly)

		1	2	3	1	2	3	1	2	3	1	2	3
4 of 3:4 -->		X			X			X			X		
3 of 3:4 -->		X				X				X			
		1	2	3	4	1	2	3	4	1	2	3	4

Executing polyrhythms correctly and with accuracy – playing the polyrhythms

Once the table is complete, use a metronome to "click" the value of each box, and play the X's when appropriate, with one row set being played with one hand and the other row set with the other hand (using whatever note you choose for each hand). When you are comfortable with playing slowly, speed up the tempo as desired.

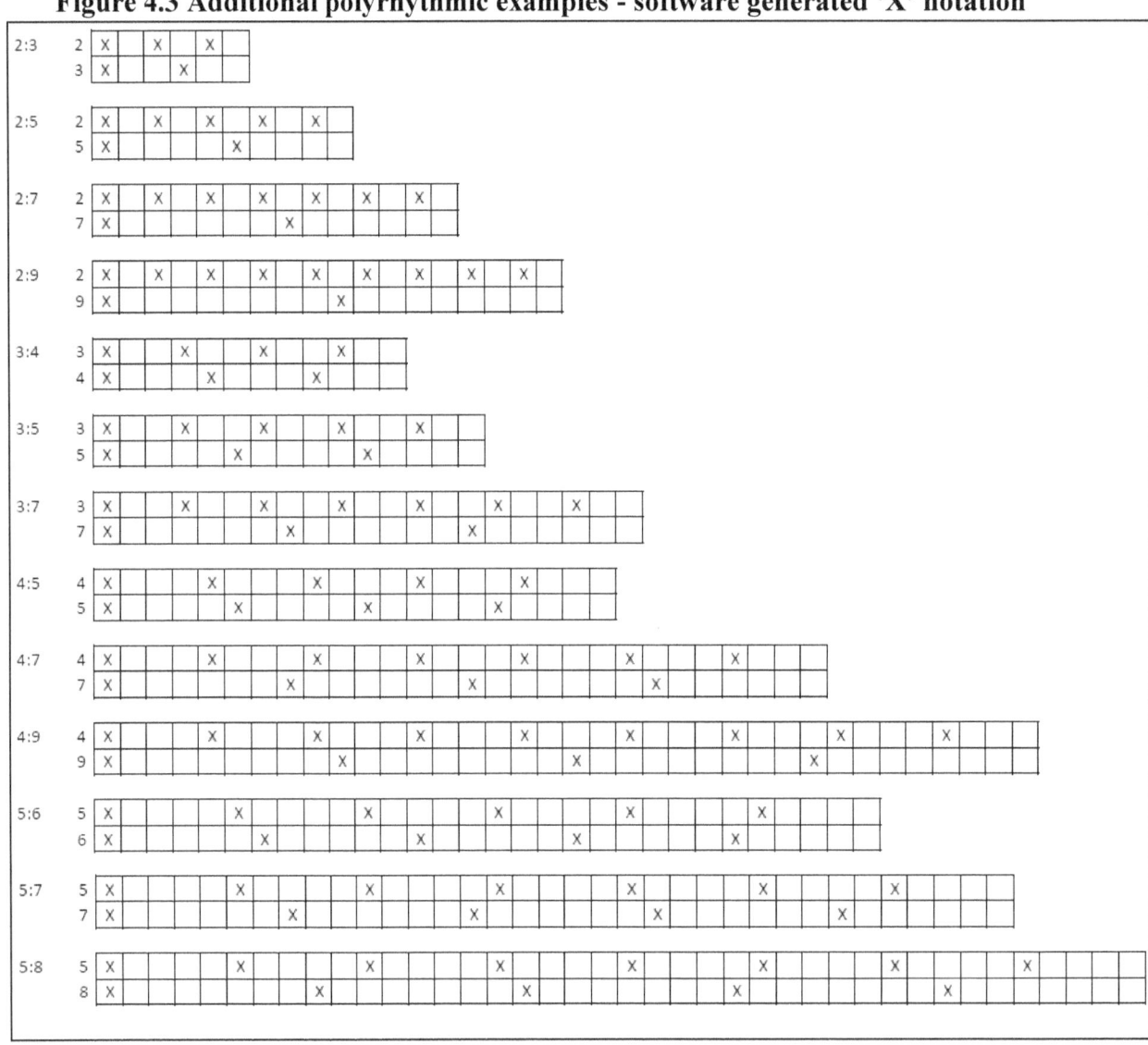

Figure 4.3 Additional polyrhythmic examples - software generated 'X' notation [4]

Exercise 4.1: practice some of the example polyrhythms above, by tapping on an object or playing on the keyboard. On the keyboard, start with one note for each hand, later progressing to chords or even tone clusters. Experiment with multiple notes as well.

Exercise 4.2: using the method described in this chapter and a piece of paper, create notation by hand for some of the polyrhythms. Compare your notation with the chart.

Exercise 4.3: practice some of the polyrhythms using the music notation on the following pages.

[4] Tables generated thanks to the programming effort of Alex J. Fineberg

Polyrhythms of various types

Jeff Fineberg

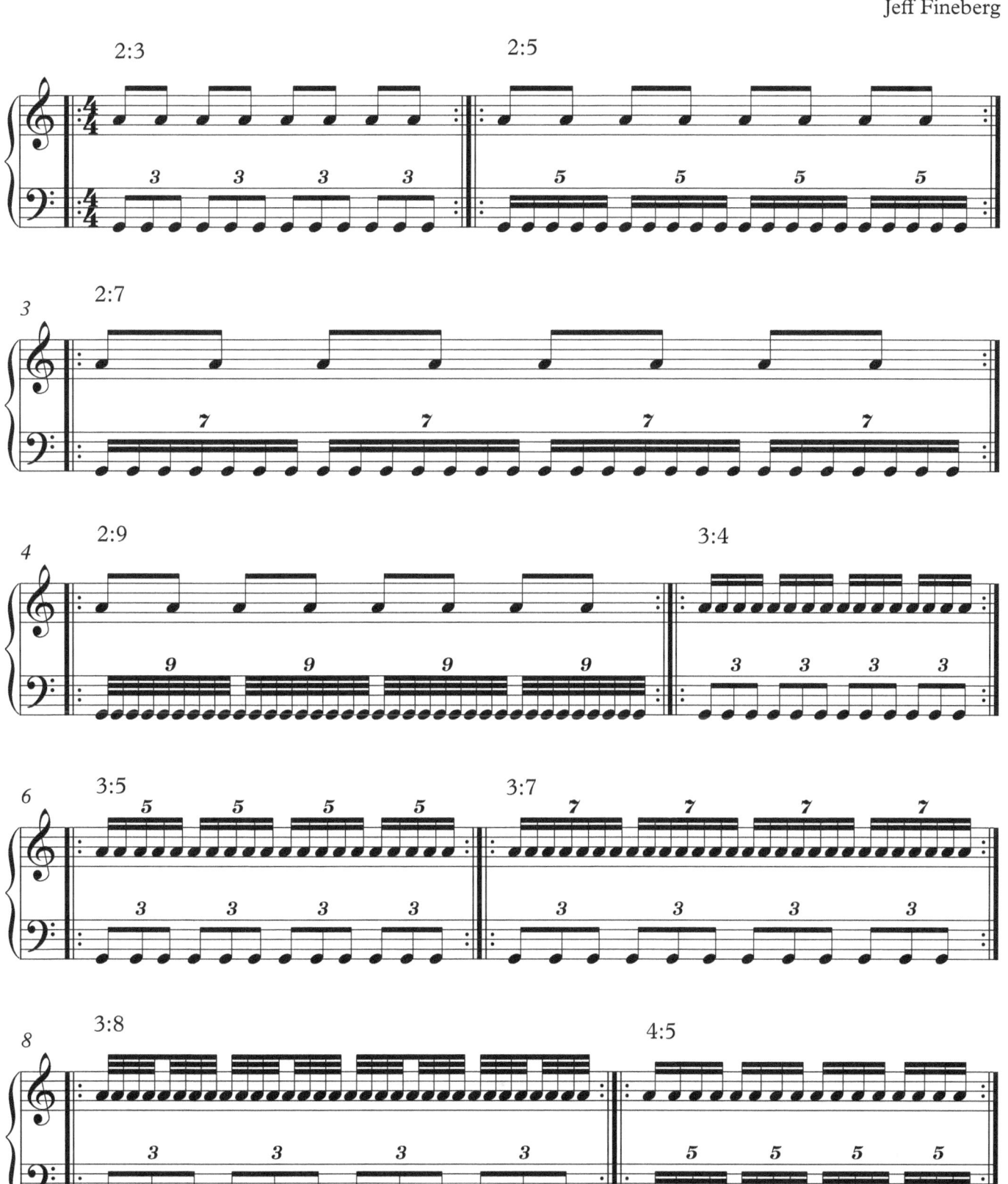

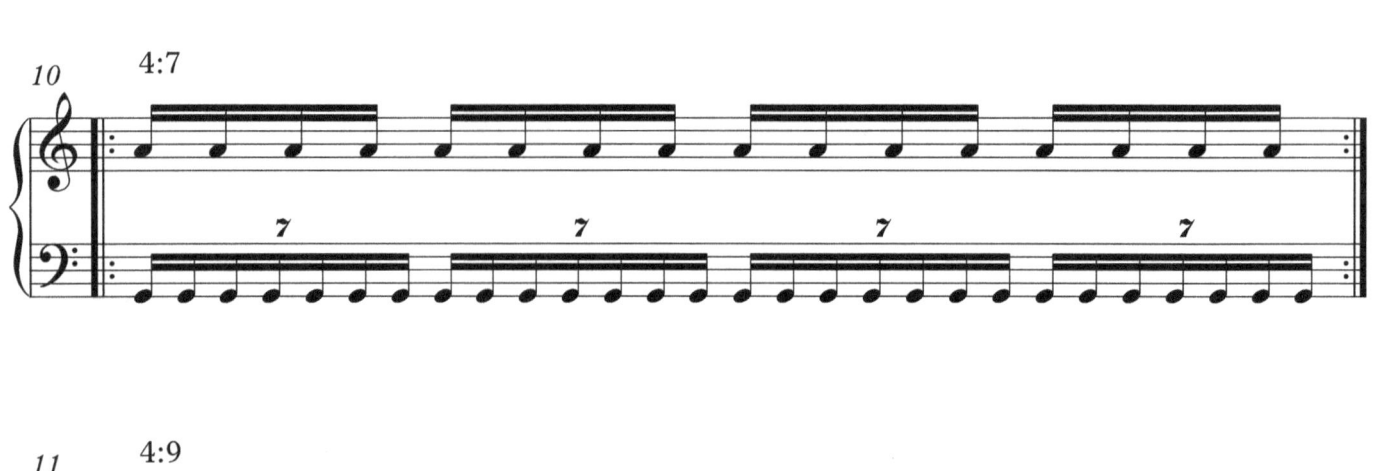
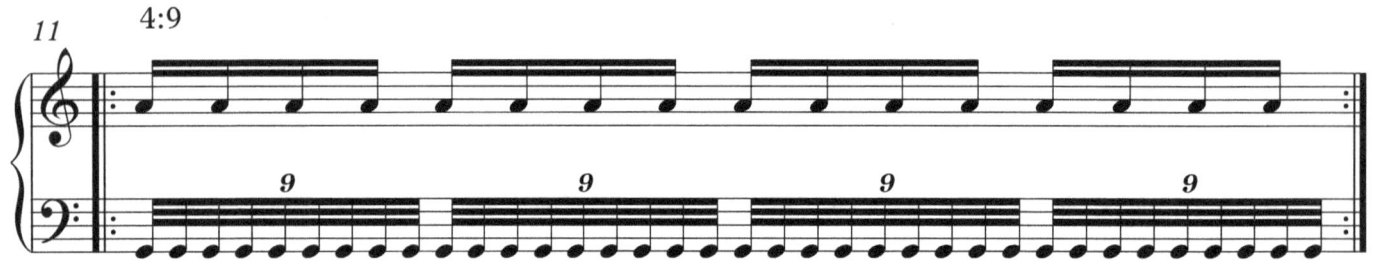
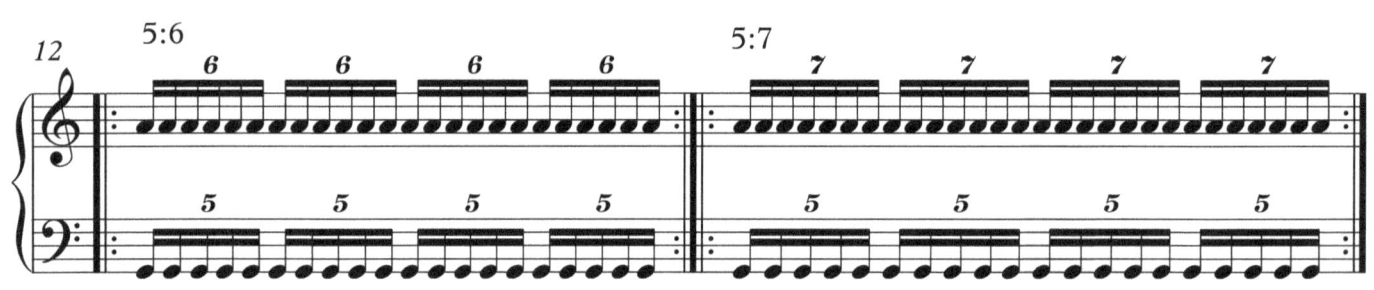
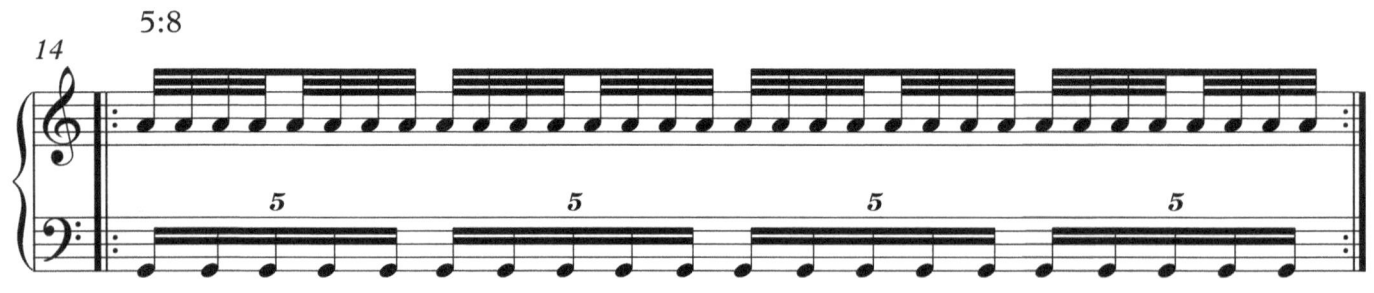
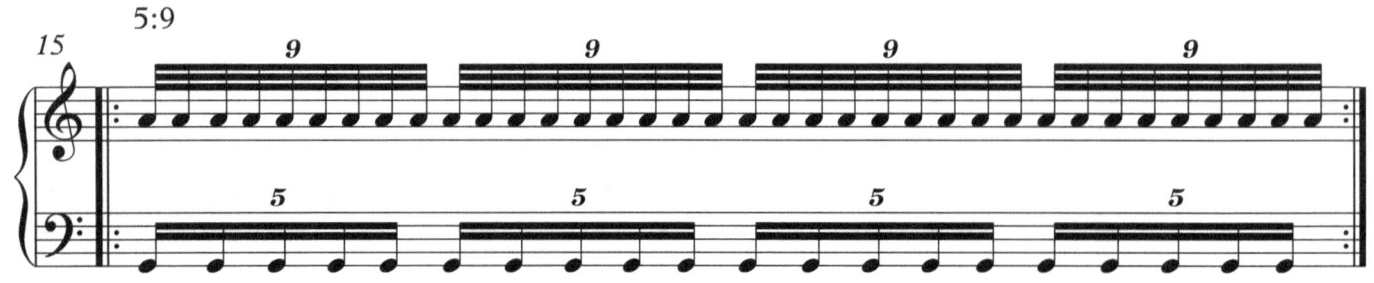

Chapter 5: Polyrhythmic Exercises and Short Pieces

In chapter 4 we discussed the fundamentals of polyrhythms, including how to play them with precision. This chapter provides an opportunity to apply the fundamentals with a variety of short pieces. Notice that each of these pieces utilizes a single polyrhythm throughout; therefore once you have mastered the particular polyrhythm you should be able to play the entire piece.

For help with determining the feel of a particular polyrhythm, review the polyrhythmic grid notation, or create your own, using chapter 4 as a guide. Feel free to experiment with a variety of tempos until you find one that suits your taste.

Tips for performing:

- The use of a metronome will definitely help confirm the accuracy of your playing.
- If you don't have a metronome, there are a number of online metronomes available, or you may want to get a metronome app if you have a smartphone, tablet, IPod, etc.
- Set the metronome to one of three possibilities:
 o The beat.
 o The right hand.
 o The left hand.
- Audio record your work to confirm your accuracy and make any corrections.
- Visit the book's website for additional resources.

Polyrhythm 2:3

Jeff Fineberg

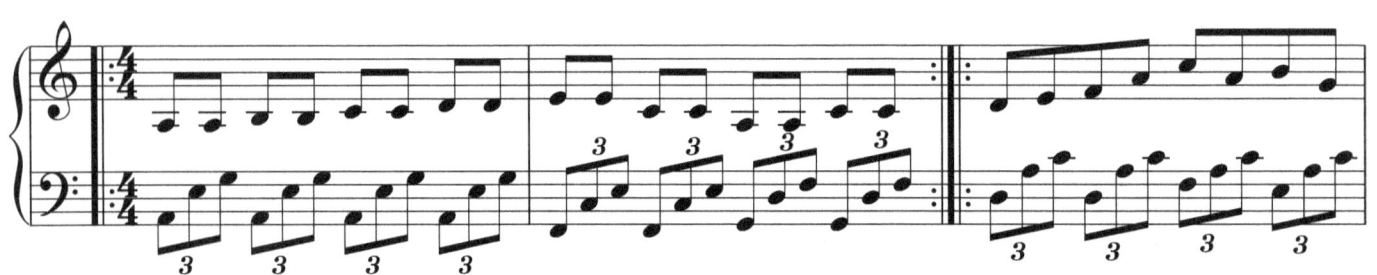
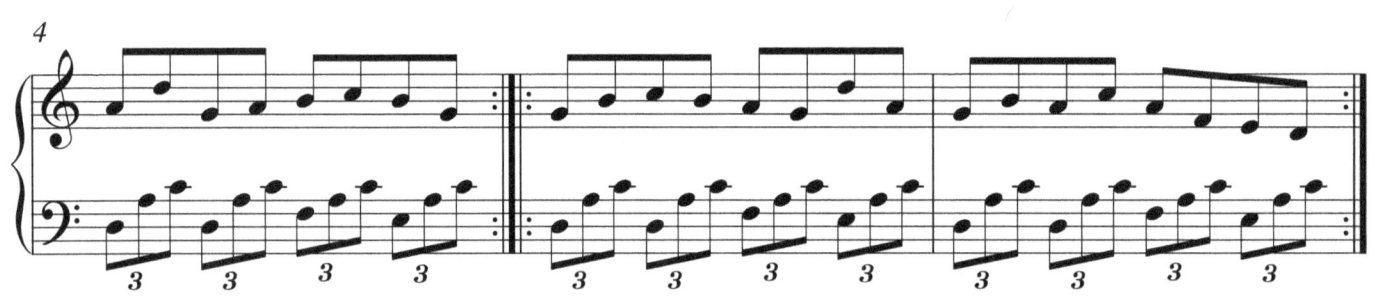
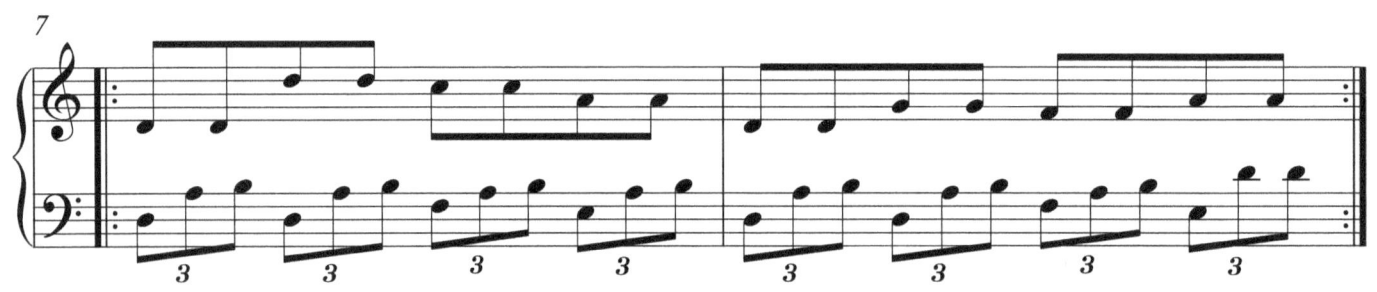
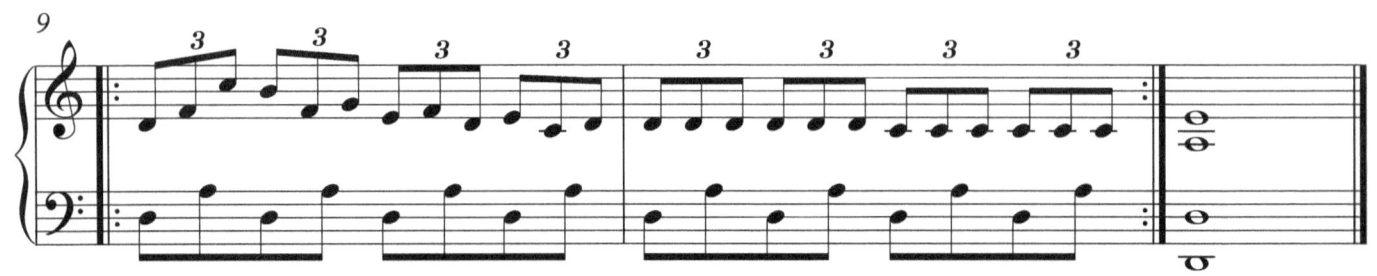

Polyrhythm 2:5

Jeff Fineberg

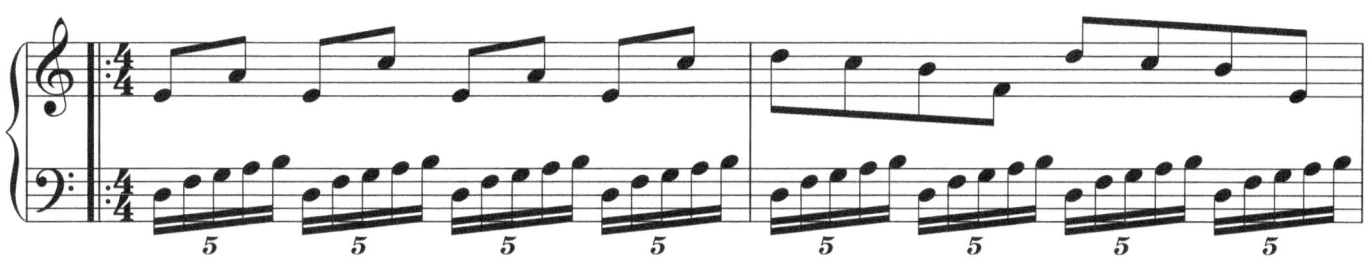

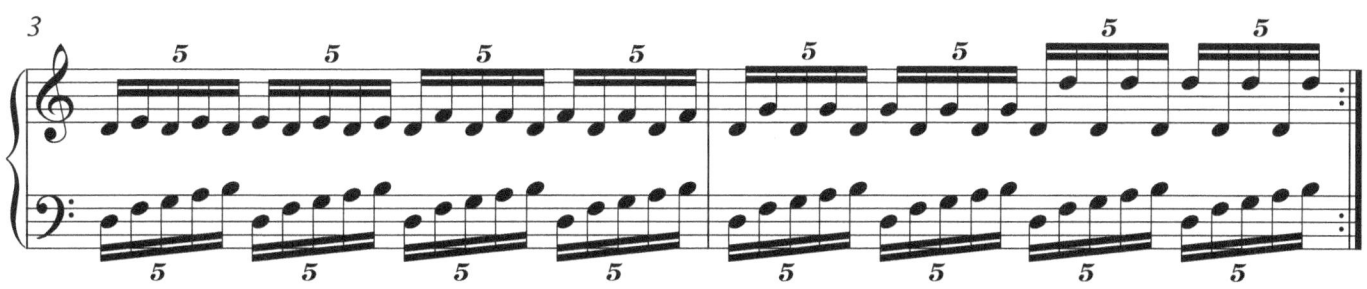

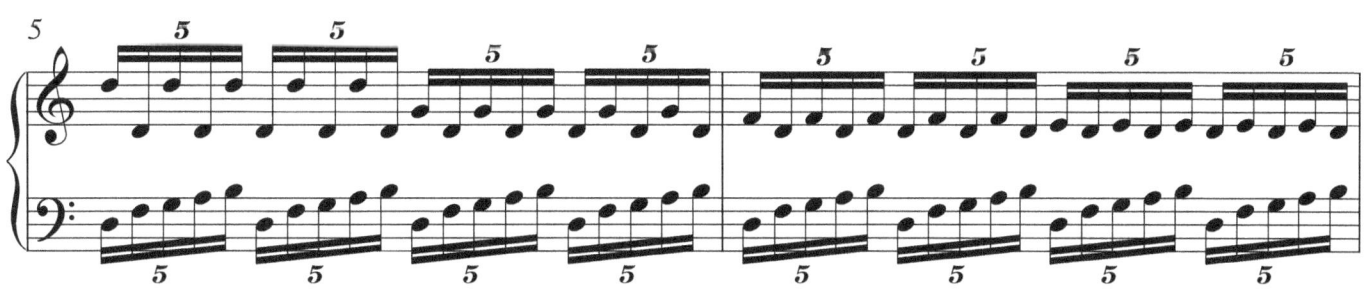

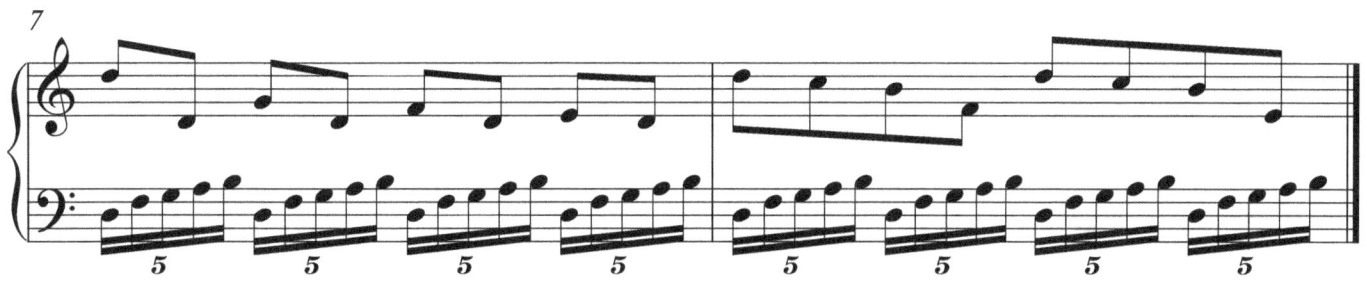

Copyright 2013

Polyrhythm 2:7

Jeff Fineberg

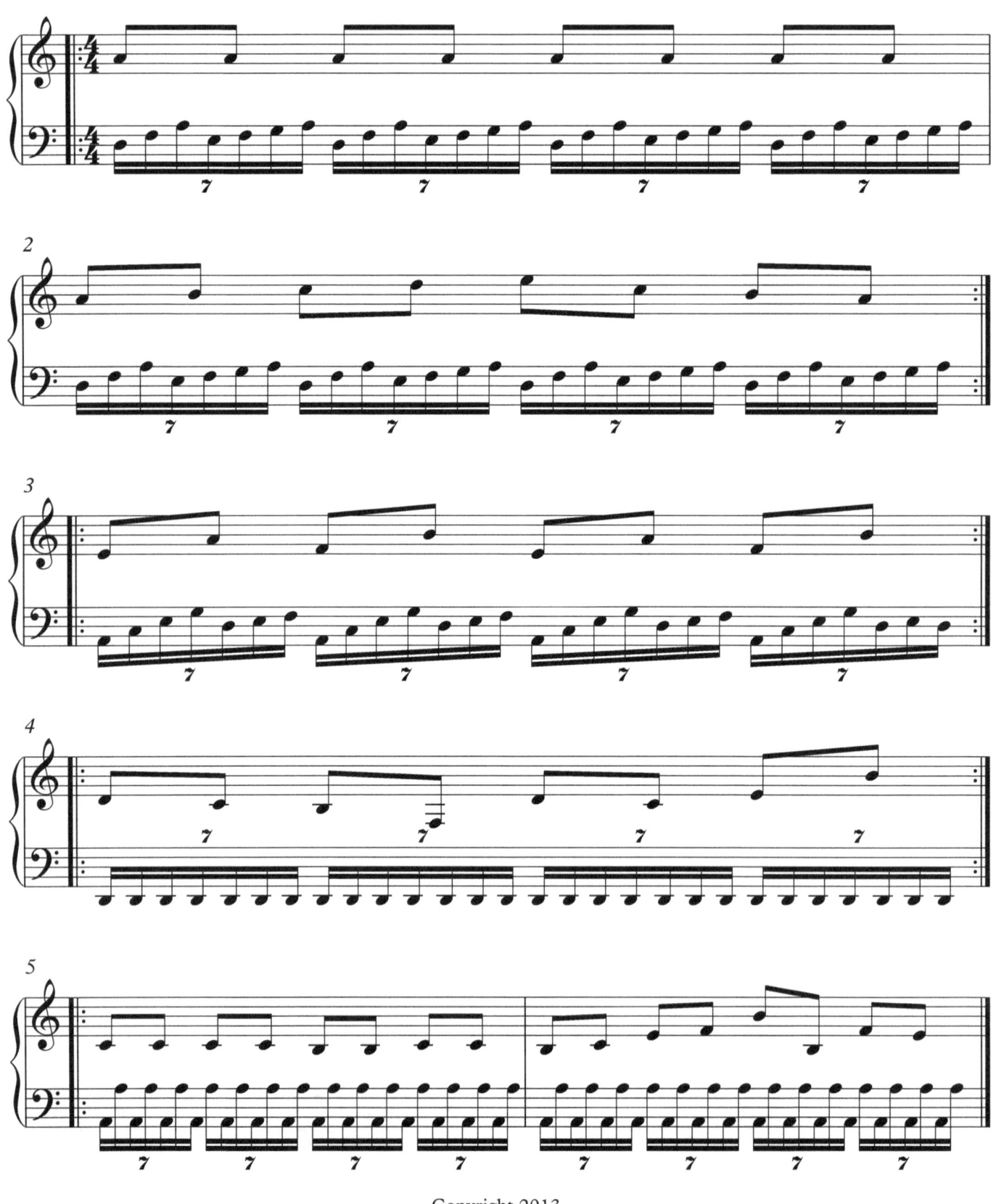

Polyrhythm 2:9

Jeff Fineberg

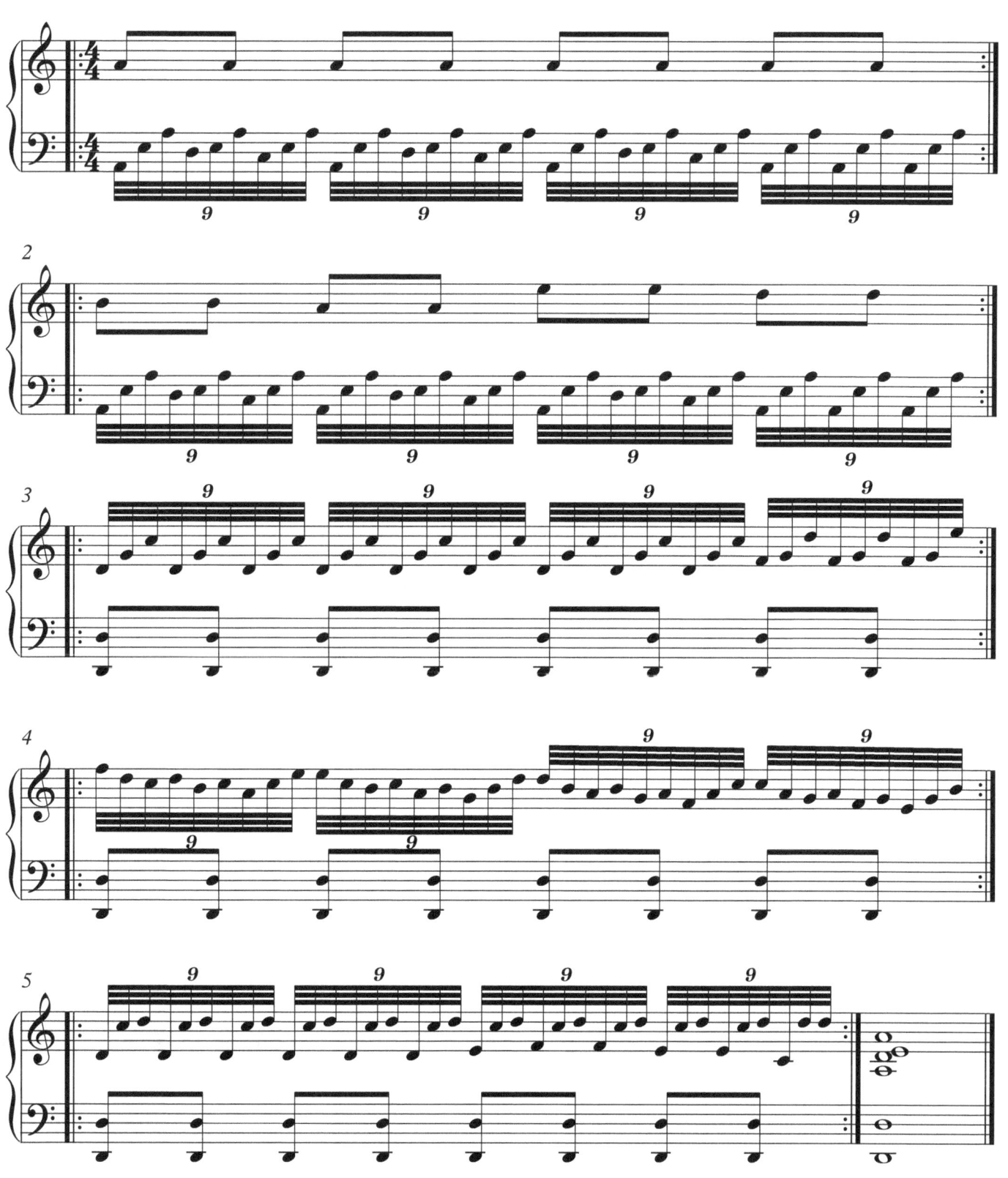

Polyrhythm 3:4

Jeff Fineberg

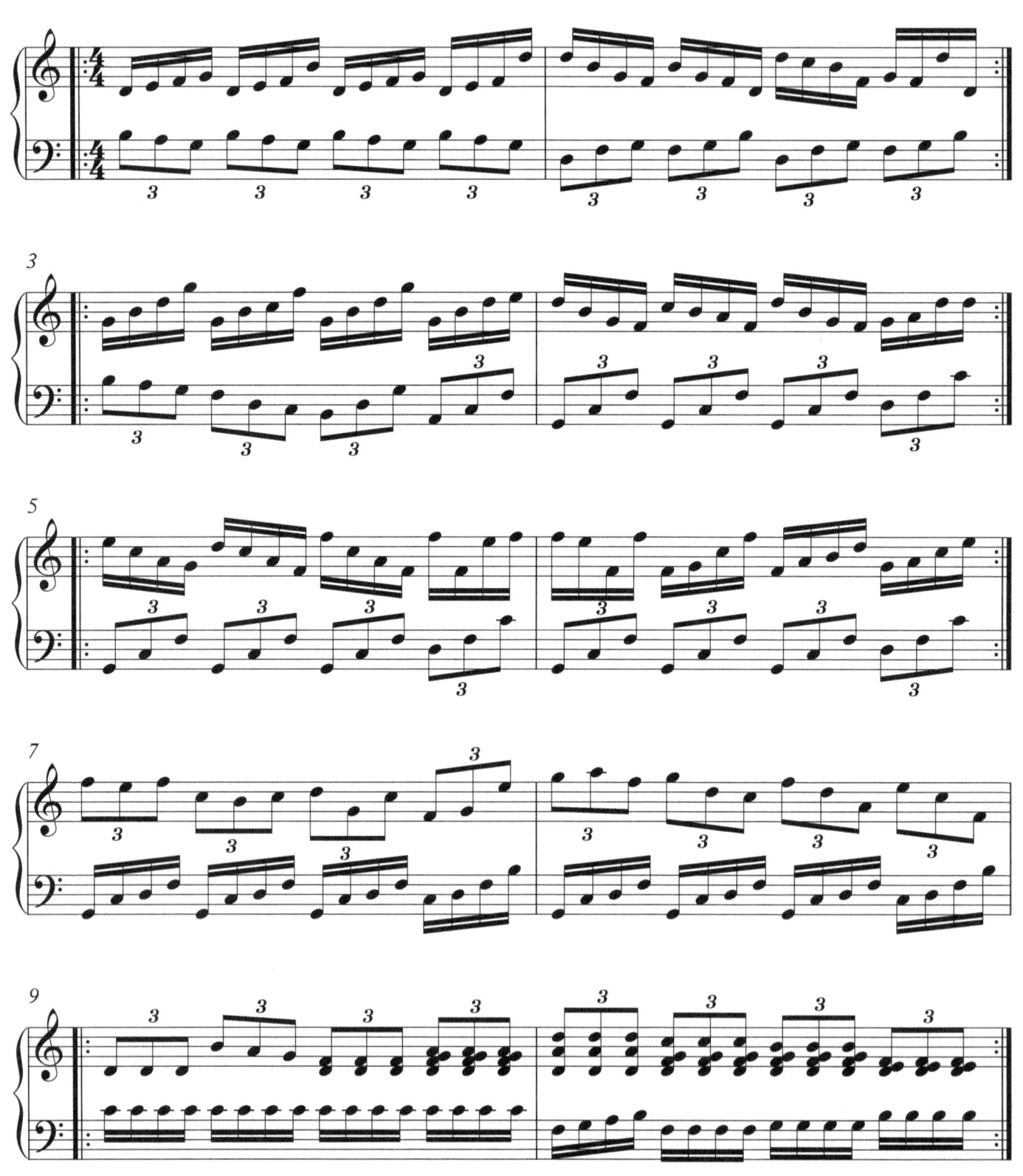

Copyright 2013

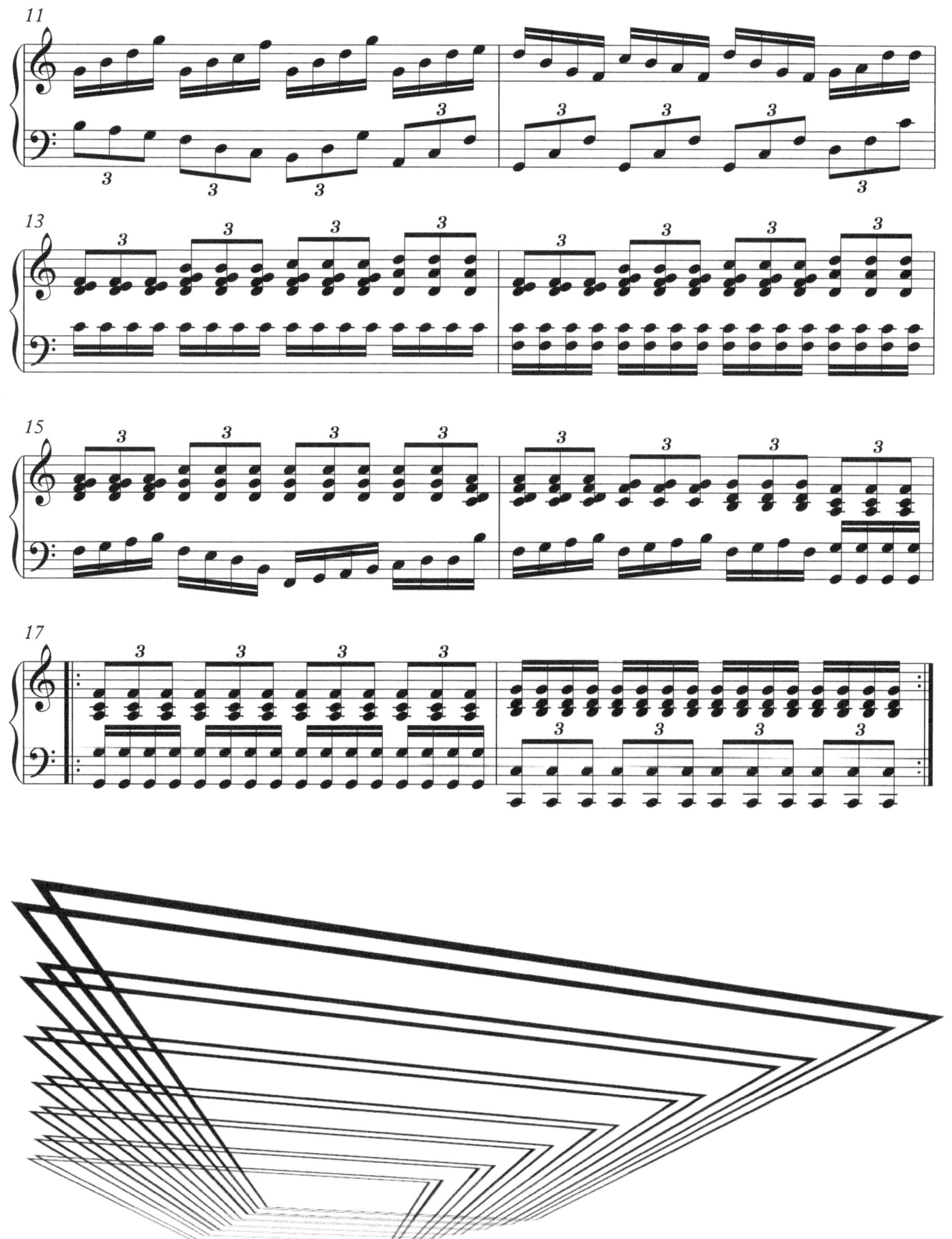

Polyrhythm 3:5

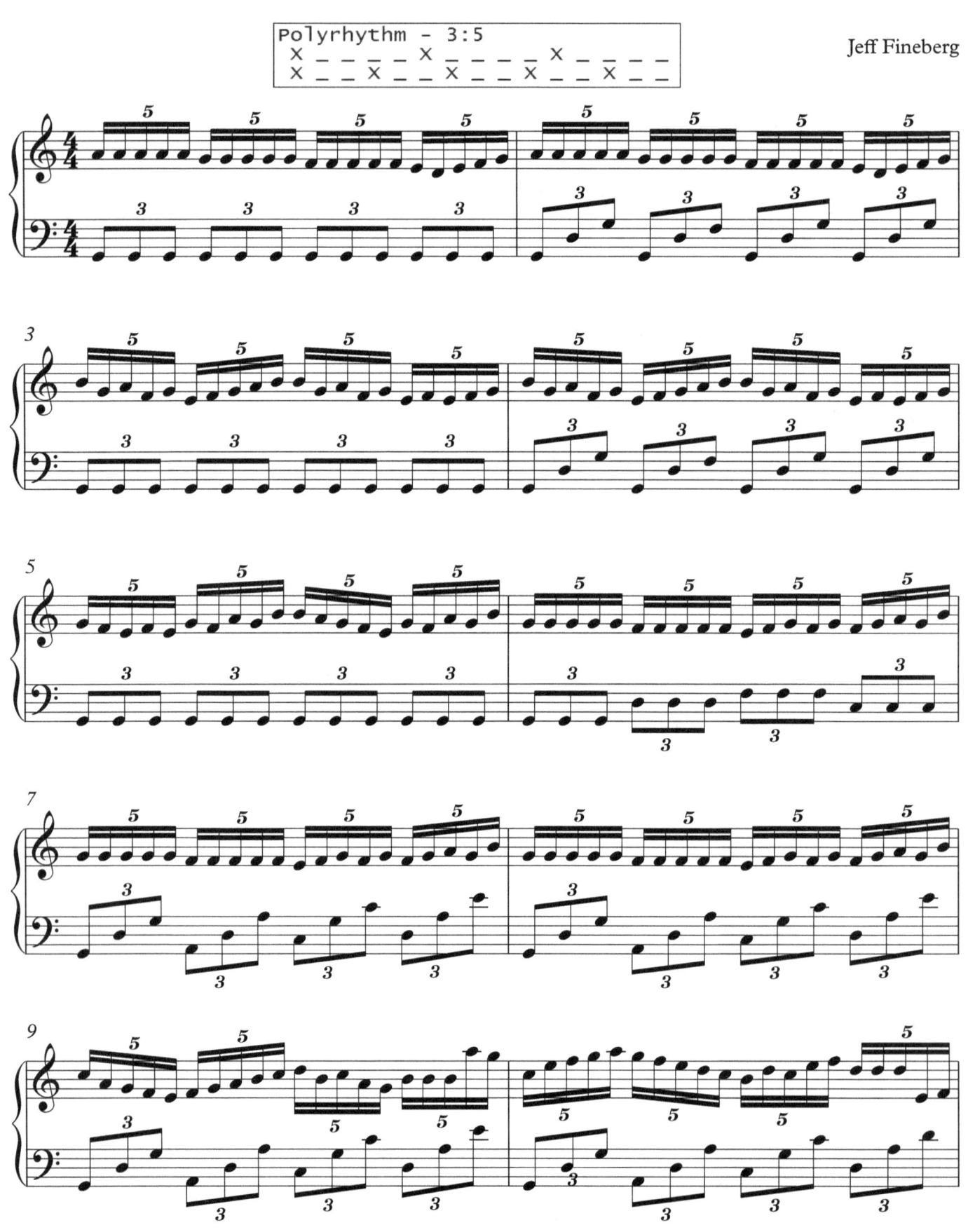

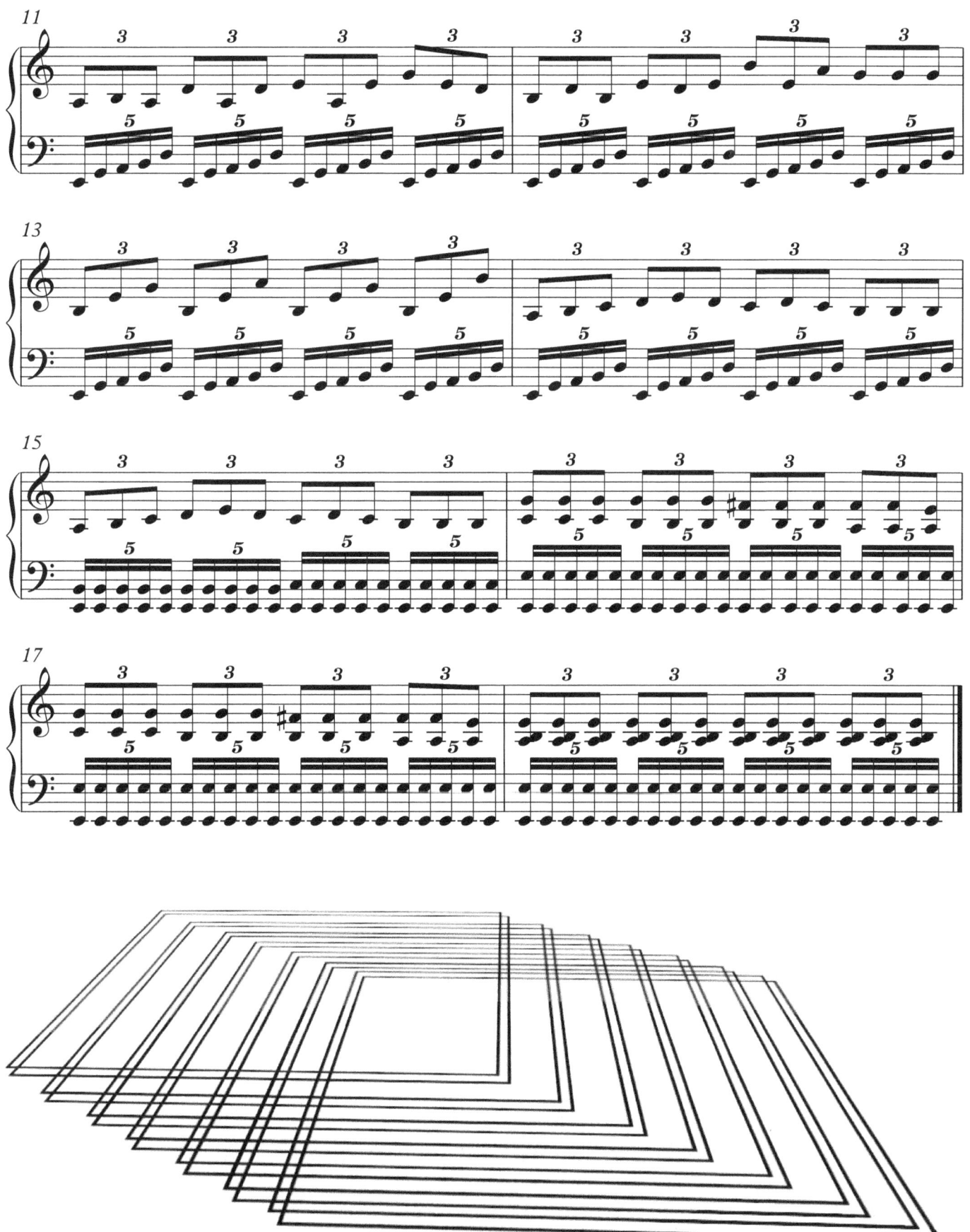

Polyrhythm 3:5 variation 1

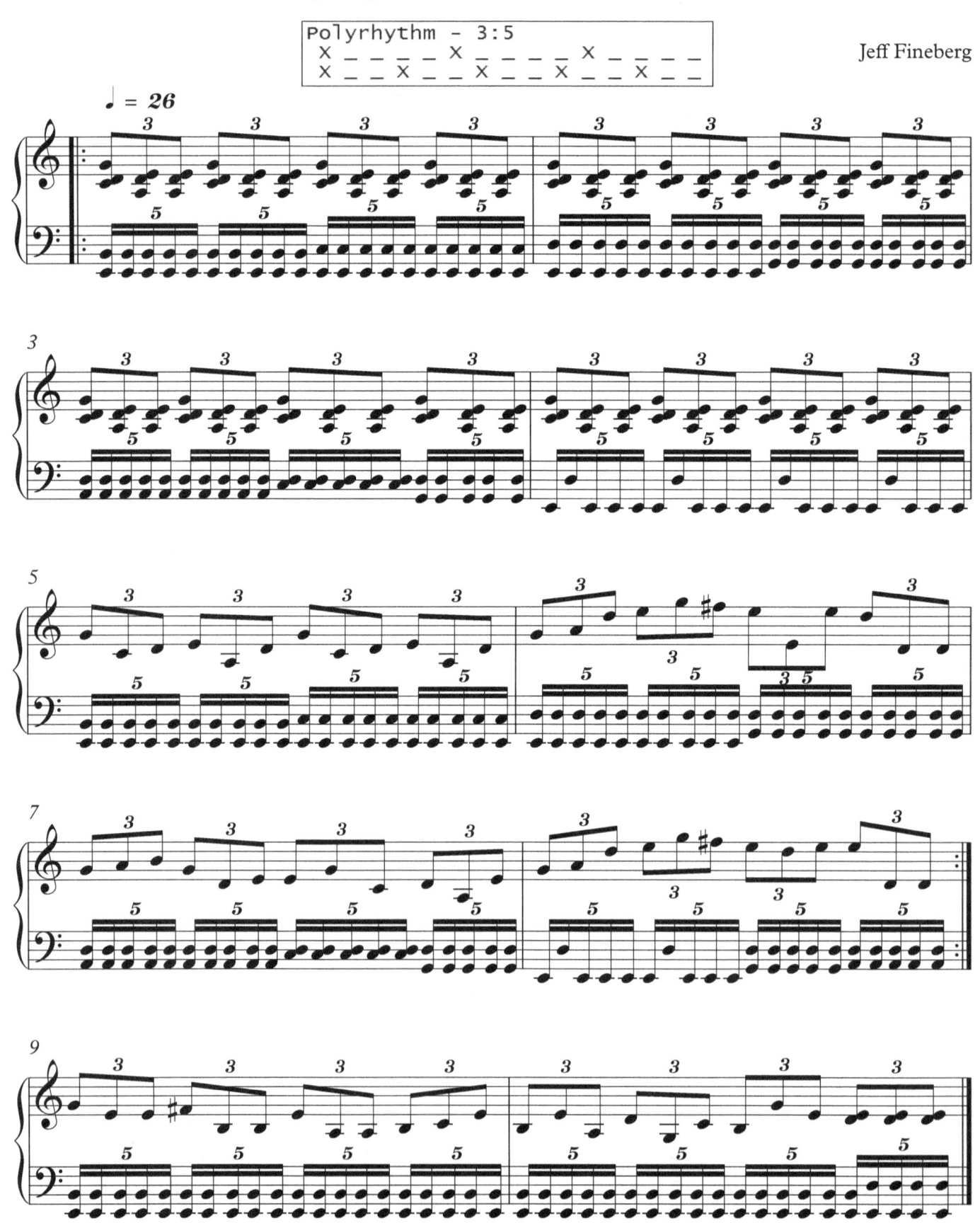

Polyrhythm 3:5 variation 2

Jeff Fineberg

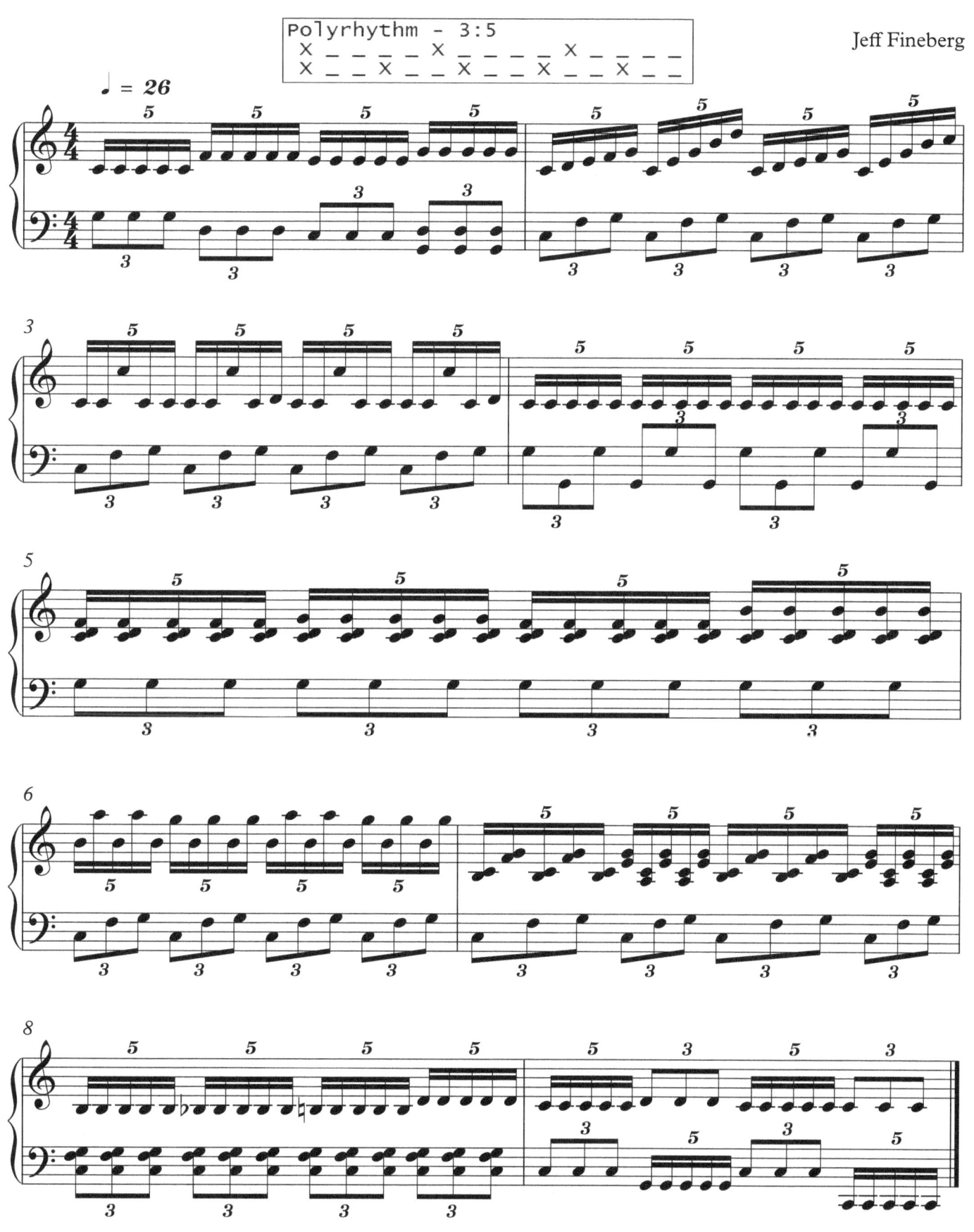

Polyrhythm 3:7

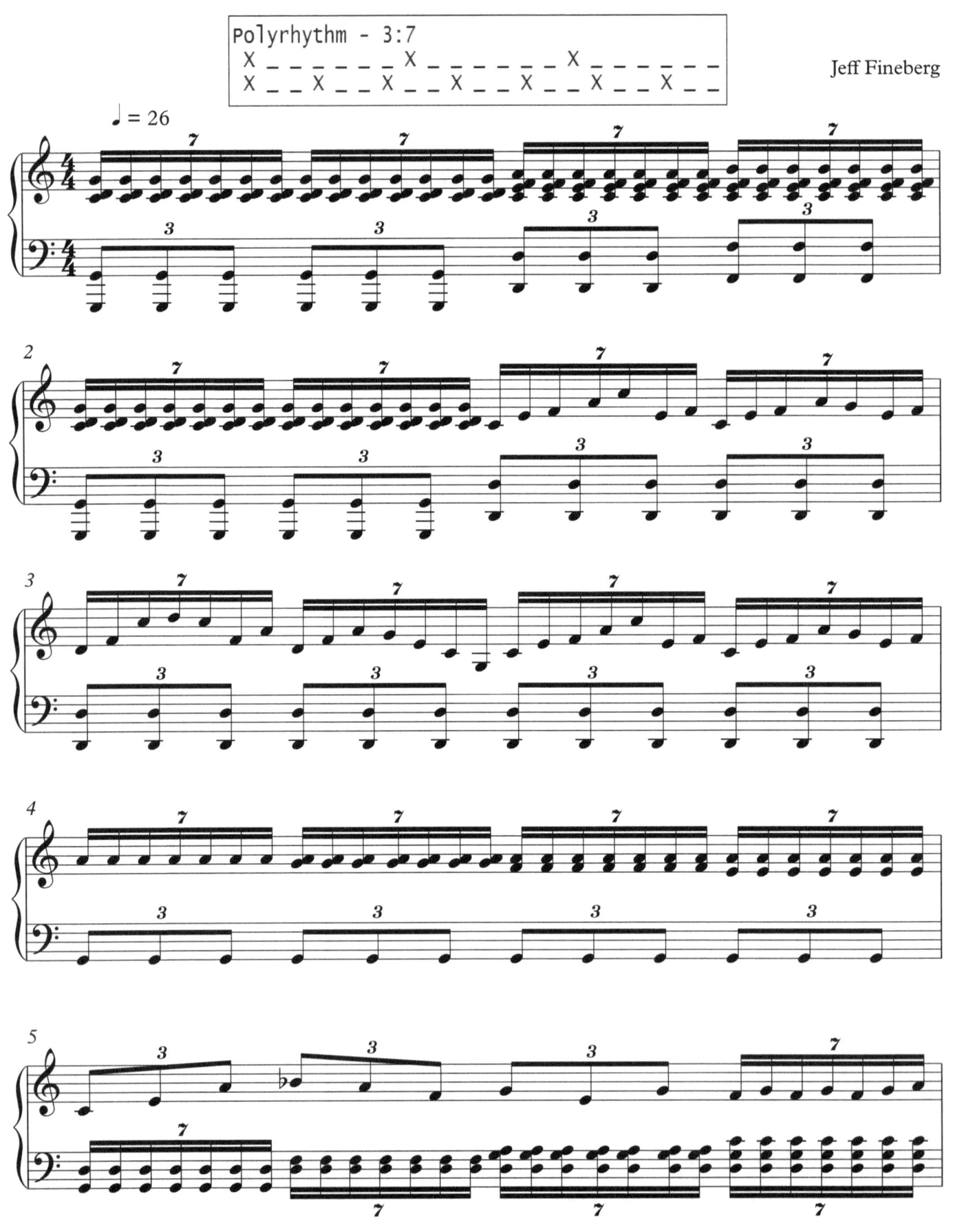

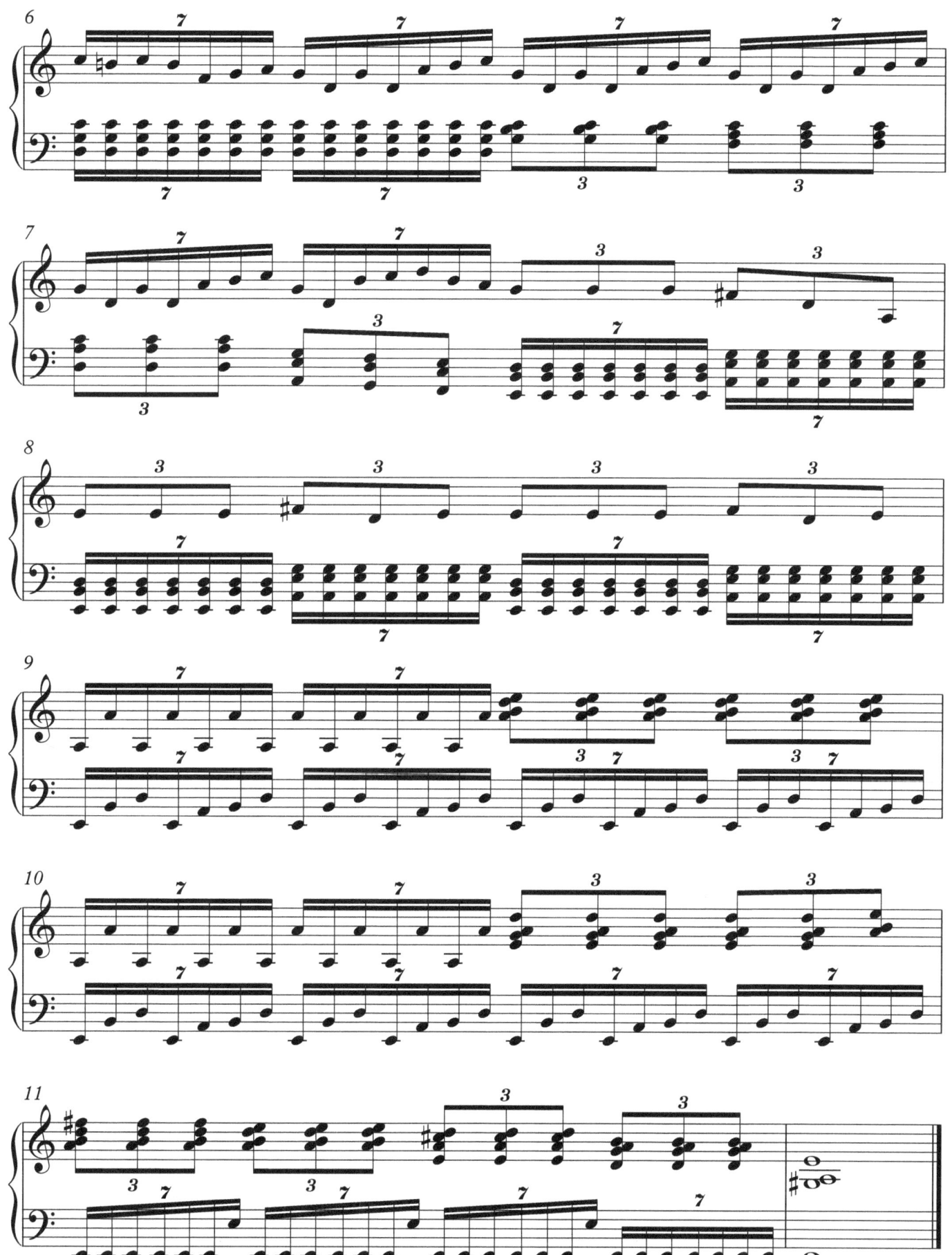

Polyrhythm 4:5

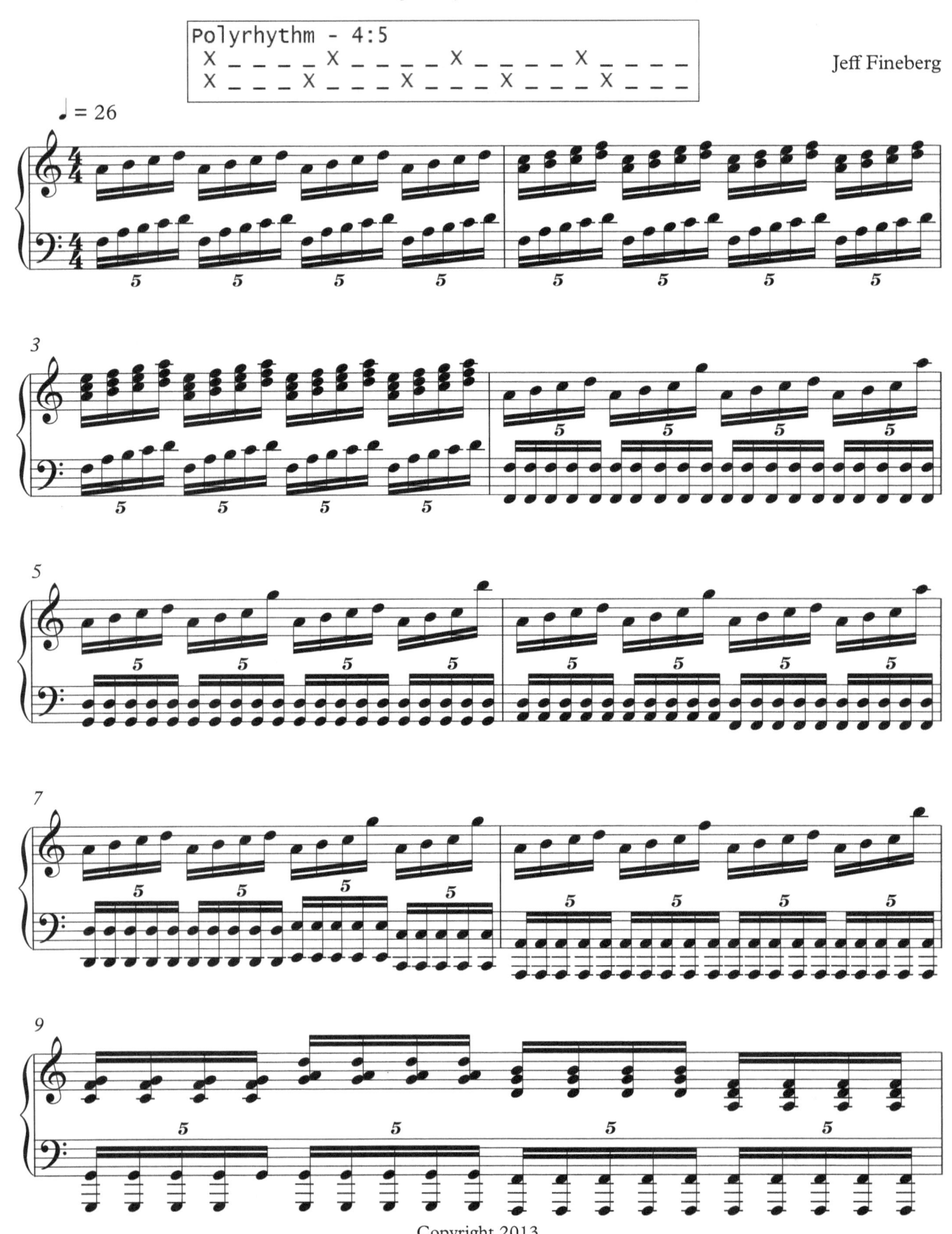

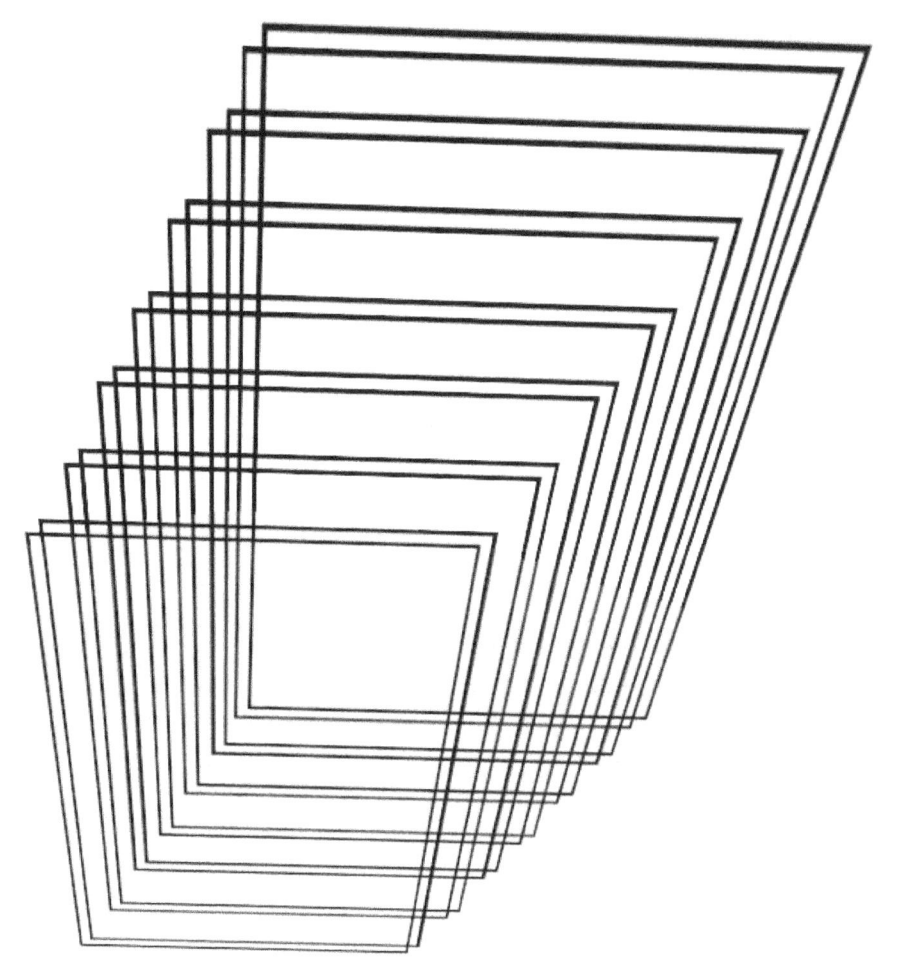

Polyrhythm 5:7

Jeff Fineberg

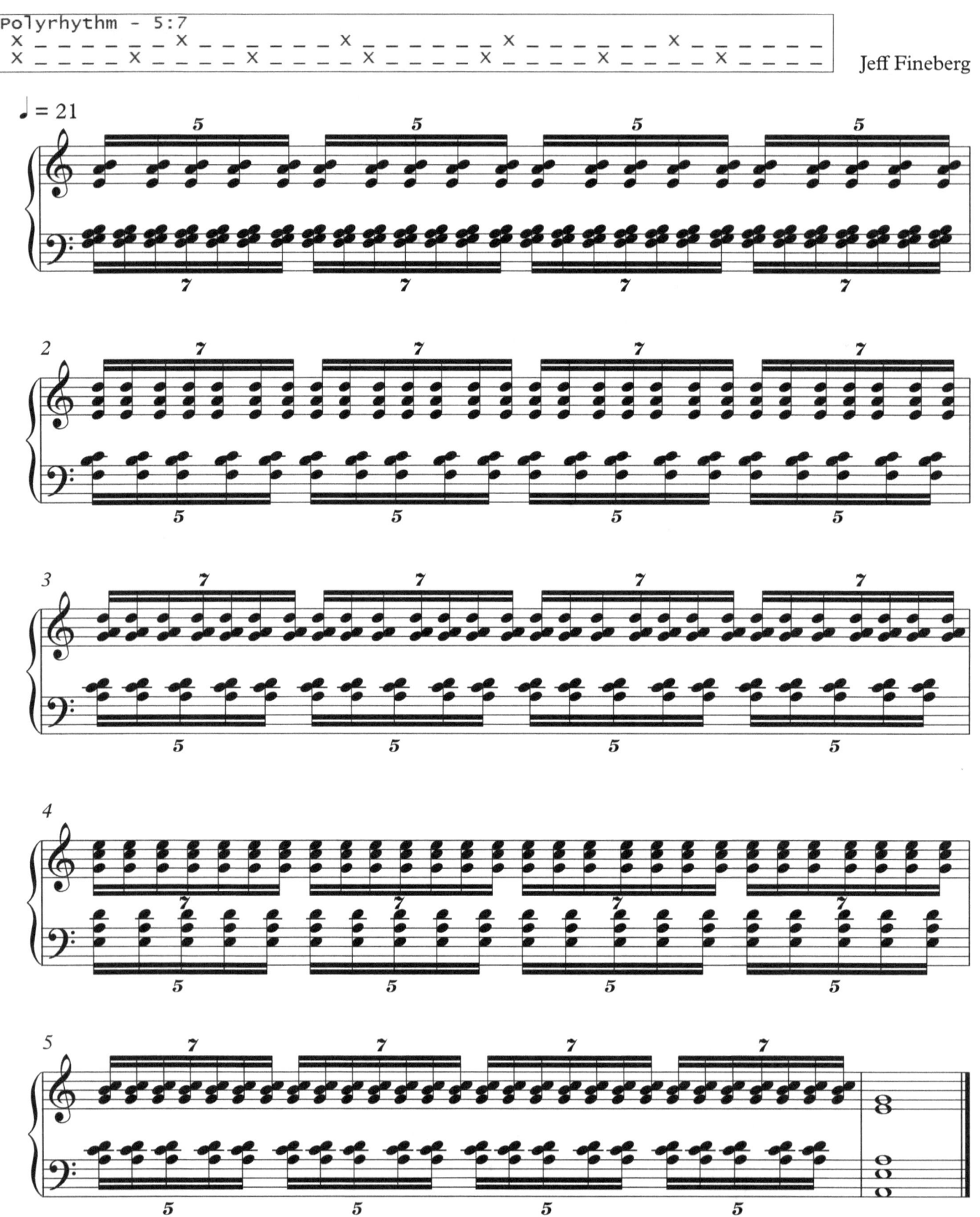

Chapter 6: Polyrhythmic Puzzles

In chapter 4 we discussed the fundamentals of polyrhythms, including how to play them with precision. In chapter 5 we played a number of structured pieces based upon polyrhythms. This chapter provides an opportunity to apply our knowledge in order to solve Polyrhythmic Puzzles.

Before proceeding, let's review an excerpt of the definition of "Puzzle" from chapter 1:

"A puzzle is typically a problem in which a set of items are "out of place" or not assembled, with the solution requiring an activity to reassemble or "solve" the puzzle."

The following polyrhythmic puzzles consist of instructions of what needs to be assembled, with the reader's responsibility being to 'assemble' a solution to satisfy the puzzle requirements.

Polyrhythmic Puzzles Instructions
Working with these puzzles will help further your understanding of polyrhythms as well hopefully provide you with new improvisational and compositional ideas. Note that since these puzzles are more open to interpretation than are the Polymetric Puzzles, there is no single correct 'answer' for them. The most critical aspect is that the playing of the polyrhythm is correct regardless of the approach. Also, to help create a sense of regularity within a segment of music, try to emphasize the beginning of each cycle to help clarify the polyrhythm.

Exercise 6.1: Review the various polyrhythmic notation of figure 4.3 in chapter 4. Before proceeding with the steps below, make sure you are able to play the fundamental polyrhythm you are interested in. Next, proceed with any and all of the following assignments:
1. Rather than playing a single note for each hand, try out your own selected notes.
2. Formulate simple melodies with each hand.
3. Experiment with intervals rather than single notes for each hand, either playing the same notes or changing over time.
4. Use Scales or scale fragments (e.g. a selected portion of a scale).
 a. Play the same scale with each hand.
 b. Play different scales with each hand (this may imply polytonality).
5. Experiment with chords, either playing the same ones or changing over time.
 a. Play the same chords with each hand at different octaves.
 b. Play different chords with each hand (these are called polychords).
6. Experiment with arpeggios, either playing the same ones or changing over time.
 a. Play the same arpeggio with each hand at different octaves.
 b. Play different arpeggios with each hand (this may imply polytonality).

7. Using a keyboard exercise technique book (such as Hannon, etc.) try applying a variety of polyrhythms to the exercises. See figure 6.1 and 6.2 for an example.
8. Take a polymetric puzzle (for example a 2:3 polymeter piece in chapter 2) and apply a 2:3 polyrhythm to the puzzle. Try this with any number of polymetric puzzles as a variation (e.g. 3:4 polymeter with a 3:4 polyrhythm, etc.). Note that this is one of the rhythmic variations described in chapter 1.
9. Improvise using any or all of these variations.
10. Compose a piece utilizing any combination of these variations.
11. Apply polyrhythms to a segment of music that you are familiar with. Initially it may be easier if you use a segment that is composed of notes containing the same duration (e.g. all eighth notes, sixteenths, etc.).
12. For any of the above assignments, change the emphasis from the beginning of a cycle to other points within the cycle. This can be quite challenging. Consider using:
 a. A fixed alternative emphasis. For example, rather than emphasizing the beginning of a cycle (beat 1), consistently emphasize on of the other notes within the cycle.
 b. A changing alternative emphasis. For example, change the beat emphasis for each cycle – for cycle 1, emphasize one note in a cycle, then purposefully emphasize a different note in the next cycle, etc.

Figure 6.1 Example exercise – chromatically ascending suspended chords in octaves

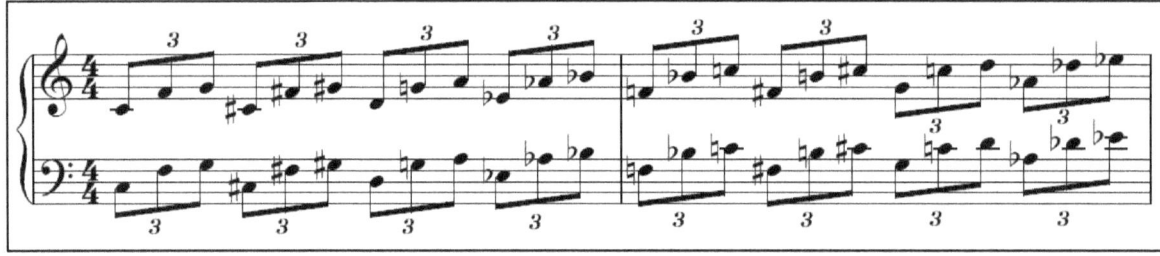

Figure 6.2 Sample solution – using #7 – applying a 2:3 polyrhythm to Figure 6.1

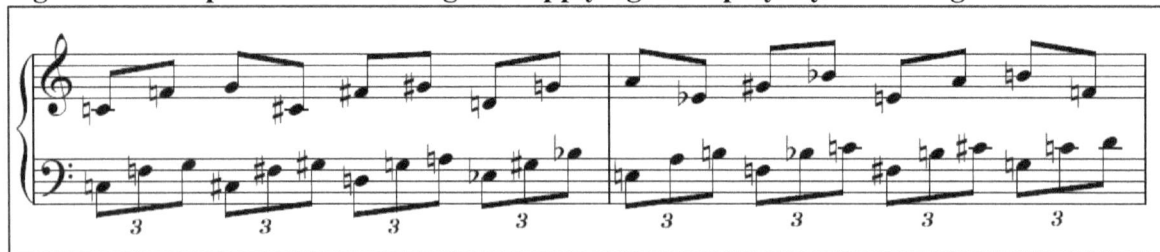

Chapter 7: An Approach Combining Polyrhythms and Polymeters

So far we have discussed and experimented with both polymeters and polyrhythms. For simplicity and clarity of concept, an attempt was made to keep them separate; however in practical use there is no reason to do so. The purpose of this chapter is to illustrate the mixture of both polyrhythms and polymeters, with a progression of increasing complexity of usage. The chapter concludes with example pieces which utilize both elements freely.

Representing Polymeters and Polyrhythms simultaneously
As one might imagine, representing both elements in notation is somewhat complex, however our examples should be reasonable enough to interpret when accompanied with an explanation. A concern is that while polyrhythms are fairly straightforward to interpret due to notation, the representation of embedded polymeters is somewhat more elusive. For our purposes, a polymeter will be a set of (equal duration) notes that repeat within a given segment of music. It is important to note that the equal duration is not mandatory; however it helps significantly to clarify our objective of learning how to play polyrhythms and polymeters simultaneously. Note that the polymeters are clearly indicated by the use of phrase marks.

Exercise 7.1: given the 3:2 polymeter segment in Figure 7.1, do the following:

1. Play it exactly as written, using quarter notes. Note that in order to play one complete cycle of 2:3 polymeter, a 2/4 measure area is repeated 3 times and a 3/4 measure is repeated 2 times.
2. Play the segment using 3:2 polyrhythm, where the group of 3 are triplets and the group of 2 are quarter notes (figure 7.2).
3. Switch the assignment of the polyrhythm for each staff. In other words, play the segment using 2:3 polyrhythm, where the group of 2 are triplets and the group of 3 are quarter notes. Note that it takes much longer to complete a cycle than in step 1 or 2 (figure 7.3).
4. Play the segment using 4:3 polyrhythm, where the group of 3 are assigned '4' and the group of 2 are '3' of the polyrhythm (figure 7.4).
5. Switch the assignment of the polyrhythm for each staff. Therefore, Play the segment using 3:4 polyrhythm, where the group of 3 are assigned '3' and the group of 2 are '4' of the polyrhythm. Note that it takes much longer to complete a cycle than in step 1 or 2 (figure 7.5).
6. Experiment by applying other polyrhythms to figure 1, such as 4:5, 7:3, etc.
7. Apply steps 1-6 to any other polymetric Puzzle exercises from chapters 2 and 3.

Exercise 7.1 (continued): **Note that the polymeter is indicated by the use of phrase marks.**

Figure 7.1 3:2 Polymeter based upon 3/4 and 2/4 meters.

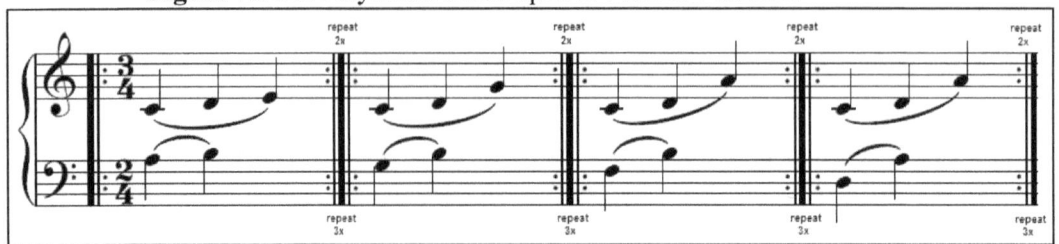

Sample solution: example of various polyrhythms applied to measure 1 of Figure 7.1 (it is left as an exercise to the reader to implement the remaining measures).

Figure 7.2 3:2 Polymeter with 3:2 Polyrhythm

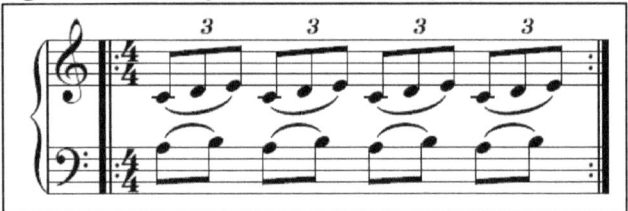

Figure 7.3 3:2 Polymeter with 2:3 Polyrhythm

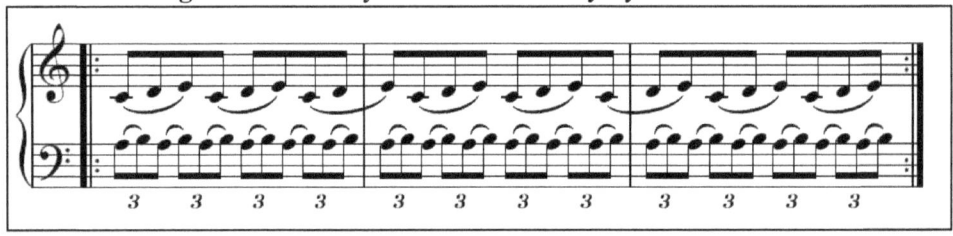

Figure 7.4 3:2 Polymeter with 3:4 Polyrhythm

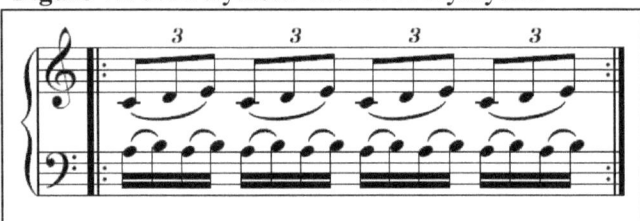

Figure 7.5 3:2 Polymeter with 4:3 Polyrhythm

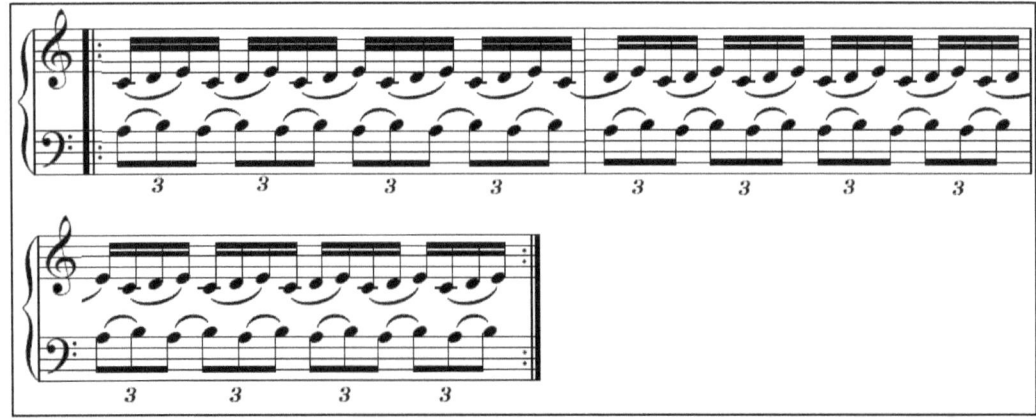

Exercise 7.2: in a manner similar to Exercise 7.1, apply the steps 1-10 to each of the various segments below. Be sure to play at least one complete cycle, or if playing longer, play to the end of a cycle. Also, try to accent the 'one' of a measure where if it helps to clarify what you're playing. *(Optional – as part of the cycle, feel free to alter a note or two per cycle, or try other variations as having been presented in the text).*

1. Play it exactly as written for one cycle, using quarter notes.
2. Use a 3:2 polyrhythm.
3. Use a 2:3 polyrhythm.
4. Use a 3:4 polyrhythm.
5. Use a 4:3 polyrhythm.
6. Use a 4:5 polyrhythm.
7. Use a 5:4 polyrhythm.
8. Experiment by applying other polyrhythms, such as 4:5, 7:3, etc.
9. Use non-polyrhythmic[1] ratios such as 2:1 or 1:2 (two notes of one hand and one of another)
10. Try other non-polyrhythmic ratios, such as 3:1, 1:3, 4:1, 1:4, etc.

Figure 7.6 6:5 Polymeter

Figure 7.7 3:4 Polymeter

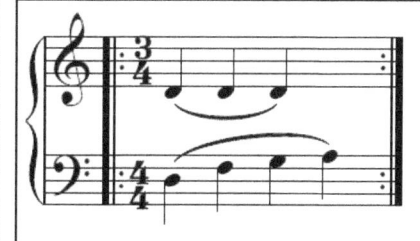

Figure 7.8 6:4 Polymeter

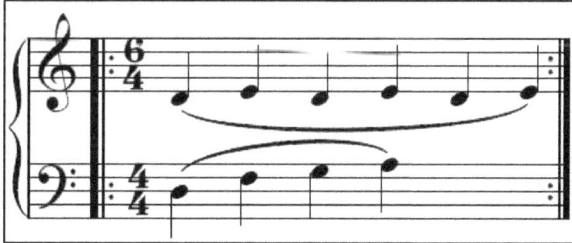

Figure 7.9 6:4 Polymeter

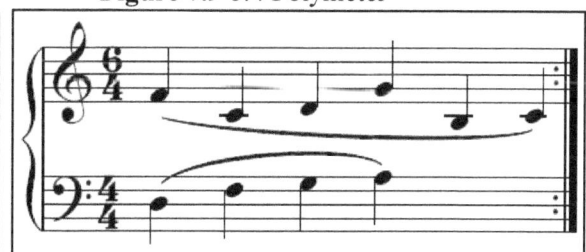

Figure 7.10 6:4 Polymeter

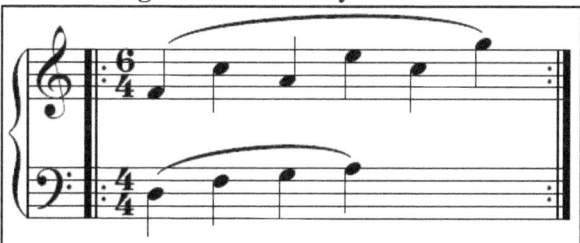

Figure 7.11 6:4 Polymeter

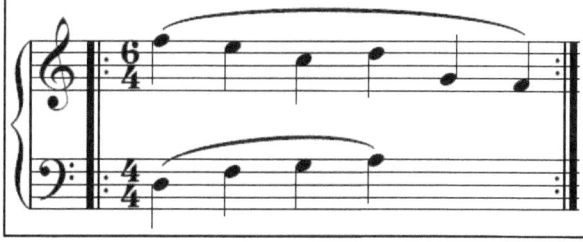

[1] These are non-polymetric ratios because in the ratio n:m, n and m are not relatively prime.

Combining Polyrhythms and Polymeters

Exercise 7.3 - follow the variations as discussed in exercise 7.2, applying different polyrhythms to each pattern. Repeat as desired.

Jeff Fineberg

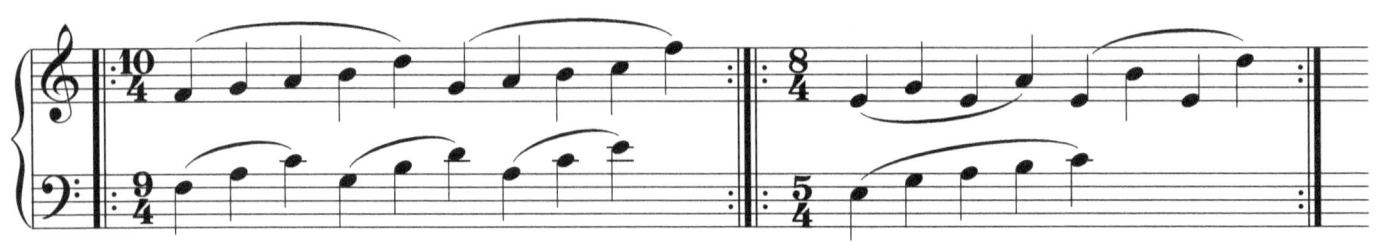

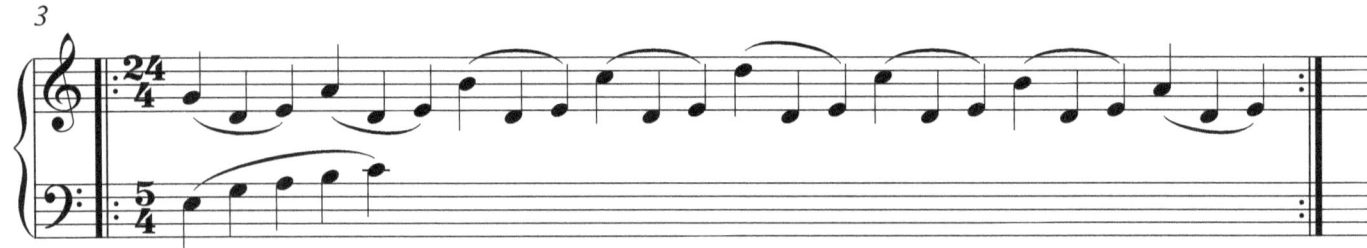

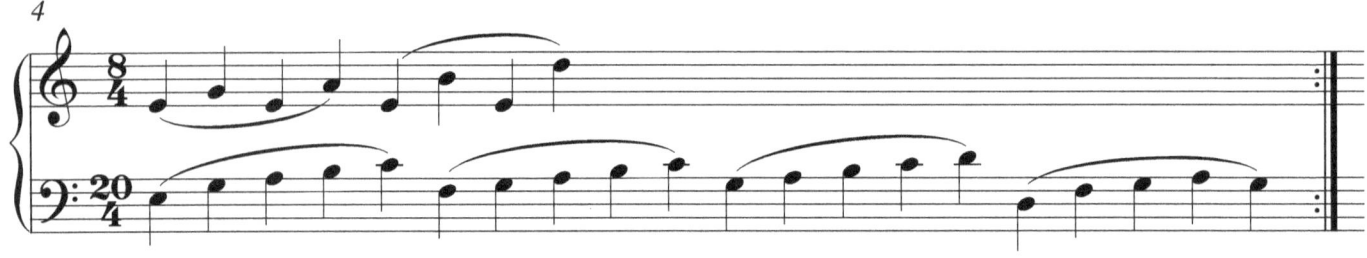

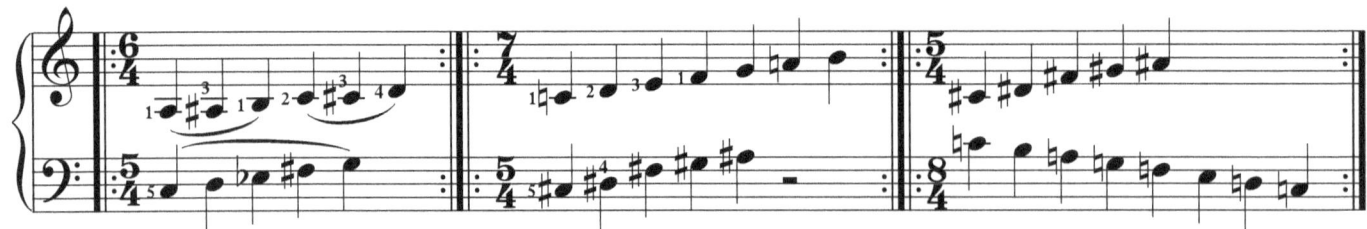

Further embellishment for methods below: consider combinations resulting in polytonality

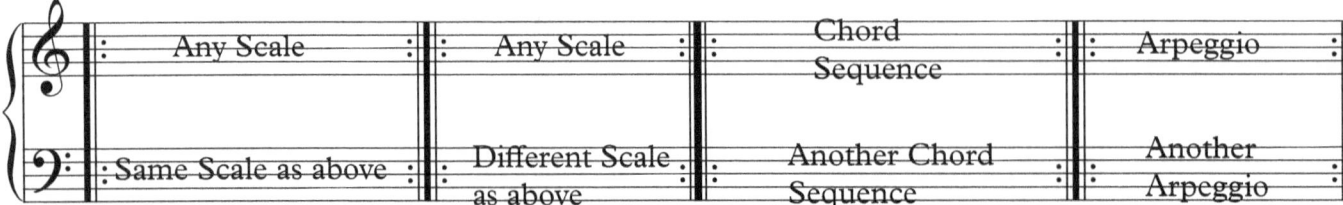

Copyright 2014

2:3 Polyrhythm within Polymetric Melodic Patterns of 5:5, 30:5, 15:5, 8:5

Jeff Fineberg

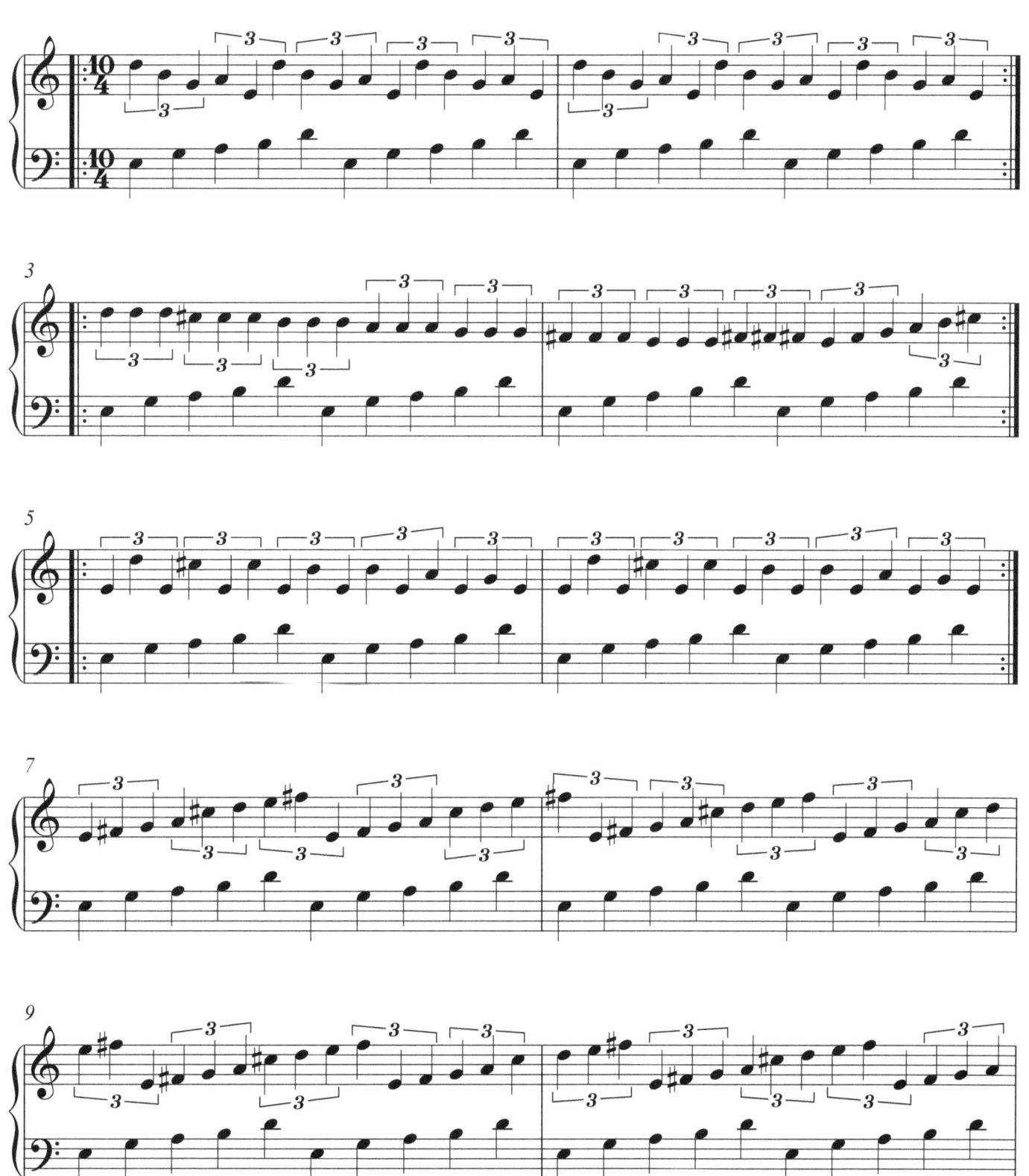

Copyright © 2011

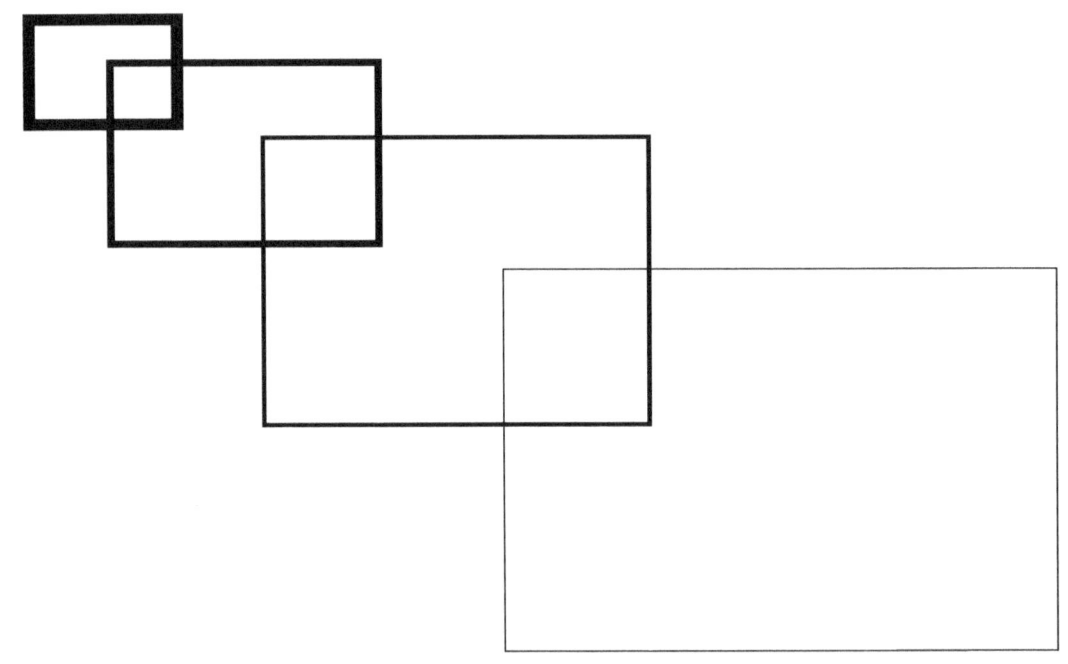

3:4 Polyrhythm with Triplets Metrically grouped in 4

Jeff Fineberg

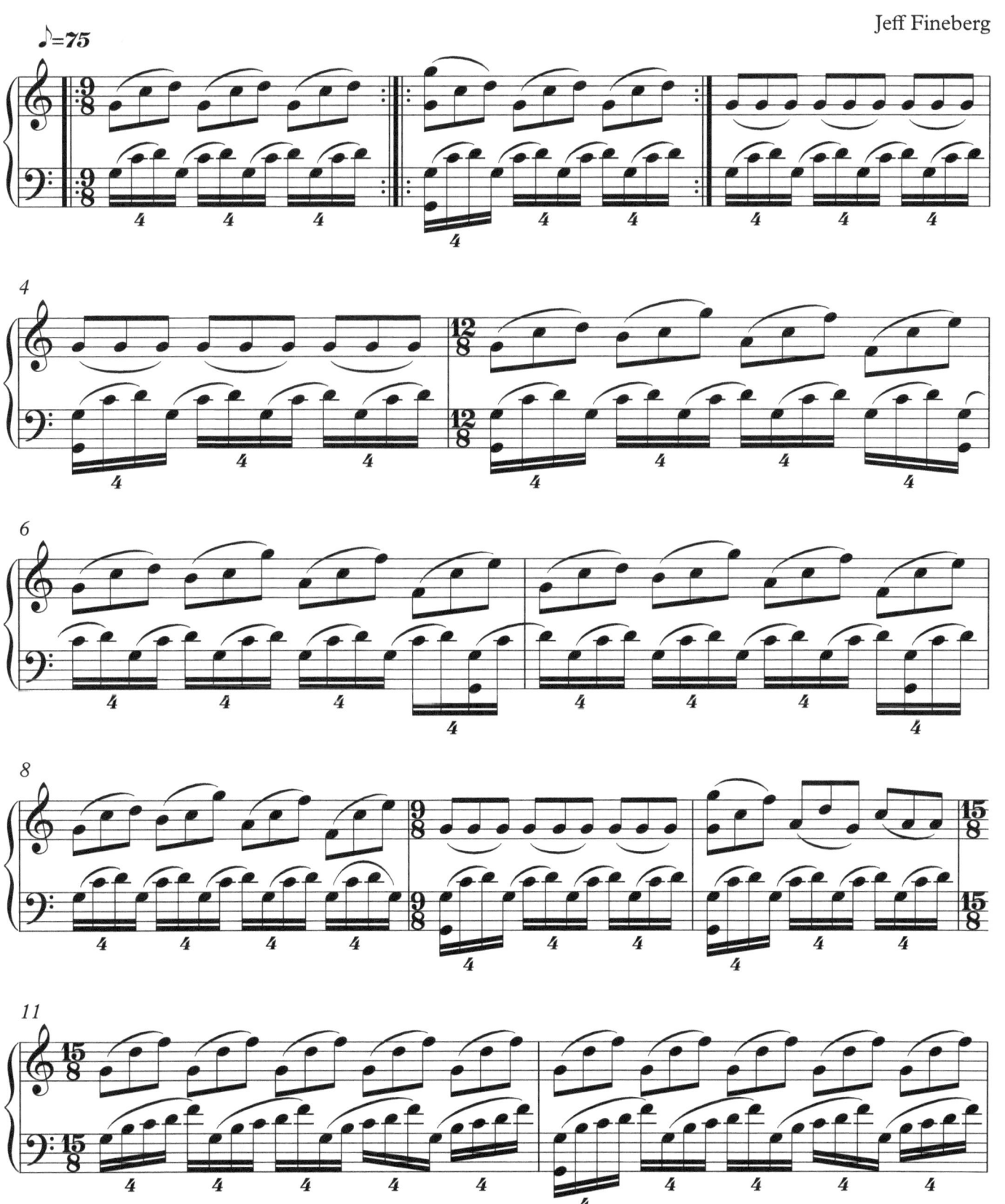

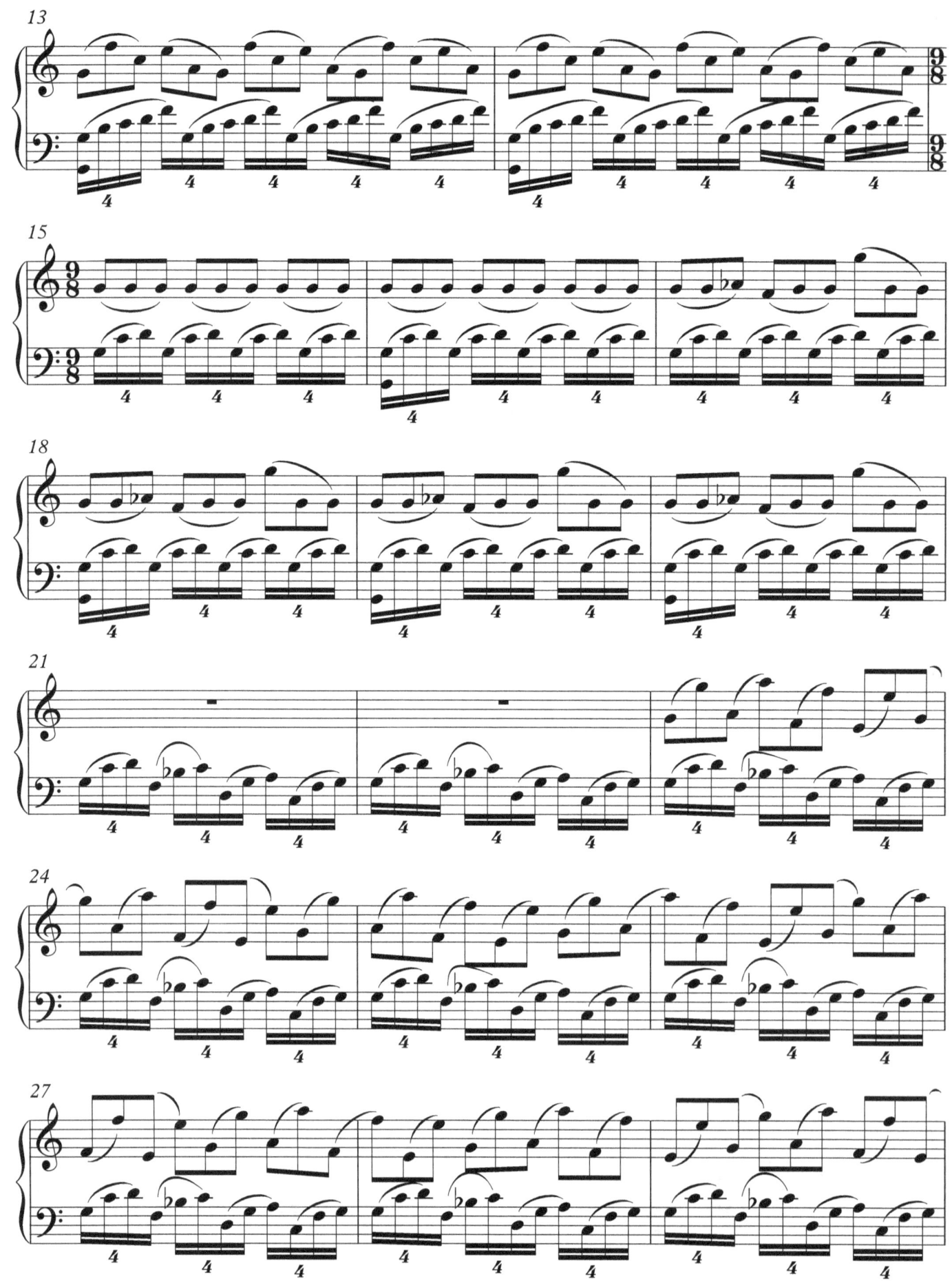

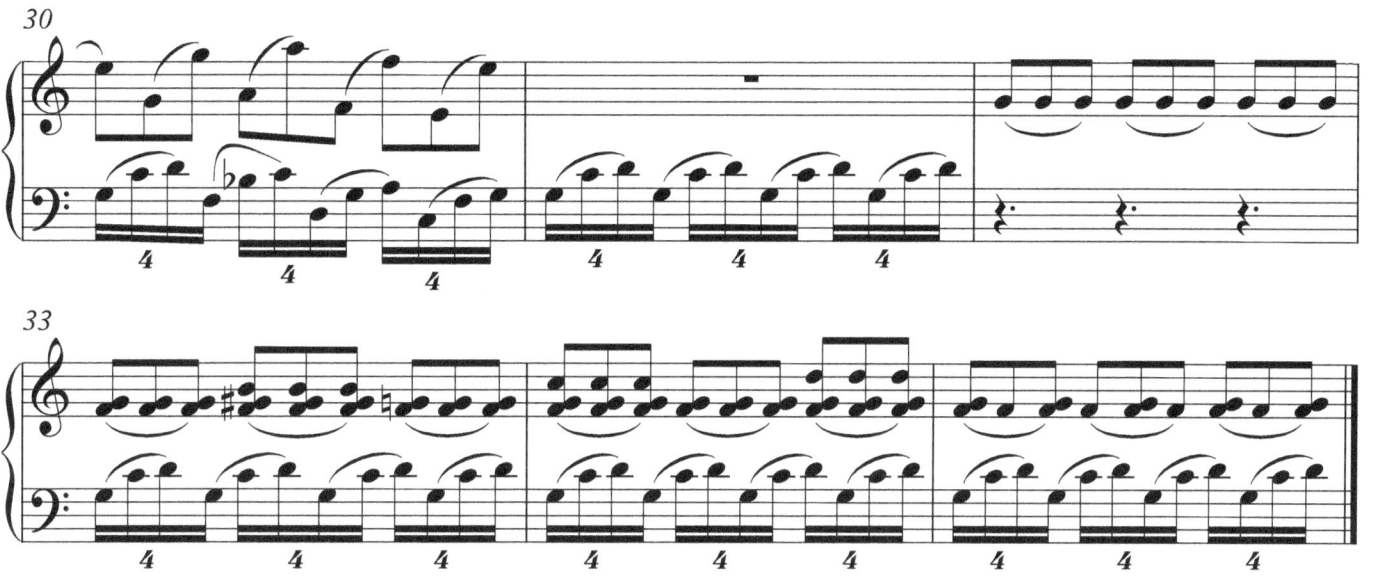

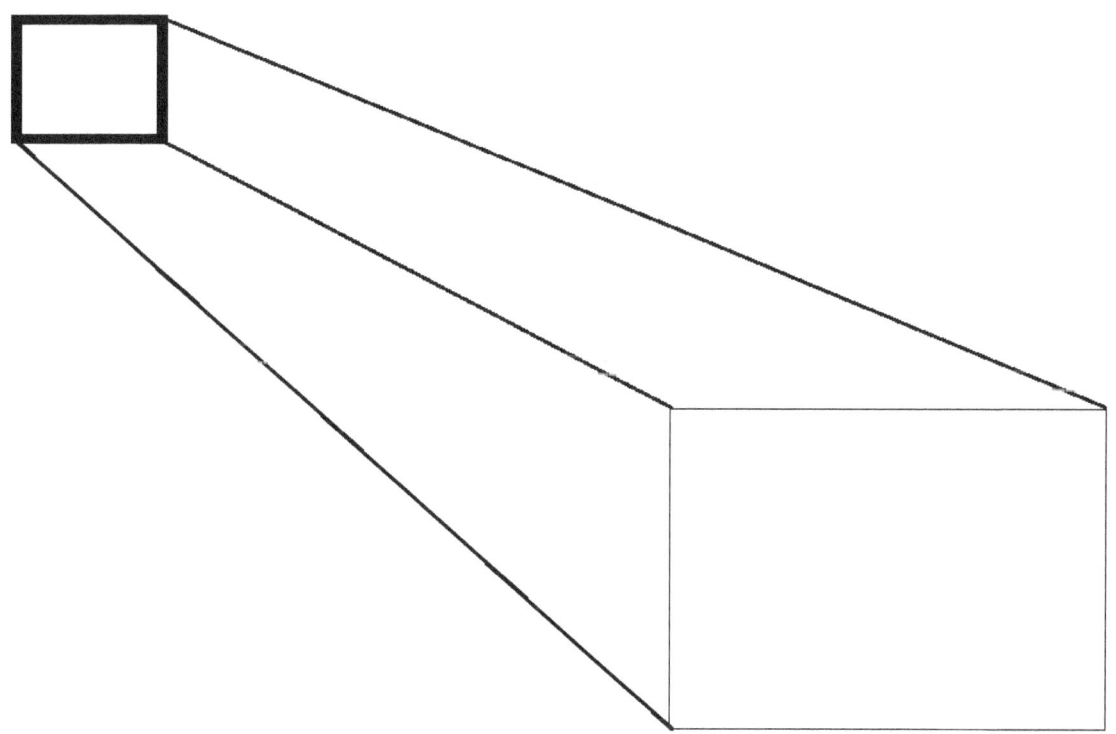

Impossible Object

Key West Tangle

(2 melodic patterns of 7 against 3 within a syncopated rhythm in 36)

Dedicated to Kim Fineberg on our 25th anniversary

Jeff Fineberg

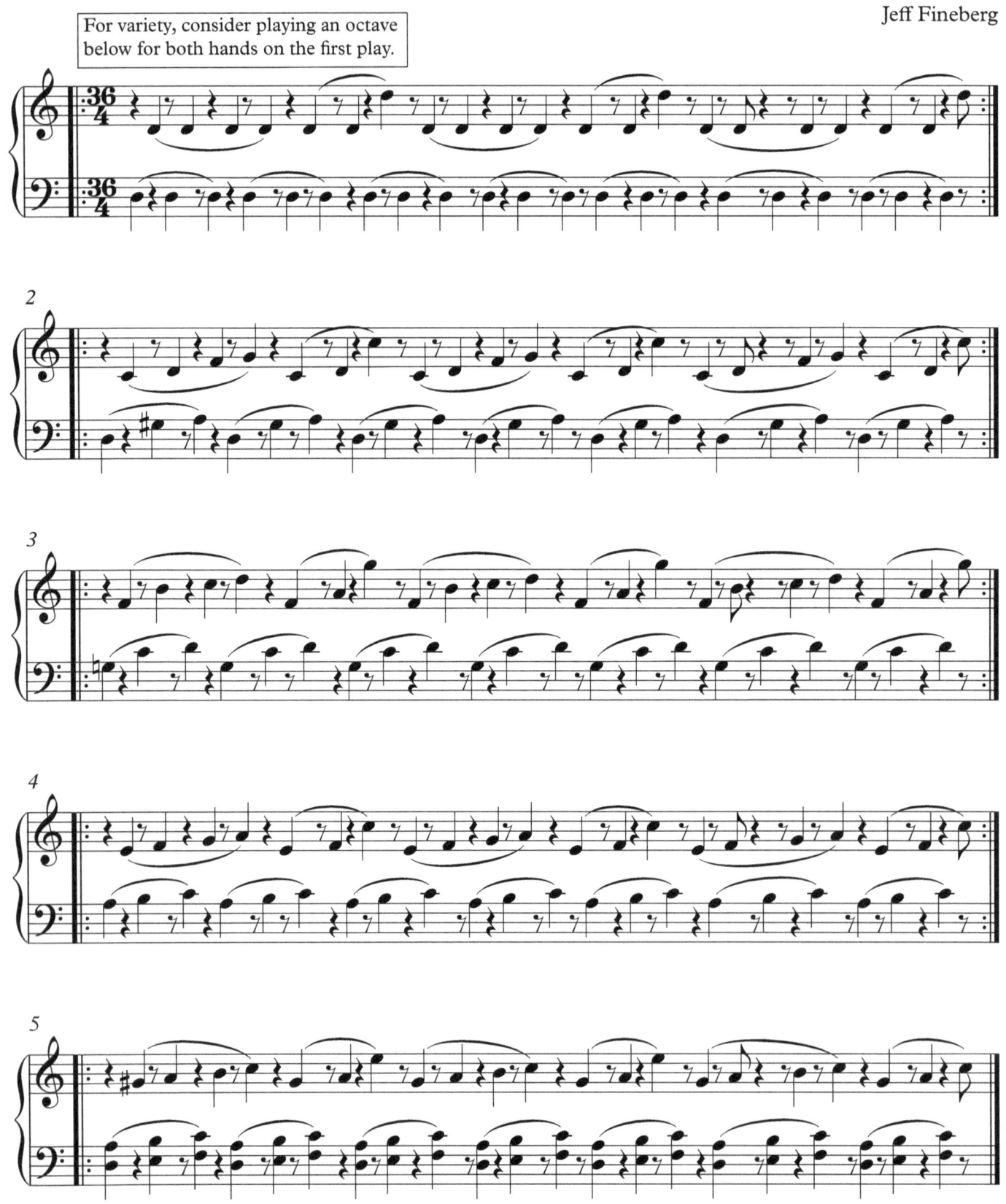

For variety, consider playing an octave below for both hands on the first play.

Copyright 2013

Protein Clock Hypothesis

Based on the title from the Corporate Mind CD "Escape from Evolution" 2013

Jeff Fineberg

Copyright 2013

Polyrhythmic Melodic Exchange - 4:5

Jeff Fineberg

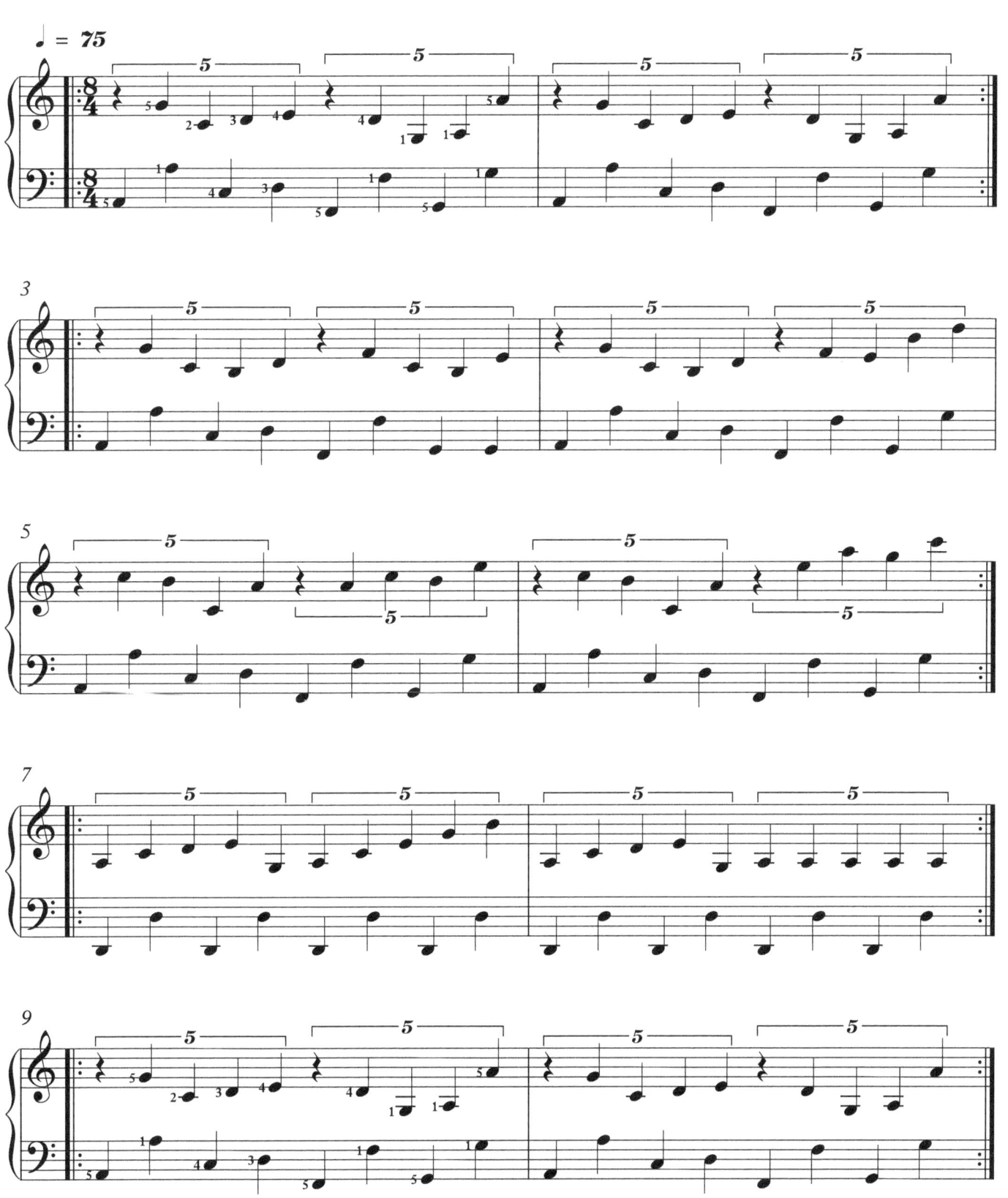

© 2014 Jeff Fineberg

Chapter 8: Out of Phase Puzzles using Asymmetric Phrases

The puzzles up to this point have been based upon polymeters, polyrhythms or a combination of both. In this chapter, the puzzles begin with a pattern of identical phrases in both hands, followed by instructions on how to transform the pattern over time. The difficulty in playing these puzzles is caused by the transformed phrases[1] becoming asymmetric (or dissimilar) in length, or somehow otherwise mismatched, such as by altered pitches. The result is an interesting weaving of melodic material which creates a challenge to maintain independence of the hands. It is up to the performer to decide how to 'solve' the problem by performing the transformations.

Before proceeding, let us clarify the difference between 'phrase' and 'phase'. When referring to a 'phrase' in our context, this is a segment of notes which are typically repeated within a measure. They are notated with slurs in the exercises. When referring to 'phase' in this context, it refers to how to phrases line up in a segment of music. When 2 phrases are of the same size cycle, they are also 'in phase'. When they are dissimilar in their cycle size, they are 'out of phase'. This characteristic can create a challenge to perform, in a manner similar to the polymetric puzzles. Below is an example of an original phrase followed by a transformation. Phrases are identified by brackets above and below each staff.

Figure 8.1 "In phase" exists when the R.H. and L.H. brackets are aligned

Figure 8.2 "Out of phase" exists when the R.H. and L.H. brackets are out of alignment.

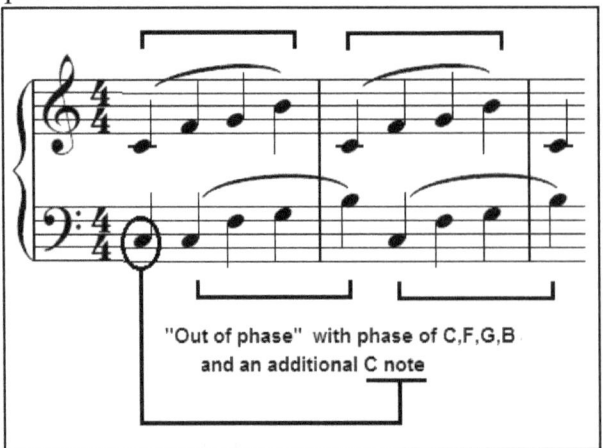

[1] Note that this method is also used in composition for creating variations of material.

Transformation Instructions
Each of the transformations has a different challenge level, depending upon the experience and ability of a musician. Feel free to try a variation alone or in combination with other variations. Of course the challenge level will increase as the numbers of simultaneous transformations are applied.

Some examples of transformations include:
- Lengthening one of the phrases by repeating one or many notes of the phrase, any number of times. Alternatively, rather than repeat a note, you may add a new note which is not part of the phrase. This modification to a phrase can happen either:
 o Once per phrase
 o Once every other phrase
 o Once for a set number of phrases (e.g. every 3 phrases, every 9 phrases, etc.)
 o Once per cycle (recall that a cycle involves repeating patterns until there is a "synch" point – when dissimilarly sized phrases have completed with the opportunity to begin again. See Chapter 1 and 2 for an overview of cycles).
- Shortening one of the phrases by removing one or many notes, similar to the above method:
 o Once per phrase
 o Once every other phrase
 o Once for a set number of phrases (e.g. every 3 phrases, every 9 phrases, etc.)
 o Once per cycle (recall that a cycle involves repeating patterns until there is a "synch" point – when dissimilarly sized phrases have completed with the opportunity to begin again. See Chapter 1 and 2 for an overview of cycles).
- Lengthening one of the phrases by uniformly increasing the duration of all notes (e.g. changing all quarter notes changed to half notes).
- Shortening one of the phrases by uniformly decreasing the duration of all notes (e.g. changing all quarter notes changed to eighth notes).
- Modifying the duration of one (or more) notes of a phrase (rather than uniformly altering all note durations).
- Applying a polyrhythm to the segment of material, such as assigning 2:3, 3:4 or other polyrhythms to a set of assigning different tuples
- Modulate (or transpose) one of the phrases to another key. This can be done to either original or transformed phrases.
- Altering one (or more) of the existing notes of a phrase.
- Mixing patterns to create contrasting material.

Examples of Puzzles and Transformations
On the following pages are 2 "Out of Phase" puzzle illustrations with sample solutions, followed by 2 challenges: "Out of Phase" Puzzle 1 and Puzzle 2. It is recommended that you study and try out the illustrations to gain an understanding of the possibilities for applying variations to the "Out of Phase" puzzles in this chapter.

"Out of Phase" Puzzle illustration using C, F and G
(duplicated notes, augmentation and polyrhythms)

Jeff Fineberg

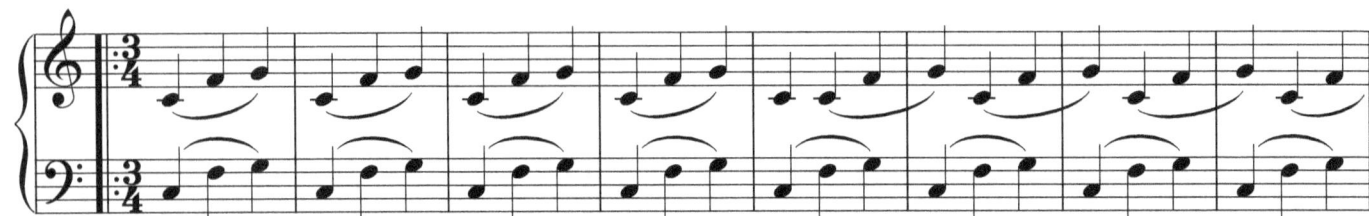

The original pattern - 4 measures of C, F and G played identically in both hands.

The pattern C, F, G is lengthened with 1 extra C note after each set of 4 measures.

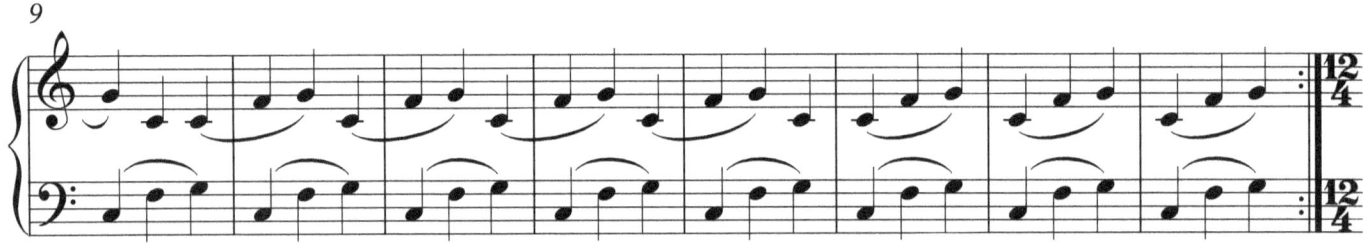

A continuation of the above pattern...

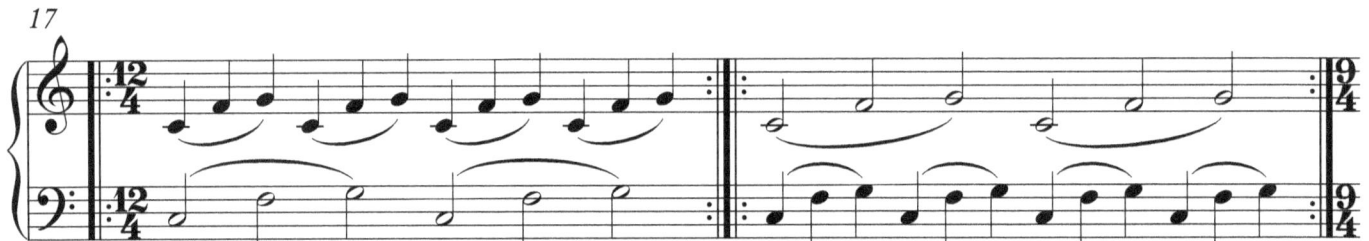

The pattern C, F, G is lengthened with augmentation, using half notes for one of the melodies.

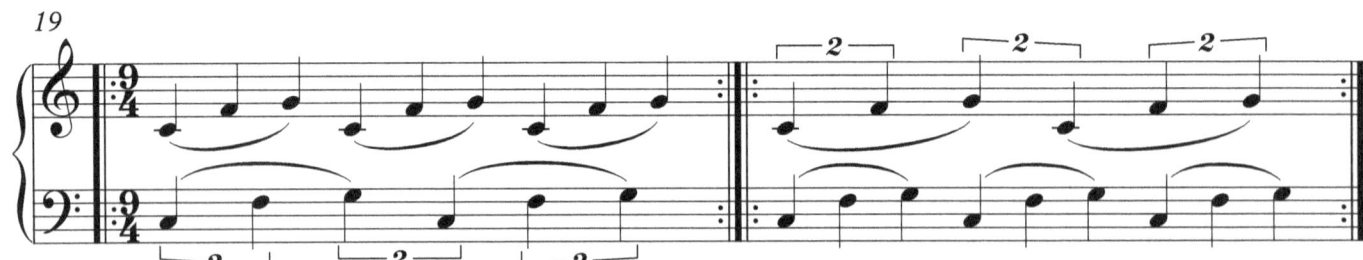

The pattern C, F, G is altered with the use of 2:3 and 3:2 polyrhythm.

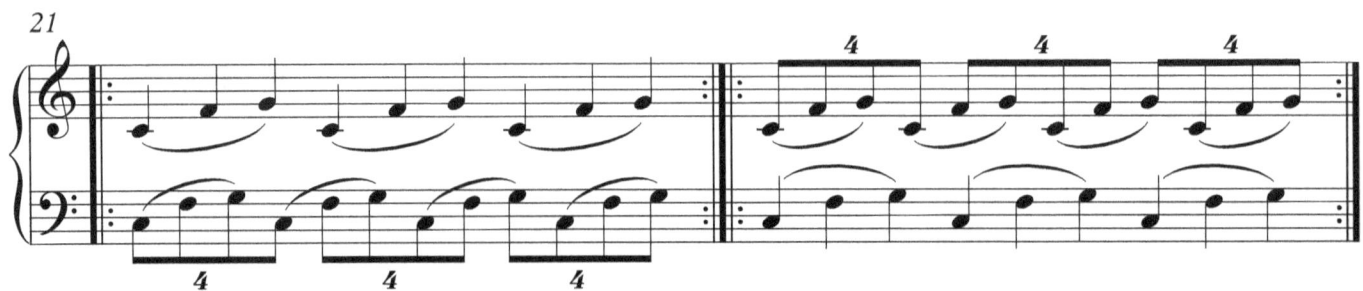

The pattern C, F, G is altered with the use of 3:4 and 4:3 polyrhythm.

© 2014 - Jeff Fineberg

"Out of Phase" Additional Puzzle illustration
(using C, F, G, B and D, F, G, A)

Jeff Fineberg

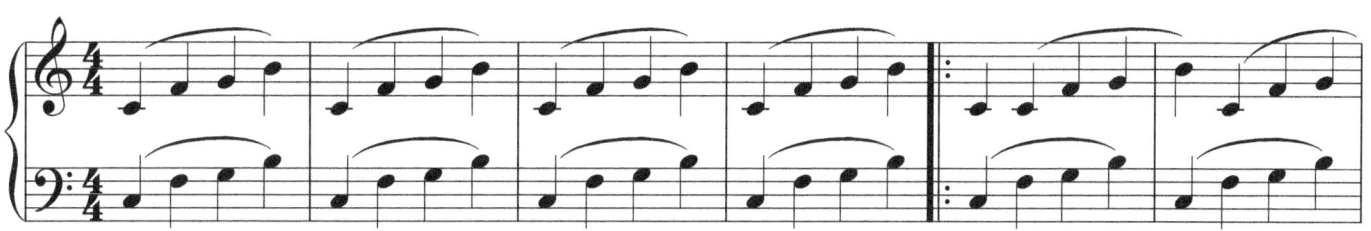

4 measures of the syncrhonized basic pattern (C, F, G, B) additional C note in R.H. every 4 patterns

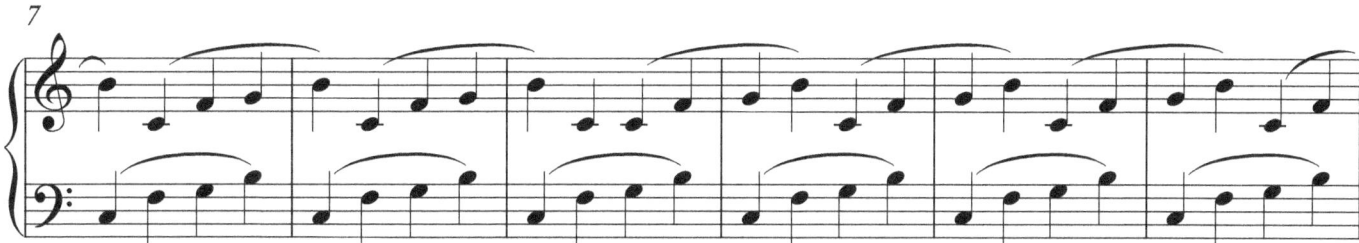

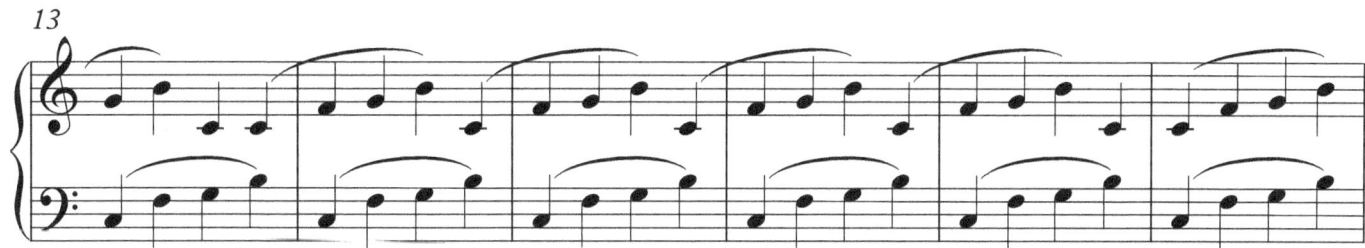

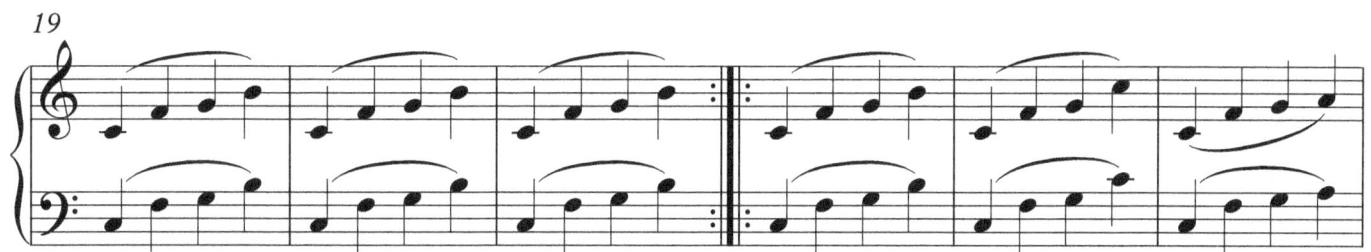

4 measures of synchronized patterns with variations in the R.H. and L.H.

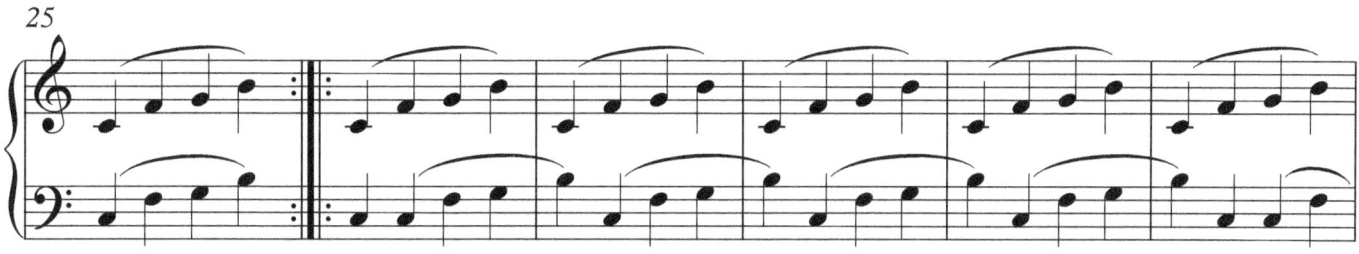

additional C note in L.H. every 4 patterns

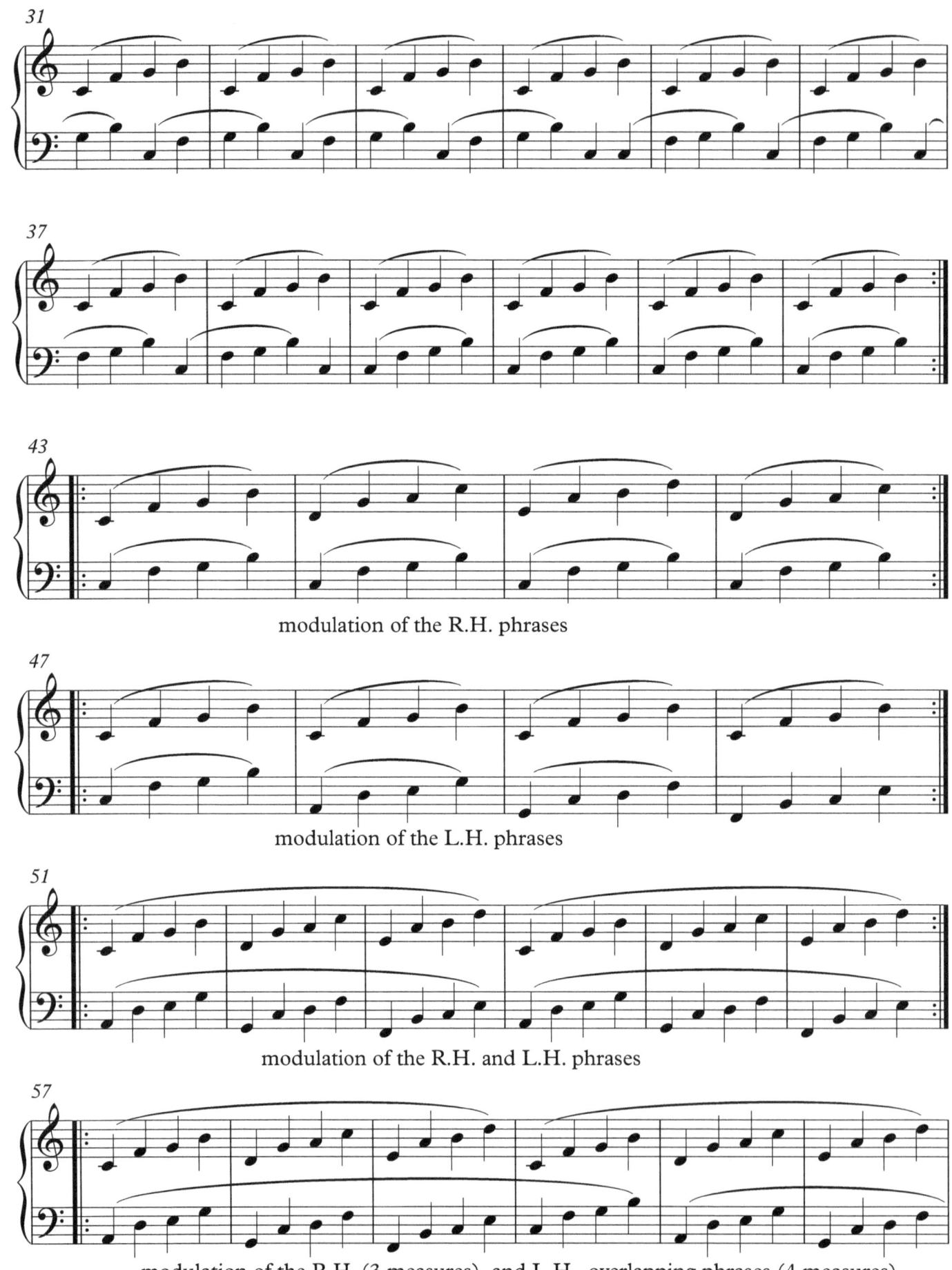

modulation of the R.H. phrases

modulation of the L.H. phrases

modulation of the R.H. and L.H. phrases

modulation of the R.H. (3 measures) and L.H. overlapping phrases (4 measures)

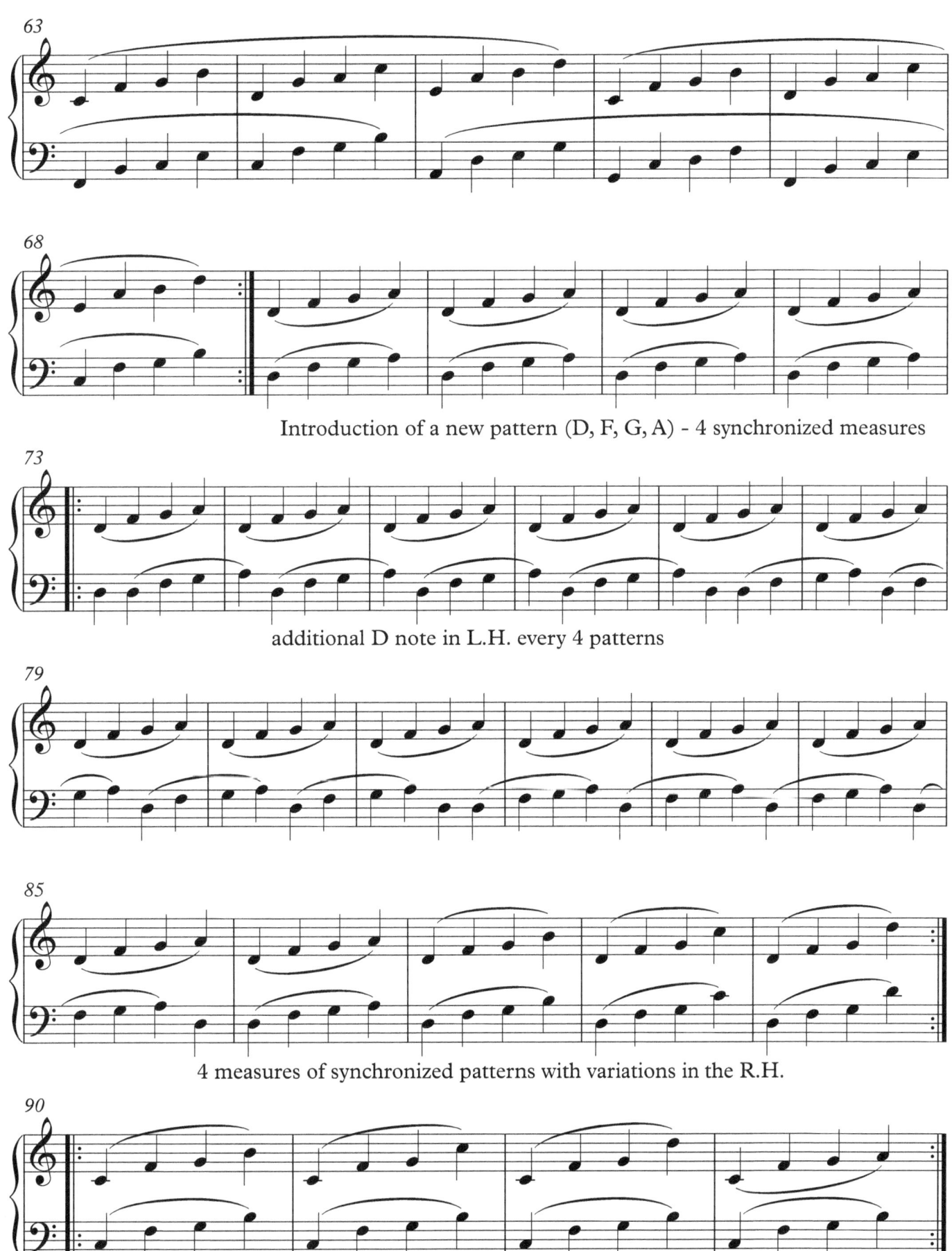

Introduction of a new pattern (D, F, G, A) - 4 synchronized measures

additional D note in L.H. every 4 patterns

4 measures of synchronized patterns with variations in the R.H.

Back to the original pattern (C, F, G, B), except altering 1 note in the R.H. for each pattern

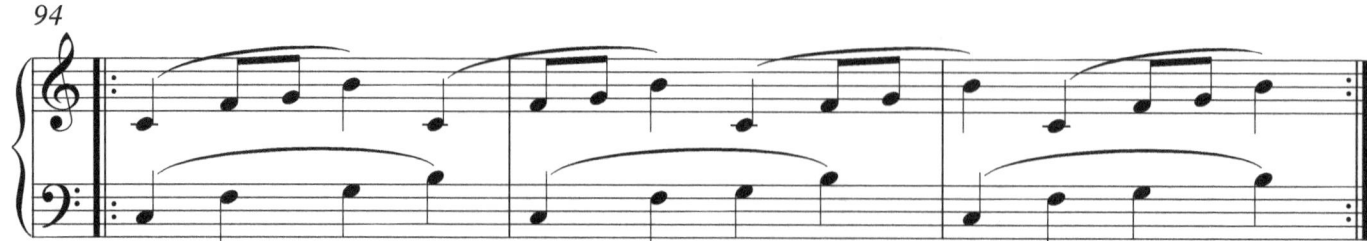

modify the duration of one or more notes - R.H.

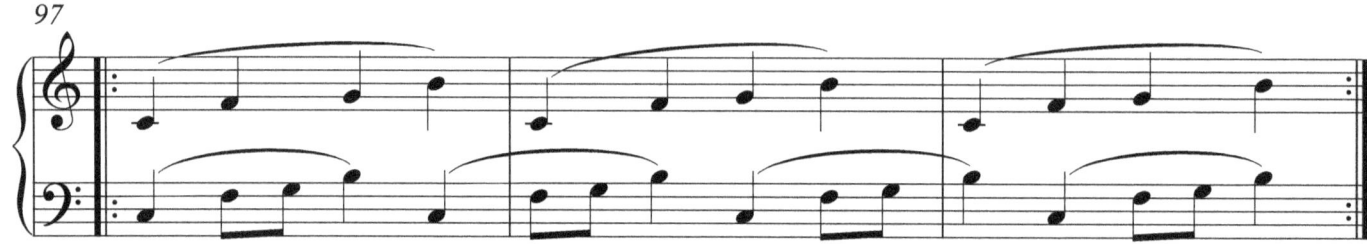

modify the duration of one or more notes - L.H.

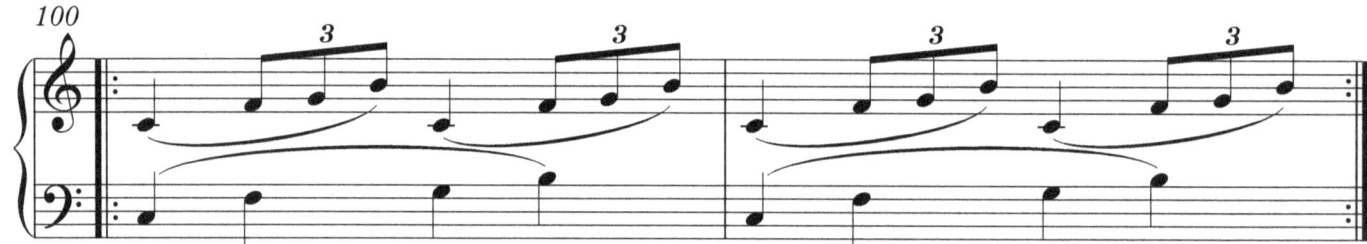

modify the duration of notes - R.H.

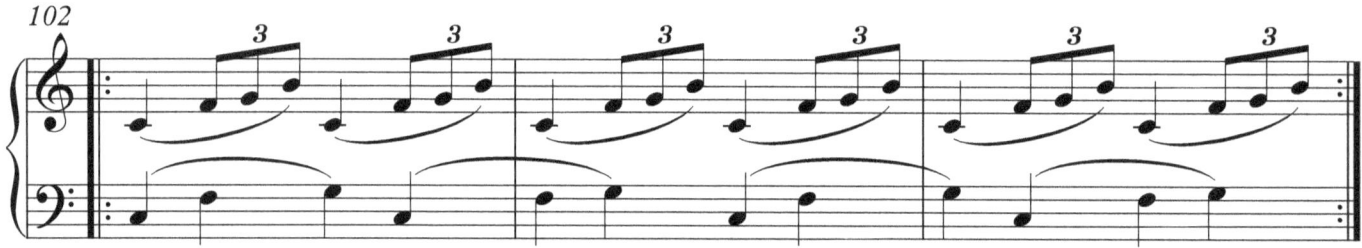

remove last note (B) of of L.H. phrase (causing overlapping patterns)

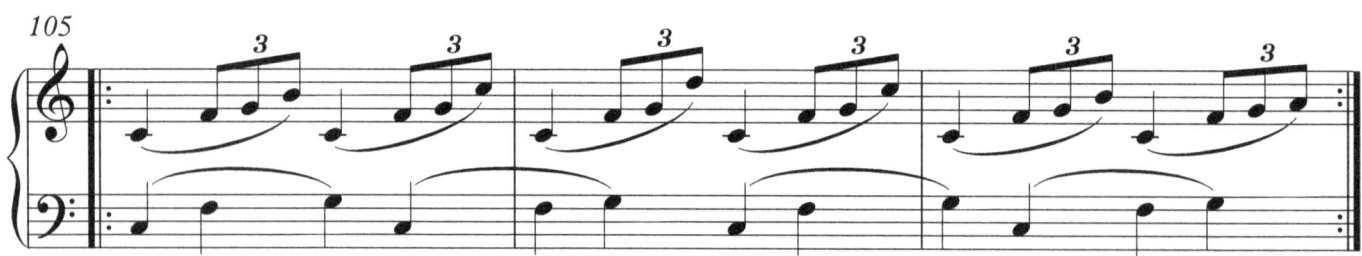

alter the last note of each triplet (overlapping patterns)

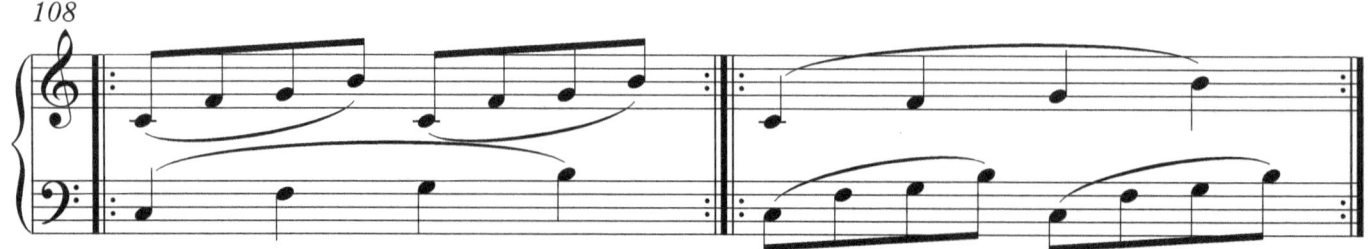

modify the duration of notes - R.H. modify the duration of notes - L.H.

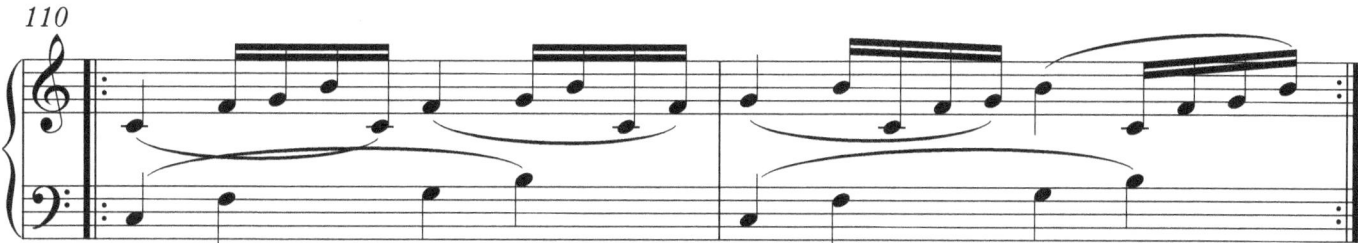

modify the duration of notes to 16ths - R.H.

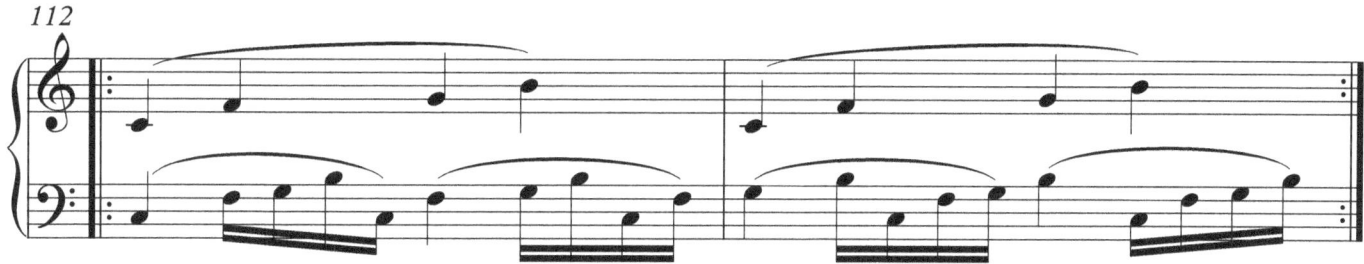

modify the duration of notes to 16ths - L.H.

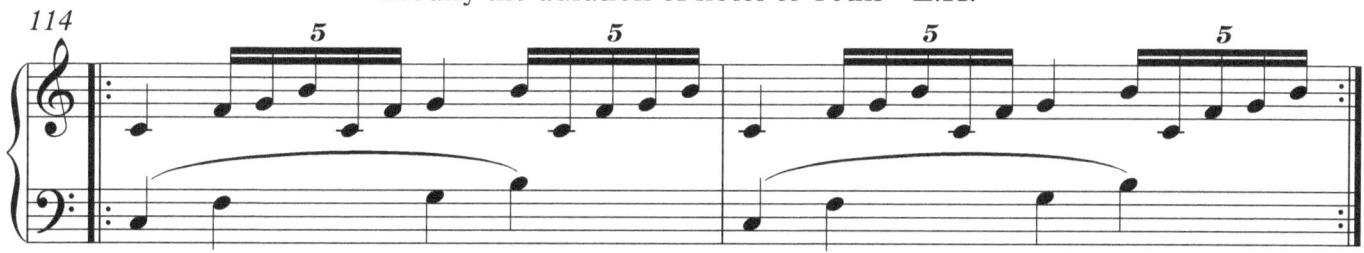

modify the duration of notes to quintuplets - R.H.

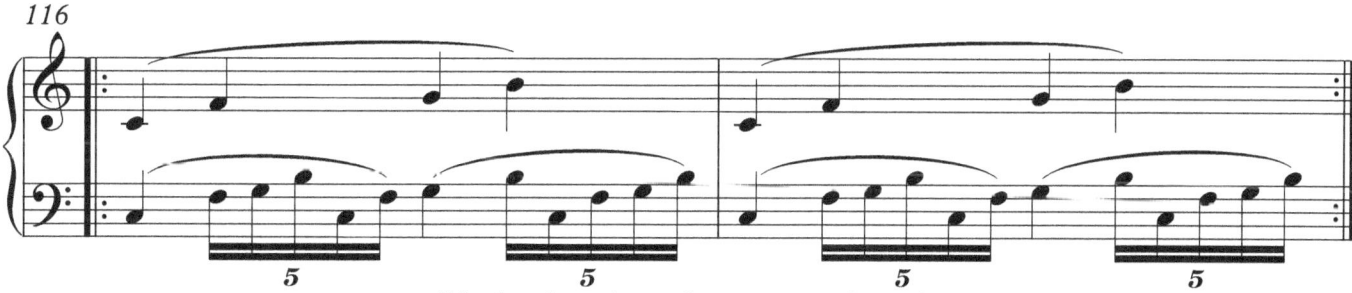

modify the duration of notes to quintuplets - L.H.

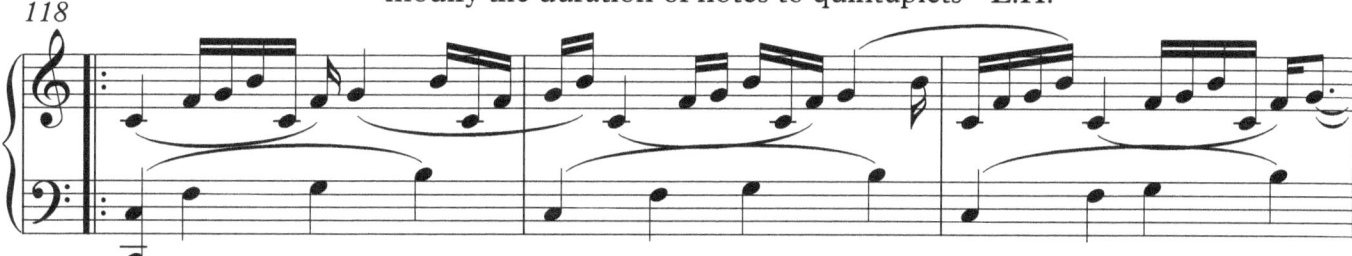

modify the duration of notes to 5 sets of 16ths, not quintuplets - R.H. (challenging)

embellish the previous set, changing the B in the R.H. to a number of different notes (also note the usage of an occasional C octave in the bass)

Ambiguous object - suggested by Sid Fineberg

"Out of Phase" Puzzle 1

Given the above as a repeating pattern, perform the following versions:

1. Play the pattern repeatedly, however with an additional "C" note on the right hand at the beginning, making it a cycle of 9 notes, while leaving the original 8 notes in the left.
2. Play the pattern repeatedly, however with an additional "C" note on the left hand at the beginning, making it a cycle of 9 notes, while leaving the original 8 notes in the right.
3. Play the pattern as originally written, except play it in a pattern of 2:3 (right hand : left hand).
4. Play the pattern as originally written, except play it in a pattern of 3:2 (right hand : left hand).
5. Play the pattern as originally written, except play it in a pattern of 3:4 (right hand : left hand).
6. Play the pattern as originally written, except play it in a pattern of 4:3 (right hand : left hand).
7. Play the pattern as originally written, except play it in a pattern of 5:2 (right hand : left hand).
8. Play the pattern as originally written, except play it in a pattern of 2:5 (right hand : left hand).
9. Play the pattern as originally written, except play it in a pattern of 3:5 (right hand : left hand).
10. Play the pattern as originally written, except play it in a pattern of 5:3 (right hand : left hand).
11. Play the pattern as originally written, except play it in a pattern of 4:5 (right hand : left hand).
12. Play the pattern as originally written, except play it in a pattern of 5:4 (right hand : left hand).
13. Play the pattern as originally written, except play it in a pattern of 2:7 (right hand : left hand).
14. Play the pattern as originally written, except play it in a pattern of 7:2 (right hand : left hand).

Additional challenges:

15. Similar to challenge 1 and 2, except add 2 repeated notes rather than 1.
16. Similar to challenge 1 and 2, except duplicate a note other than the first note.
17. Similar to challenge 1 and 2, except rather than duplicate an additional note, add any note of your choice.
18. Similar to challenge 15, 16 and 17, except add more than one note.
19. Utilize any of the polyrhythms, applying them to challenge 15-18.

"Out of Phase" Puzzle 2

Jeff Fineberg

> Note: select ANY or ALL measures as desired. Repeat and variate ANY of the measures with ANY or ALL of the methods discussed - to your preference.

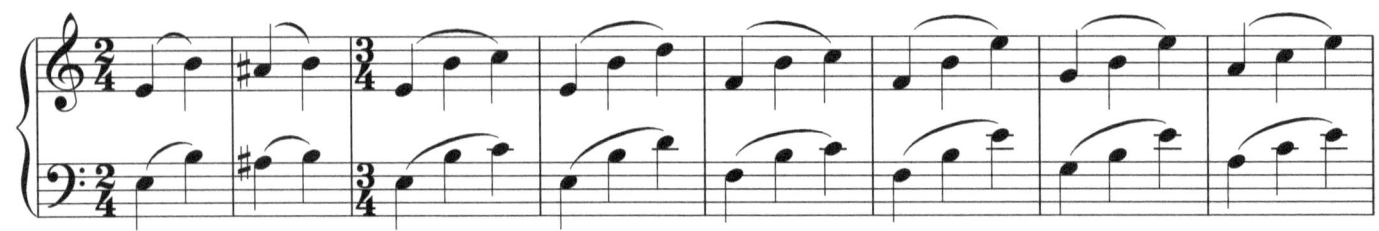

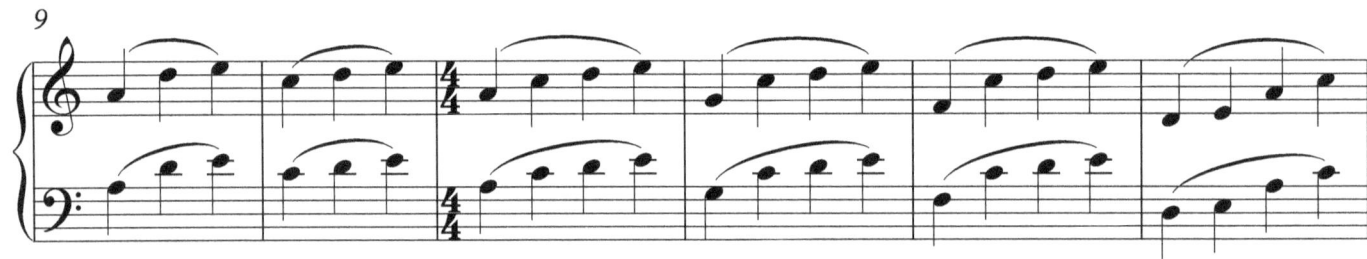

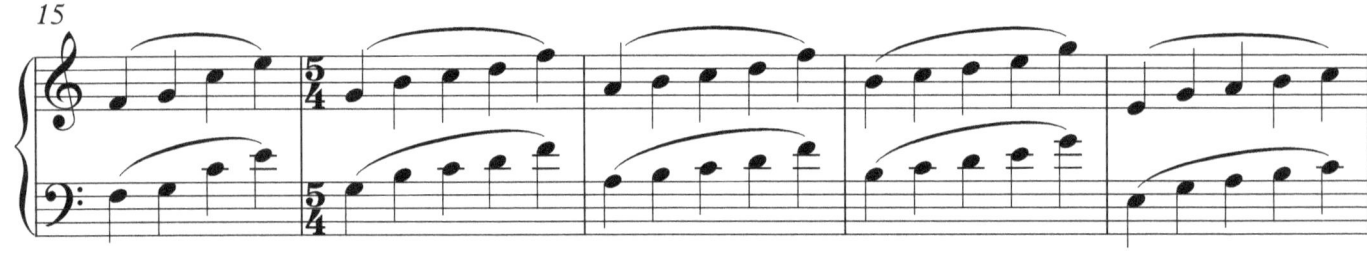

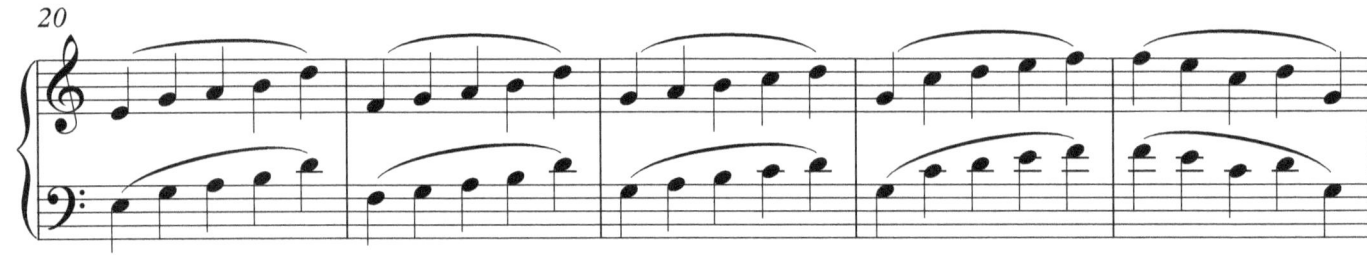

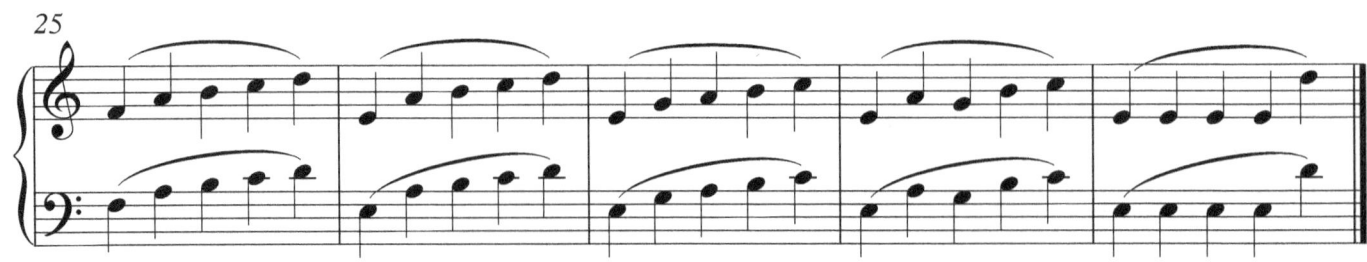

© 2014 - Jeff Fineberg

"Out of Phase" Puzzle 1 - solution
(using duplicated notes, augmentation and polyrhythms)

Jeff Fineberg

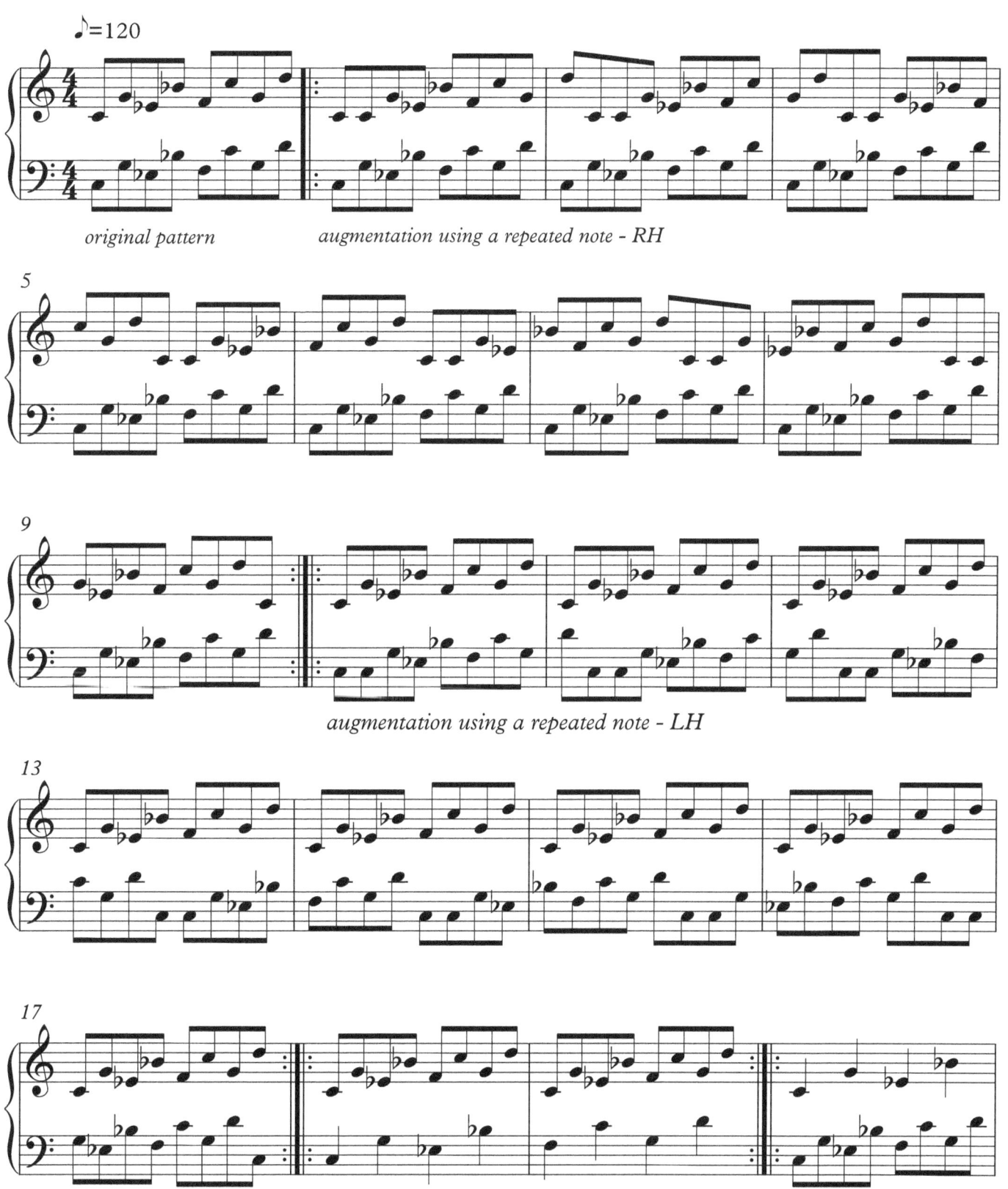

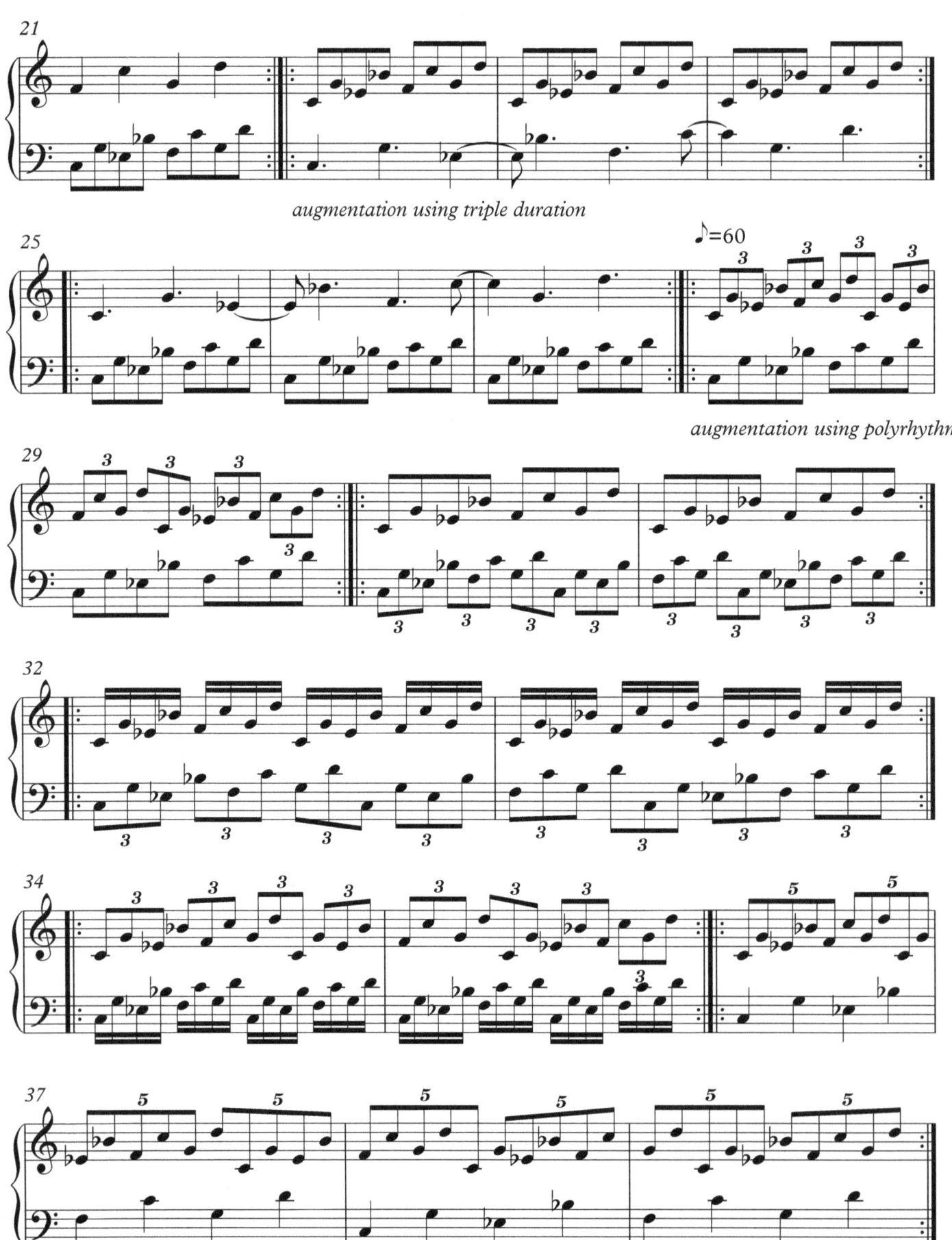

augmentation using triple duration

augmentation using polyrhythms

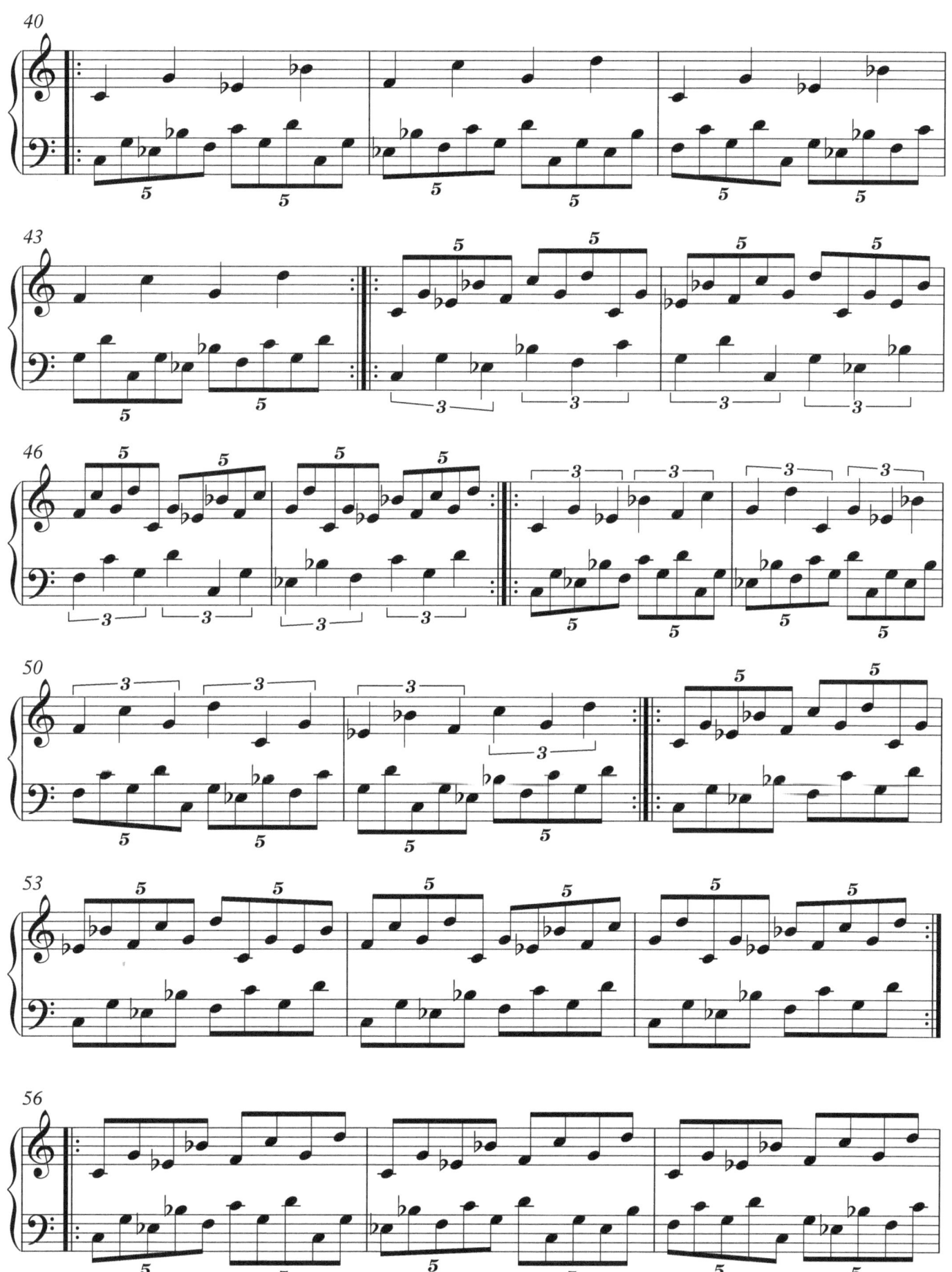

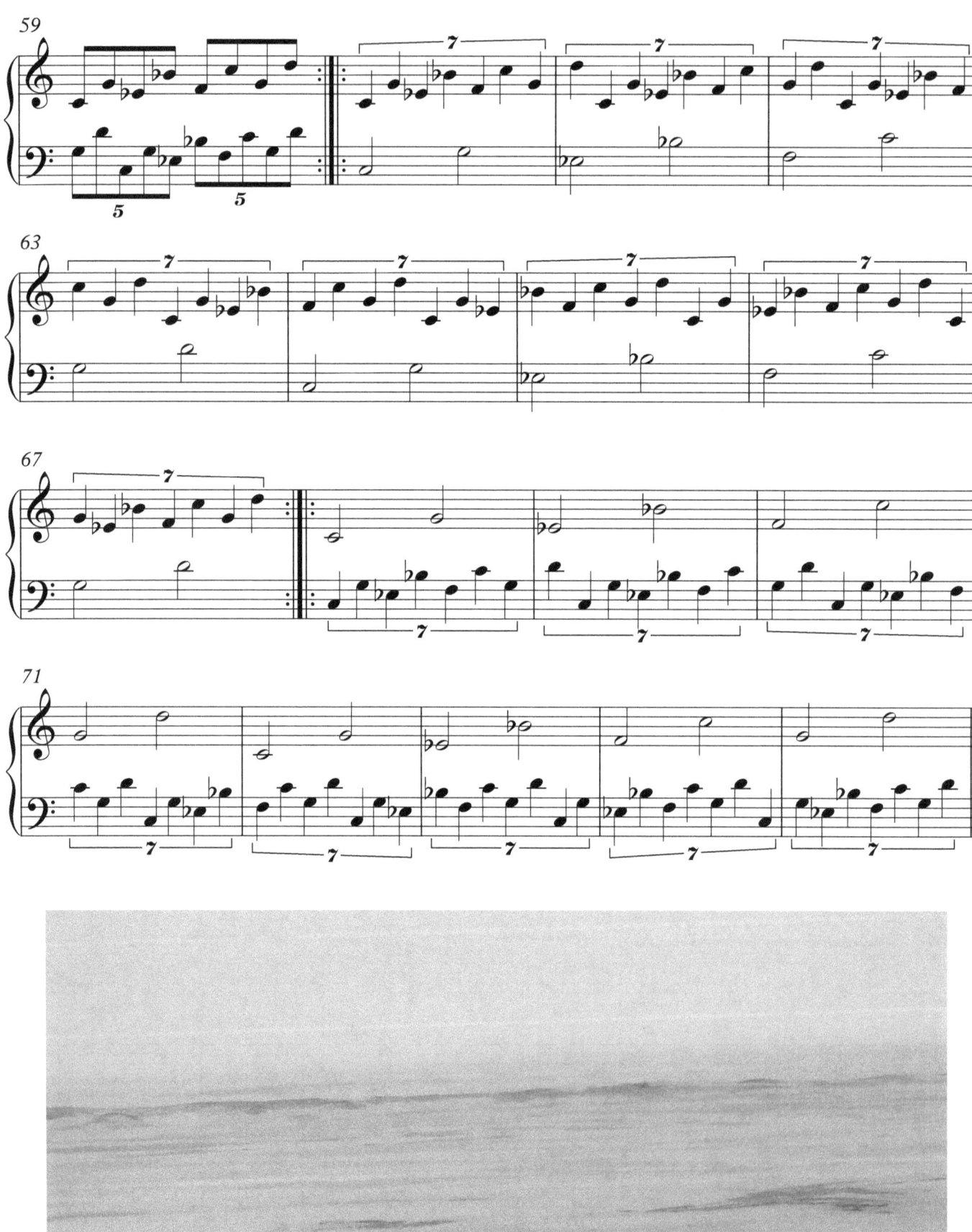

94

Chapter 9: Free-Form Polymetric Puzzles

At this point we're ready to push experimentation to a new limit! While it is true that we have experimented previously with variations that alter notes[1], in this chapter there are absolutely no specific notes that you are required to play. In this chapter, we will be deciding upon note values based upon a series of suggested generic patterns. This opens the door for much experimentation to help strengthen skills in both improvisation and music composition. Let's get started!

Tables used for determining note values
The tables in figures 9.1, 9.2 and 9.3 contain possible note sequences for creating customized polymetric puzzles. For demonstration purposes, the length of possible note sequences is 2, 3, 4 and 5, however additional lengths are possible. Also notice that for each note in a sequence, there are up to 5 possible values to select from, which corresponds nicely to the fingers numbers for a hand (1,2,3,4,5). Depending on what the values represent, we may want values higher than 5. For example, we may want to represent 7 degrees of a scale.

The tables below contain sequences based upon random values with three characteristics:
1. **No duplicates are allowed.** In this case a note sequence cannot be longer than the number of degrees to select from; otherwise duplication would be necessary (by the pigeon-hole principle). For example: (1,3,4,5), (4,2,5,1,3), etc.
2. **Duplicate notes are allowed but not with consecutive notes.** For example: (2,3,2,3), (5,4,3,5), etc.
3. **Any (and all) duplicate notes are allowed.** For example: (2,2,3,5), (3,3,3,3), etc.

Figure 9.1 Random 2, 3, 4 and 5 note sequences – **no duplicate notes**

2 note		3 note			4 note				5 note				
5	3	2	1	4	3	1	4	5	3	1	4	5	2
2	5	5	3	4	5	2	3	1	5	3	4	2	1
4	1	3	4	2	3	4	1	2	3	5	4	1	2
4	2	2	5	1	2	5	3	1	3	2	4	5	1
5	2	5	4	3	4	1	3	2	5	2	1	4	3
4	5	2	5	3	2	1	5	3	5	2	3	4	1
3	2	4	3	1	4	3	2	1	2	4	5	3	1
3	5	4	2	1	1	5	3	2	3	2	5	1	4
2	1	5	2	4	5	3	2	4	1	5	2	3	4
5	4	2	4	5	2	3	1	4	2	4	1	5	3
5	1	2	1	3	5	1	4	3	2	1	4	5	3
1	3	5	1	4	1	4	3	5	2	4	1	3	5
3	1	2	3	4	3	5	2	1	1	4	2	5	3
2	3	4	2	3	2	5	4	1	1	2	4	5	3
1	4	2	4	3	2	4	1	5	3	4	2	1	5
1	5	4	5	1	1	3	4	5	3	1	2	5	4
3	4	5	1	3	3	2	4	1	5	3	1	4	2
2	4	5	2	1	3	5	2	4	2	5	3	4	1
1	2	1	3	5	1	2	5	4	3	2	1	5	4
4	3	3	5	2	5	2	1	3	2	1	5	3	4

[1] If you haven't had a chance to experiment with variations using different notes from chapter 1, you may want to review this.

Figure 9.2 Random 2, 3, 4 and 5 note sequences –
duplicates allowed but not with consecutive notes

2 note		3 note			4 note				5 note				
5	1	3	4	5	3	2	4	5	3	4	2	3	4
1	3	2	3	2	3	5	3	2	2	5	4	2	1
3	5	2	5	3	2	3	4	1	5	3	1	5	3
1	4	1	5	3	3	4	2	1	1	4	2	1	2
2	4	4	1	2	4	2	4	2	4	3	4	1	2
2	3	2	3	5	5	3	5	2	5	3	1	2	3
3	1	3	1	2	4	5	3	4	4	2	1	3	4
4	5	5	2	1	4	5	4	1	5	4	5	4	2
5	4	1	5	2	4	1	3	2	1	3	5	2	5
5	3	1	2	4	1	2	4	3	1	4	1	2	3
1	5	5	1	2	3	2	5	2	4	2	3	5	2
2	5	4	1	5	4	1	5	2	3	2	1	4	5
3	2	4	2	4	5	4	3	5	2	4	1	3	2
4	3	4	2	5	2	4	3	5	1	5	2	4	3
1	2	2	4	3	5	3	4	5	2	4	3	5	4
5	2	4	1	3	5	1	3	2	1	3	1	4	3
2	1	1	3	2	2	1	2	1	5	2	3	5	3
4	1	2	4	1	1	4	5	1	4	3	5	3	2
4	2	5	3	4	4	3	2	1	1	3	2	4	2
3	4	2	1	5	4	1	3	4	2	3	1	3	4

Figure 9.3 Random 2, 3, 4 and 5 note sequences – **any duplicate notes allowed**

2 note		3 note			4 note				5 note				
3	1	2	3	4	4	3	4	4	4	4	2	3	2
2	5	3	4	1	2	3	2	3	2	5	4	4	2
5	5	4	2	1	4	2	1	2	5	3	2	4	1
3	2	2	1	3	2	5	5	5	2	5	4	1	1
2	3	3	1	3	4	1	4	1	4	2	2	2	4
5	4	3	1	1	3	1	5	5	2	4	3	3	1
5	2	3	1	5	3	1	2	3	1	4	3	1	4
2	1	1	4	3	2	3	4	2	5	4	4	1	4
4	1	1	1	1	2	4	1	3	5	5	2	4	1
1	4	5	5	1	3	4	5	4	4	4	4	2	5
4	5	4	1	5	4	1	1	2	4	1	4	1	4
1	5	5	2	3	3	3	4	4	4	1	2	5	4
2	4	1	2	5	5	2	3	4	5	3	2	1	5
4	2	4	1	3	4	1	1	1	1	3	2	4	5
3	5	1	1	4	2	5	5	3	2	3	3	4	2
1	1	5	2	2	2	4	1	4	3	4	1	3	1
4	4	4	5	3	1	2	1	2	2	2	4	4	5
5	1	2	4	3	1	5	5	2	3	3	5	4	1
5	3	2	2	3	3	5	1	1	5	4	3	5	4
3	3	3	4	4	4	5	3	2	1	4	3	5	5

Steps for Building a Custom Polymetric Puzzle

In keeping with the theme of "Free Form Polymetric Puzzles", there are likely many ways to use the tables for creating exercises and pieces. Below is one such example in 3 steps.

Step 1: Select the desired patterns
1. Decide on a polymeter puzzle that you would like to create, for example: 2:3, 3:4 or 4:5 (based upon the sequences we have available).[2]
2. Decide the characteristic you want for your patterns (defined previously), such as 'any and all duplicates', 'no adjacent duplicates' or 'no duplicates at all'. Use the corresponding table for the next step.
3. Select two patterns (left and right hand) from the table corresponding to your polymeter, whether it is '2 note', '3 note', '4 note' or '5 note'.

Step 2: Decide on a method and map the numbers to note values
Notice that the sequences values use numbers rather than note names. This is because it is up to you to decide how you want to determine a note value. Some possibilities are:
1. **Simpler approach - map the numbers to finger numbers.** You may choose:
 a. Finger numbers to be part of a scale (as #1 above, except finger numbers are not necessarily decided with that approach).
 b. Finger numbers to be part of chord or arpeggio.

 In either case (a or b), you need to decide what position your hand is in relative to the actual notes, such as finger 1=A, finger 2=B, etc.

2. **More complex approach - map the numbers to the degree of a scale.** [3]
 a. Decide both the scale type (major, minor, whole tone, chromatic, etc. or create your own scale).[4]
 b. Decide the key that the scale is in (key of G, G, C#, etc.)

 In either case (a or b), since you are representing actual notes with the sequence values, you need to decide what finger plays each note

Step 3: Playing the Puzzle
The pattern from each group is to be played repeatedly until a cycle is completed. The cycles can be repeated as desired. Also, consider the use of variations. Refer to the variations for Polymetric Puzzles from chapter 1. A very small sample of these variations includes:
- Applying accents at various beats.
- Applying various polyrhythms to the polymetric pattern.
- Modulate the patterns to various keys.
- For more of a music composition form, change to various patterns as desired.

[2] While you can certainly try it, 2:4 does not qualify as a 'Polymetric Puzzle' since the numbers are not 'relatively prime' (refer to chapter 1 for details).

[3] If you are not familiar with degrees of a scale, try a web search "degrees of a music scale" or consider a book on music theory.

[4] Try a web search for "music scales" to see an abundance of scales developed throughout the world.

Example usage of the tables

The following excerpts were created after deciding to create a 4:3 polymeter. Once that was decided, we used various note sequences selected at random from figures 9.1, 9.2 and 9.3. After some experimentation, the number sequences were mapped to finger numbers where 4=B on the R.H. and 5=G on the left hand. Each excerpt contains an entire cycle and also uses the same note mapping.

Figure 9.4 R.H. note sequence from the 9.3 and L.H. note sequence from 9.2

Figure 9.5 R.H. note sequence from the 9.3 and L.H. note sequence from 9.2

Figure 9.6 R.H. note sequence from the 9.1 and L.H. note sequence from 9.2

Figure 9.7 R.H. note sequence from the 9.1 and L.H. note sequence from 9.3

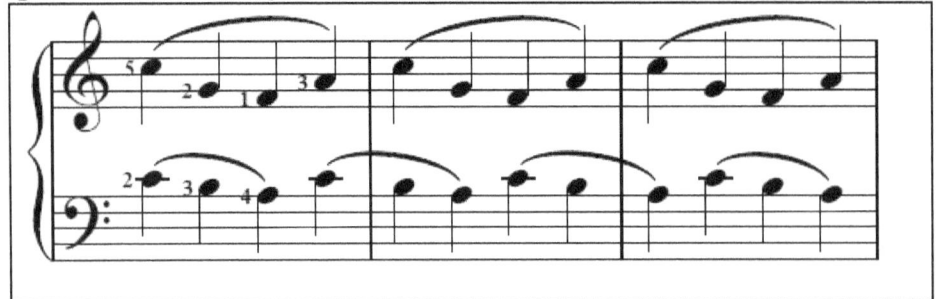

Extending the idea
Due to the free-form nature of this approach, as mentioned previously there are many alternative techniques you may consider to utilize.

Further elaboration
1. You may want to create your own tables of data for your note values. To do this you can create tables with the desired values (random or determined). Obtaining random values can be done using a variety of methods, such as rolling dice, computer generated or otherwise. For example, you can use spreadsheet software to obtain a set of random values.
2. You may decide to utilize polymeters of sizes larger than 5. (Use item 1 to build your values).
3. You may also decide additional criteria for mapping of numbers to note values.

Mash-ups – blending of various material
1. Consider using scales with one hand, and arpeggios with the other hand.
2. Consider mixing your favorite exercises, such as a Hannon exercise, with a scale or arpeggio (one for each hand).
3. Consider mixing fragments of music along with scales, arpeggios, exercises or polymetric puzzle fragments.
4. Inject polyrhythms with your mash-ups.
5. Inject phase music by dropping out (or adding) notes to create asymmetric phrases (see previous chapter for examples).

Final recommendation: feel free to experiment and gravitate towards notes, scales and arpeggios which create the type of sound that interest you. Consider using your created puzzle as a sketch of your own music composition.

Chapter 10: Tools for Improvisation and Composition

In chapters 1-6, we explored several patterns using polymeters and polyrhythms. We experimented with variations on exercises, giving the opportunity for creative choices as part of the learning process.

In chapters 7, 8 and 9 we discussed techniques to expand the options for variations, including:

- Applying various polyrhythms over polymeters (e.g. using 4:3 polyrhythm to a 3:2 polymeter).
- Shortening or lengthening phrases, creating new patterns.
- Selecting randomly constructed patterns to build our own composite "Polymetric Puzzles"
- Creating mash-ups of different works to create new works.

Throughout this book we have used somewhat "structured" approaches that could be used as a basis for improvisation.

The purpose of this chapter is to discuss improvisation in a more general sense by illustrating additional tools and methods. By having these tools at our disposal, we can become better equipped with our options for improvisation, which may also be useful for gaining an understanding of some possibilities for composing music.

What is improvisation in music?
For our purposes, I would define improvisation as "a creative activity consisting of experimentation on a music instrument without a detailed plan of what to play"[1].

Improvisation typically consists of a mixture of structured material and free ideas, with the structured material being a set of instructions or a plan, while the free ideas become material created "in the moment". The structure within an improvisation is optional, however is used often.

Structured and Free Improvisation
When improvising, we may want to have an agreed upon set of rules for structure such as: deciding on specific notes to play, melodies, a key signature, scales, modulation, time signatures, etc.. Alternatively we may consciously decide not to use any rules and improvise freely. A relatively common (and balanced) approach is to combine the approaches of improvisation with some structure, as it may help to provide some order to a piece while still allowing the freedom of exploring during improvisation.

[1] If you are interested in learning more, it would be useful to do some web searches or review books on the subject.

Categorization of Structured and Free Improvisation Elements
The following 4 categories provide an overview illustrating the varying degrees of improvisation and structure in music. We will see examples of these categories later in the chapter.

- **A. Fully Structured** – a work such as this is not really improvisation. Pieces contain all instructions, with no improvisation intended by the composer. This would be a fully a notated piece, such as a Bach invention. Alternatively, it might contain less formal notation yet with no allowance for improvisation. For illustrative purposes, an extreme example of this type of work might be a one minute work containing instructions such as "play middle C, once every second for 60 seconds".

- **B. Highly Structured** – this would be a mostly structured piece with some improvisation. An example may include a fully notated piece of music that has a solo at some point. This form can be seen in many types of Jazz, Blues and Rock, etc. where there exists a song format, such as those pieces in a "fake book". You may have also experimented with this format as variations with some of the Polymetric Puzzle pieces.

- **C. Mostly Improvised** – these pieces contain a large amount of improvisation with some structure. An example may include a piece which requires a small amount of instructions such as: "play whatever you want using a 4/4 time signature and in the key of A minor followed by a modulation and time signature of your choice". This form may be seen in experimental music, heavily improvised Jazz as well as "Jam Sessions" where only a skeleton structure is discussed prior to playing. There will be examples of this form later in the chapter.

- **D. Free improvisation** – a work containing pure improvisation with no defined structure. There are no instructions in this case. If there were an actual instruction, there would be only one for all pieces, which would be "play whatever you want for as long as you want". This approach can be used with individuals or in groups, usually with quite varied results, depending upon the attitude, music knowledge and experience of the players.

Figure 10.1 shows the 4 categories along a continuum, with different amounts of structured and improvisational material within a piece of music. The highly structured approaches exist towards the left of the diagram, with more freedom of improvisation allowed towards the direction to the right. The focus of our examples will be utilizing categories B and C, since A has been used throughout the book, and D requires no instructions (by definition).

Figure 10.1 Illustration of the ratio of structured vs. free material in a piece of music.

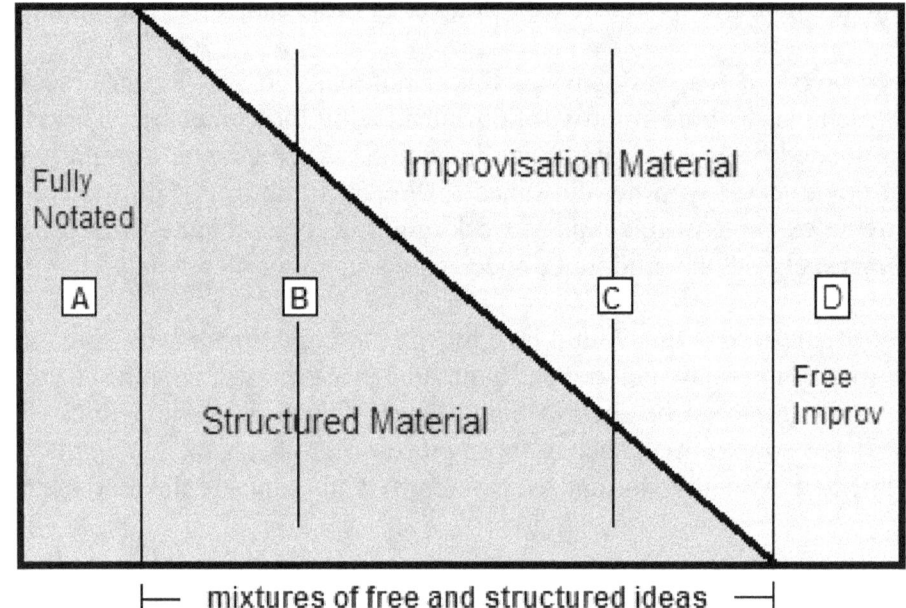

Gaining experience with all of these levels can certainly enhance the musical maturity of a musician. In addition, the more music theory knowledge, performance and listening experience one obtains the more material they will have to draw from for their improvisation.

The decision to use improvisation is made based upon the goal of the improvisers. In some cases the purpose of improvisation is to enjoy the creative process, while other times we may want to utilize improvisation as a tool for creating material to be used later on with a music composition.

Tools and Approaches for Improvisation
Much of the material in this book can be used to help provide ideas for improvisation. An example would be to use a polymetric puzzle for structure while using the suggested variations as for improvisation. Feel free to use (or modify) the various approaches discussed next in any combination to suit your approach to improvisation. Be sure to record your improvisations and review them to see what you find interesting. You may decide to use some of the improvisation material for a composition.

Highly Structured (category B) approach 1
1. Take any polymetric puzzle exercise that interests you and apply variations (refer to chapter 1).
2. Apply a variety of meters, rhythms, dynamics and articulation to your work.
3. Try to imply a melody by modifying the pattern you're playing.

Highly Structured (category B) approach 2
1. Take any polymetric puzzle exercise that interests you and apply variations from chapter 1.
2. Create a form to your improvisation so that you are deliberately using:
 a. Introduction
 b. Body
 c. Conclusion

Mostly Improvised (category C) approach 1
1. Experiment with an improvisation containing 12 sections of one minute each. Within a single octave, for section 1 only use one note, section 2 use two notes, etc., until section 12 which contains all 12 notes within that octave.
2. Play notes one at a time (melodically).
3. Play notes simultaneously, experimenting with intervals, chords and tone clusters.
4. Apply a variety of meters, rhythms, dynamics and articulation.

Mostly Improvised (category C) approach 2
1. Experiment with an improvisation by creating a 3:4 polymeter using a 3 note pattern in one hand and 4 note pattern in another.
2. Change the pattern to use different notes.
3. Exchange the note patterns between hands.
4. Superimpose polyrhythms over polymeters. For example, take a polymeter of 3:4 and play a 2:3 or 2:5 polyrhythm over it.
5. Repeat any patterns or sections you find interesting.

Mostly Improvised (category C) approach 3
1. Experiment with an improvisation using a scale of your choice (chromatic, major, minor, blues, etc.)
2. Consider using a tonal center, for example a note that recurs enough to imply a key.
3. Modulate tonal centers, either in an advance agreement (if in a group), or in random fashion.
4. Play notes one at a time (melodically).
5. Play notes simultaneously, experimenting with intervals, chords and tone clusters.
6. Apply a variety of meters, rhythms, dynamics and articulation.

"Loose Form" approaches – a category C method on the edge of D
Next we will look at improvisations which specify instructions at a very high level, allowing a large amount of interpretation. Since these approaches are close to "Free Form", we refer to them as "Loose Form".

Mostly Improvised (category C - loose form) approach 1
1. Play 10 minutes of meditative bliss.

Mostly Improvised (category C - loose form) approach 2
1. Play 5 minutes of the strangest sounds from your instrument(s).

Mostly Improvised (category C - loose form) approach 3
1. Play 5 minutes of highly percussive activity using anything and everything you've ever learned from meter and rhythm (as well as polymeters and polyrhythms).

Mostly Improvised (category C - loose form) approach 4
1. Using electronic instruments play 5 minutes of electronic effects, emphasizing the outer edge of capabilities in playing and electronics (caution: may result in a blown circuit).

Mostly Improvised (category C - loose form) approach 5
1. Pick a word from the dictionary, learn about it, and then improvise on it as the central content of your piece.
2. Obtain any number of words to improvise on.

Mostly Improvised (category C - loose form) approach 6
1. Create your own criteria for an improvisation and write it on paper for notation.
2. Perform your multiple times, record the performances and analyze the results.

Additional examples for use in groups or individuals
The following examples (figures 10.2-10.9) contain more detail over the previous, to enforce more specifics regarding form, but not specific notes (as in category B).

Figure 10.2 Specific instructions for each minute.

Timeframe	Rhythmic Tempo	Notes – any and all octaves for ONLY these notes
Minute 1	Fast and furious	C, C#
Minute 2	Slow and sloth-like	F, G
Minute 3	Fast and furious	C, C#, D
Minute 4	Slow and sloth-like	F, G, A
Minute 5	Fast and furious	C, C#, D, D#

Figure 10.3 General instructions for each minute.

Timeframe	Rhythmic Tempo	Dynamics	Tonalities
Minute 1	Start slowly, gradually increase speed throughout the piece until infinitely FAST at the end!	Start quietly, gradually increase volume throughout the piece – not too obnoxiously loud at the end.	**Play ALL notes with no bias towards any particular note**
Minute 2			
Minute 3			
Minute 4			
Minute 5			

Figure 10.4 General instructions for each minute.

Timeframe	Rhythm	Dynamics	Tonality
Minute 1	Several strange Polyrhythms morphing randomly. Follow yourself.	Random yet wildly changing, as a group – follow percussion.	Pick a motive or short melody, play 5 times. Rinse and repeat until end of piece.
Minute 2			
Minute 3			
Minute 4			
Minute 5			

Figure 10.5 General instructions for each minute.

Timeframe	Rhythmic Tempo and complexity	Dynamics	Tonality
Minute 1	Completely random, yet varied.	Completely random, yet varied.	Half the chromatic scale (C to G) or C, C#, D, D#, E, F, F#, G
Minute 2			
Minute 3			
Minute 4			
Minute 5			

Figure 10.6 General instructions for a 3 minute piece comprised of 3 one minute movements.

3 movements, separated by 30 seconds of silence			
Timeframe	Rhythmic Tempo and complexity	Dynamics	Tonality
Minute 1 – that's all there is!	Completely random, varied or not.	Completely random, varied or not.	Completely random, varied or not.

Figure 10.7 Using random dictionary words to create imagery

Timeframe	Randomly Generated Phrase	Rhythmic Tempo	Dynamics	Tonality
Minute 1	fishpond upriver horsemen rouse	Play as it describes each phrase for each minute.	Play as it describes each phrase for each minute.	Play as it describes each phrase for each minute.
Minute 2	media calamity intention beam			
Minute 3	syzygy fantasy peripheral cricket			
Minute 4	fool embark stitch contumacy			
Minute 5	beauteous prototype merry whee			

Figure 10.8 Specifying tonalities as textures.

Timeframe	Rhythmic Tempo and complexity	Dynamics	Tonality textures
Minute 1	Random	Loud	Single pitches (monophonic)
Minute 2	Random	Soft	Clusters (all pitches are game)
Minute 3	Random	Soft	Single pitches (monophonic)
Minute 4	Random	Loud	Clusters (all pitches are game)

Figure 10.9 Coordinating multiple players for each minute for an 8 minute improvisation.

Timeframe	Central Instrumentation while others are very quiet	Description or characterization	Tonalities
Minute 1	Any and All	Intro-like	All tonalities which are enhancing to the moment. Microtones are also encouraged.
Minute 2	Bass 1 *_____	**	
Minute 3	Guitar 1 *_____	**	
Minute 4	Percussion 1 *_____	**	
Minute 5	Percussion 2 *_____	**	
Minute 6	Guitar 2 *_____	**	
Minute 7	Bass 2 *_____	**	
Minute 8	Any and All	Conclusive-like	

Notes: * Fill in performers name if known
**Each performer writes in their description / characterization.

Improvisation and Music Composition

One of the most interesting aspects of improvisation is that we can create new material quickly and spontaneously. Whether you are improvising alone or in groups, it can be an enlightening experience, especially when the results are interesting. The most important aspect of good improvisation is to keep an open mind, as this helps creativity to flourish.

A discussion of improvisation should also include music composition[2]. The reason for this is because there is a strong relationship between composition and improvisation. It is important to recognize that the two methodologies can be complementary to each other, as we will see.

Composition is the act of creating music elements and constructing them into a piece of music. Significant work goes into taking melodic and harmonic material and performing manipulation and variations with that material. A composer may spend hours, days, months or years reworking the material into a final product. Once a piece is complete, it can be performed nearly the same every time as it is typically fully notated. I mention "nearly the same" because music is open to interpretation, so there will be subtle differences in a performed composition whether the same person performs it multiple times or different people perform the same composition.

Improvisation was discussed earlier in this chapter with a simple definition of "a creative activity consisting of experimentation on a music instrument without a detailed plan of what to play". The key difference is that the finished work in an improvisation is occurring while it's being played, whereas a composition is typically finished before it is performed.

It's important to note that many musician/composers may consider "Structured Improvisation" (figure 10.10) as a type of music composition, especially in modern music. Therefore the distinction between music composition and improvisation is not always clear due to this difference of interpretation. Also, if executed well, an improvisation may actually appear as a composition to the listener.

Figure 10.10 Open to interpretation: is this a composition, an improvisation, or both?

Piece for 2 Emsembles		
Timeframe	Ensemble	Guidelines
Minutes 1 through 5	Group 1	Explore Infinite Possibilities
Minute 6 through 10	Group 2 joins Group 1	Explore Infinite Possibilities
Minute 11-15	Group 2	Explore Infinite Possibilities

[2] Both improvisation and composition are broad topics which are covered at a very high level in this chapter. If you are interested in learning additional details about music composition and improvisation, you should research the topics on the web and consult books in these areas.

Figures 10.11 and 10.12 illustrate the similarities and differences between improvisation and composition. It is important to recognize the strengths of both methods and how you may best utilize them depending upon your need.

Figure 10.11 Similarities between improvisation and composition

Improvisation and Composition
Both are creative activities.
Composition methodologies may utilize experimentation with music elements during the composition process, such as improvisation to help discover new material.
Compositions may include improvisation as part of the performance of a work.
Improvisation may utilize a structure to improvise within, which could be considered a composition approach (refer to "tools for improvisation" earlier in this chapter for examples).

Figure 10.12 Differences between improvisation and composition

Improvisation	Composition
Typically generates many new ideas with minimal development of those ideas.	Typically generates less ideas but develop these ideas greatly.
Requires little or no planning because the emphasis is on playing.	Requires detailed planning and documenting and is generally a complete work before it is actually played.
May have little or no notes/instructions written out.	Typically all of the notes/instructions are written out.
Every performance of a work is unique.	Every performance of a work is very similar.
Some techniques use no construction at all, such as "free improvisation".	Some techniques use no improvisation; instead use algorithms, random elements, etc.

Improvisation as creative input to Music Composition
The most encouraging aspect of working with composition and improvisation is that there are great opportunities for utilizing improvisation as a tool for generating compositional material. Improvisation can be the stream of creativity that feeds composition in many cases. I say "many cases" because there are also compositional techniques which don't utilize improvisation, as mentioned in figure 10.12. An example might be designing a method by which music may be composed, such as using dice to determine notes to be selected, note values, etc. More recently, the use of computer programs can generate random values and assign various music elements based upon those values. Another example might be a composer hearing a melody in their head, constructing harmonic material and further developing the work using compositional techniques, without the use of improvisation directly.

Ideas and Tools for both Improvisation and Music Composition

The following tools and techniques can be used for both improvisation and composition, including how the material in this book can help. Note that these lists are not complete by any means. As a result, you may want to come up with additional ideas to suit your interests.

Expand your horizons
- Listen to your favorite music and analyze what elements appeal to you. Consider using these elements (not the actual notes) in your pieces.
- Collaborate with other musicians and composers who are open-minded to experimentation.
- Collaborate with lyricists and vocalists.

Ideas for Improvisation
- Keep an open mind.
- Improvise alone, in small groups and large groups as each provide a different experience.
- Experiment with different instruments.
- Listen to, and experiment with different types of music from around the world, not just your local area.
- Get inspiration by improvising in many different locations, such as in nature, an outside park, open-mike gatherings at a coffee house, etc.
- Listen, analyze and learn to play some of your favorite music, as this can be a powerful method of inspiration, and may help you develop your ideas.

Ideas for Music Composition

Improvisation-feed composition (a three-step process)
- Record your improvisations
- Analyze the improvised recordings to see which ideas would make good compositions.
- Create compositions based upon these recordings

Composition techniques[3]
- Limit the selection of available material for a given composition, such as using only 5 notes or a selected scale in a piece.
- Generate material using some methodology, such as assigning pitch and/or rhythmic elements based upon rolling dice and other random elements.
- Experiment with short music fragments – melodies, chords, etc.
- Write down or record the fragments you find interesting.
- Create variations of your fragments, elaborating on existing ideas rather than generating additional material.
- Construct a music composition form by designating sections (e.g. A,B,A,B,C,A)[4]
- Experiment with the music fragments to see how they may fit within the form.

[3] You can obtain a more comprehensive detail for music composition techniques by performing web searches and studying from books on the subject.

[4] Look for "song forms" or "music composition forms" on the web for more examples.

Tools for Improvisation and Composition
- Record material to help document your ideas. Use recording methods which are simple and easy to use. Consider a commonly available tool such as an IPod or cell phone app.
- There is available free recording software for computers, such as a program called Audacity. Look for free legal software before purchasing any, such as Open Source software. Carefully research before embracing a tool so you have one that is a "best practice". There usually are good reasons most people are using a tool.
- Consider multitrack software for creating dense works. Examples include Audacity, Cubase, Garage Band, Pro Tools, etc.
- Music notation software (such as Sibelius, Finale, etc.).
- Metronomes (also available as software on the web, for computers or mobile devices such as Iphone and Android).
- Consider using a drum machine or software to help with rhythmic aspects.
- Consider using electronic keyboards such as synthesizers for a wide variety of sounds. These are available as keyboards, software or even mobile apps.
- Find portable instruments for playing wherever you want inspiration (non-electronic and portable electronic). Some examples include:
 o Battery operated keyboard
 o Kalimba
 o Toy piano
 o Drums
 o Dulcimer
- Experiment with "Looping Software" and hardware. This provides an interesting method for experimentation.

Music Palette – consider using this list of music elements as a pallet of sound to select from when improvising or creating compositions. Add elements to the list to create your own custom set of tools.
 o Scales (major, minor, modes, exotic, etc.).
 o Harmonies
 - Intervals
 - Chords – including triads, suspended, sevenths, ninths, elevenths, etc.
 - Tone clusters
 - Jazz and Blues tonalities.
 o Chord progressions.
 o Introduce accidentals (sharps and flats) as part of compositional development.
 o Modulation.
 o Meters
 - Straight meters 2/4, 3/4, 4/4
 - Odd meters 7/4, 11/4, etc.
 - Polymeters
 o Polyrhythms
 o Polytonality.
 o Microtonal music elements, such as quarter tones, etc.
 o Music elements of different cultures – various types of "World Music"[5]

[5] Try a web search on "world music" to see a number of examples.

Music Composition Exercises – in all pieces try to develop the material using any variations mentioned in the book or that you think of. Also consider use of the "music palette" as mentioned in this chapter.

General Composition
1. Create a short composition that uses only one note. It can be played by any fingers and can be in any meter or rhythm.
2. Create a short composition in which you can only select from a small group of notes. For example, 6 notes to play – 3 notes per hand. Use any meter or rhythm.
3. Create a composition using broken chords of a dissimilar number of notes – 3-note chords in one hand and 4-note chords in the other.
4. Create a "mash-up" of 2 classic exercises. For example, play a C major scale with your left hand and a C major chord arpeggio with the right hand with note durations of 1:1, 2:1, etc.. Try rhythmic variations such as 2:3 polyrhythm, etc. Also, alter the scale from C to something else and the chord as well.
5. Create a composition using intervals, such as all fifths. Try all major seconds. Try other intervals as well. Apply various polyrhythms.
6. Create a composition using various chords in both hands. Apply various rhythms and polyrhythms.
7. Create a composition for 2 hands made entirely of the chromatic scale.
8. Experiment with chord progressions to create a composition. [6]

Working with melodic content
9. Think of a melody in your mind and write it down. Come up with some sort of accompaniment for it, using either a second melody (polyphony) or chords (homophony).
10. Write an expressive and free flowing melody that has variable tempo (or rubato). Once this is complete, consider creating either a second melody or harmonic accompaniment.
11. Write a composition of music to accompany the reading of a poem.
12. Write a melody for a set of lyrics or a poem that could function as lyrics. You can either use one note per word or subdivide notes as necessary. Create an accompaniment with chords, a bass line or interwoven melody.

Compositions based upon Polymetric Puzzles concepts
13. Take exercises from the book you find interesting and create variations using:
 - Improvisation-feed composition (based upon your experimentation)
 - Composition techniques that you found on the web.
14. Create a one measure repeating composition (for 2 hands) that is so difficult that it's nearly impossible to play with one person.
15. Create a composition using concepts from chapter 8.
16. Create a composition using concepts from chapter 9.
17. Create a composition using one of the improvisation forms in this chapter (select from figures 10.2 – 10.9).

[6] Do a web search on "common chord progressions" or get a book on music theory for details.

Abstract Compositions
18. Listen for sounds in your environment (either in nature or man-made). Try to write a composition based off of this material.
19. From what you've learned with polyrhythms, create a short composition using a non-pitch based object (such as a table top). Try to use some metric modulation – for example, playing a 2:3 polyrhythm followed by a 3:4 polyrhythm then a 4:5 polyrhythm.
20. Create a composition using tone clusters and metric modulation.
21. Use dice (or other generated data – random or not) to help with choices in composition.
22. Write a composition…period…a composition.

Appendix 1 – Selected Puzzle Solutions

Due to space limitations, there are a number of selected puzzle solutions in this appendix. For additional solutions which may be available in the future, please refer to:

Email: bookinfo@polymetricpuzzles.com

Website: www.polymetricpuzzles.com

2:3 Polymetric Puzzle - solution

Jeff Fineberg

Note: feel free to play the measures in the order shown or experiment with alternatives. Repeat measures as desired.

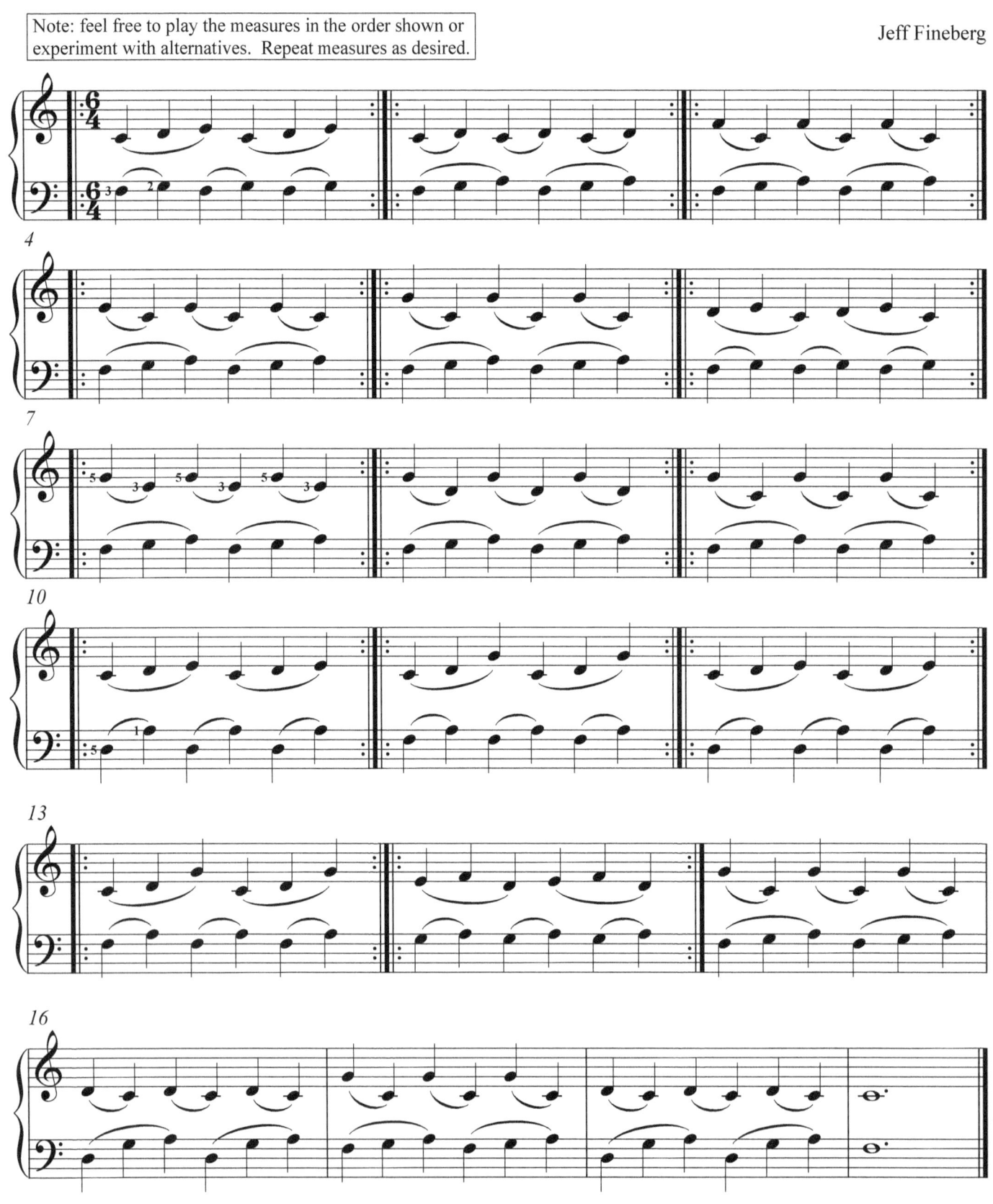

Copyright © 2014

2:3 Polymetric Puzzle - Variation 1 - solution

Jeff Fineberg

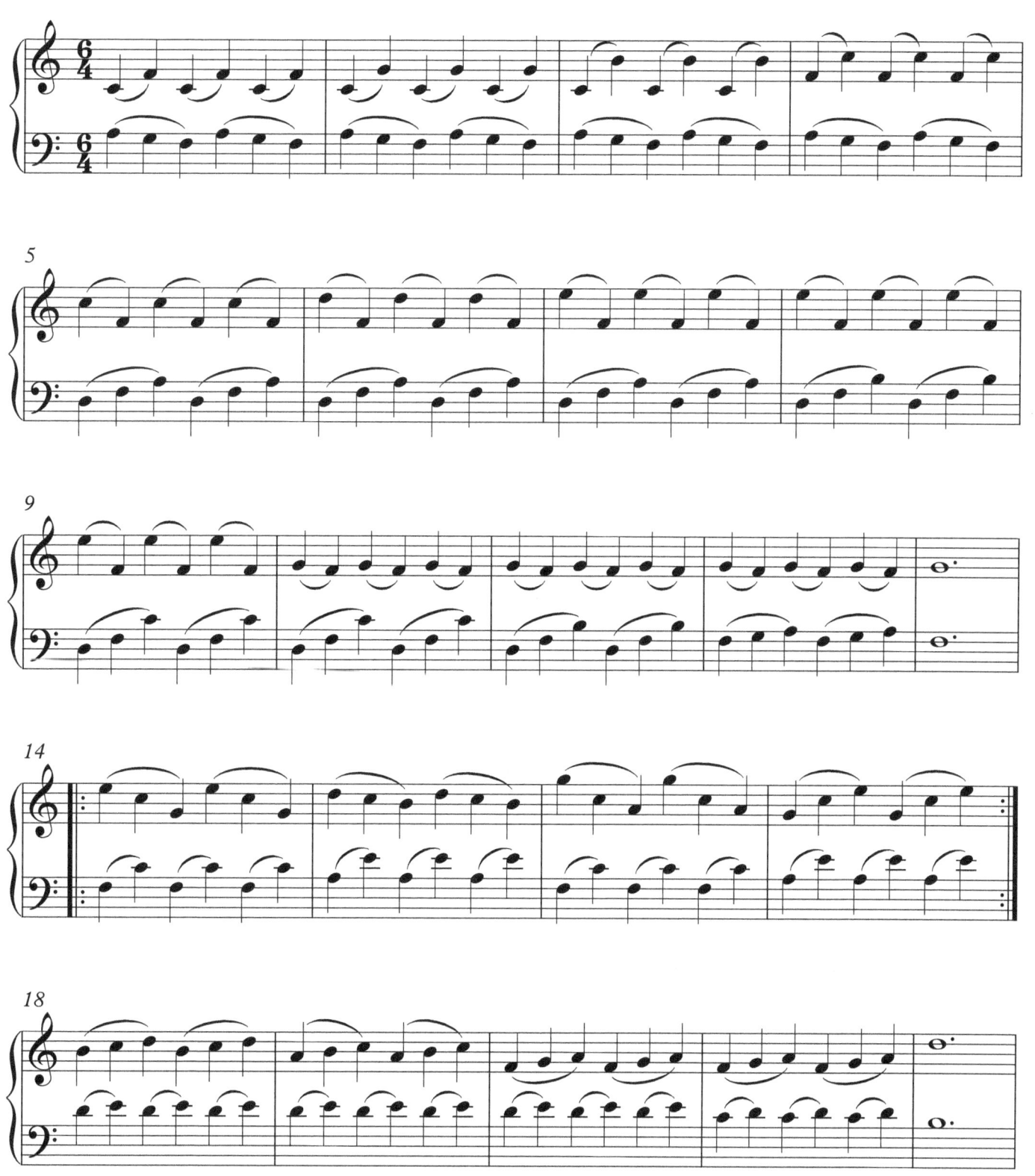

© 2014 Jeff Fineberg

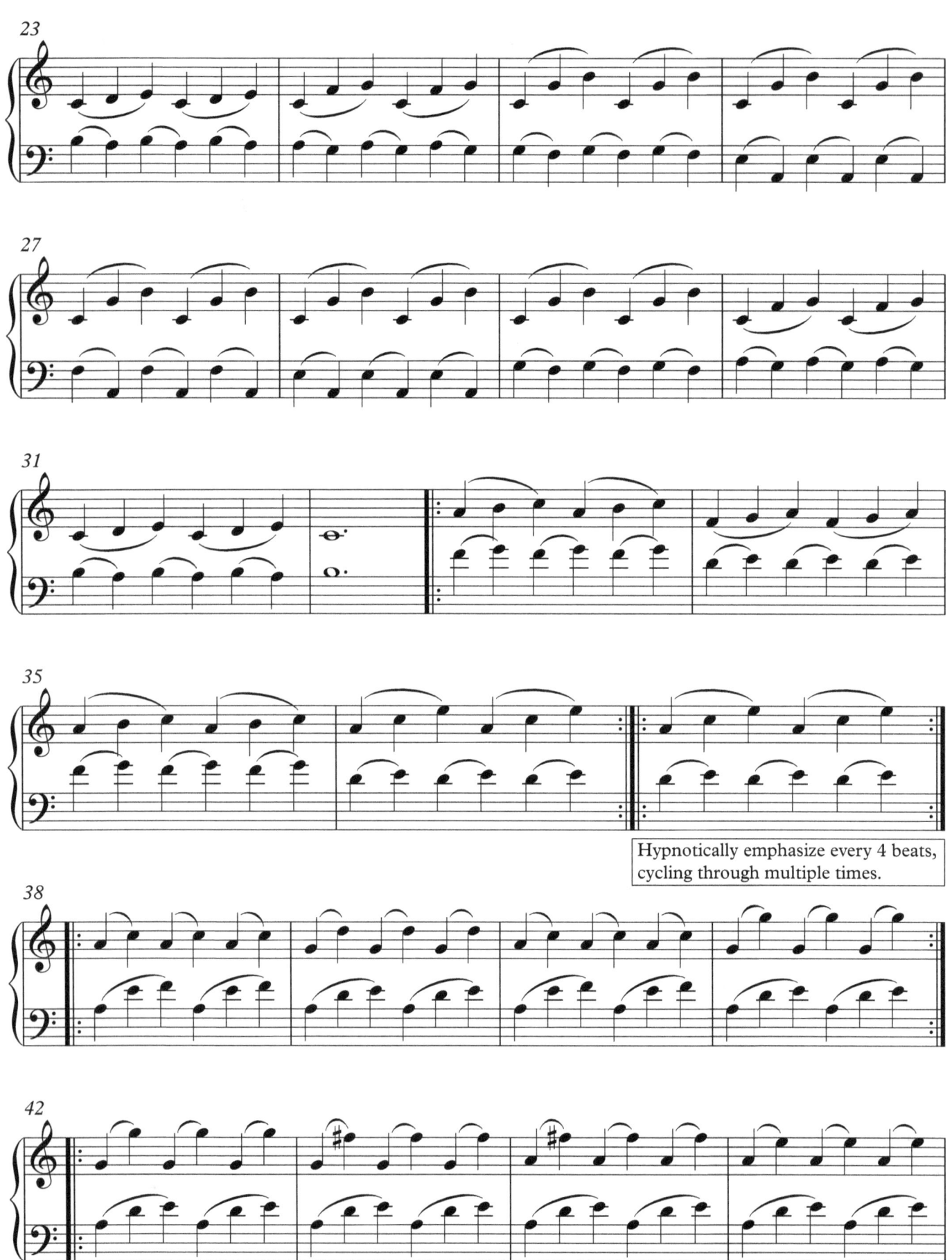

Hypnotically emphasize every 4 beats, cycling through multiple times.

© 2014 Jeff Fineberg

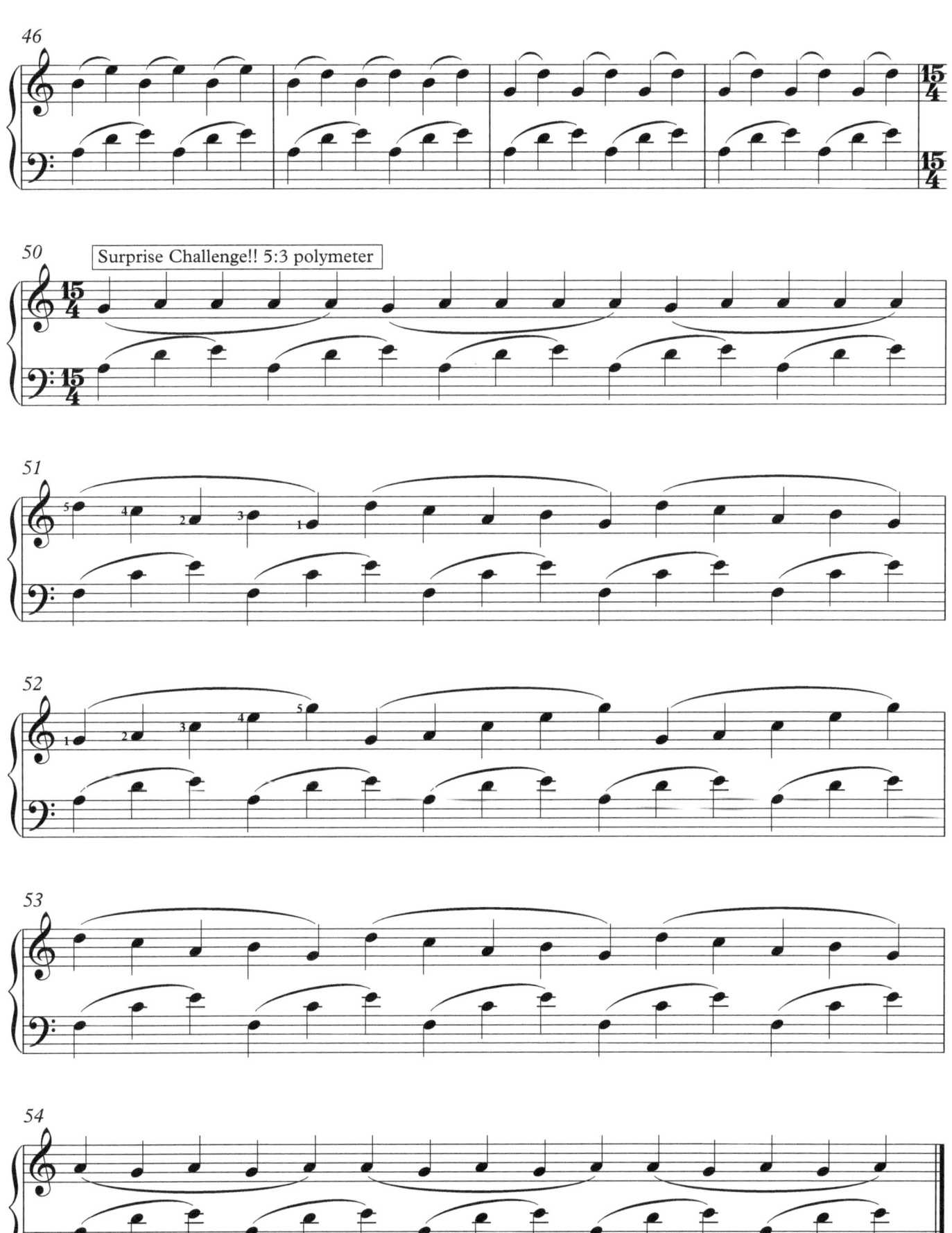

3:4 Polymetric Puzzle - Variation 1 - solution

Jeff Fineberg

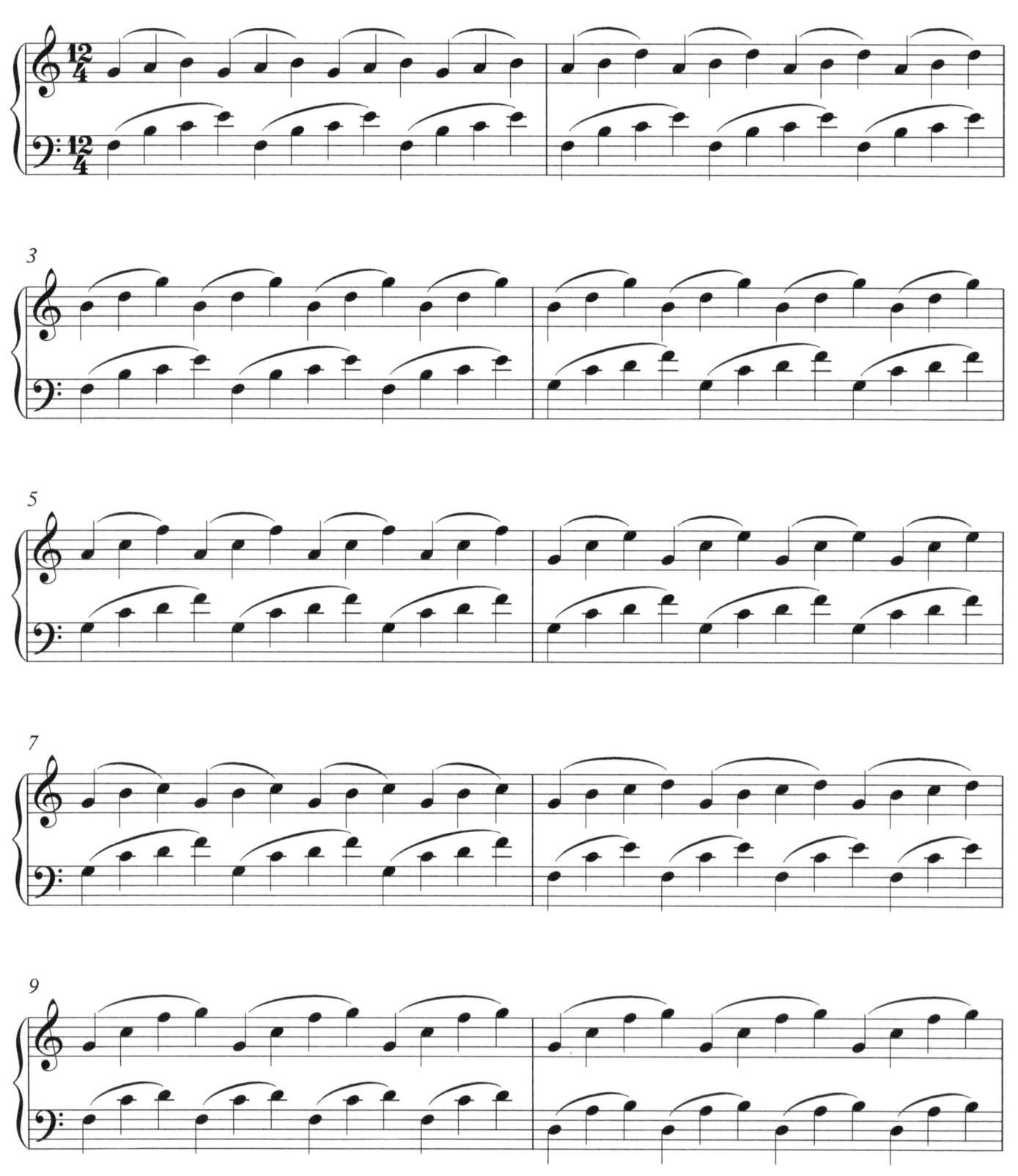

© 2014 Jeff Fineberg

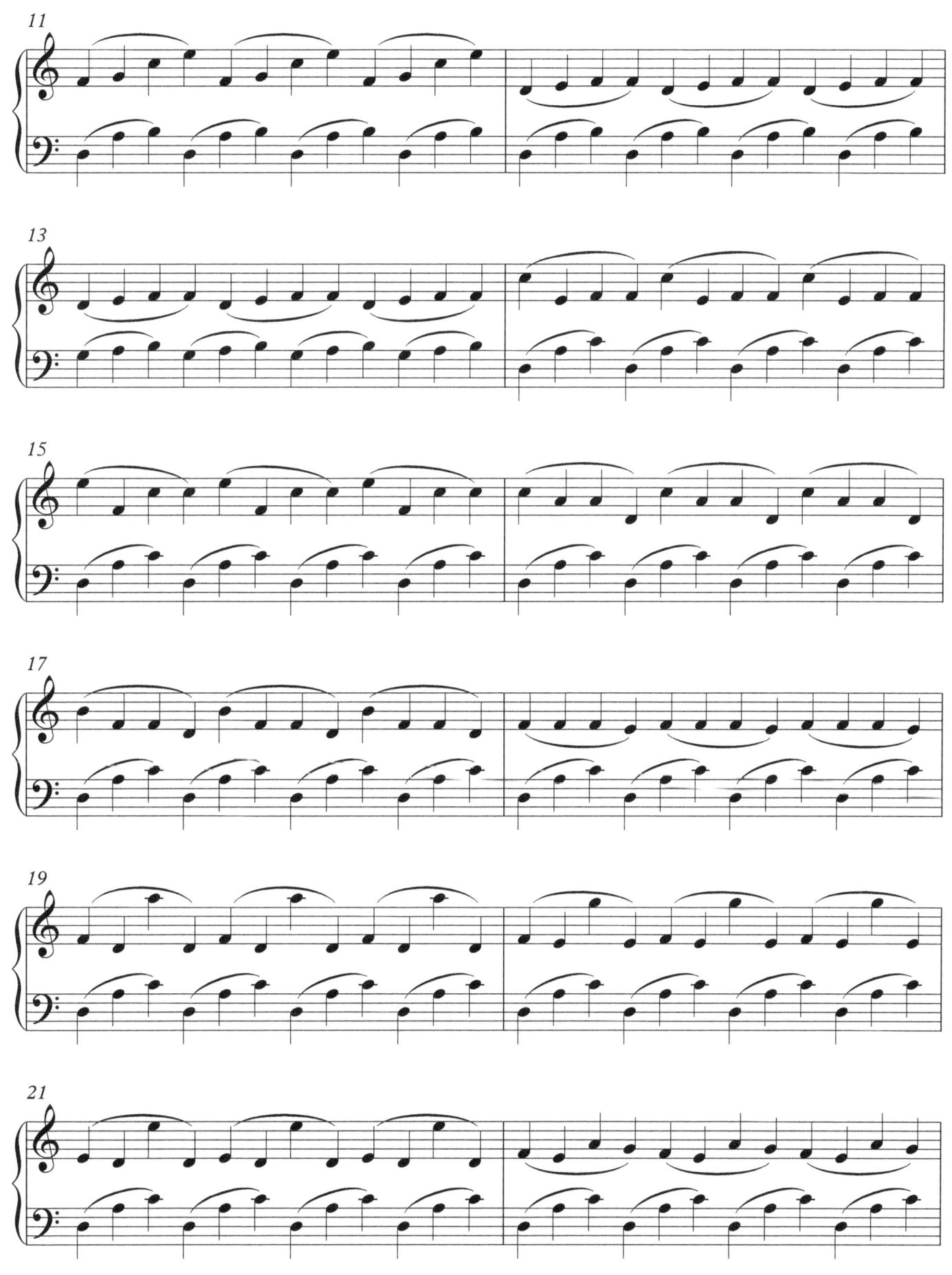

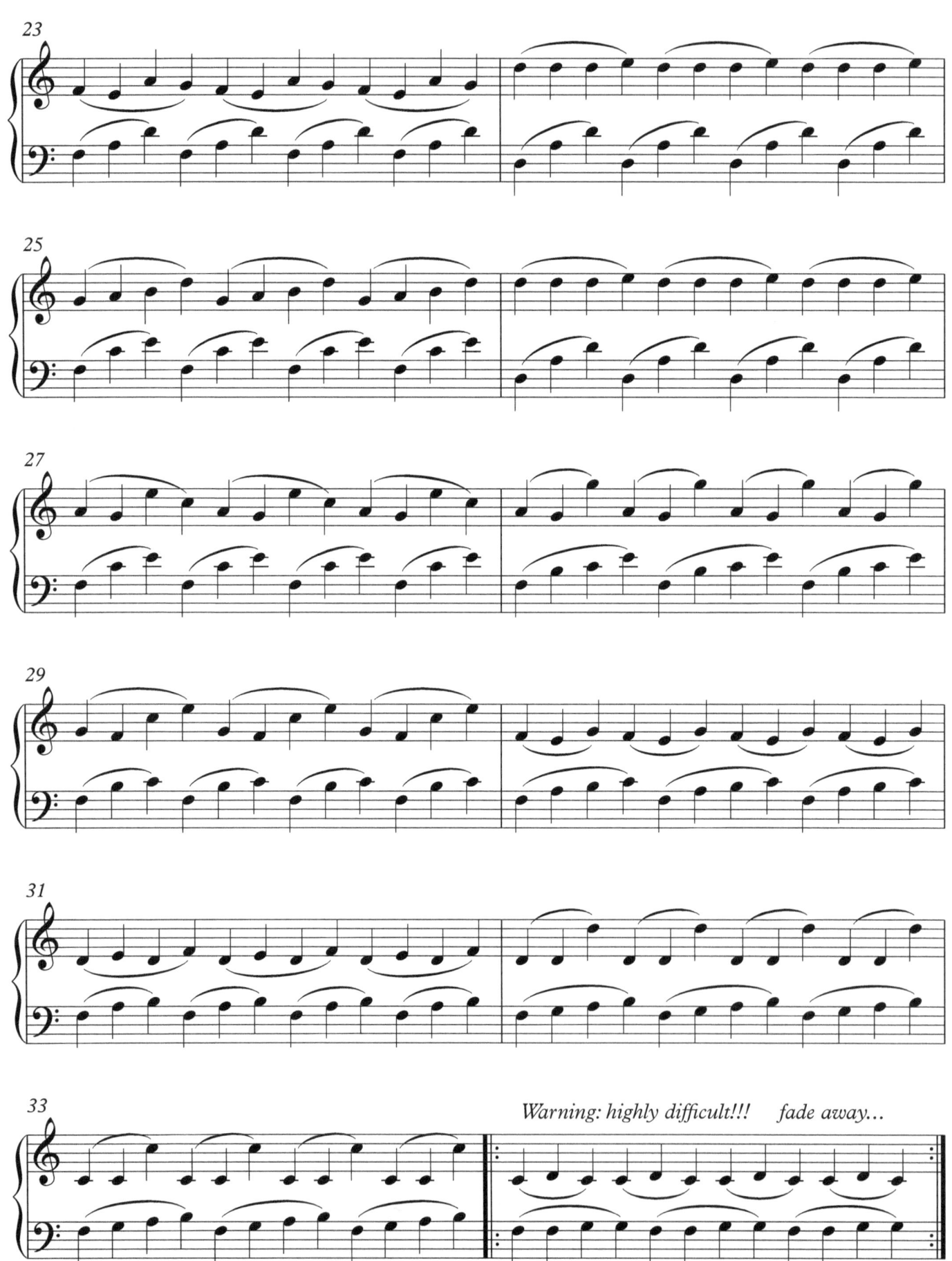

4:5 Polymetric Puzzle - Variation 1 - solution

Jeff Fineberg

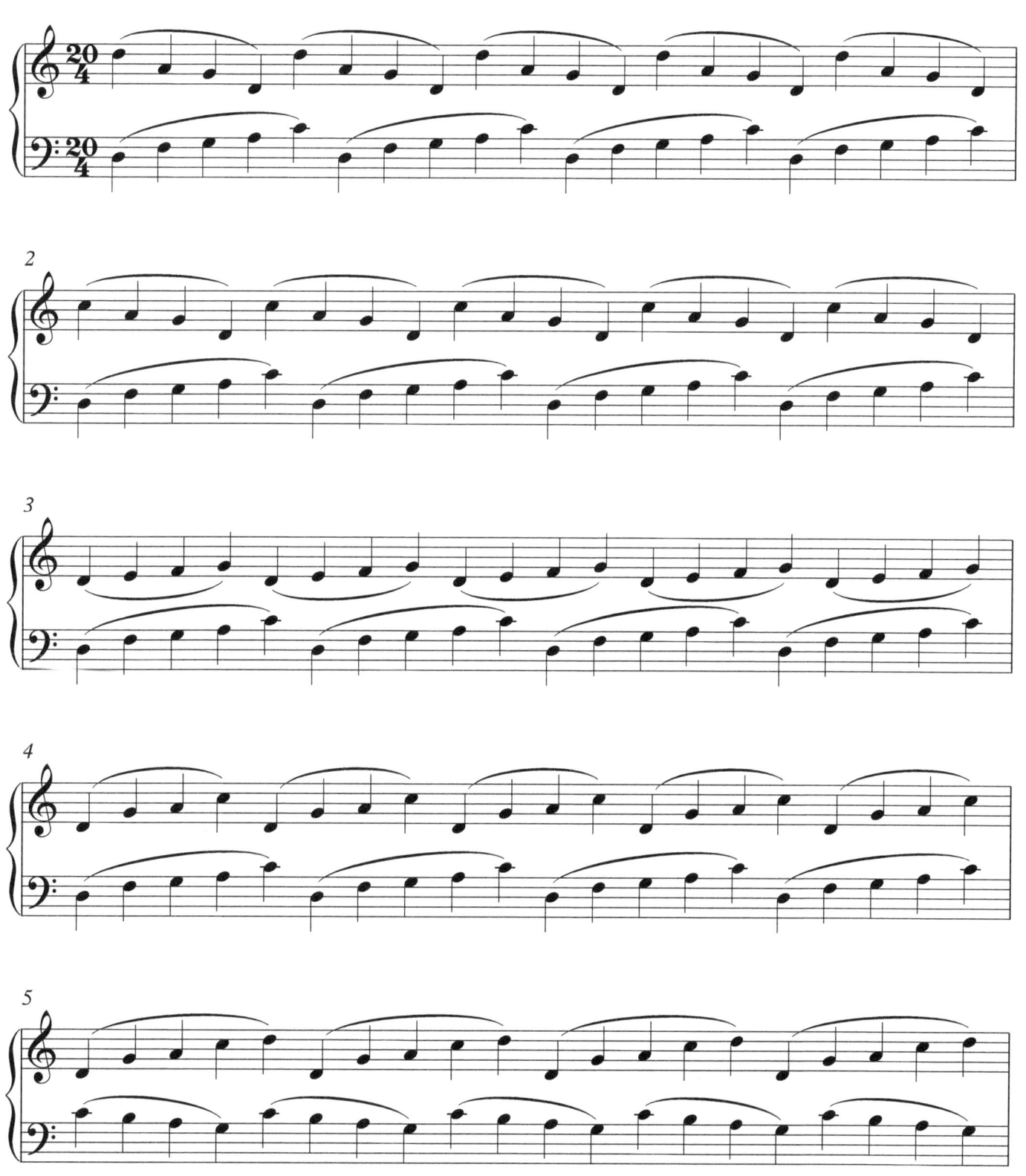

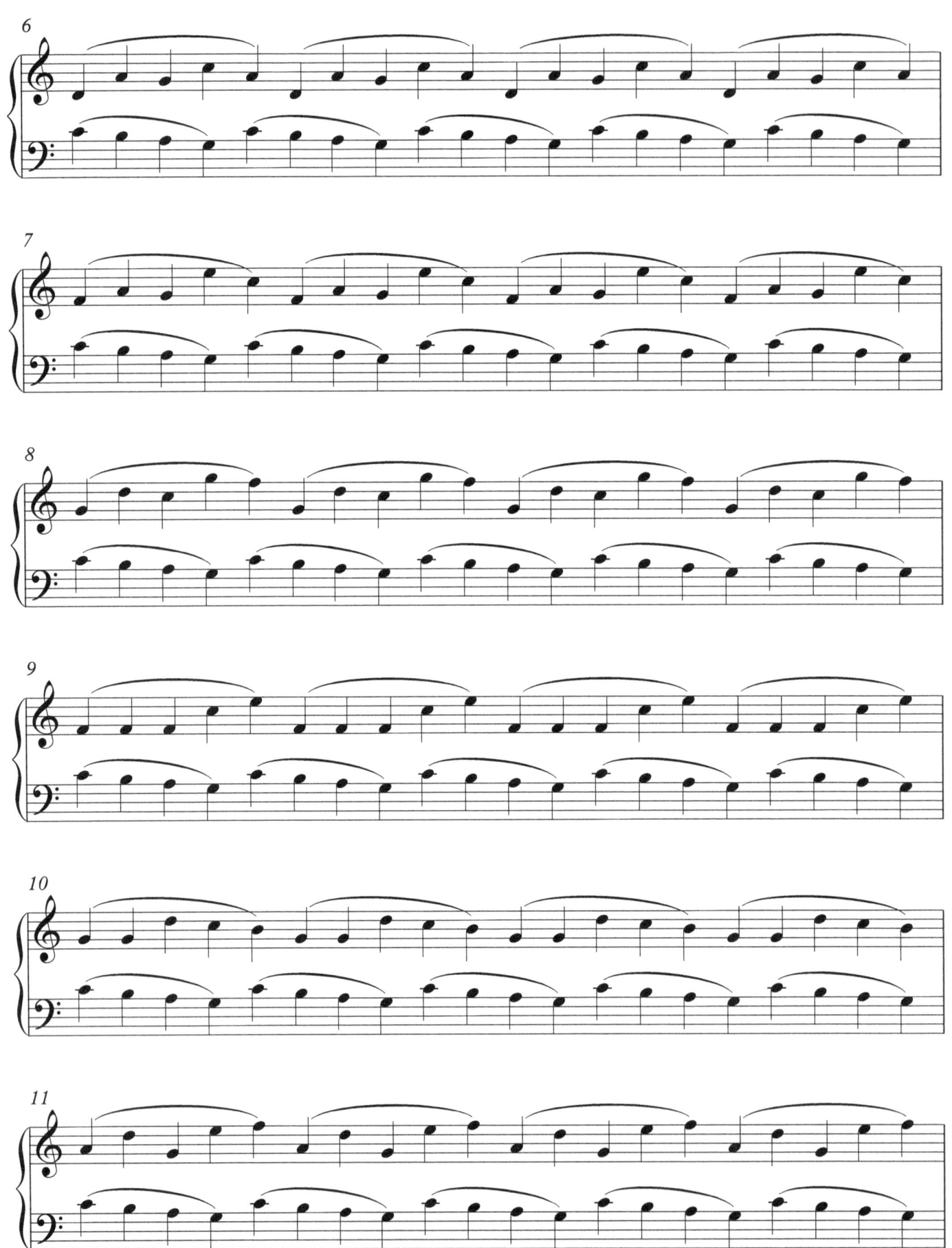

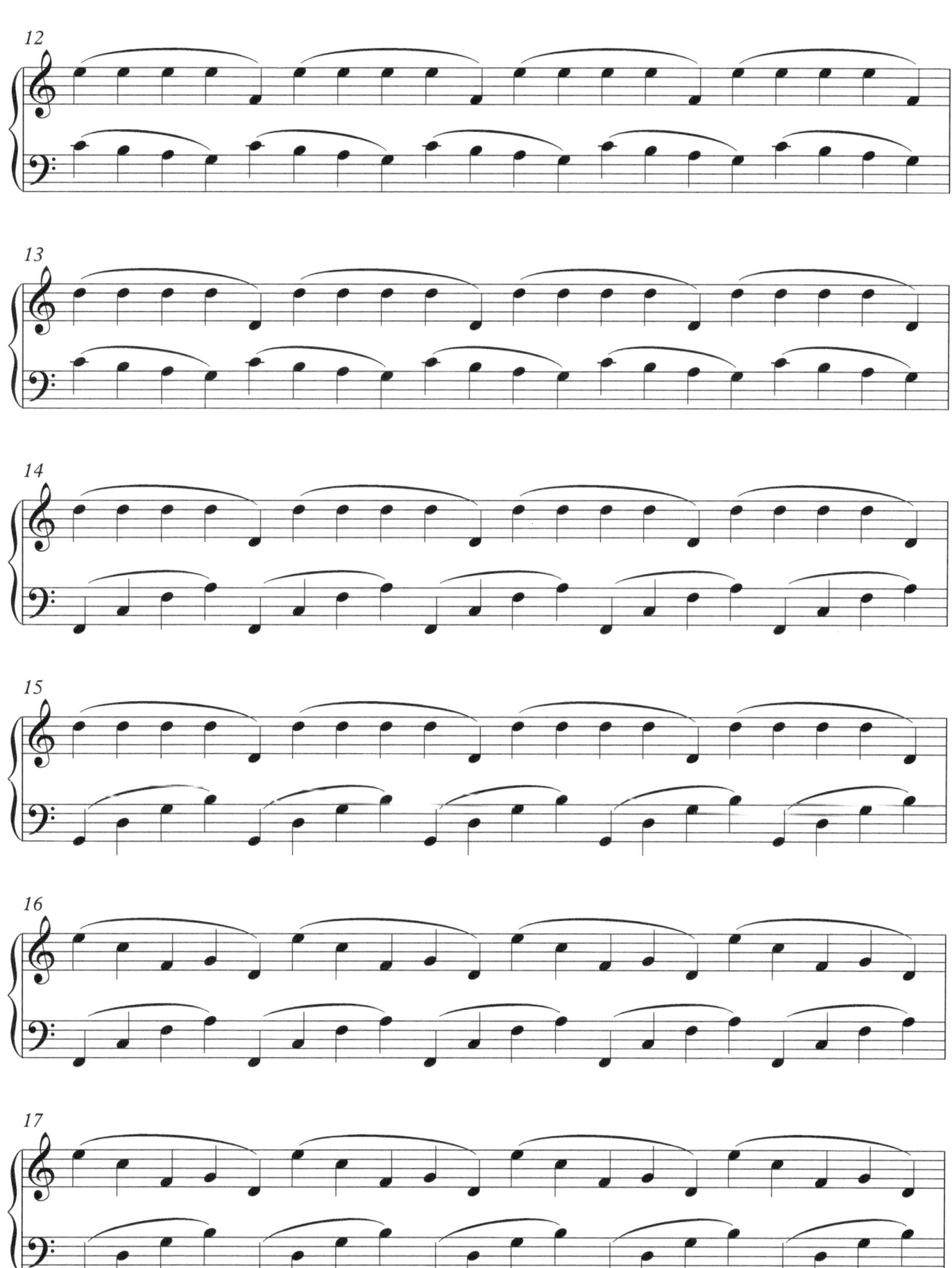

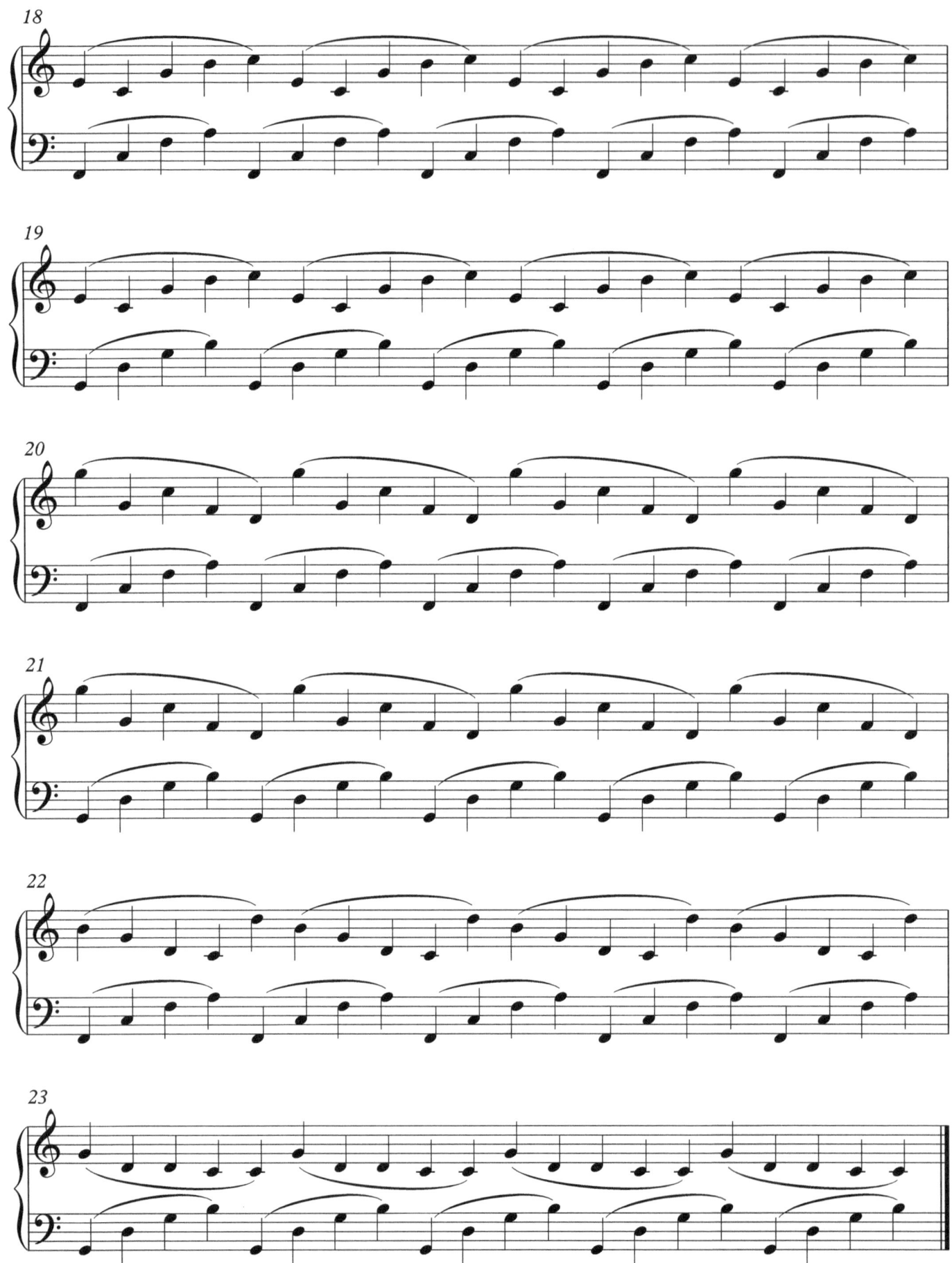

5:6 Polymeter Puzzle - Variation 1 - solution

Jeff Fineberg

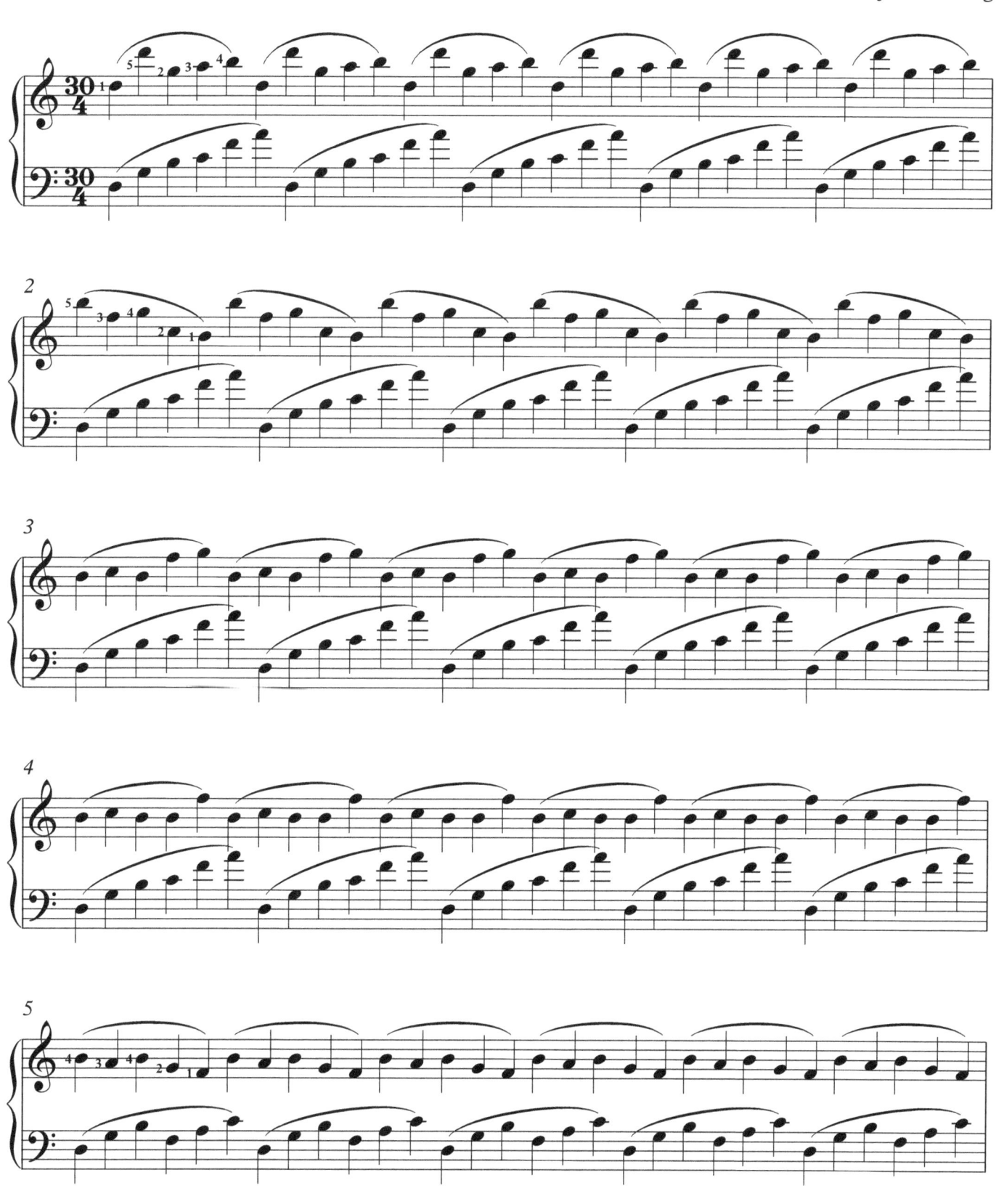

© 2014 Jeff Fineberg

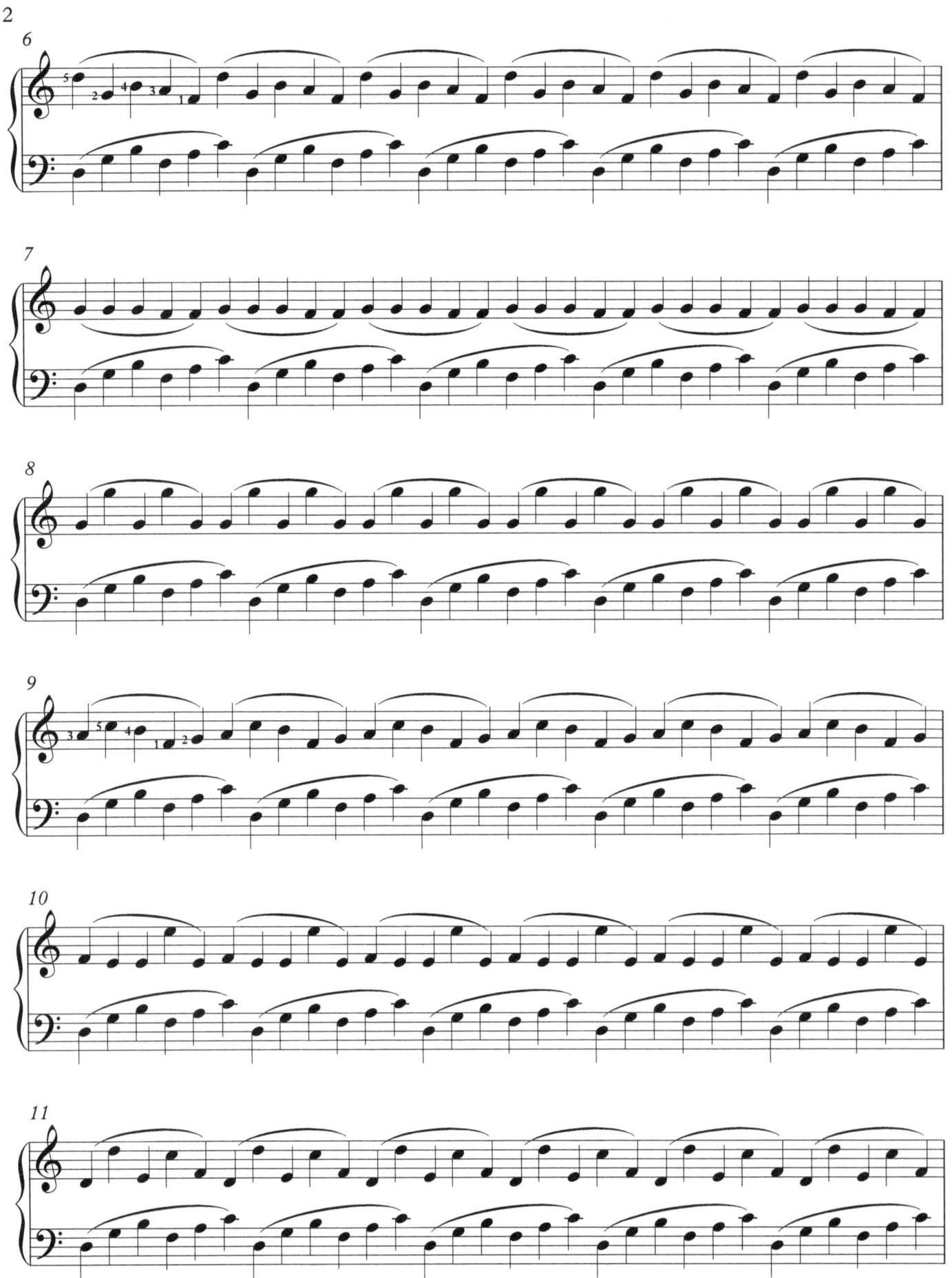

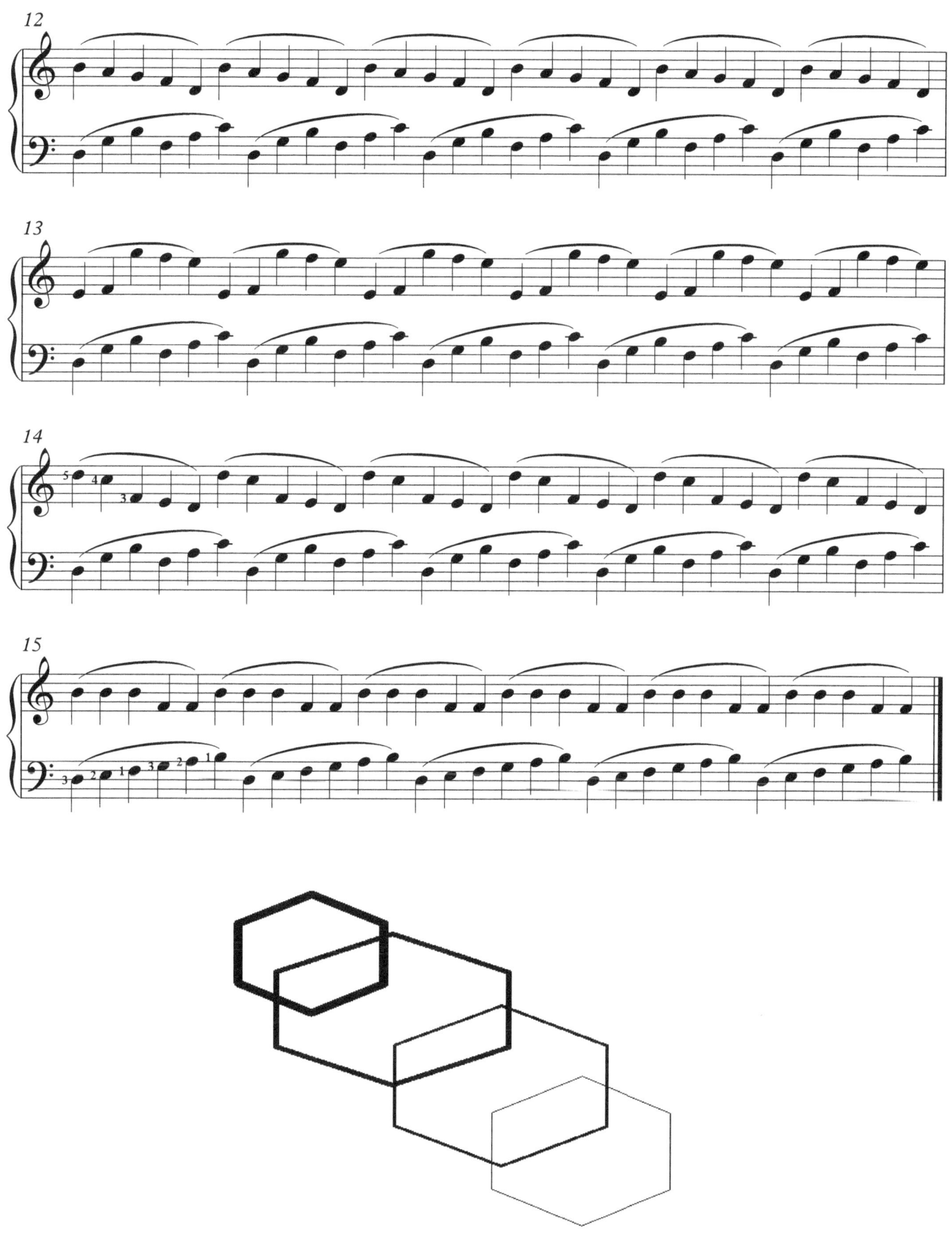

6:7 Polymetric Puzzle - solution

Jeff Fineberg

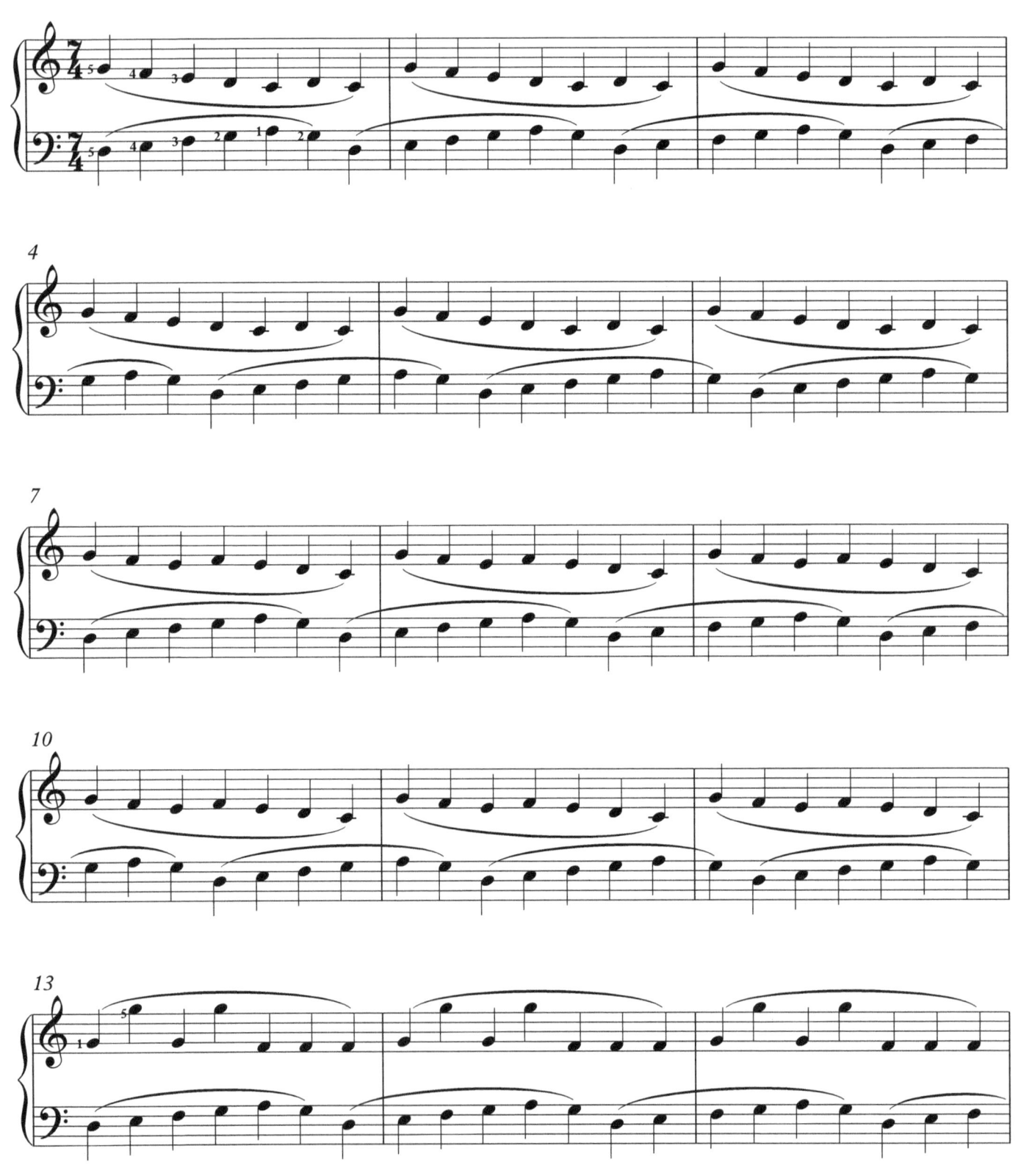

© 2014 - Jeff Fineberg

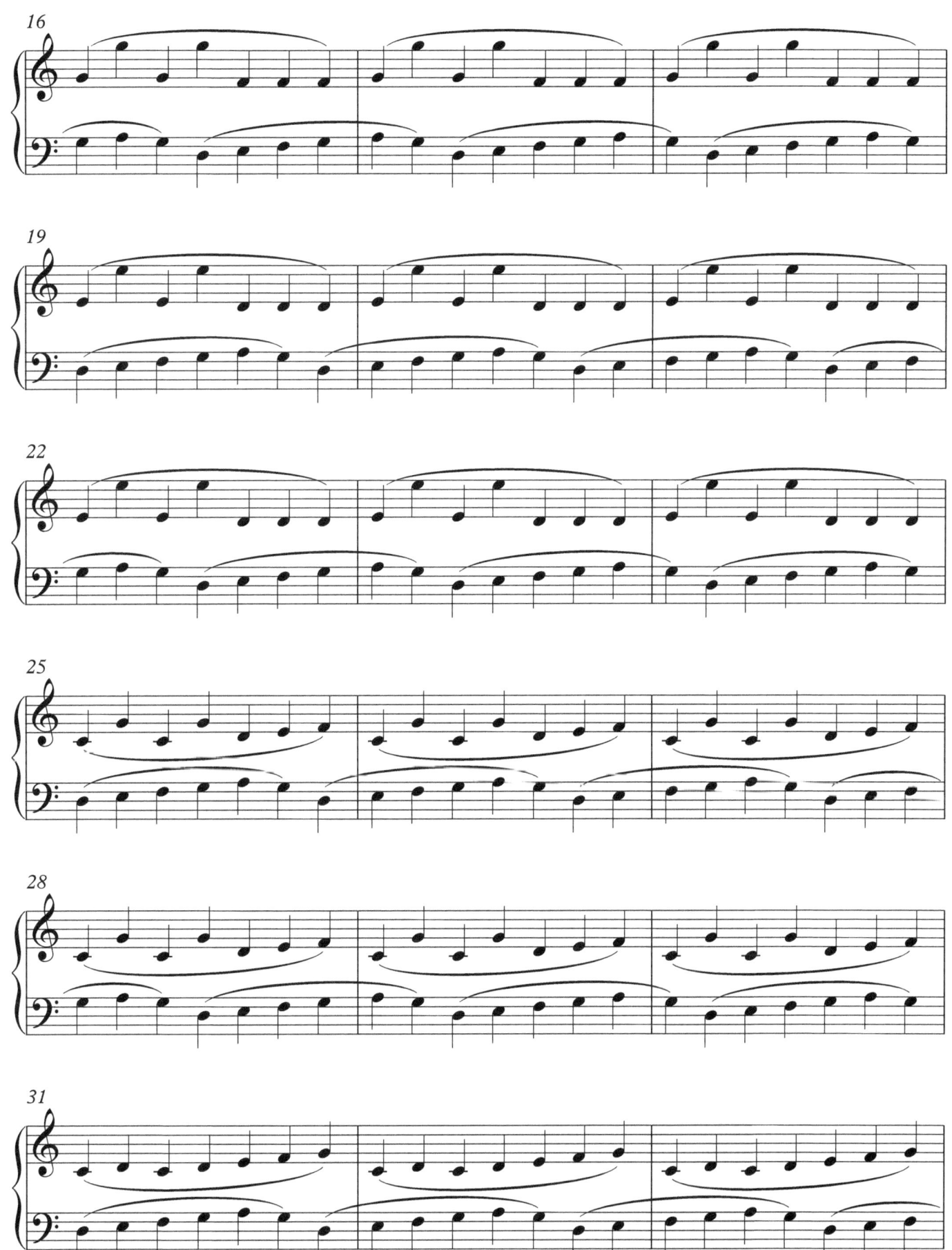

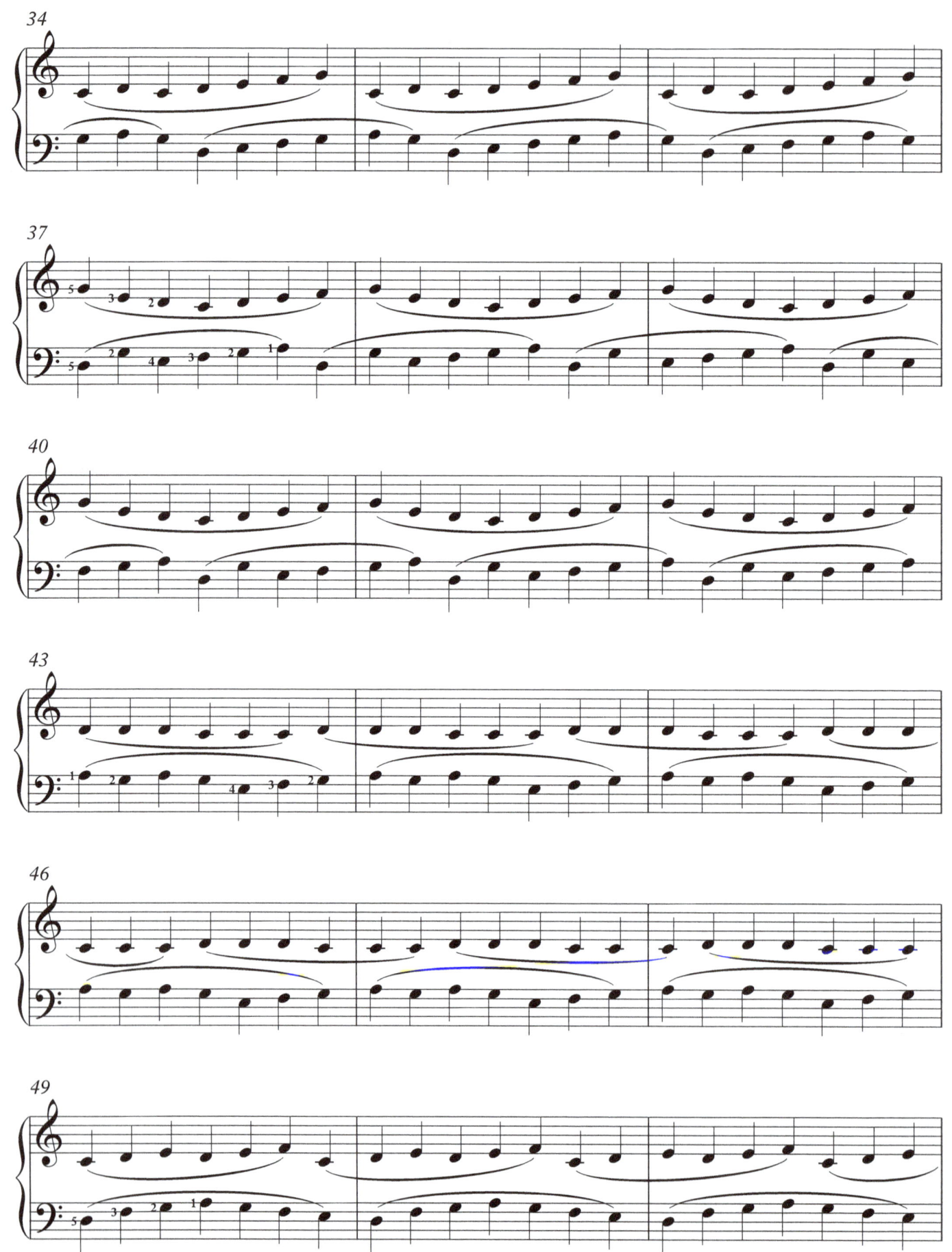

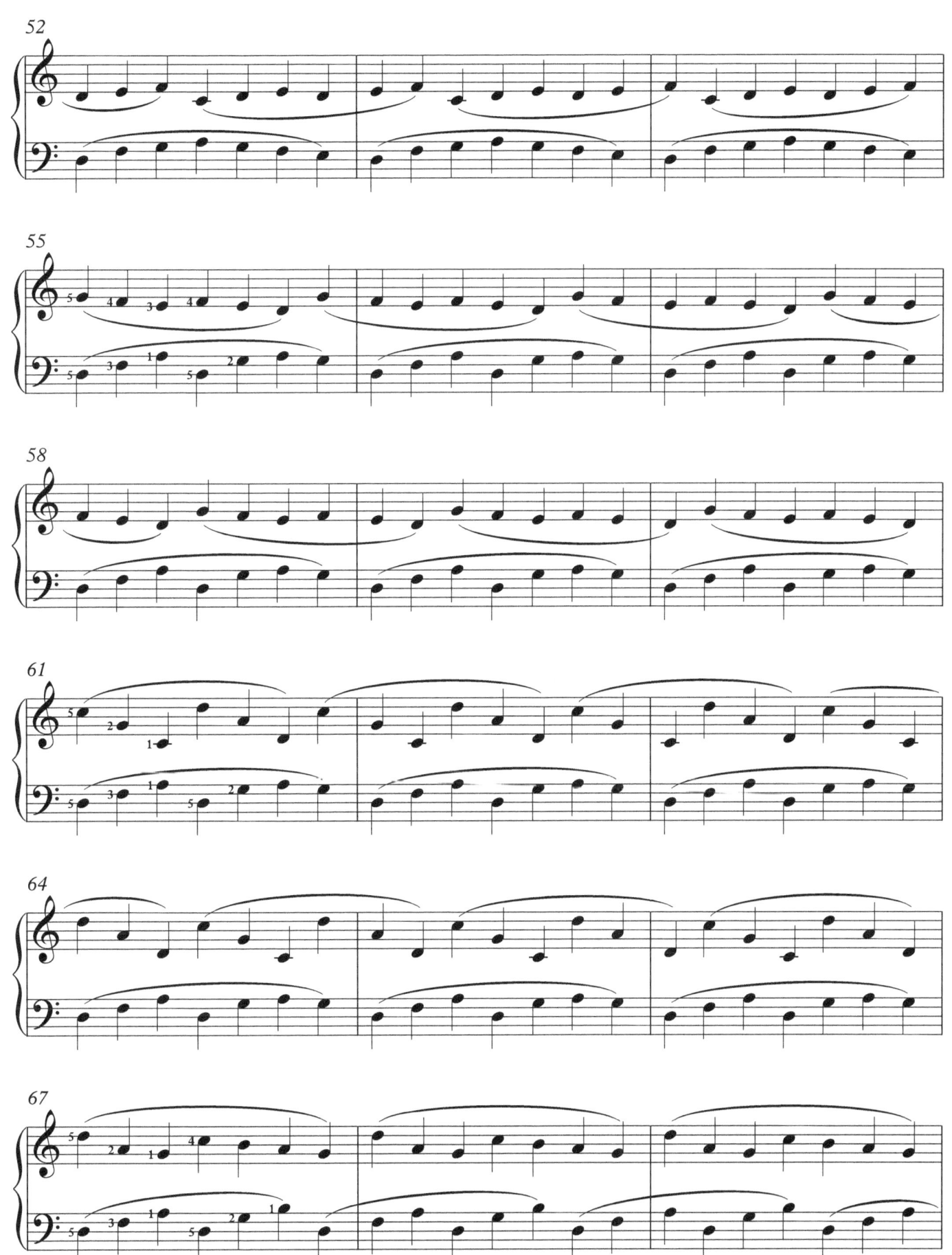

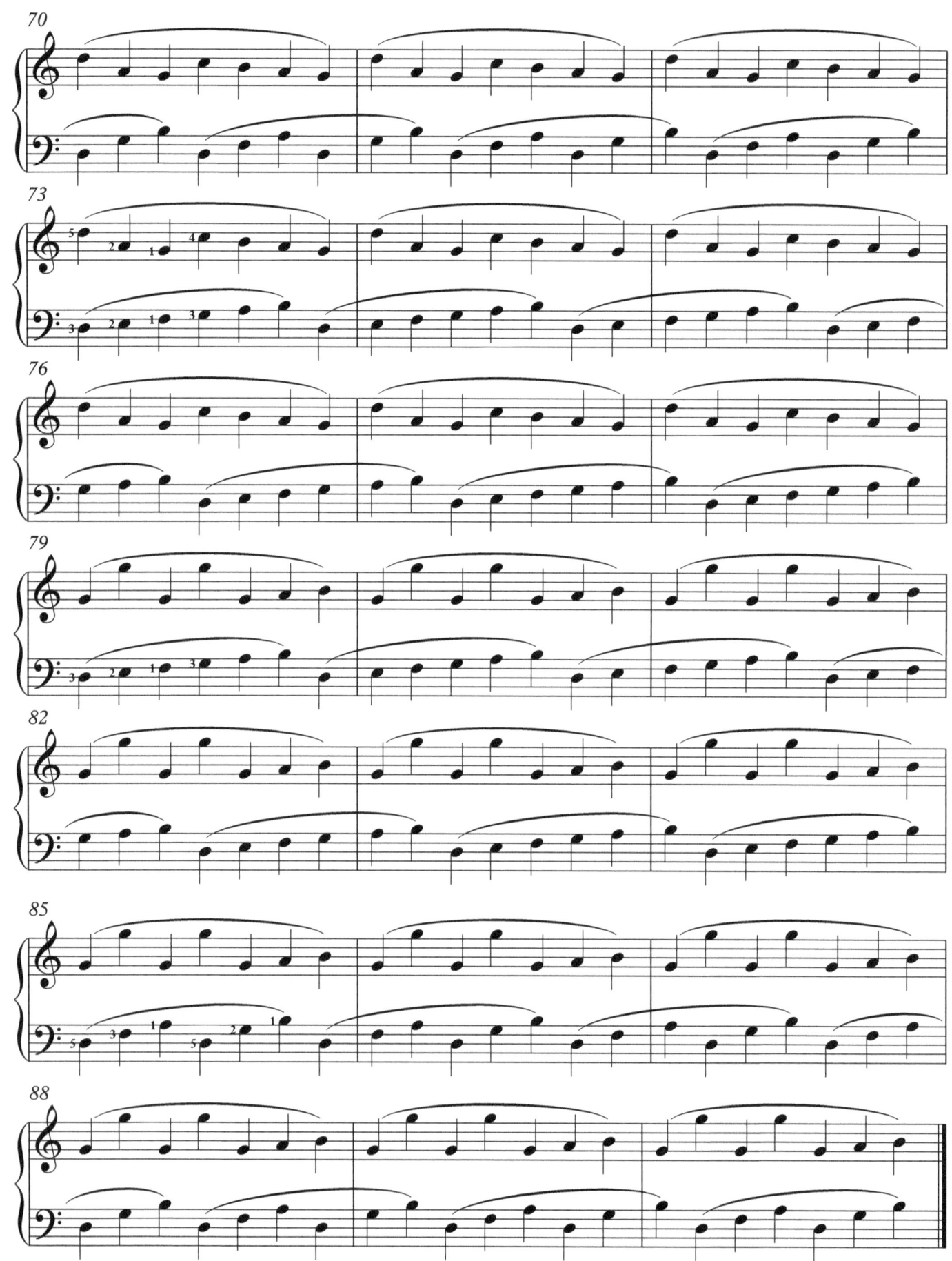

6:7 Polymetric Puzzle - variation 1 - solution

Jeff Fineberg

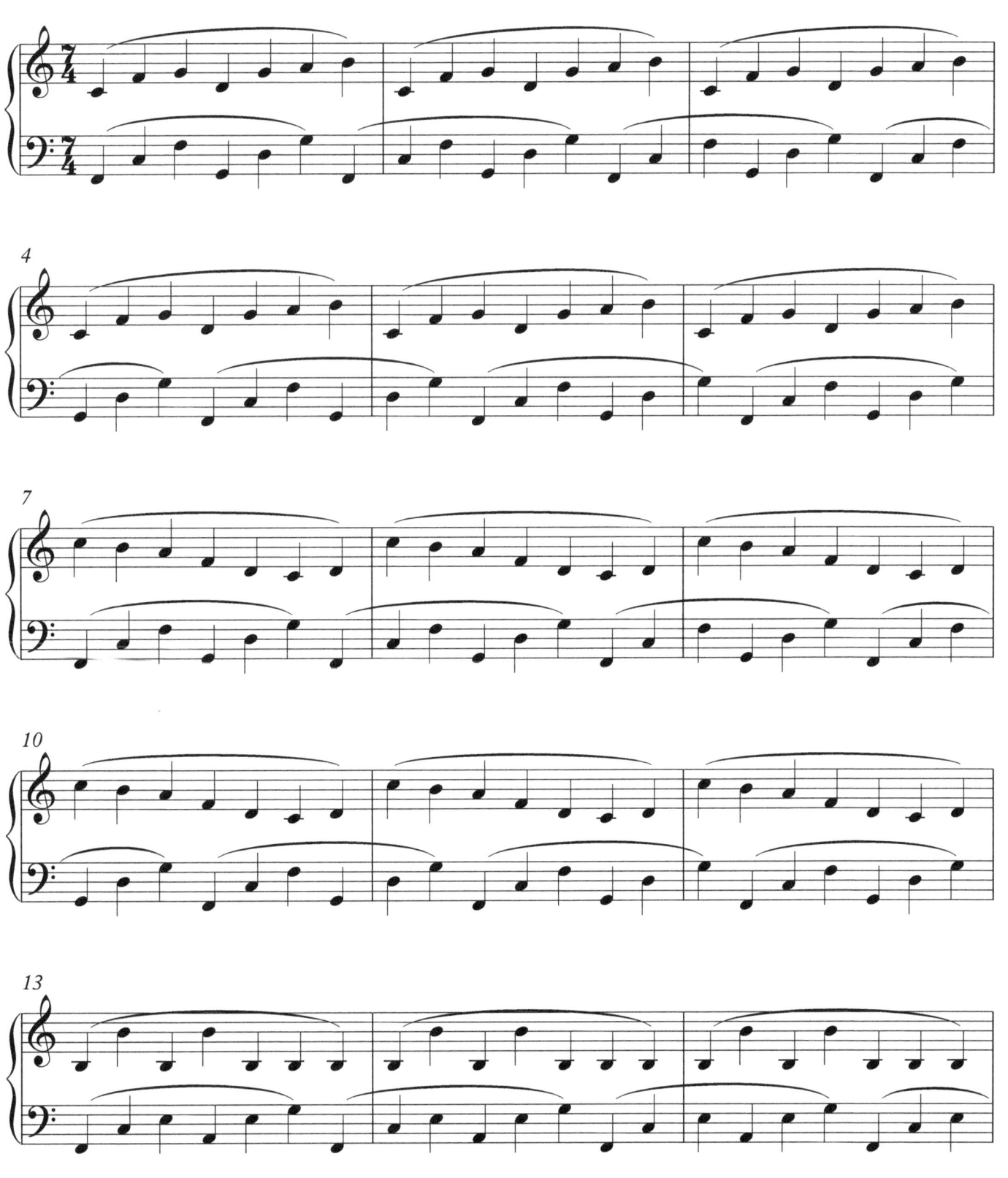

© 2014 - Jeff Fineberg

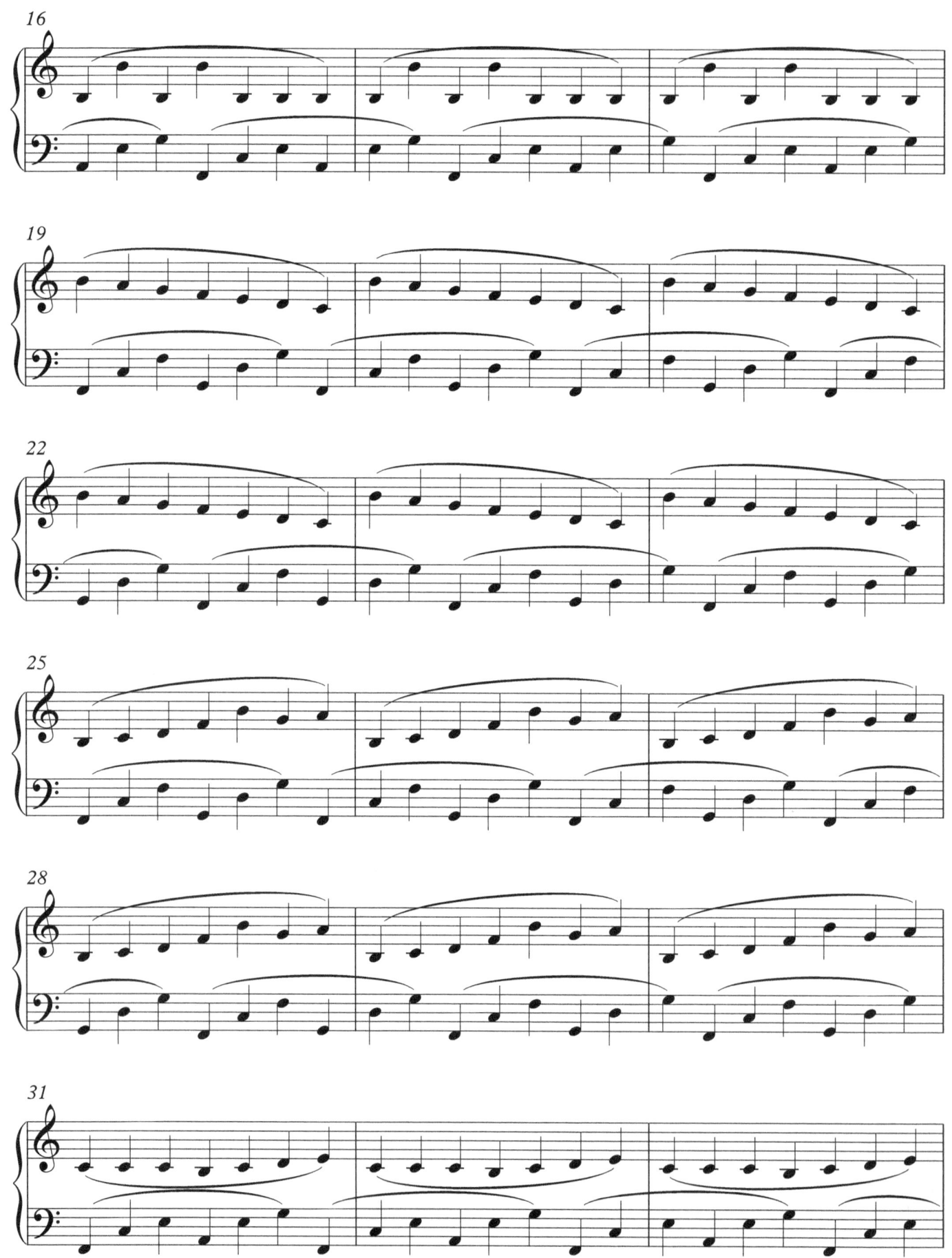

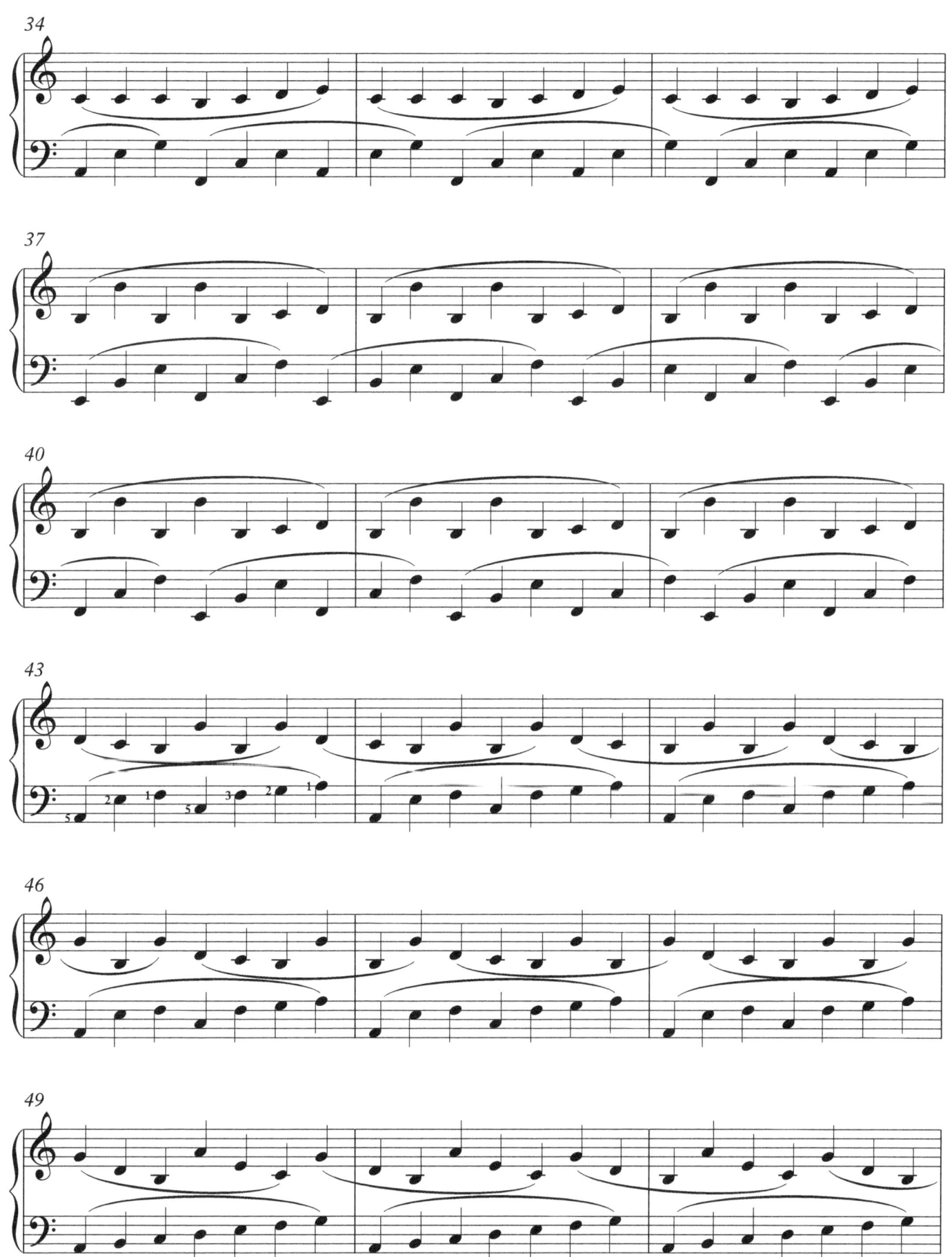

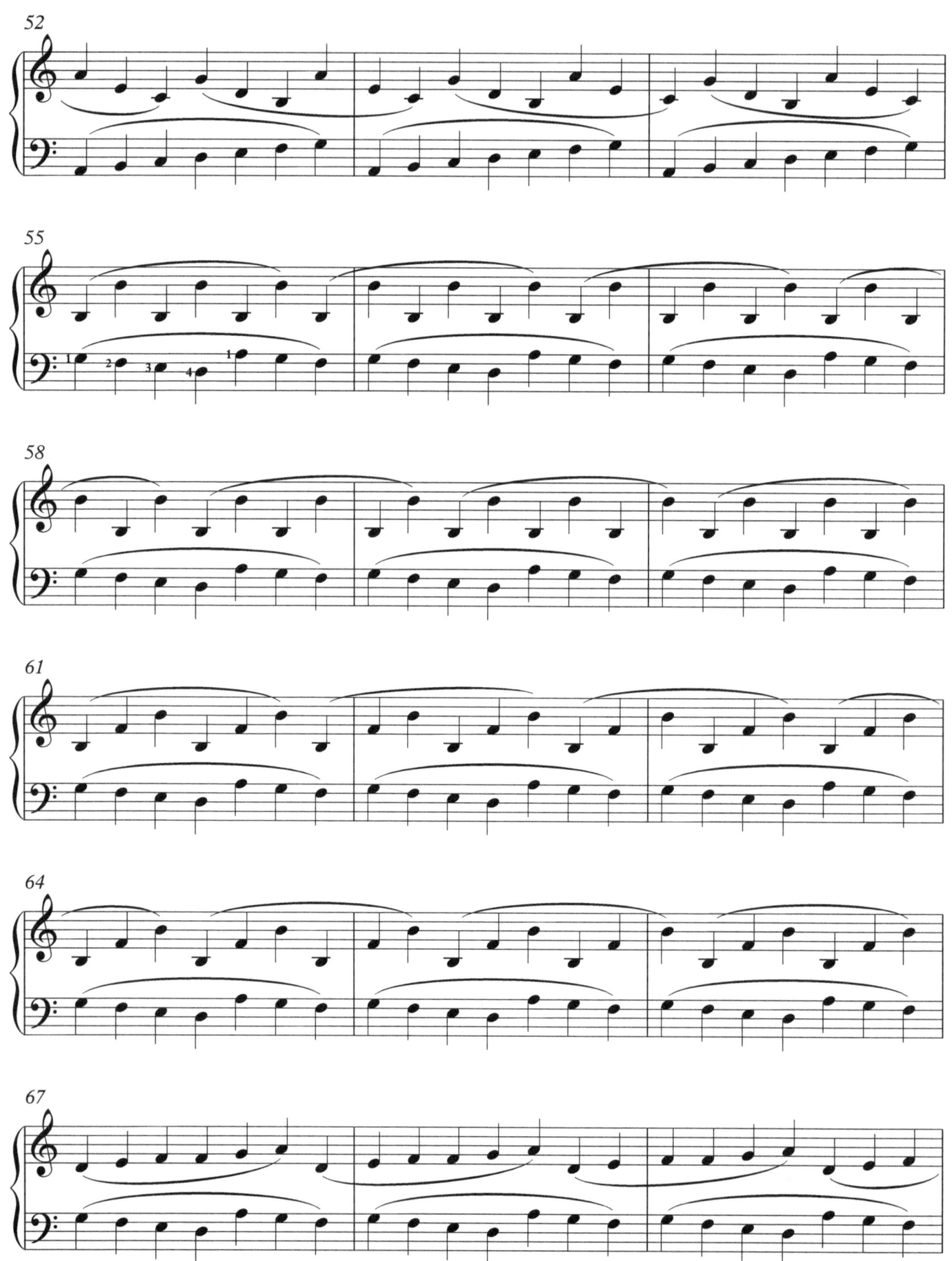

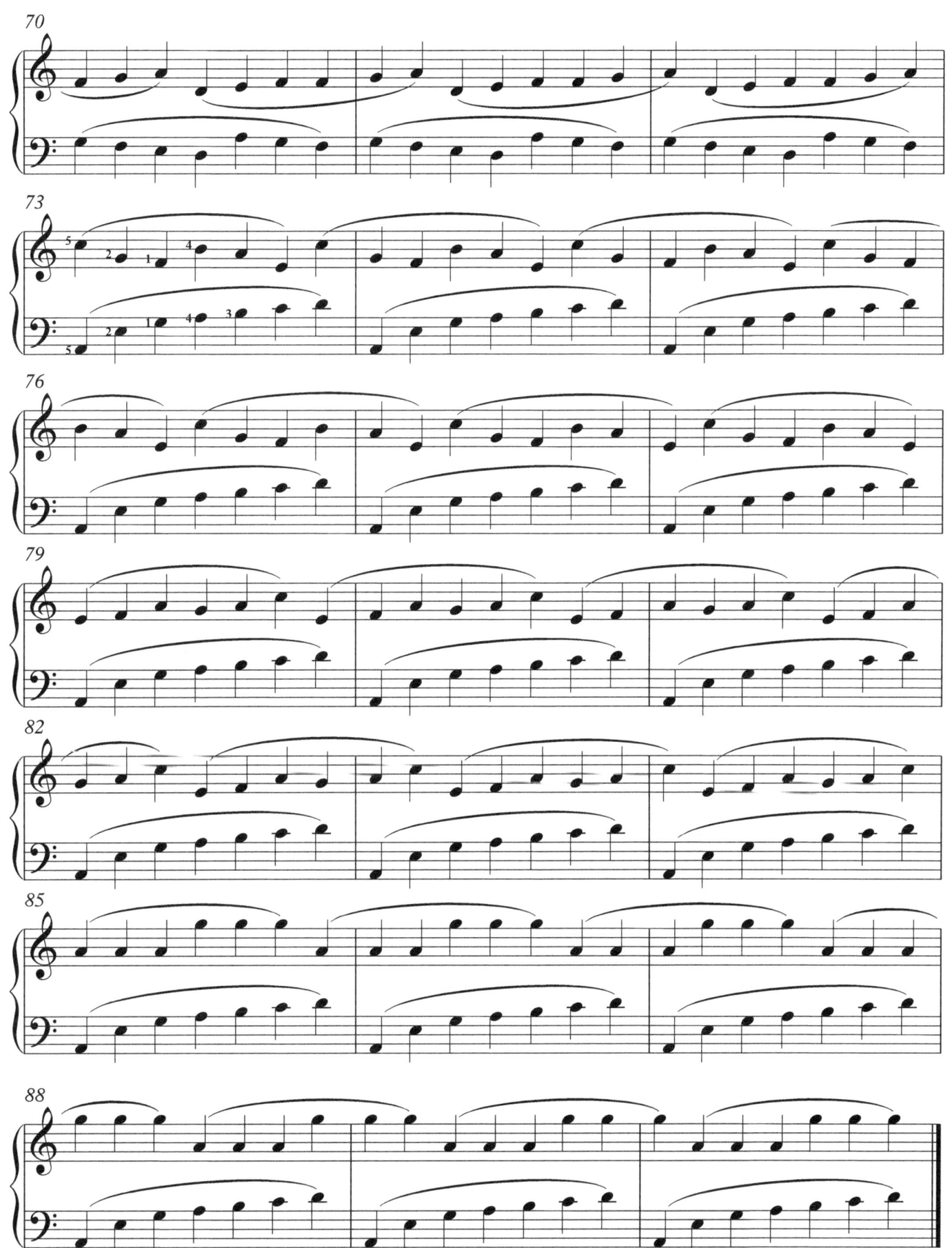

5:2 / 5:3 Polymetric Puzzle Solution

Jeff Fineberg

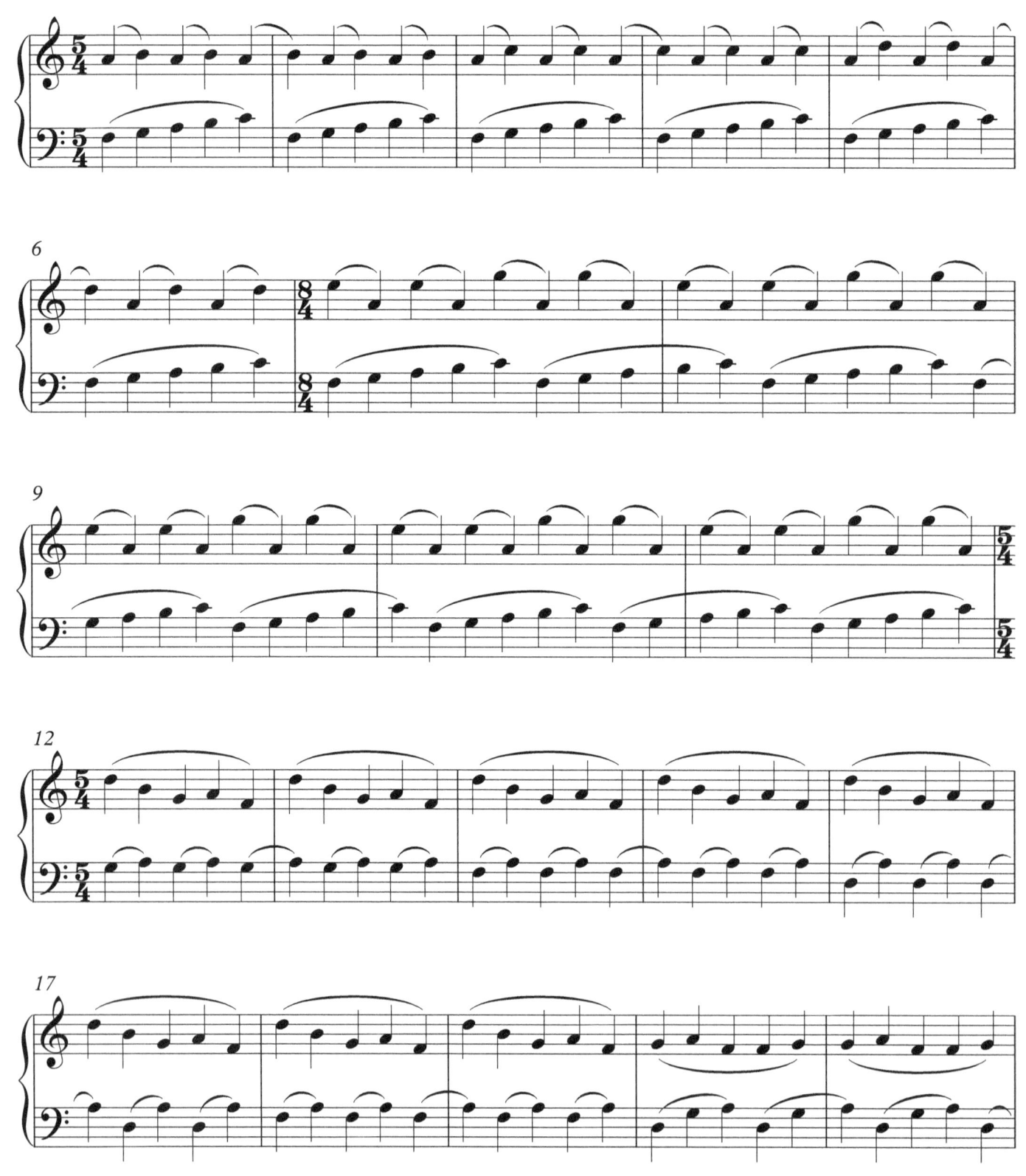

© 2013 - Jeff Fineberg

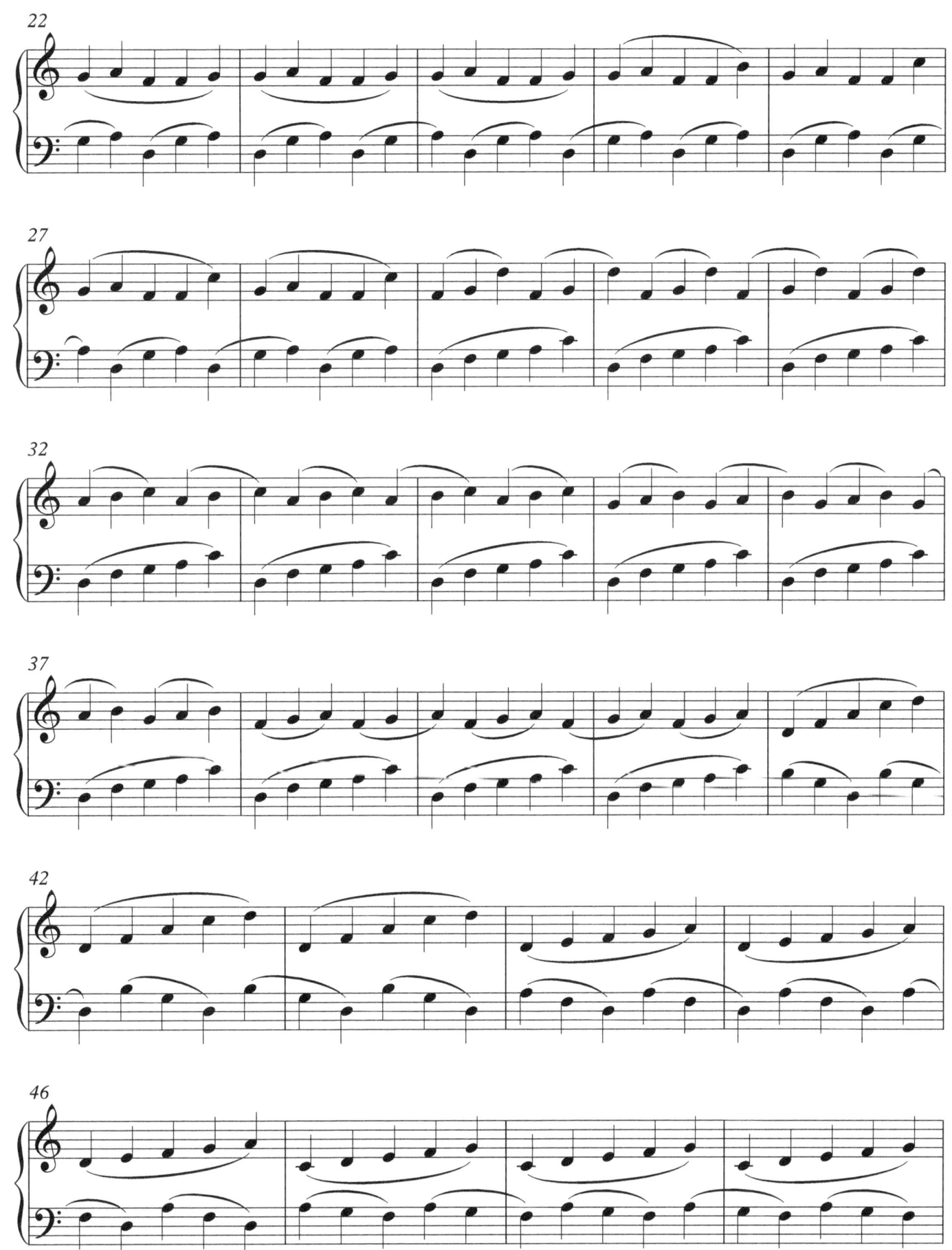

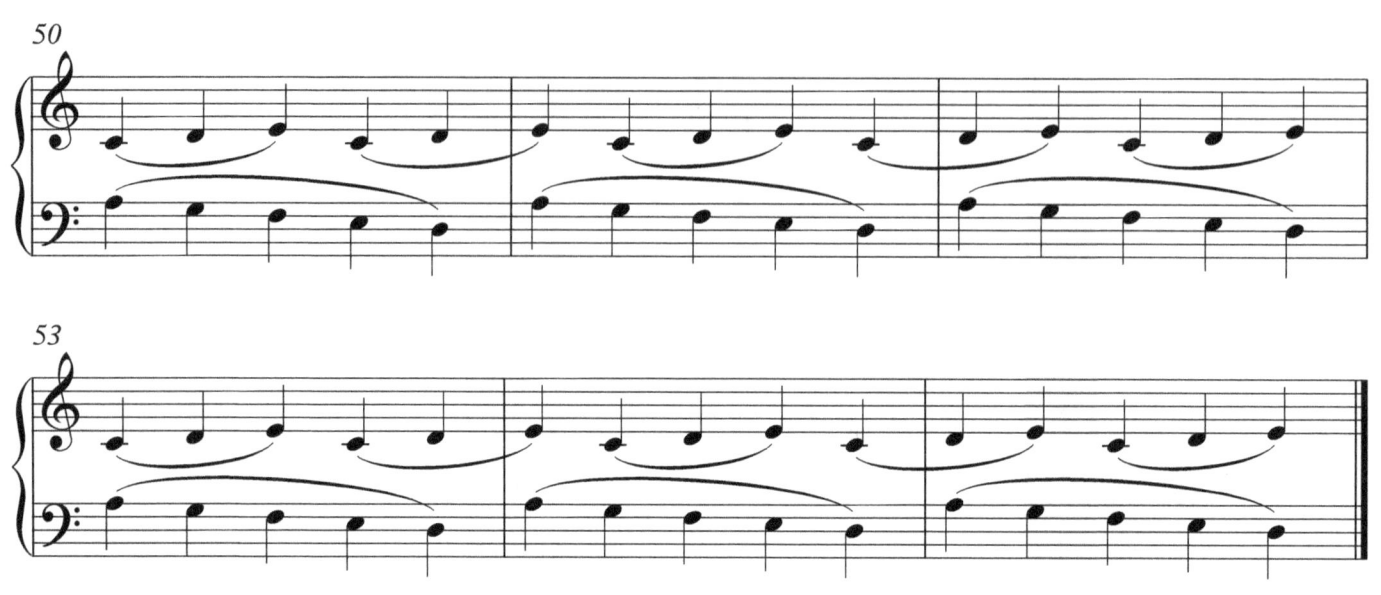

Polymetric Song - Variations in 11 (solution)

Jeff Fineberg

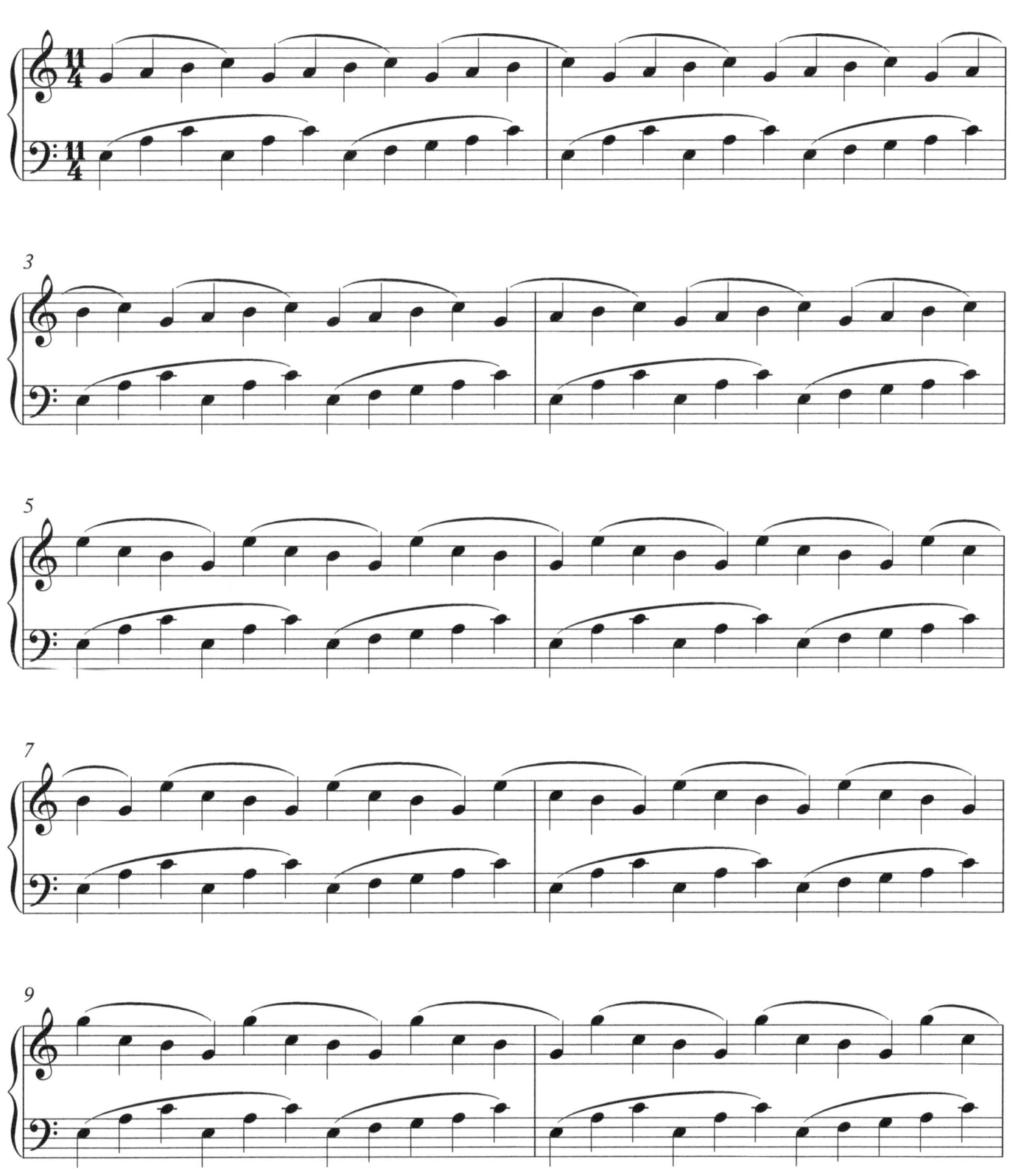

© 2013 - Jeff Fineberg

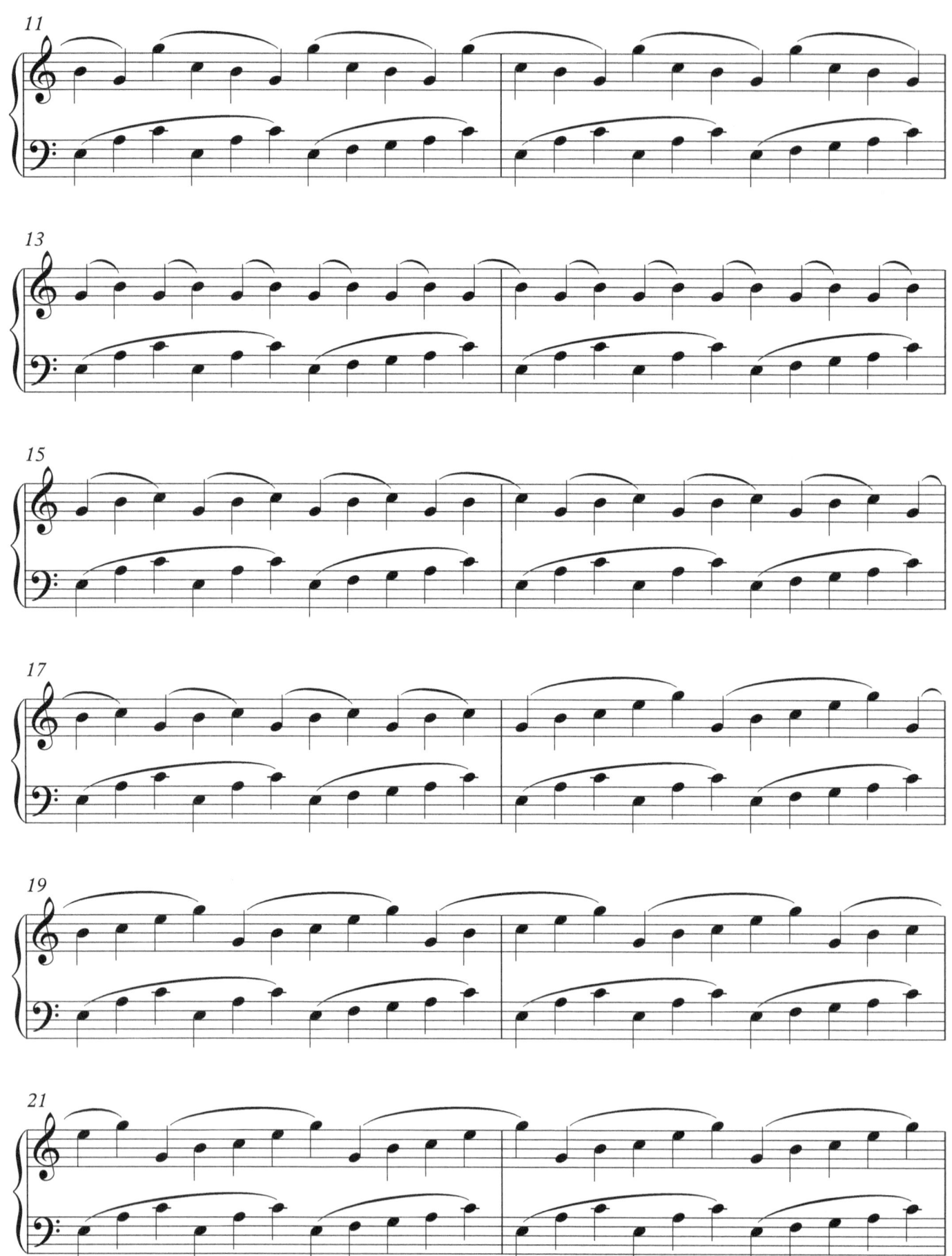

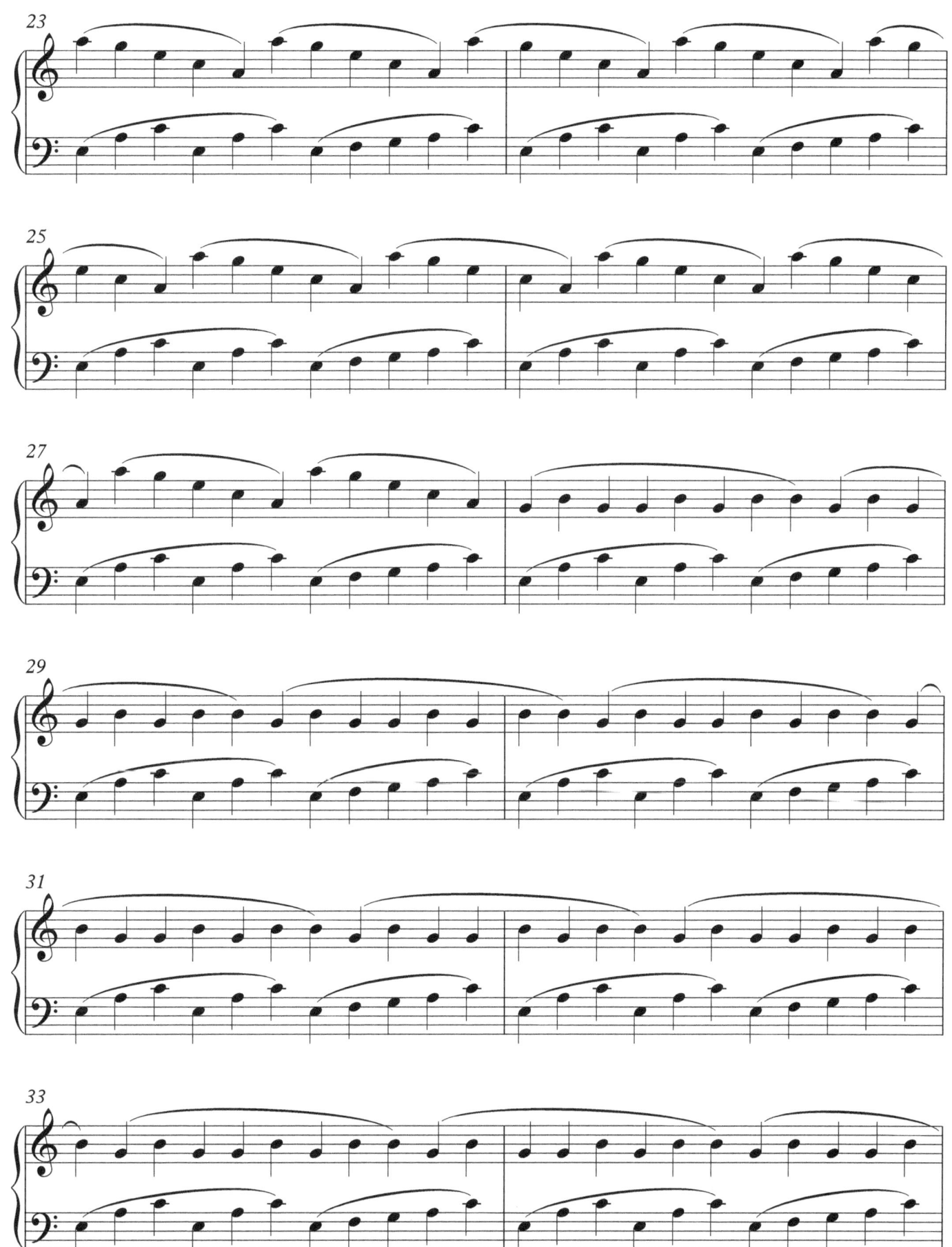

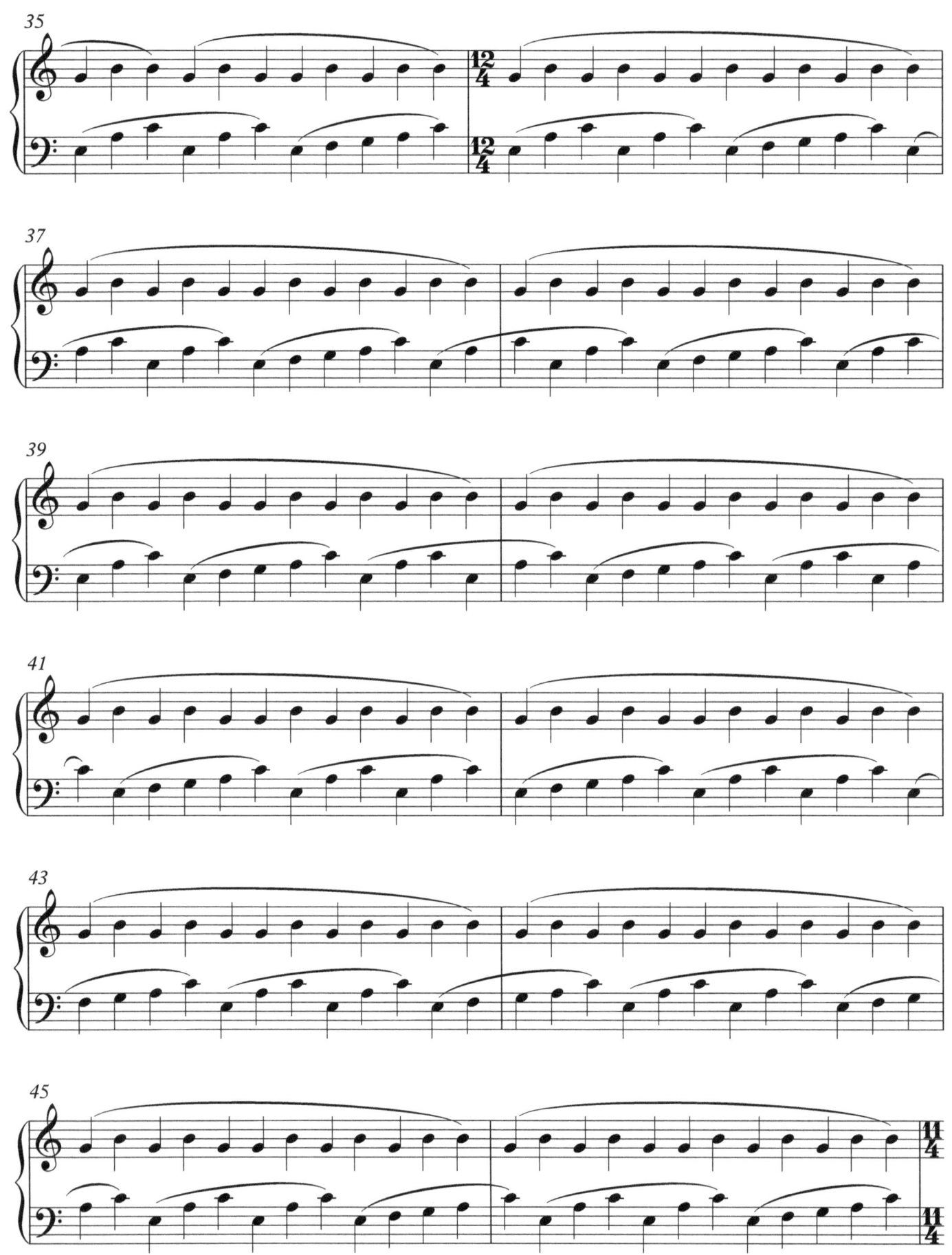

144

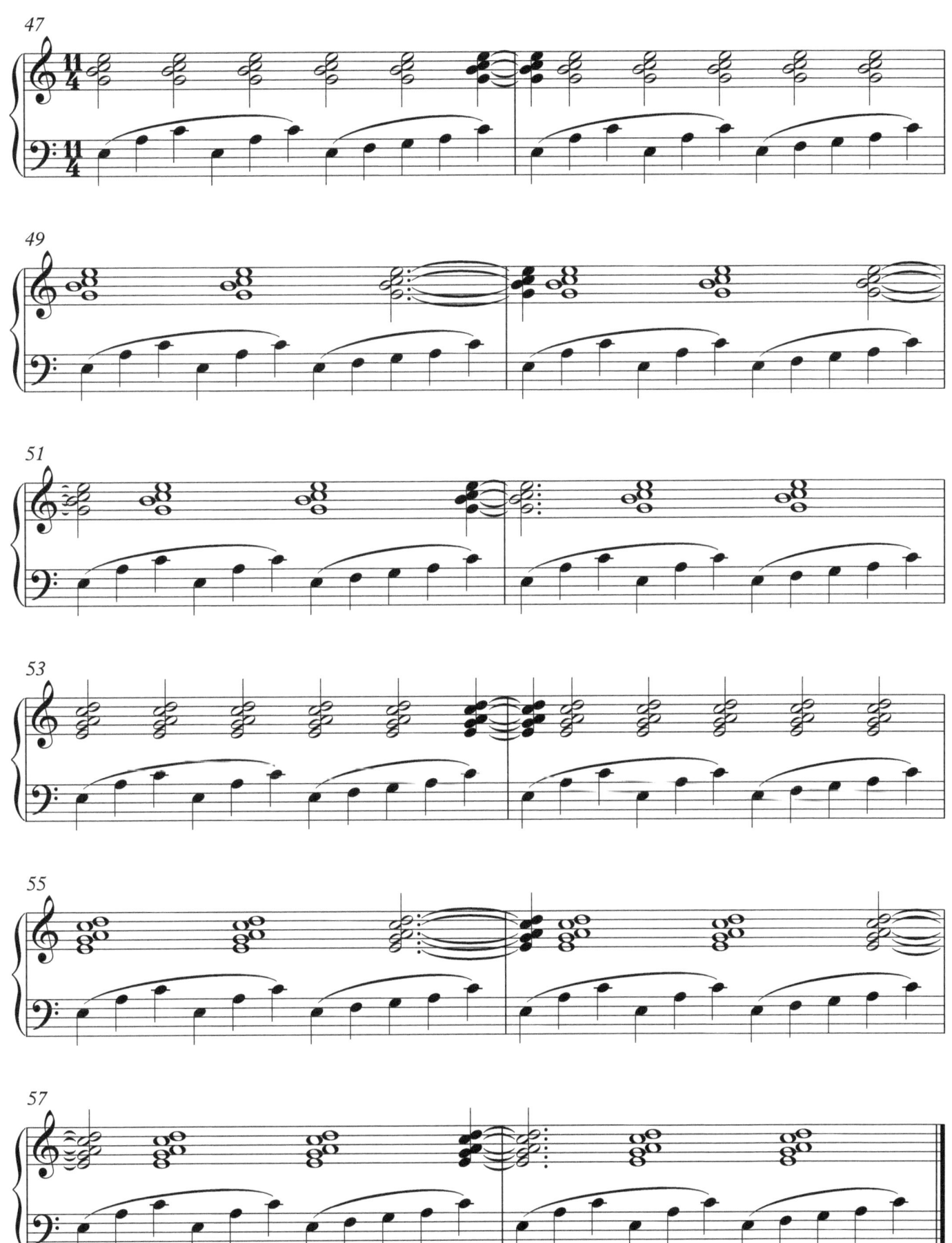

Polymetric Song - Variations in 12,9,5,4,3,2 (solution)

Jeff Fineberg

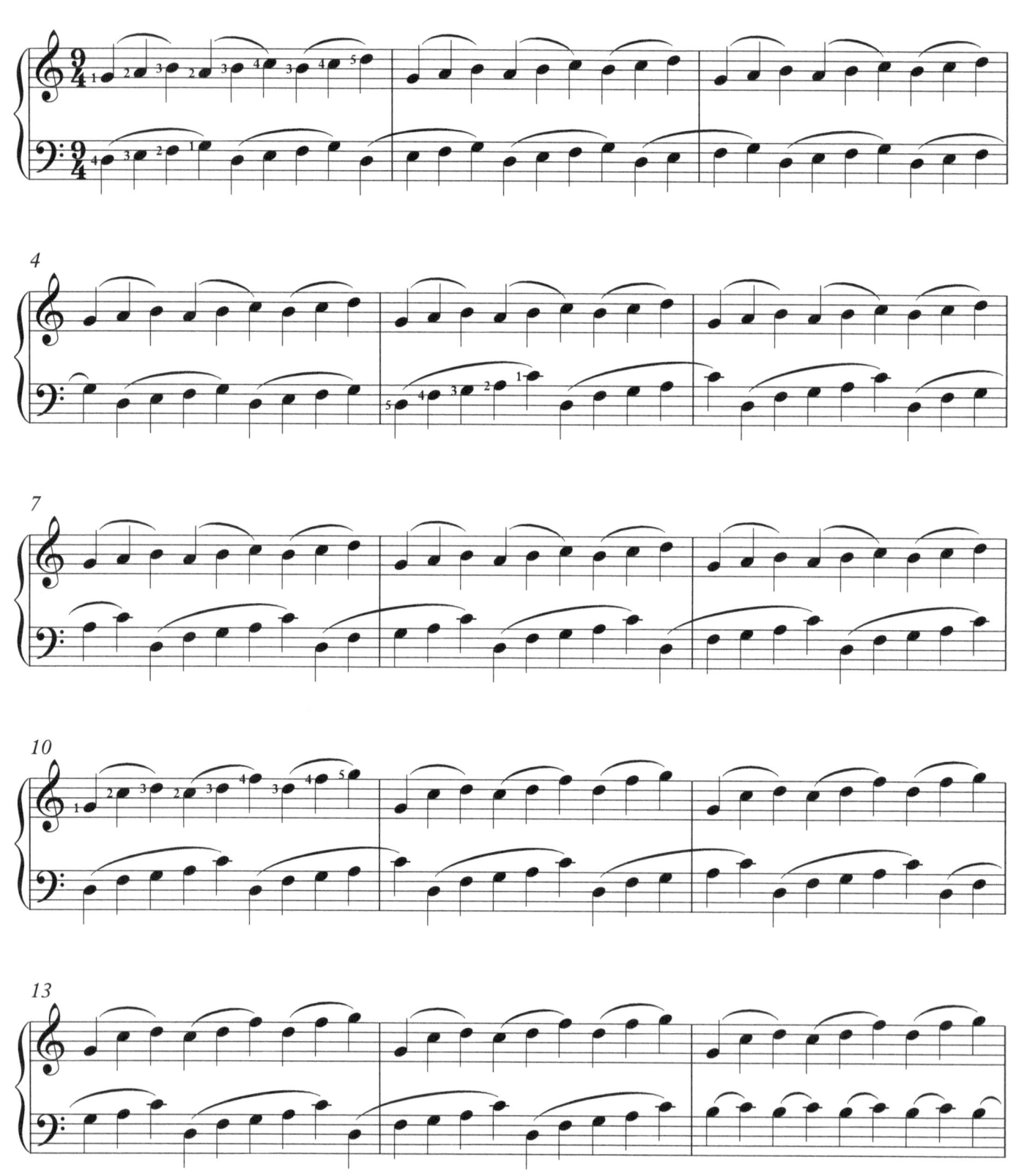

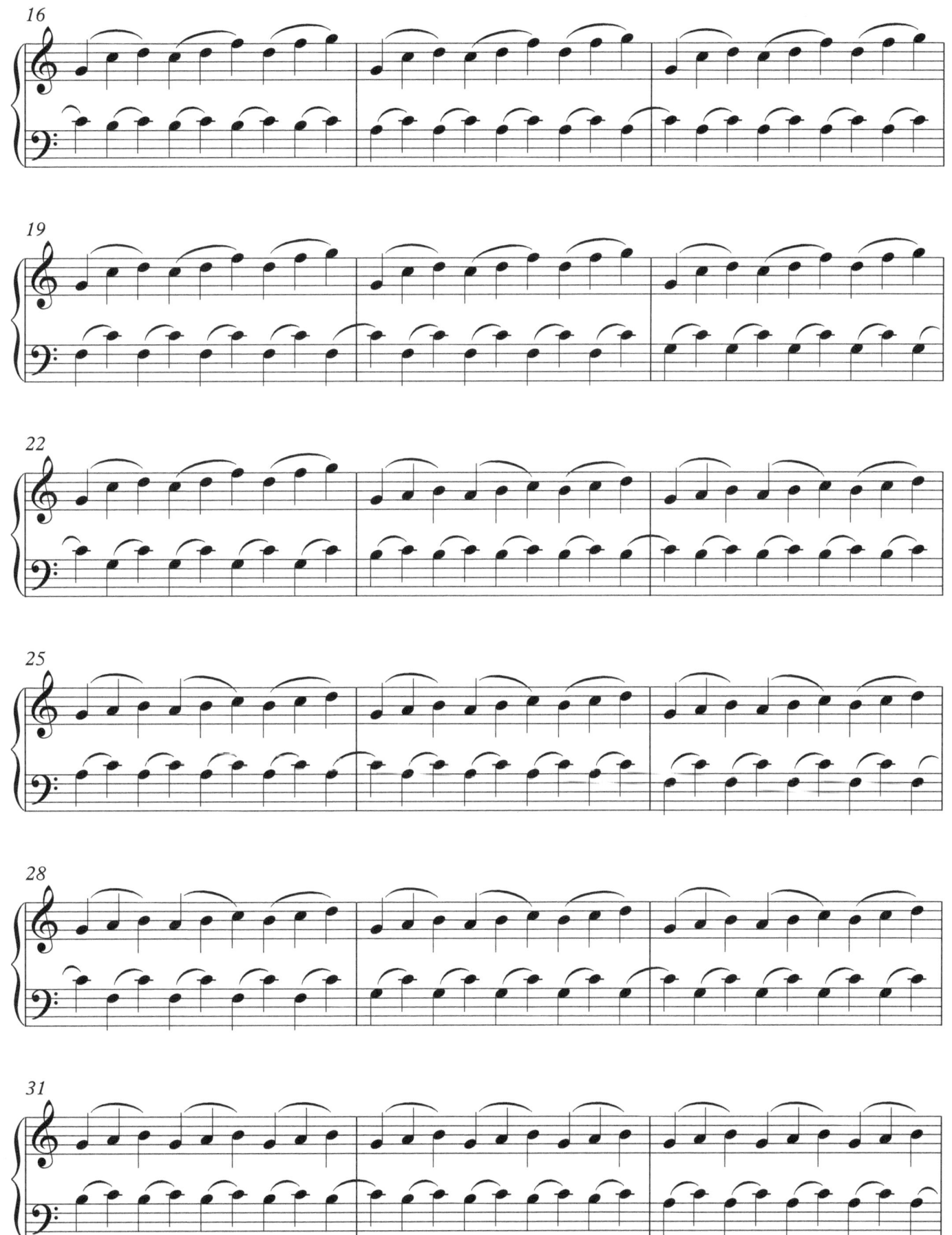

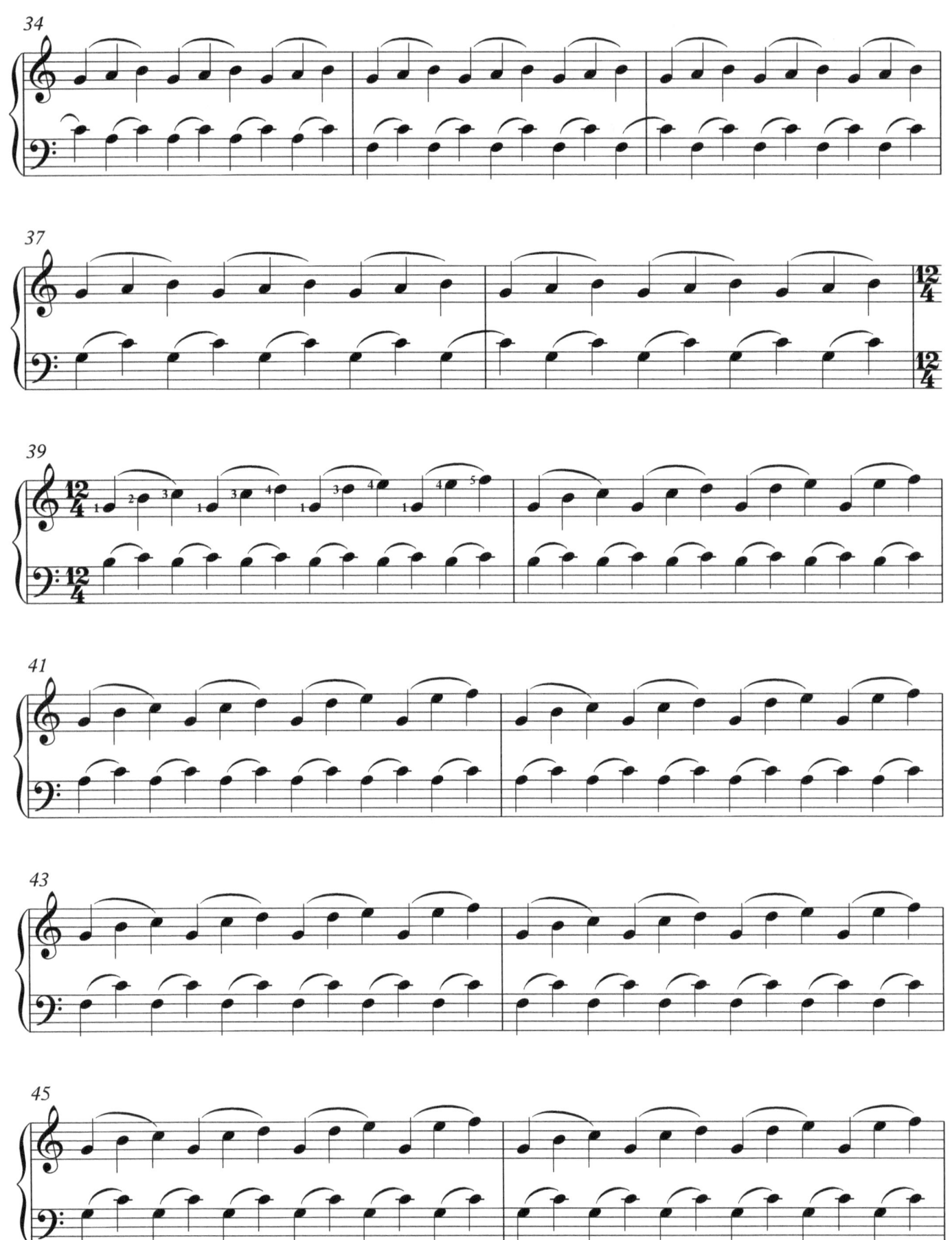

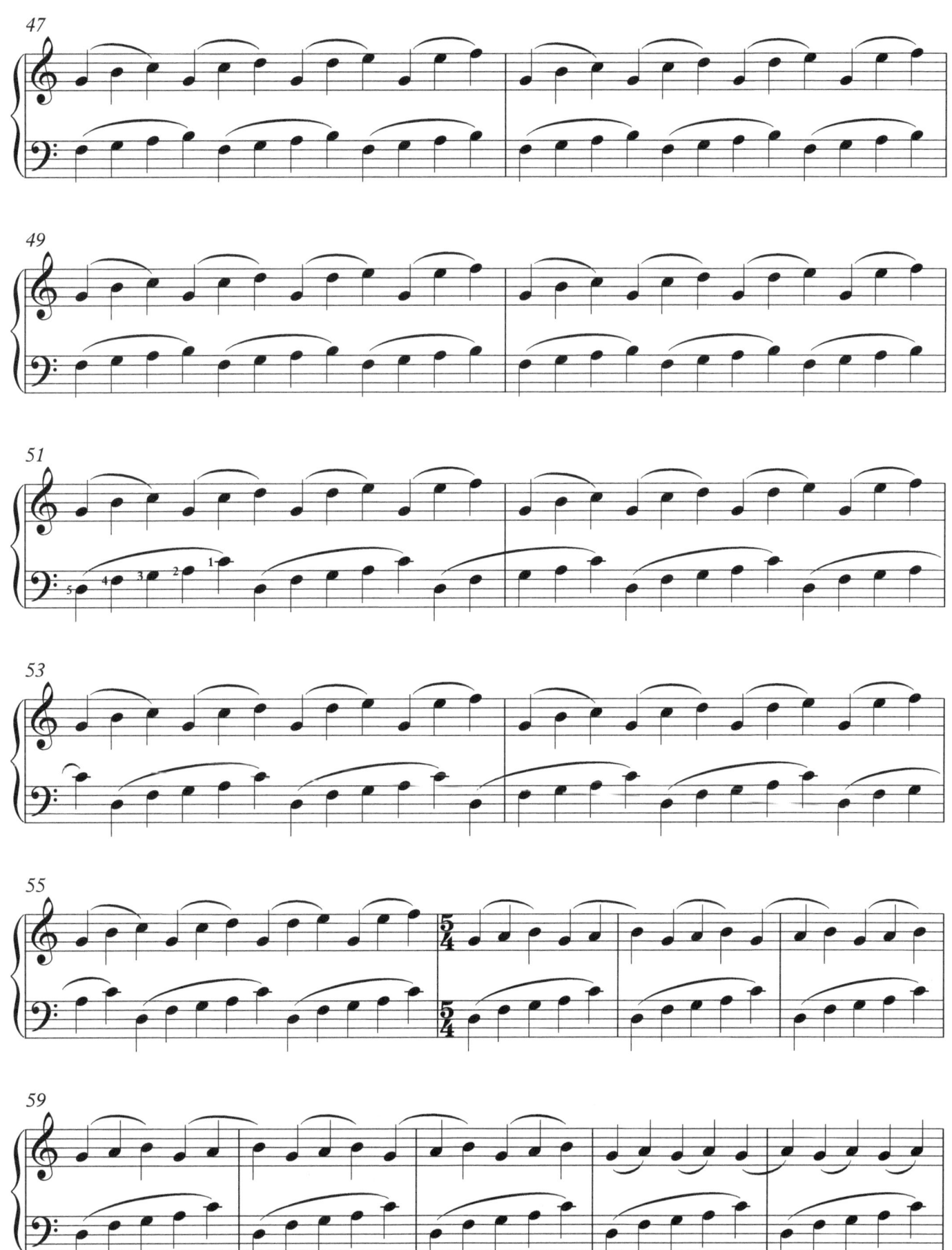

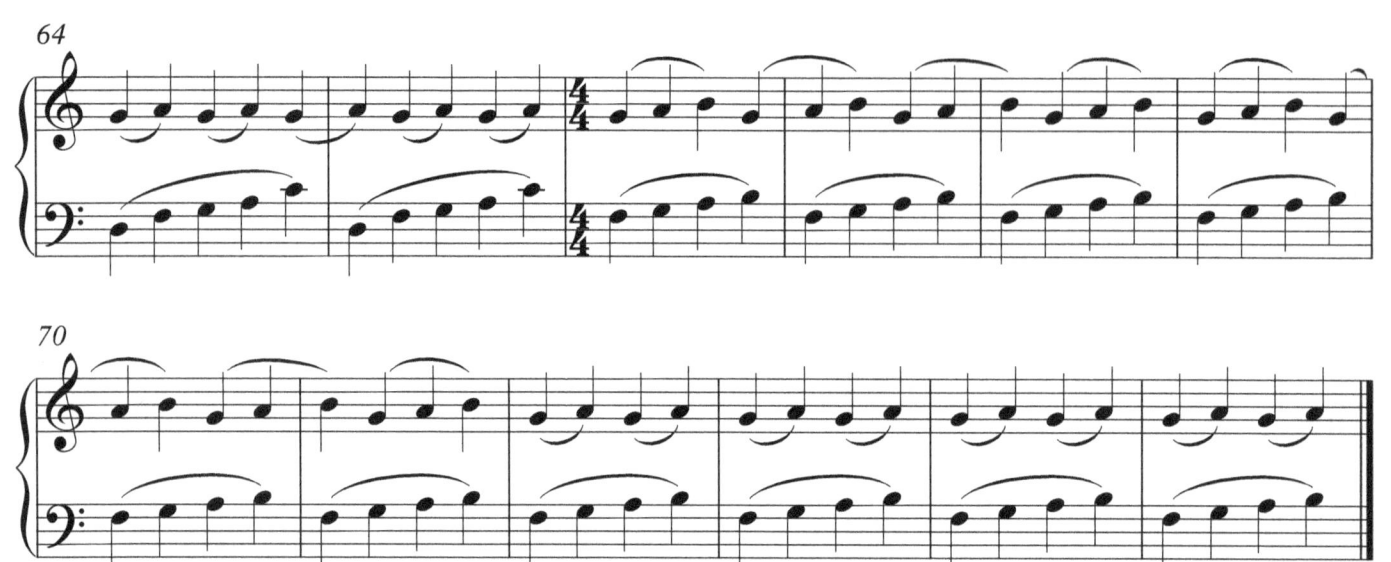
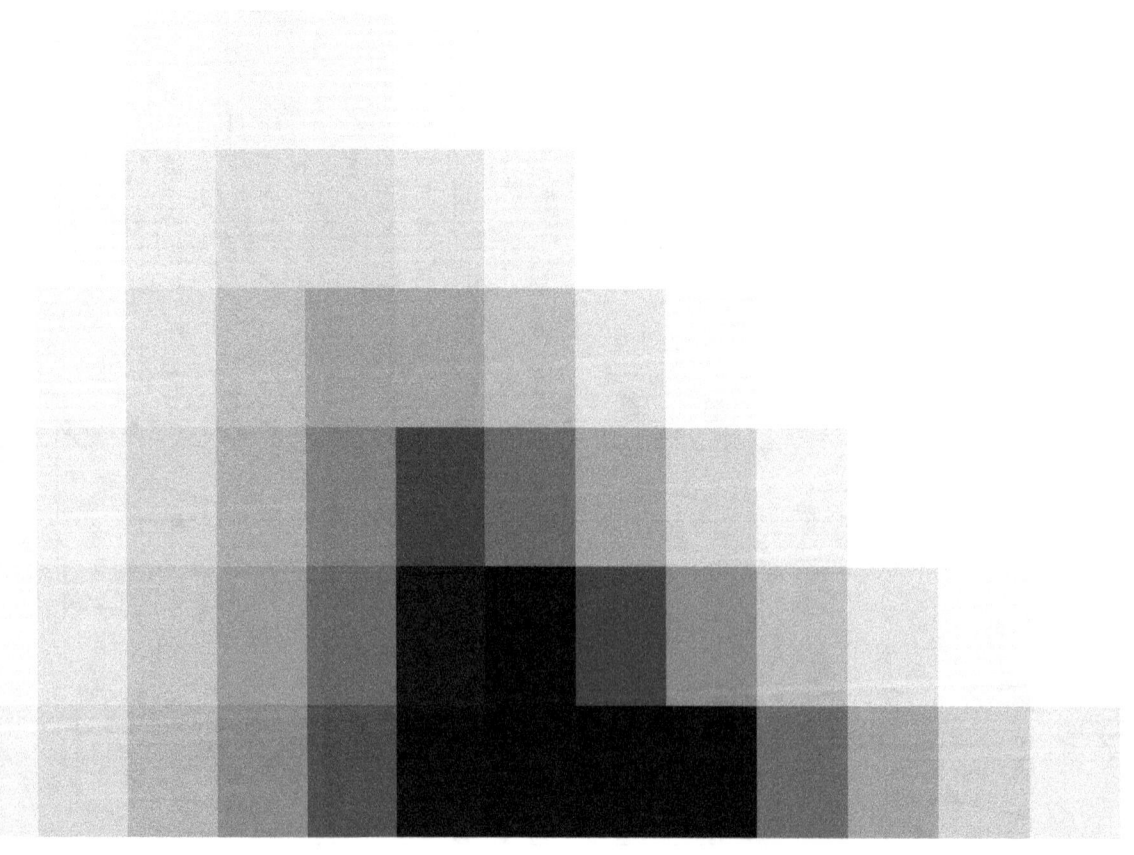

Polymetric Song - Variations in 20,10,5,4,3,2
- solution -

Jeff Fineberg

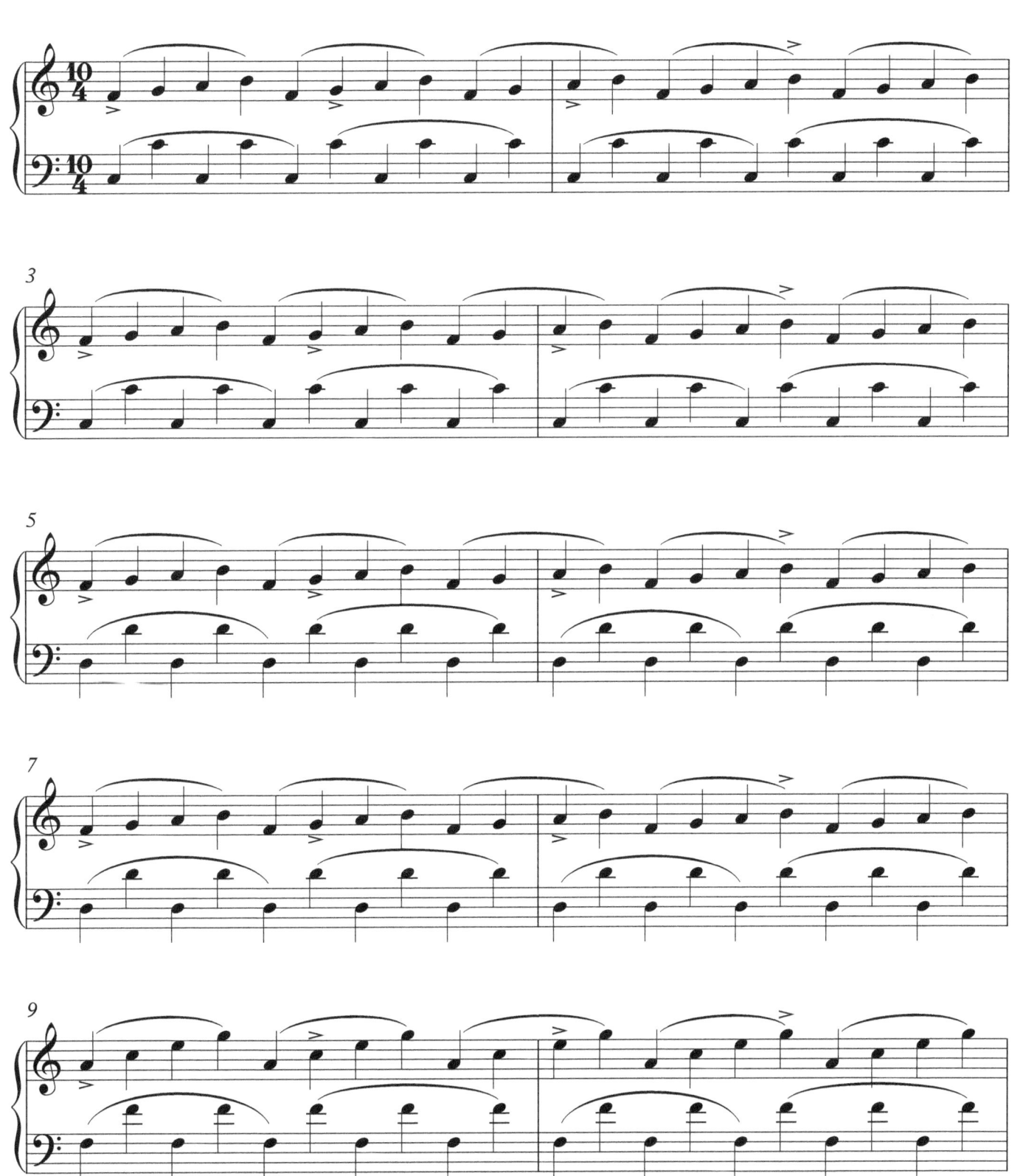

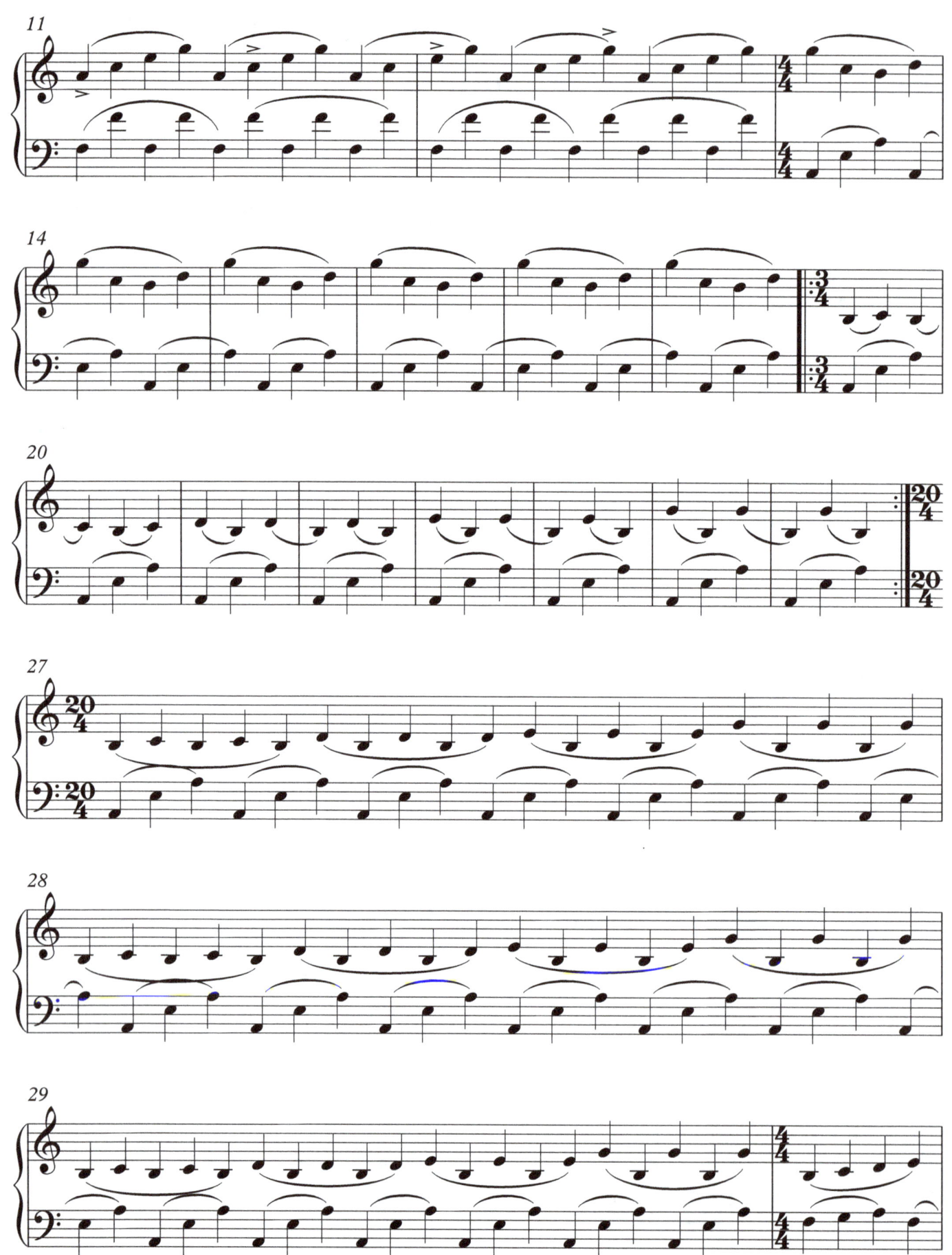

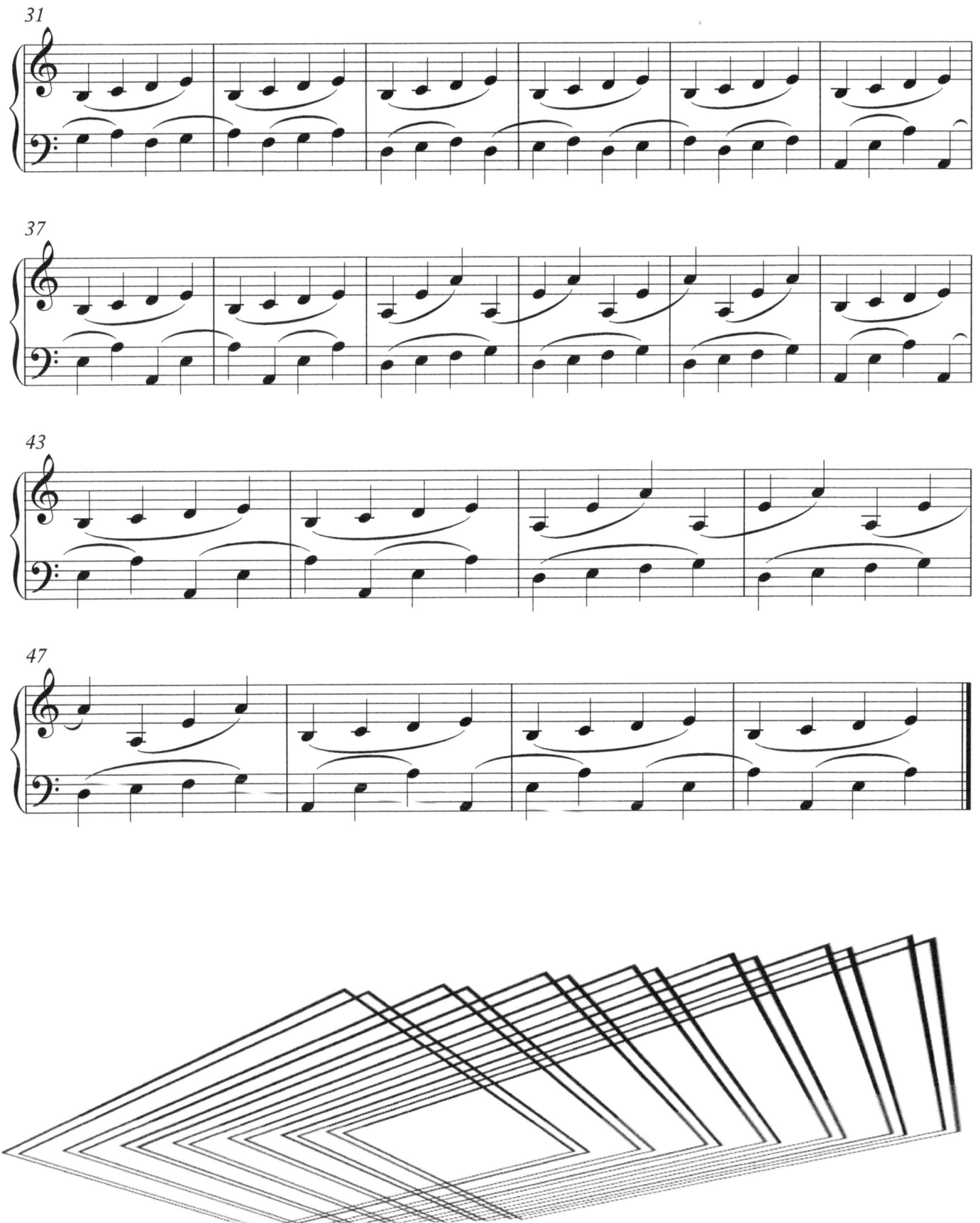

Polymetric Song - Variations in 13,11,7,6,5,4,3,2,1 (comprehensive exam!)
-solution-

Jeff Fineberg

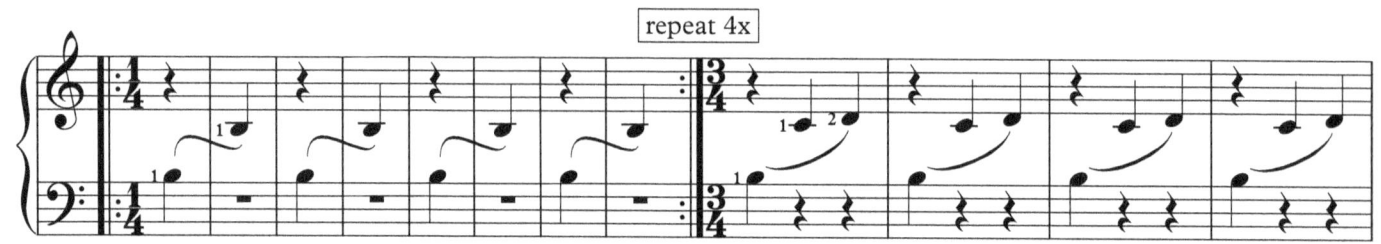

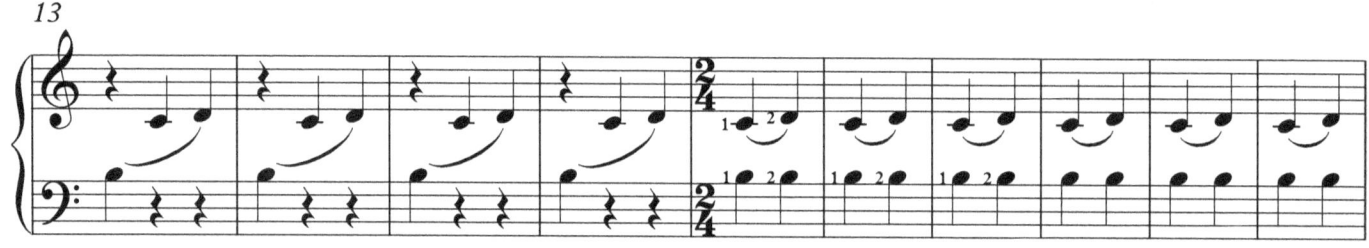

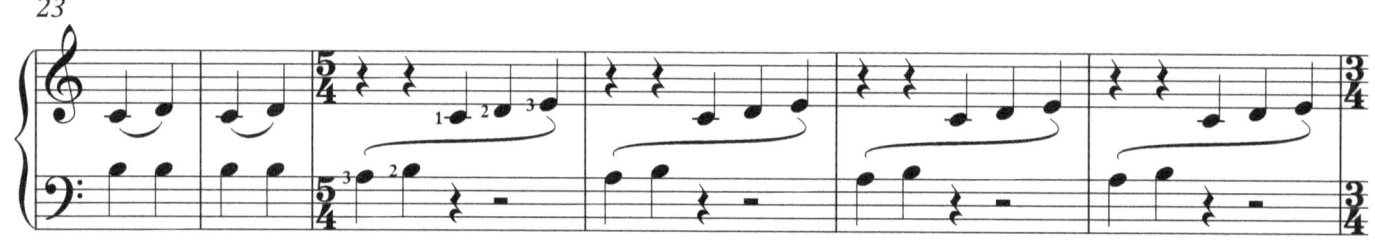

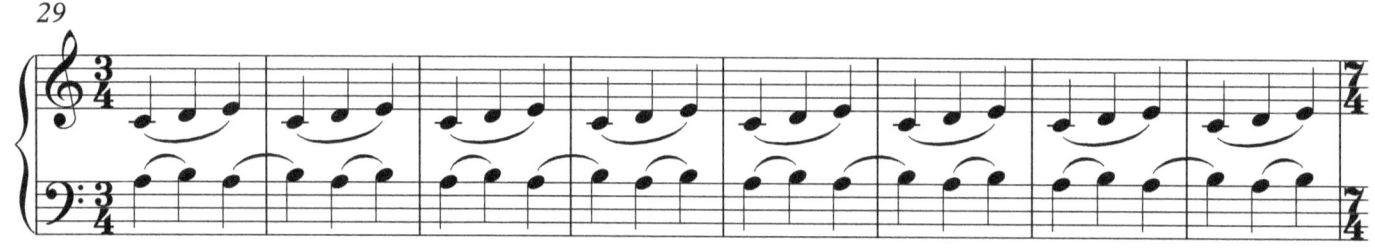

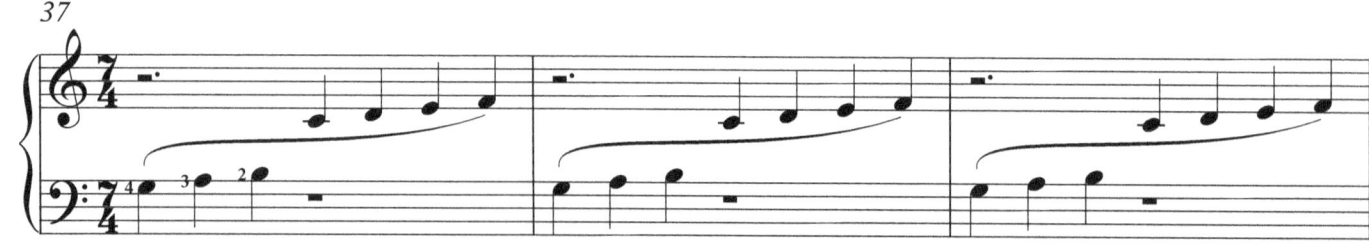

© 2013 - Jeff Fineberg

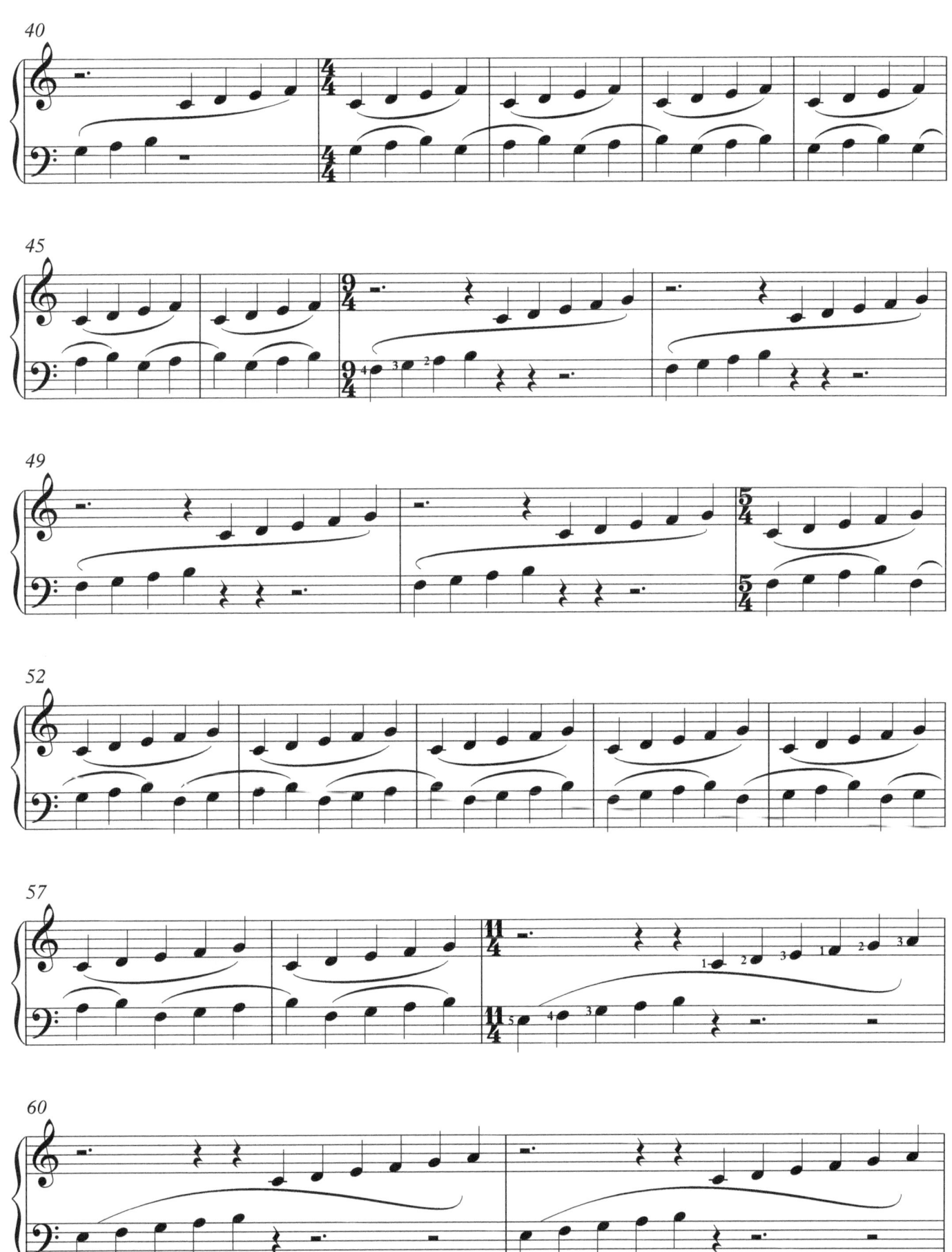

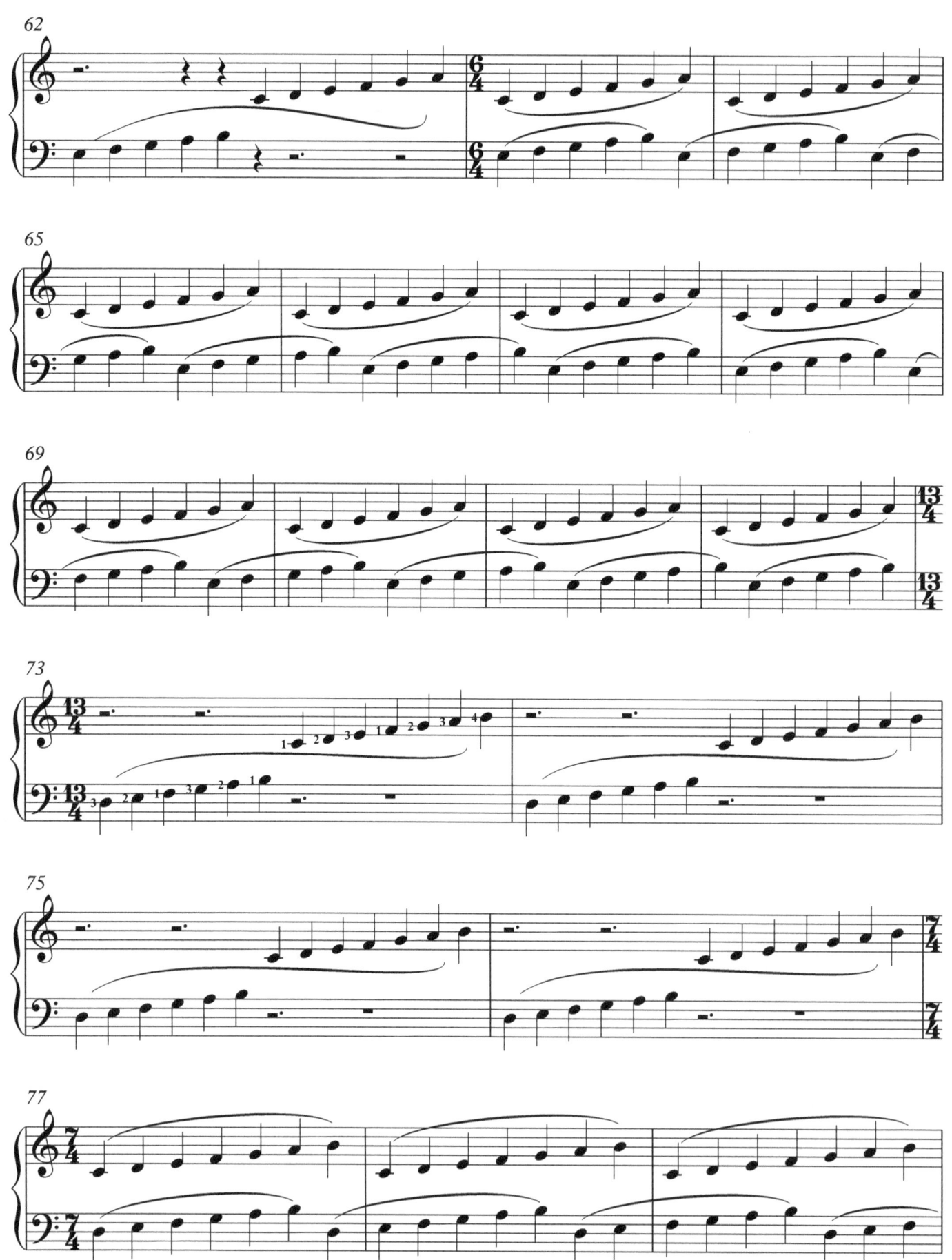

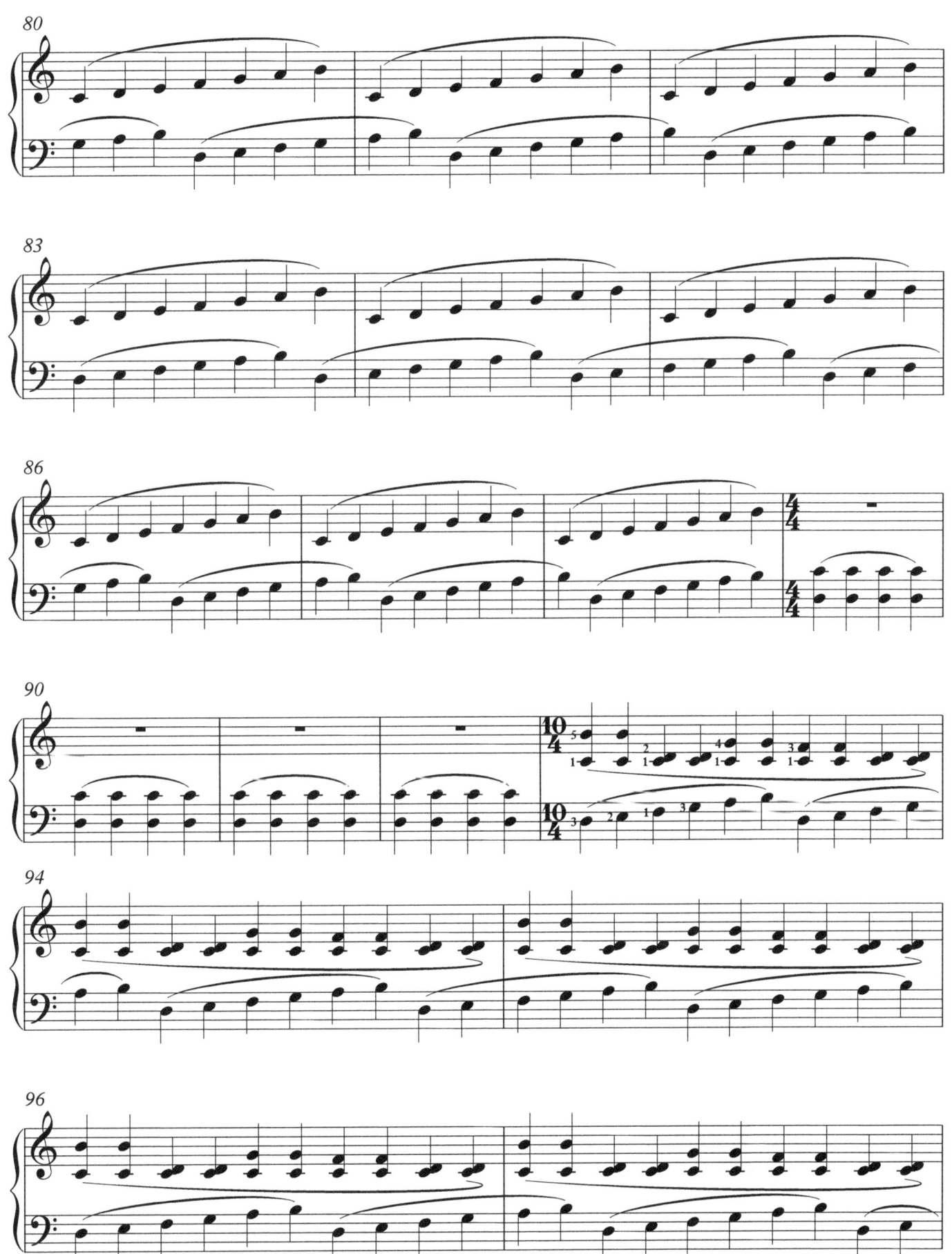

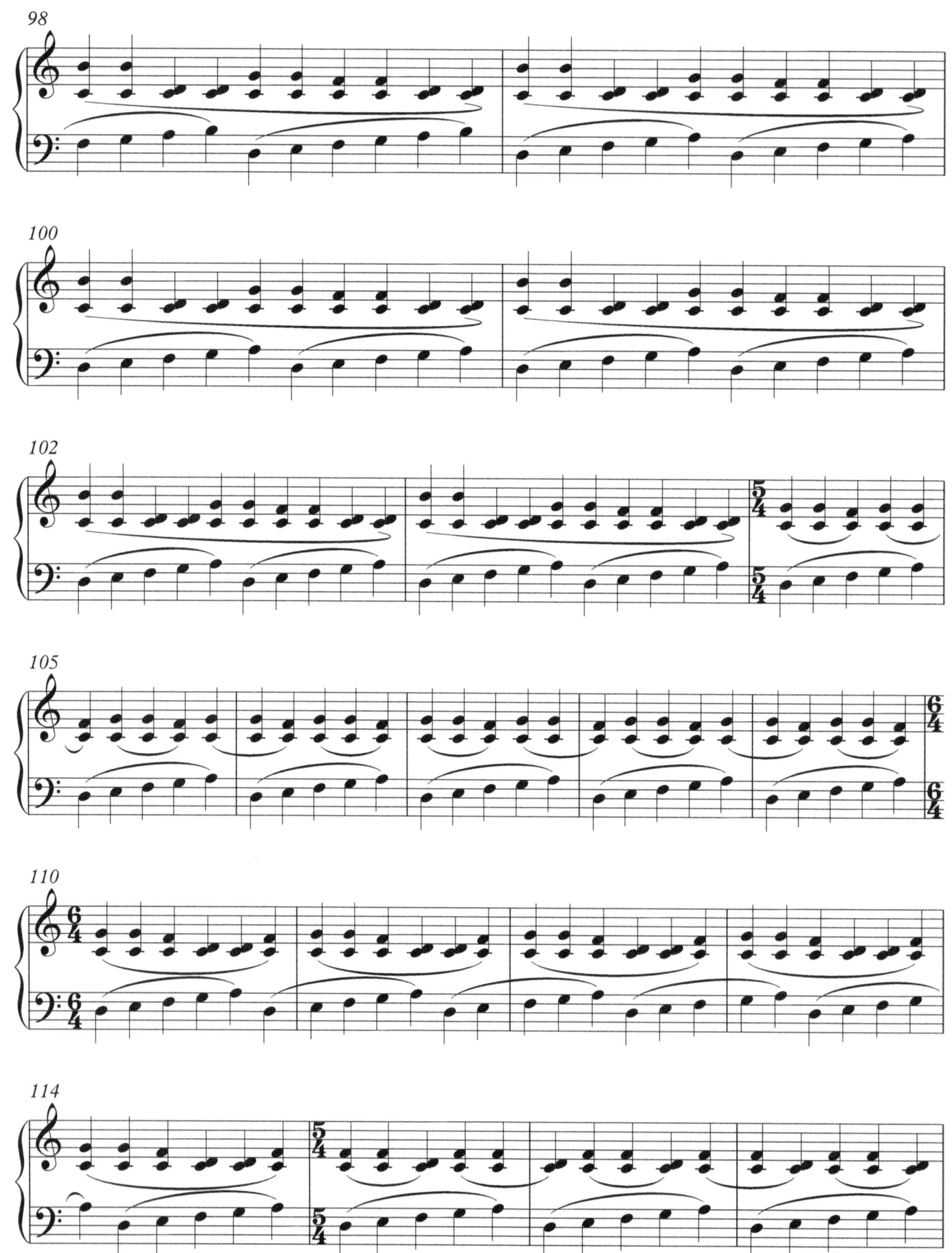

11:12 Polymetric Single Measure Challenge
- solution -

Jeff Fineberg

Deceptively Simple Polymetric Puzzles
- solution -

Jeff Fineberg

© 2014 - Jeff Fineberg

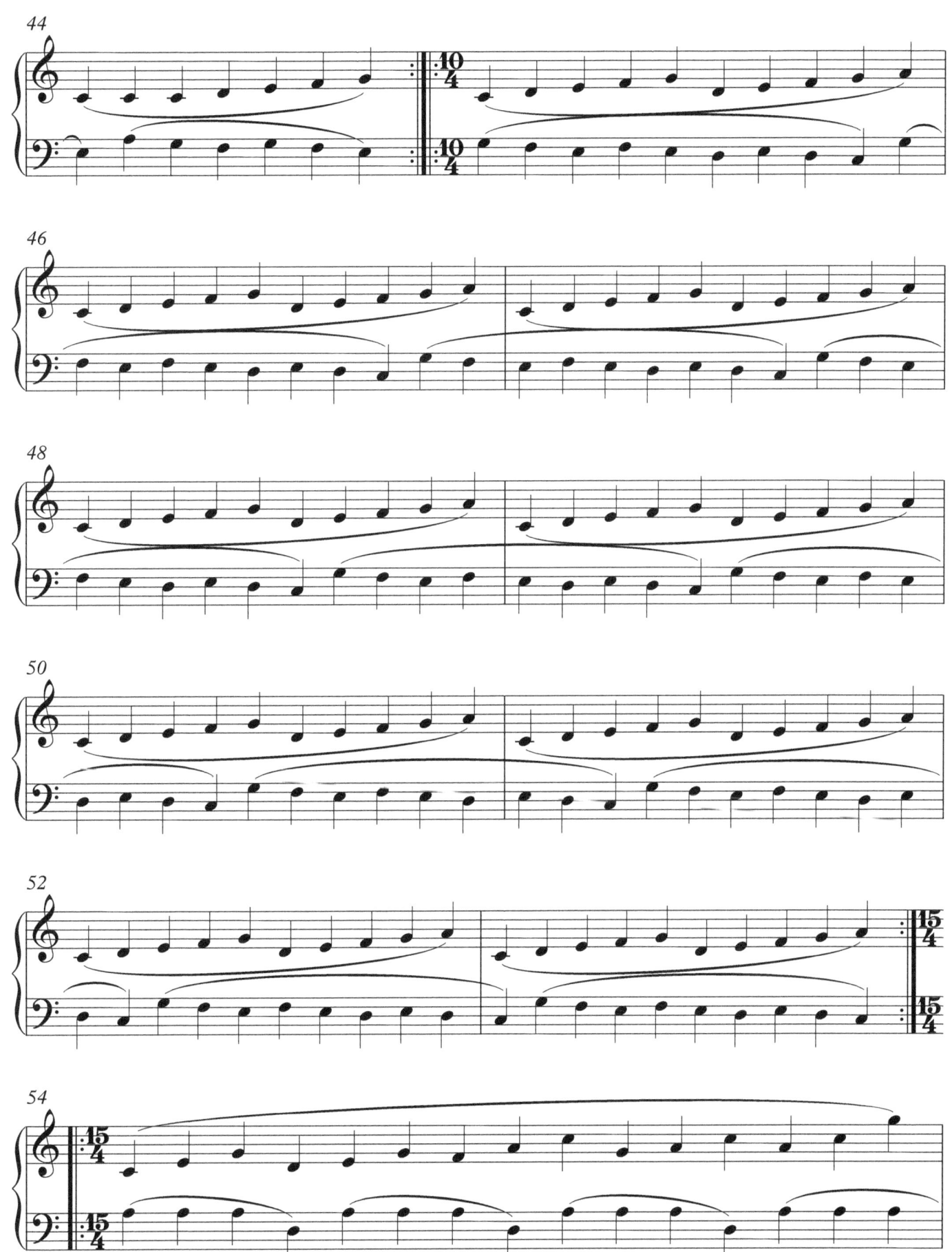

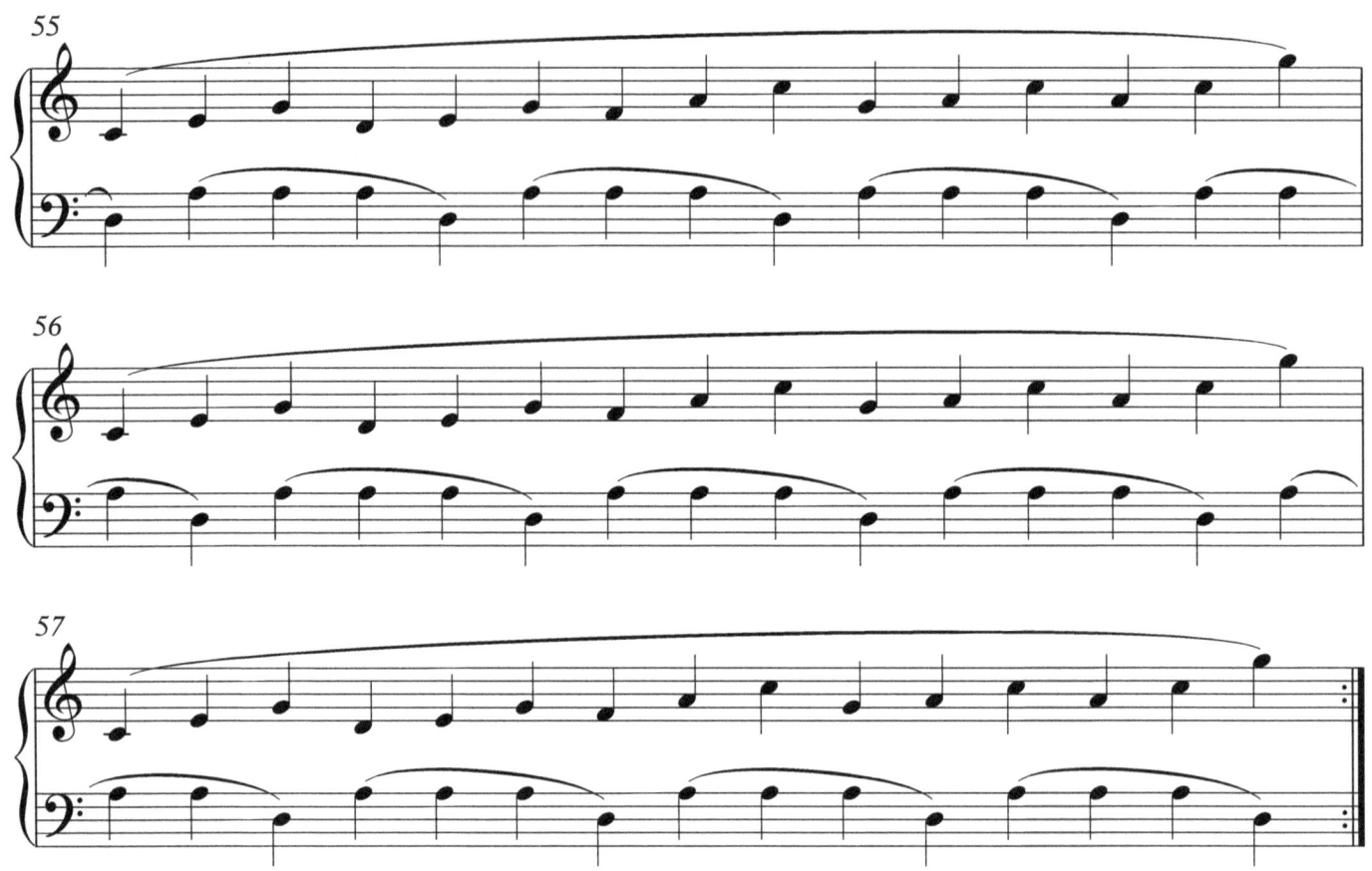

Polymetric Dissonance Variations
- solution -

Jeff Fineberg

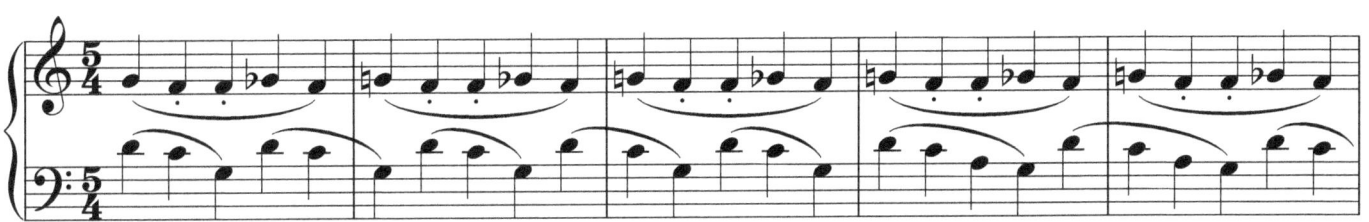

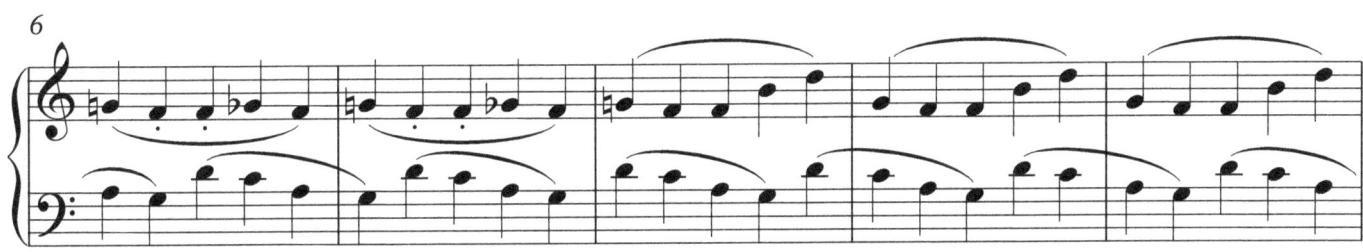

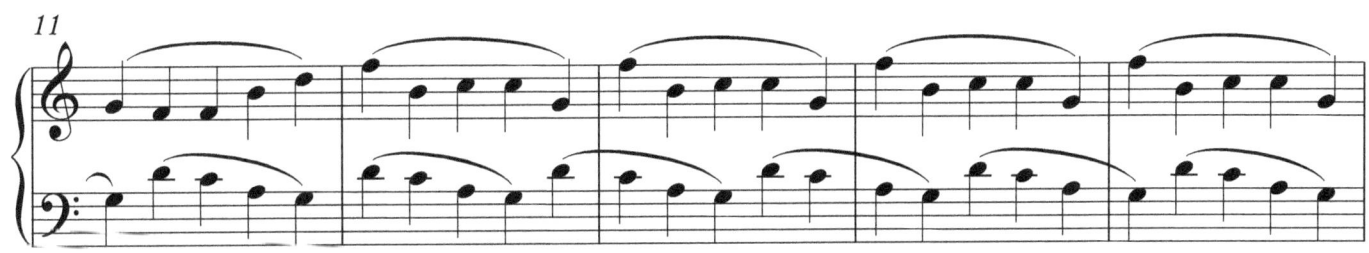

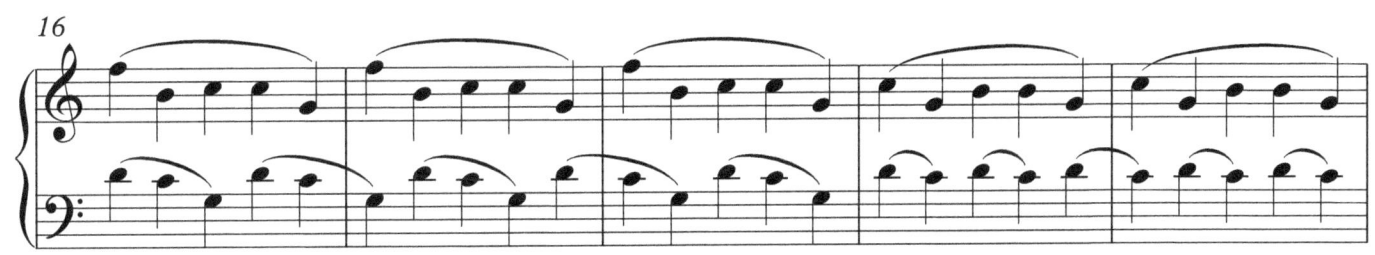

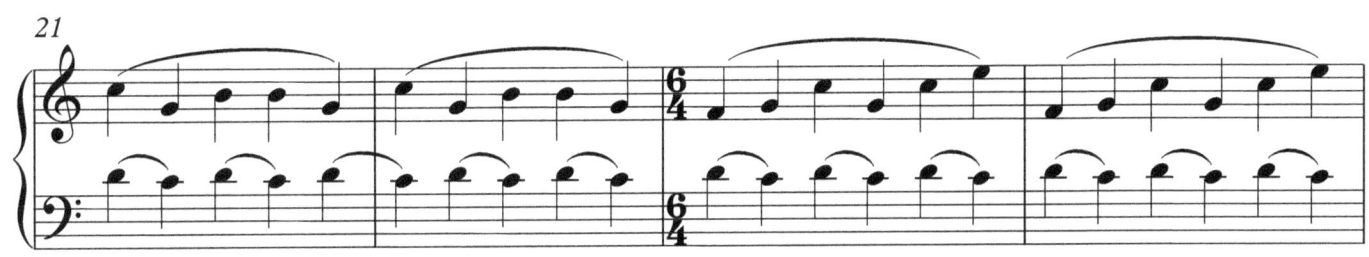

© 2013 - Jeff Fineberg

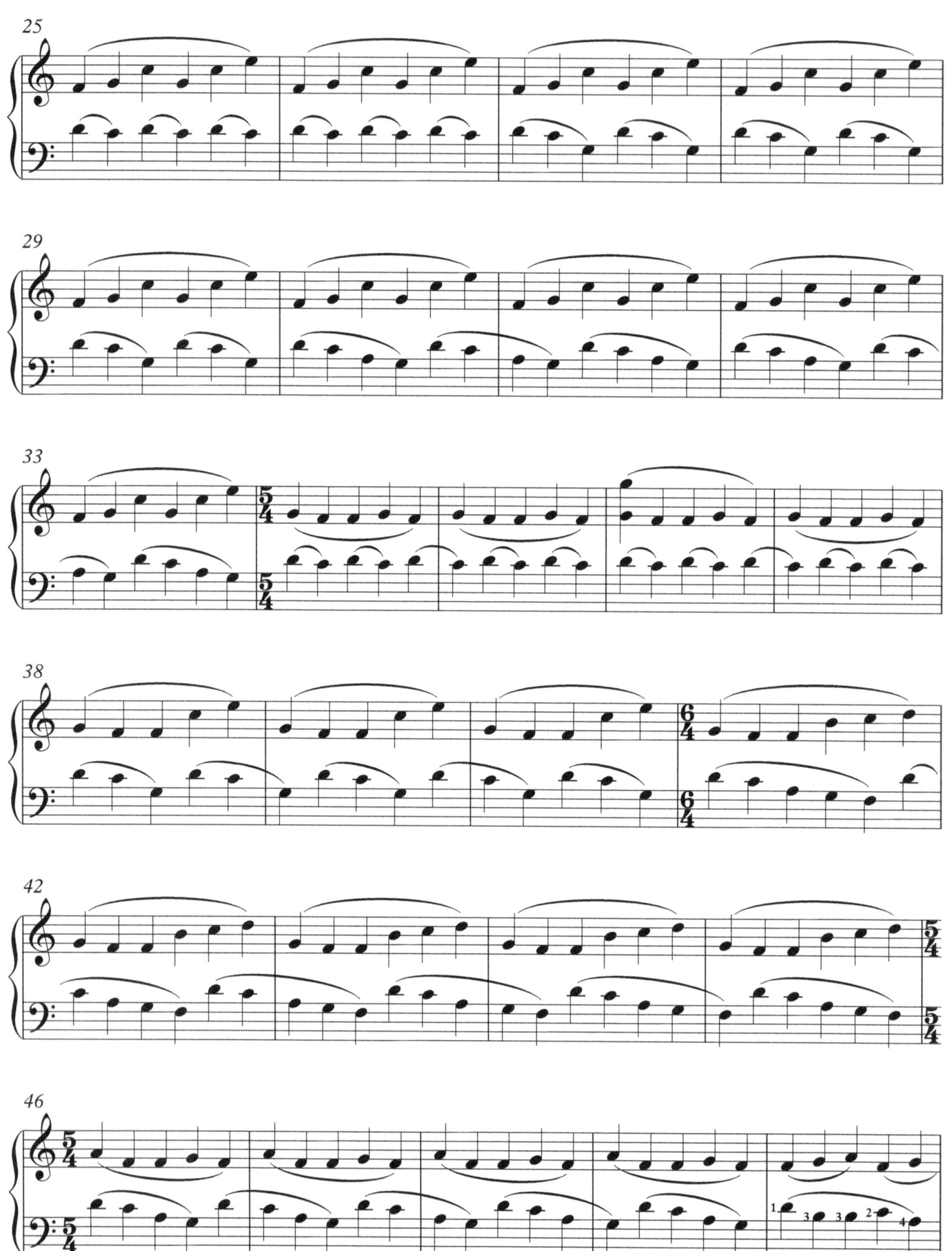

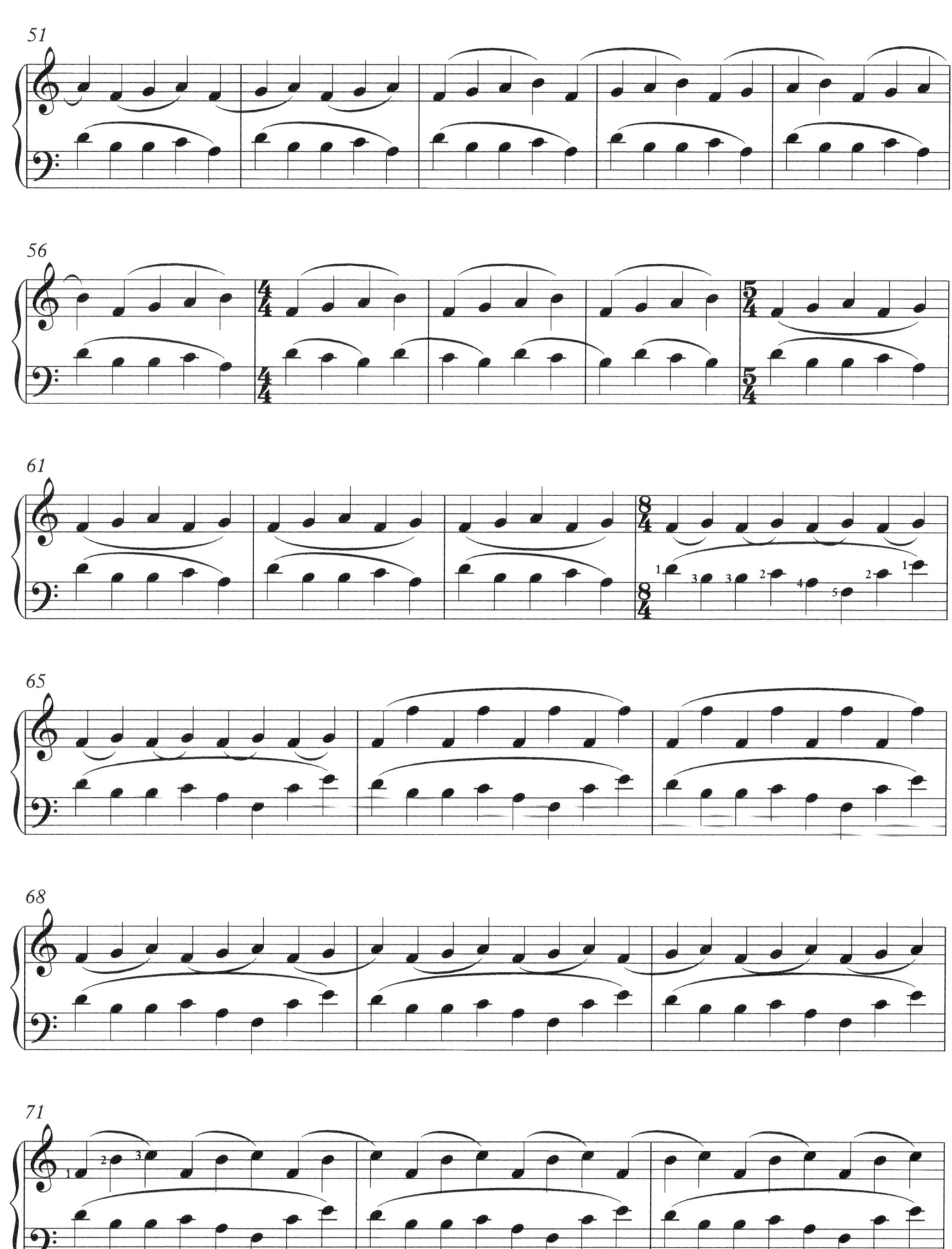

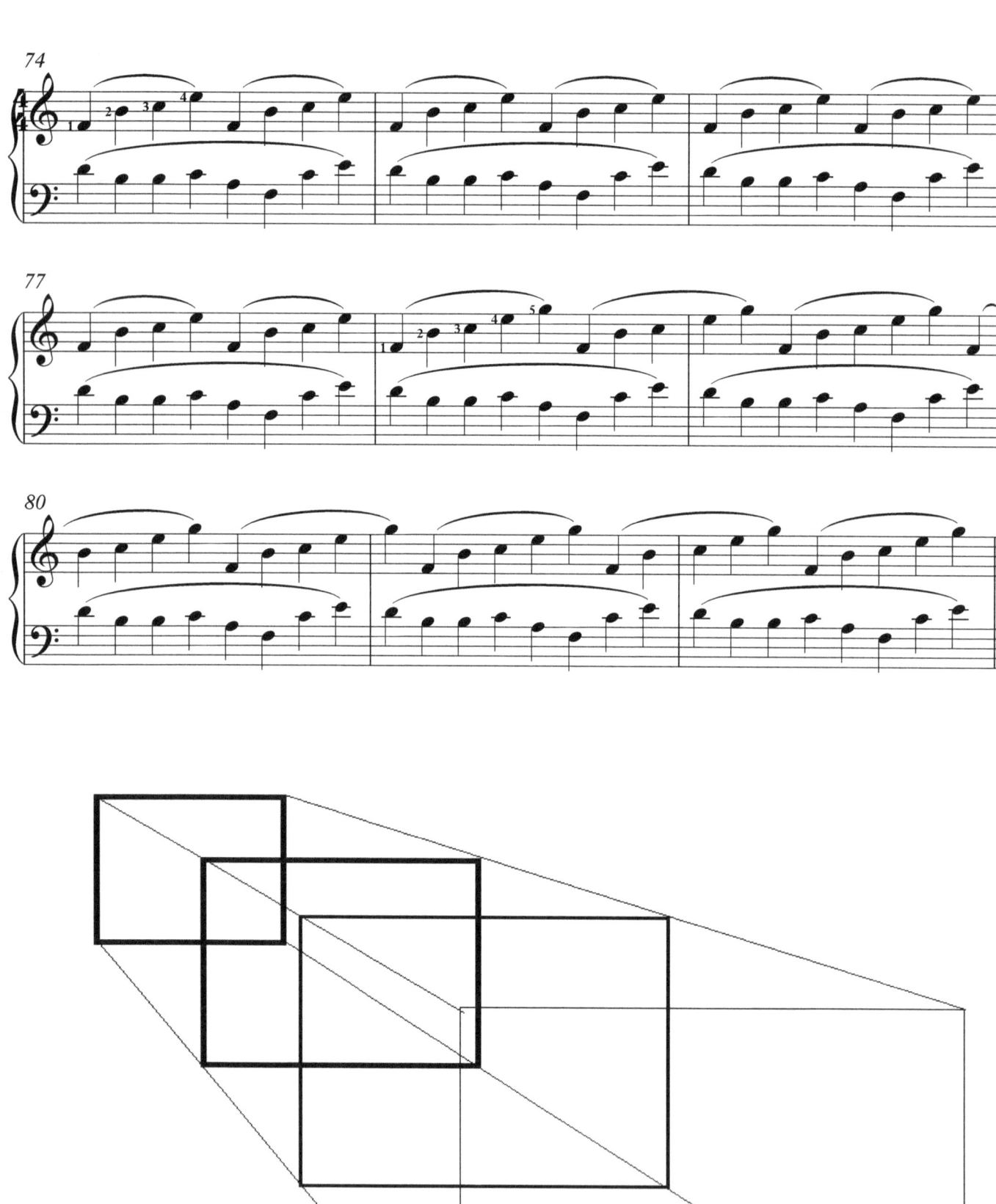

Polymetric Polytonally Dissonant Variations
- solution -

Jeff Fineberg

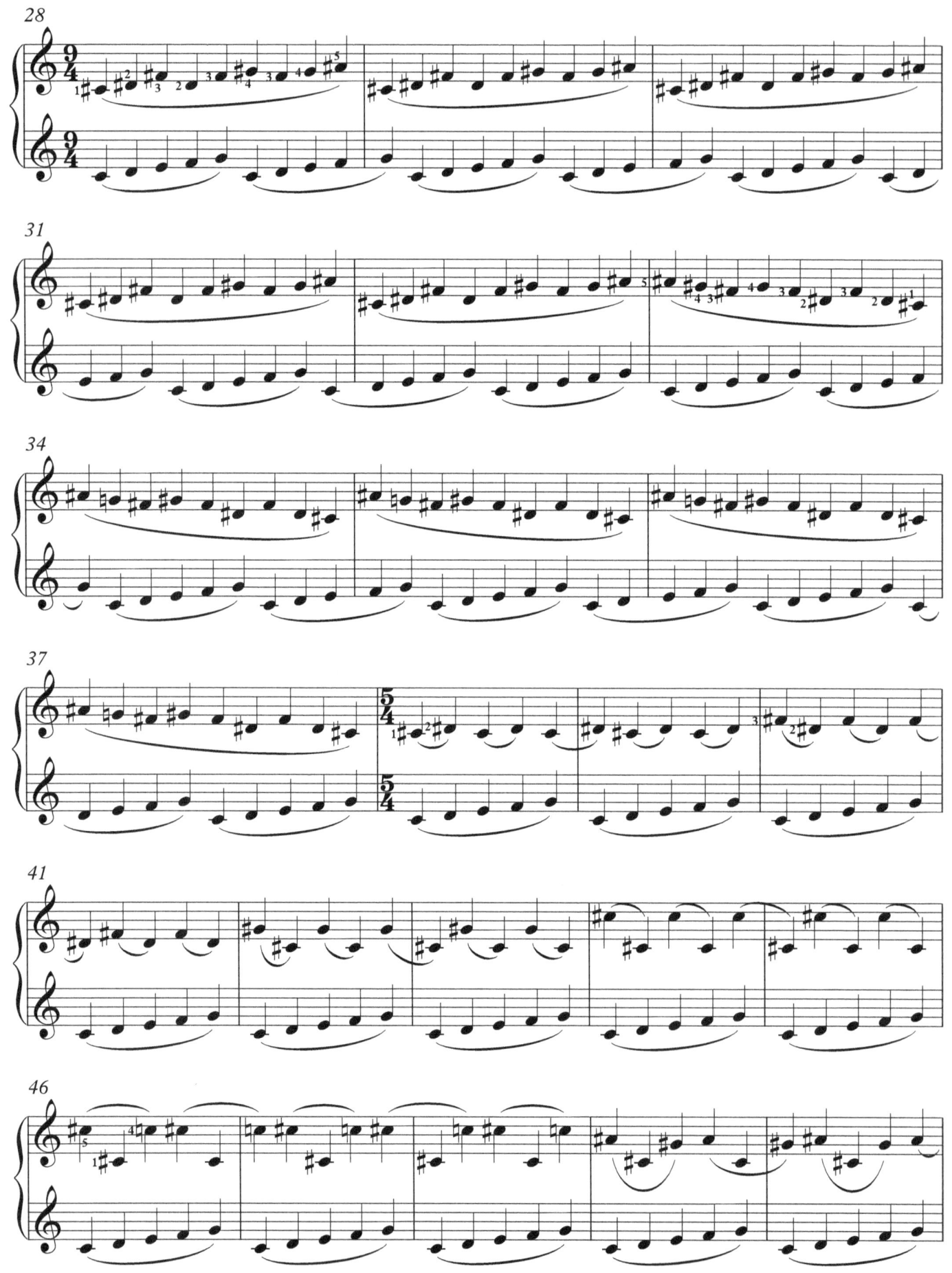

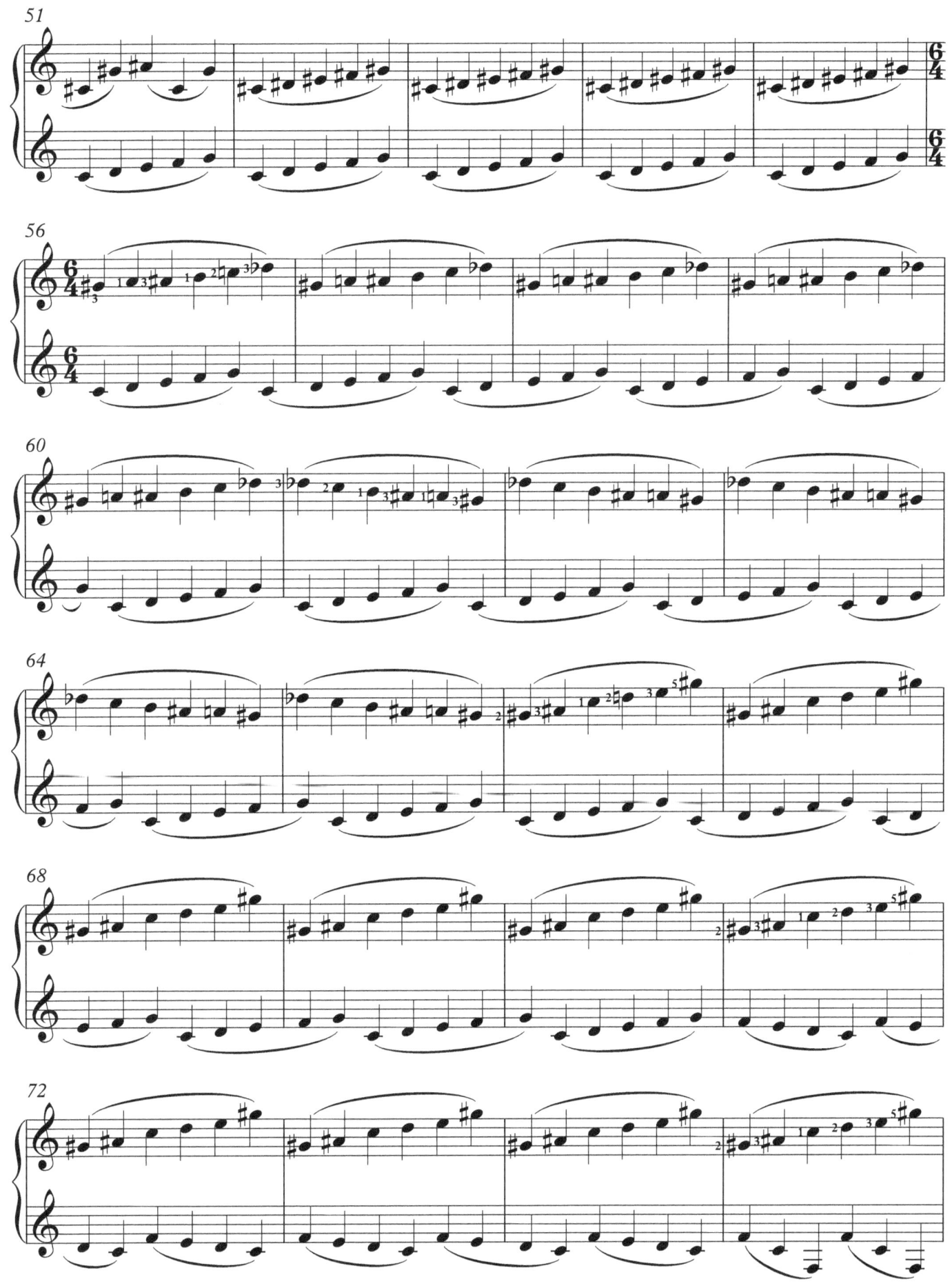

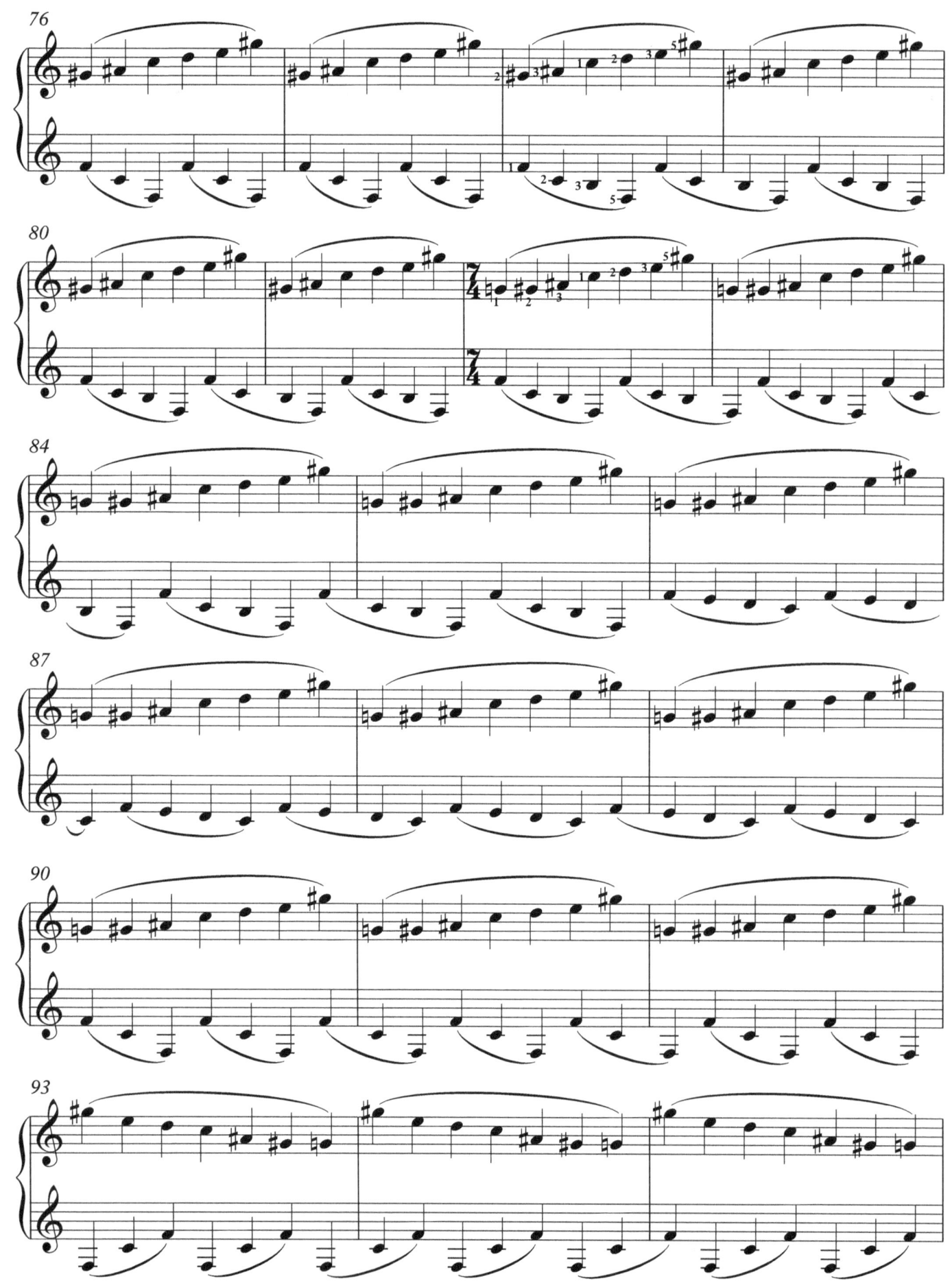

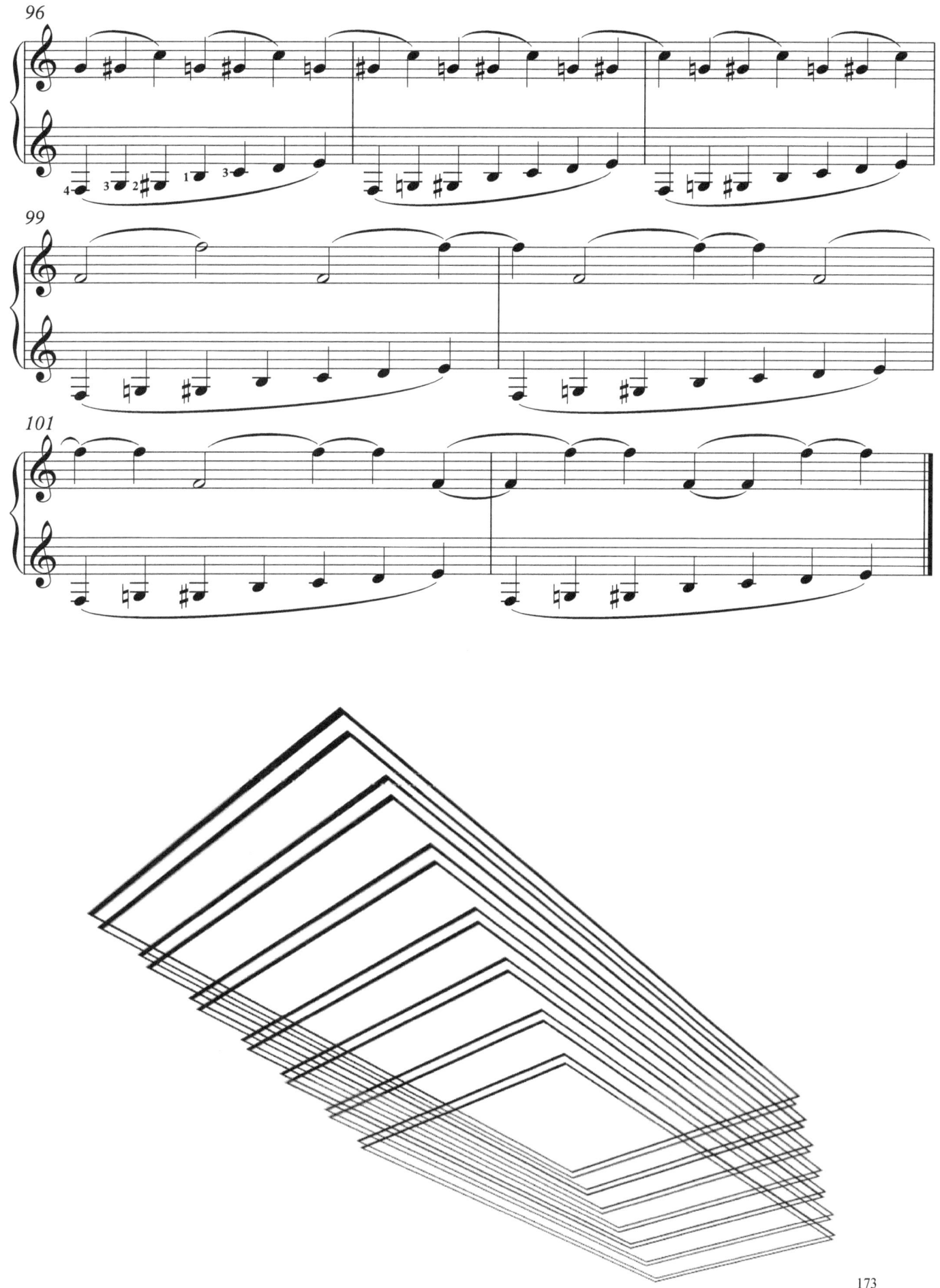

Polymetric Chordal Distraction
- solution -

Jeff Fineberg

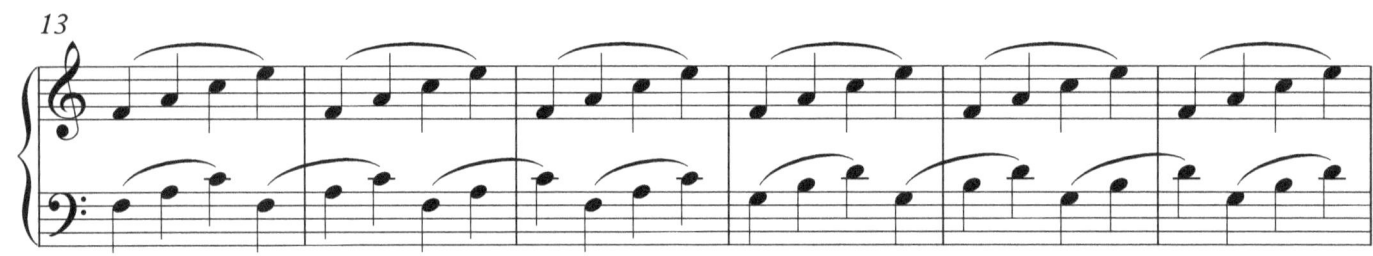

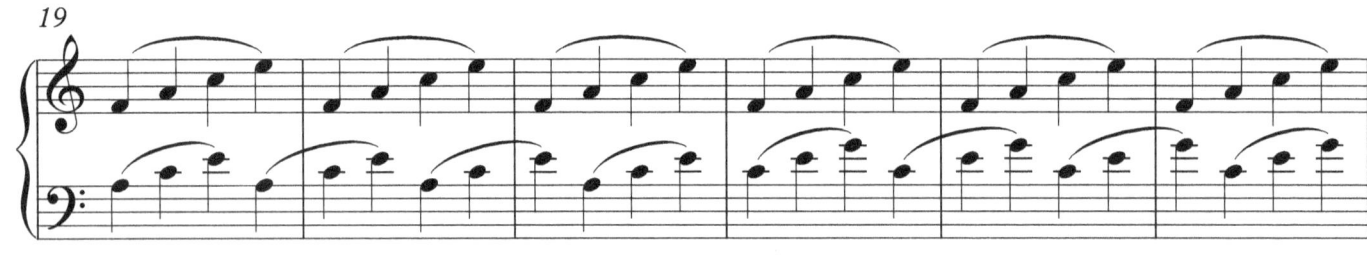

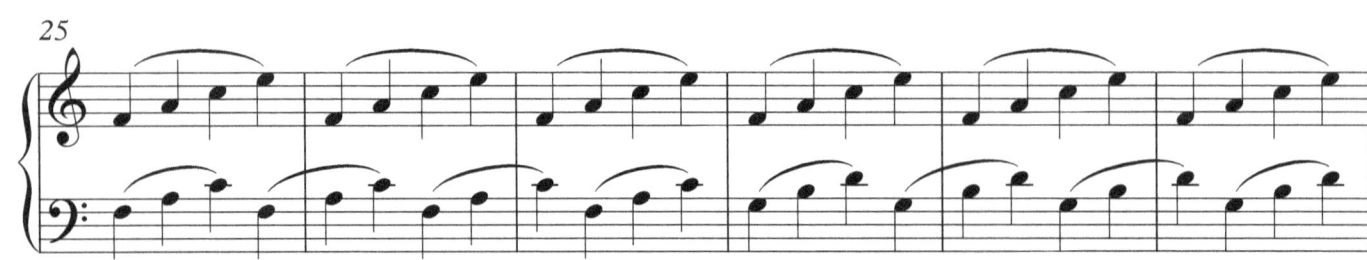

© 2013 - Jeff Fineberg

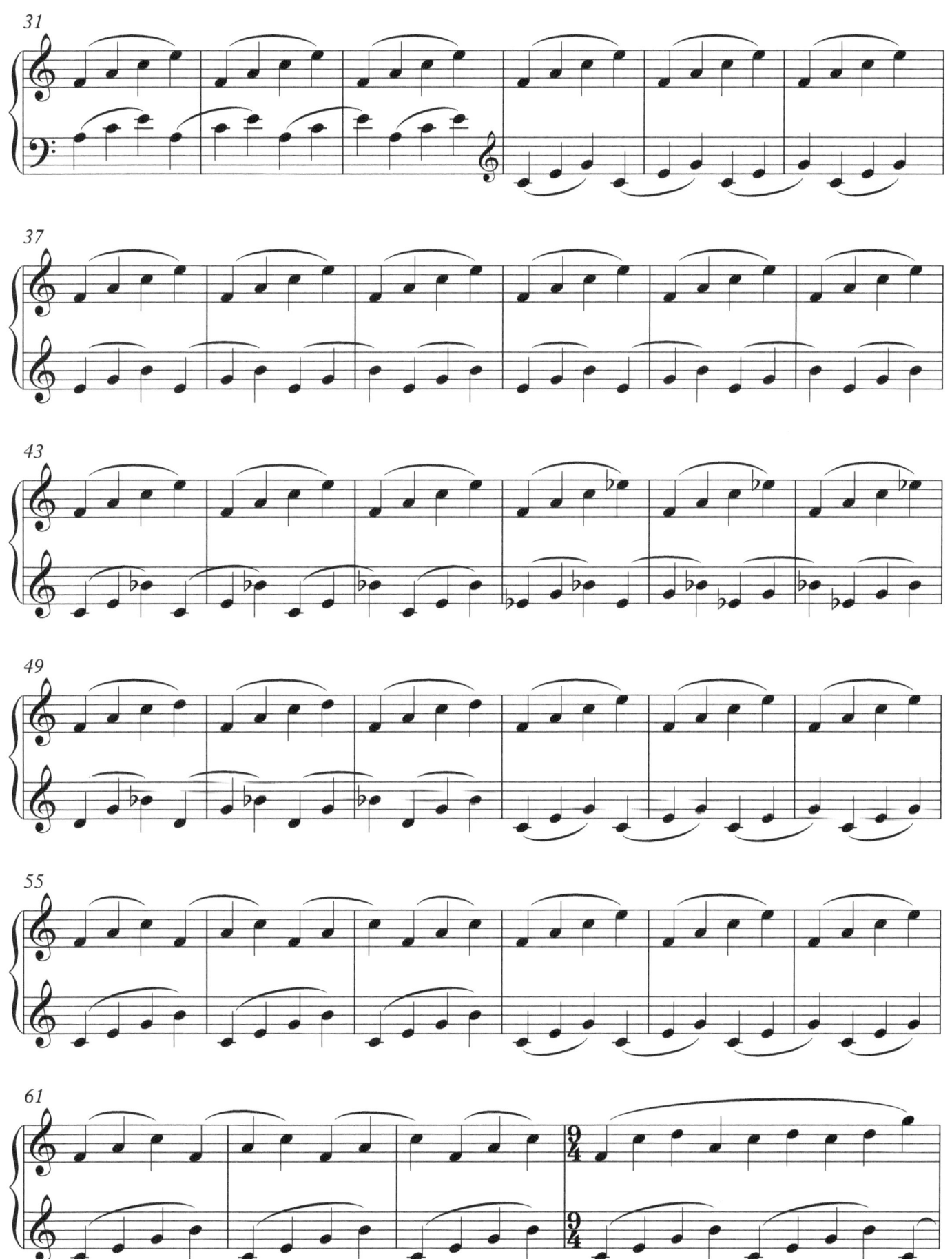

175

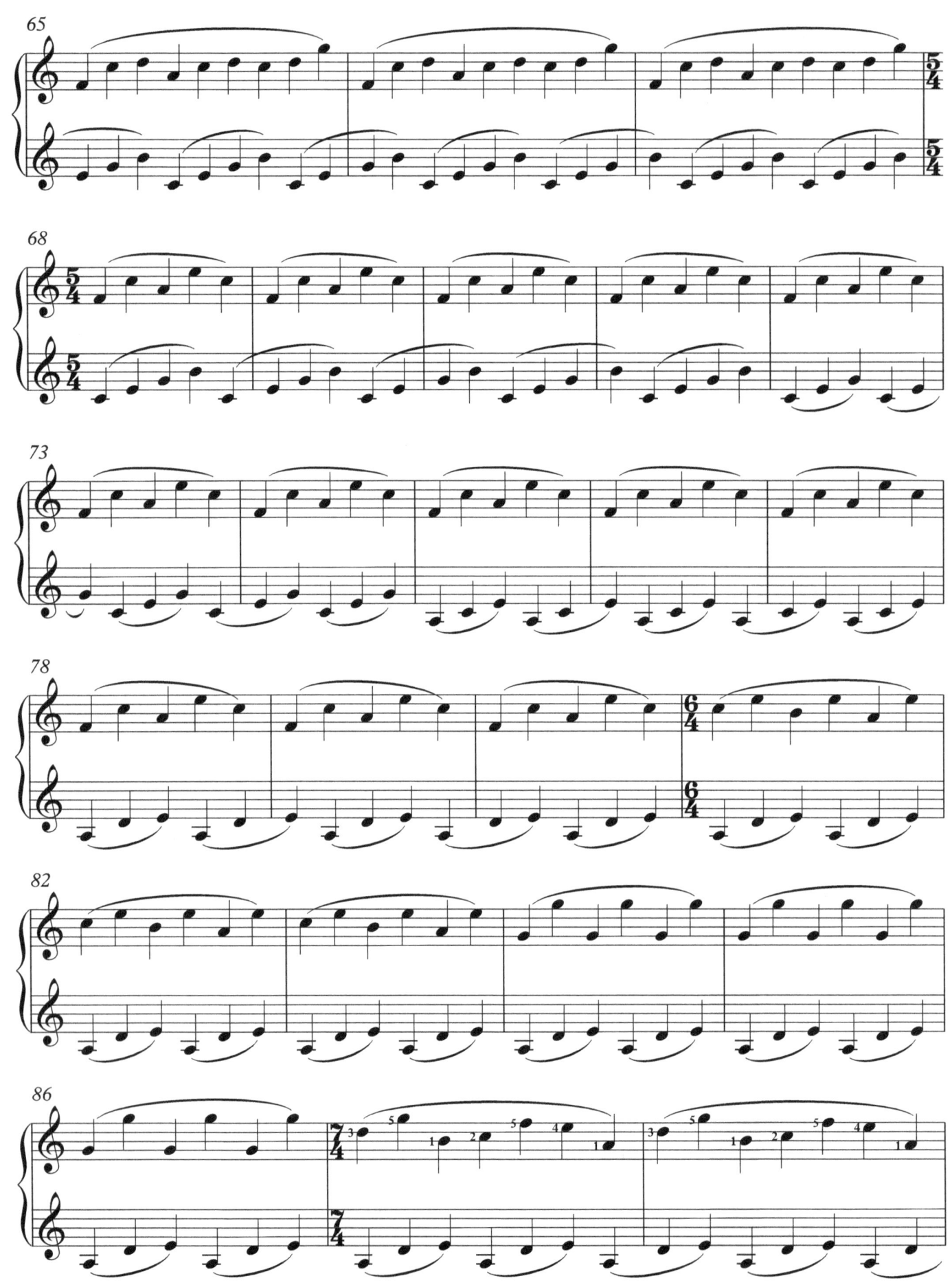

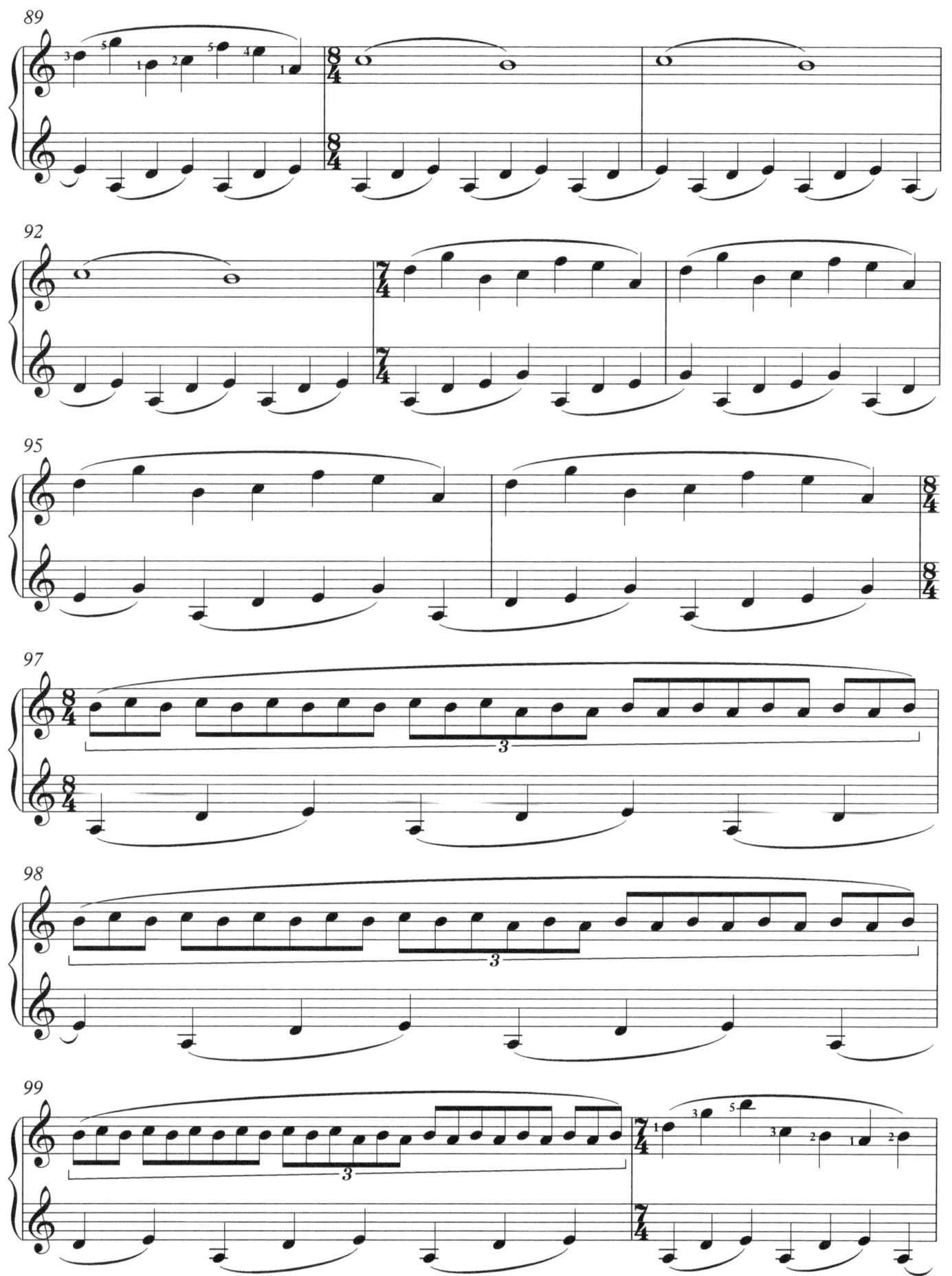

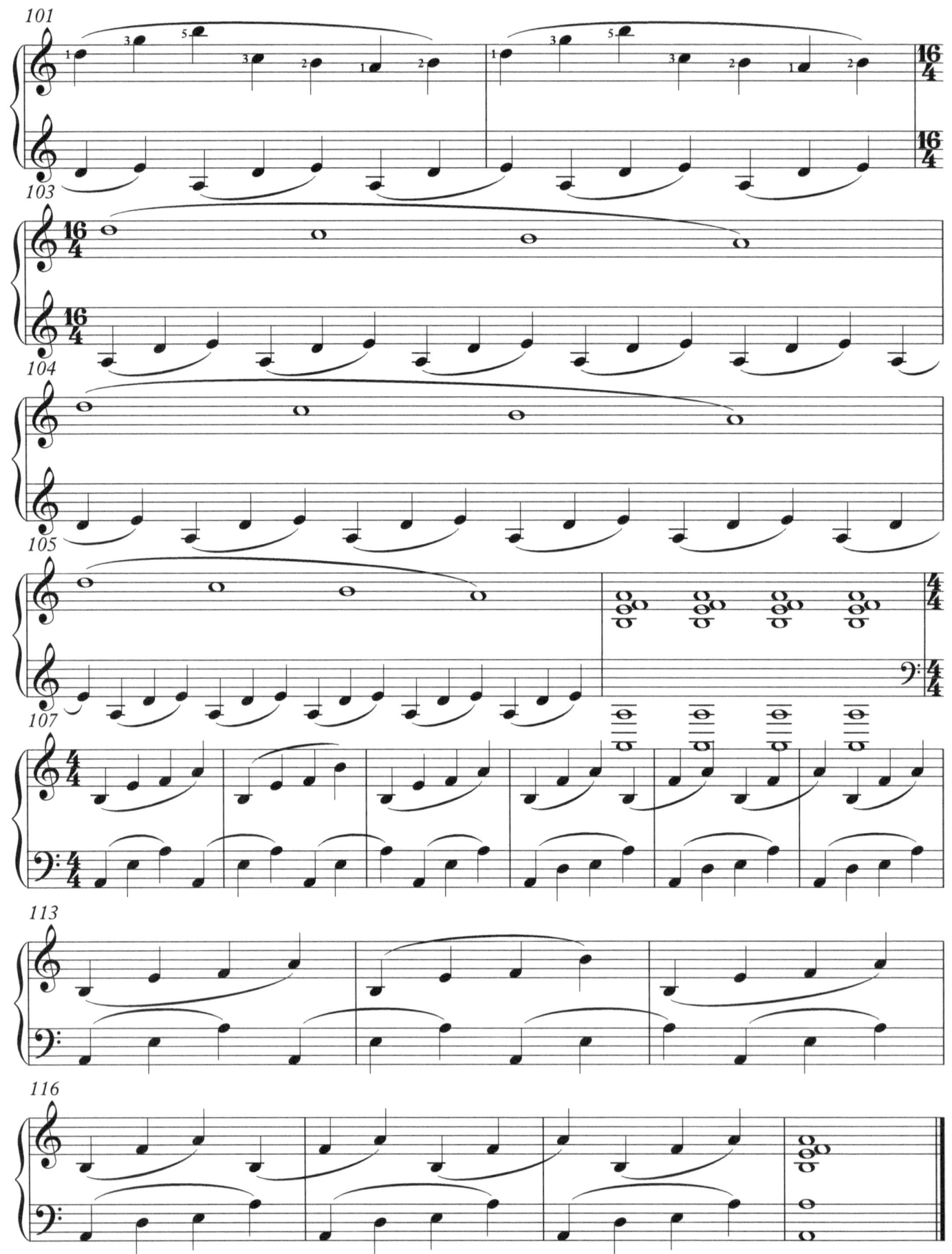

Sunrise Comet
- solution -
As played on the Crystal Radio "Decategorized Sound" CD 2008

Jeff Fineberg

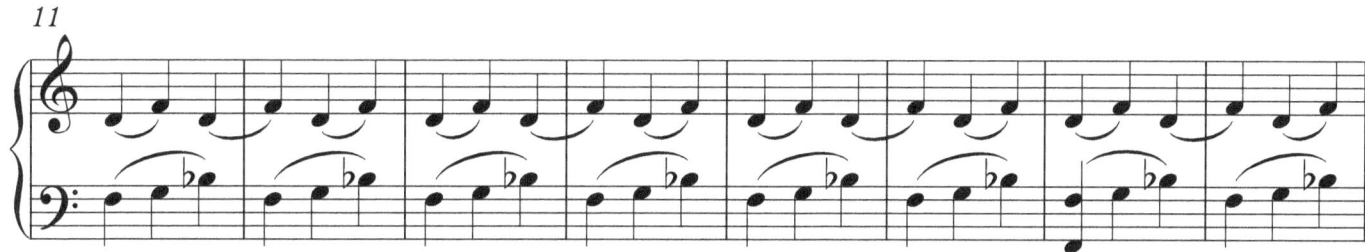

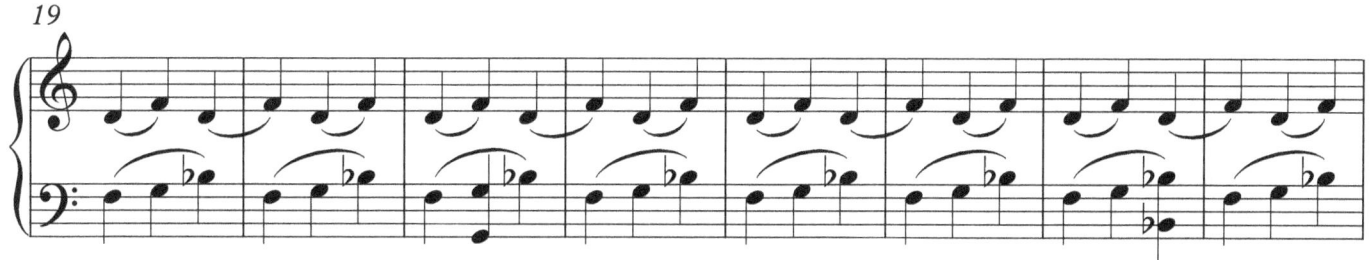

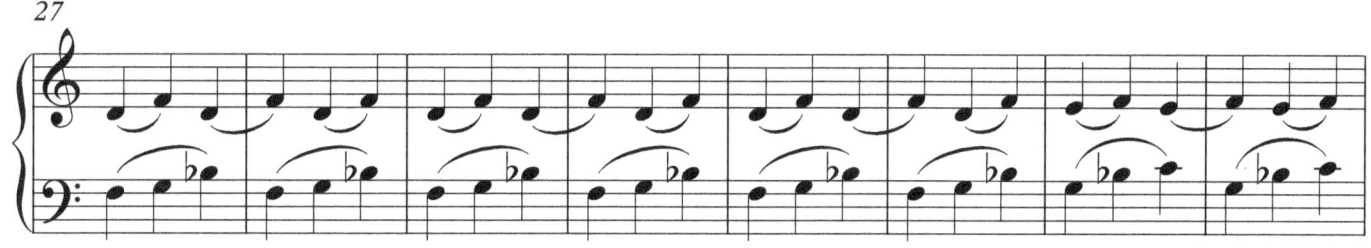

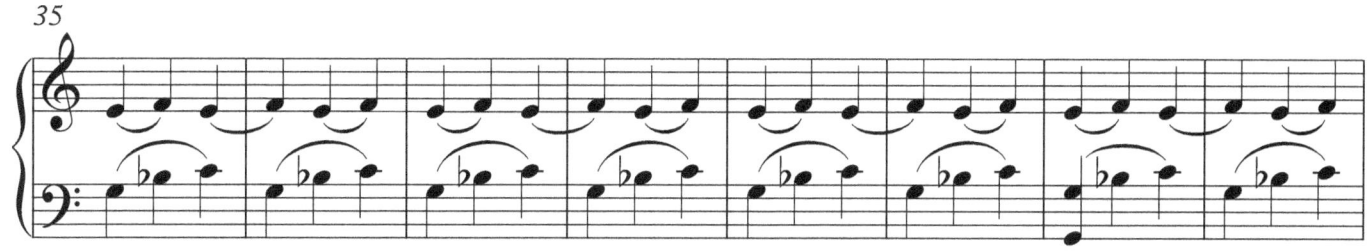

© 2008 / 2013 - Jeff Fineberg

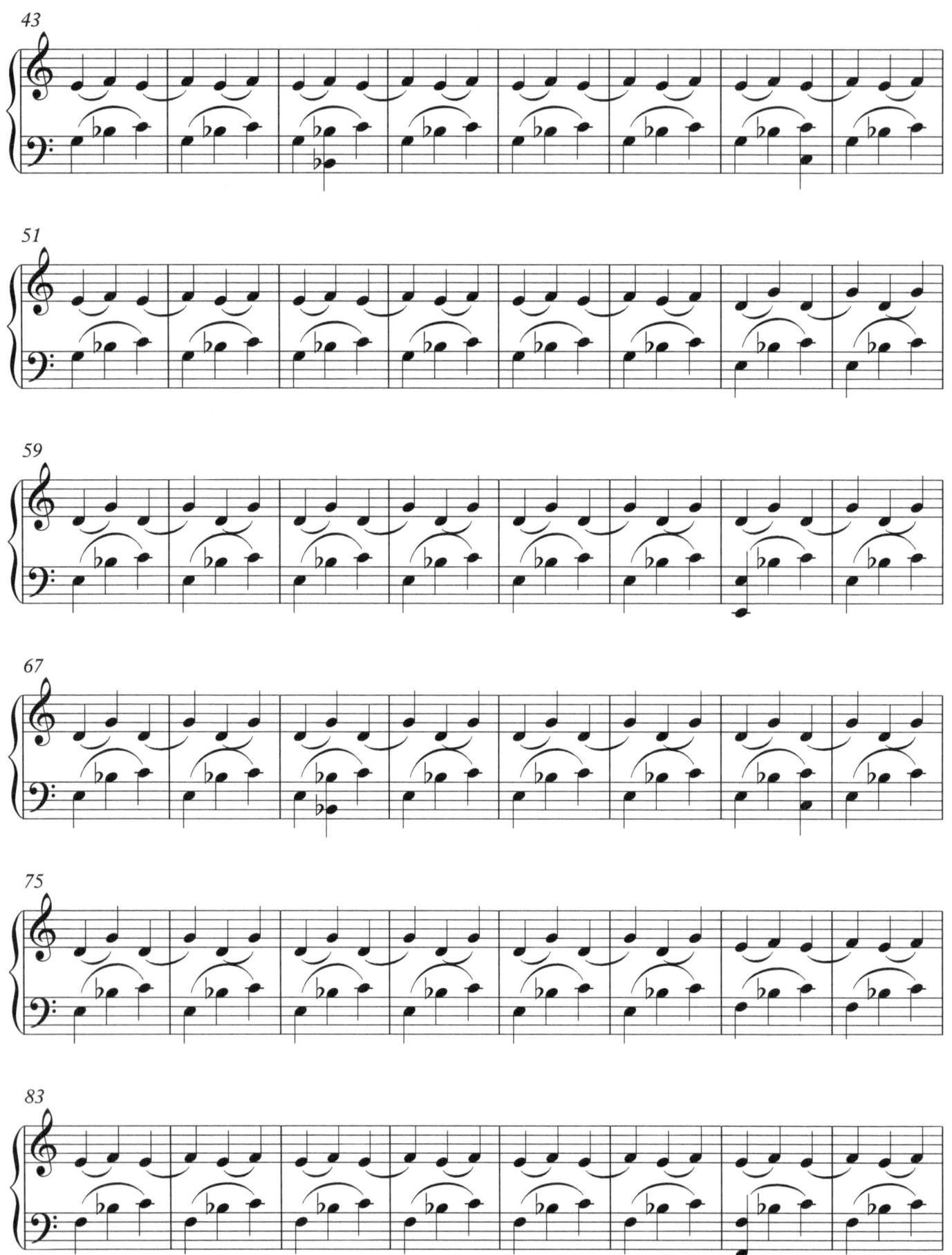

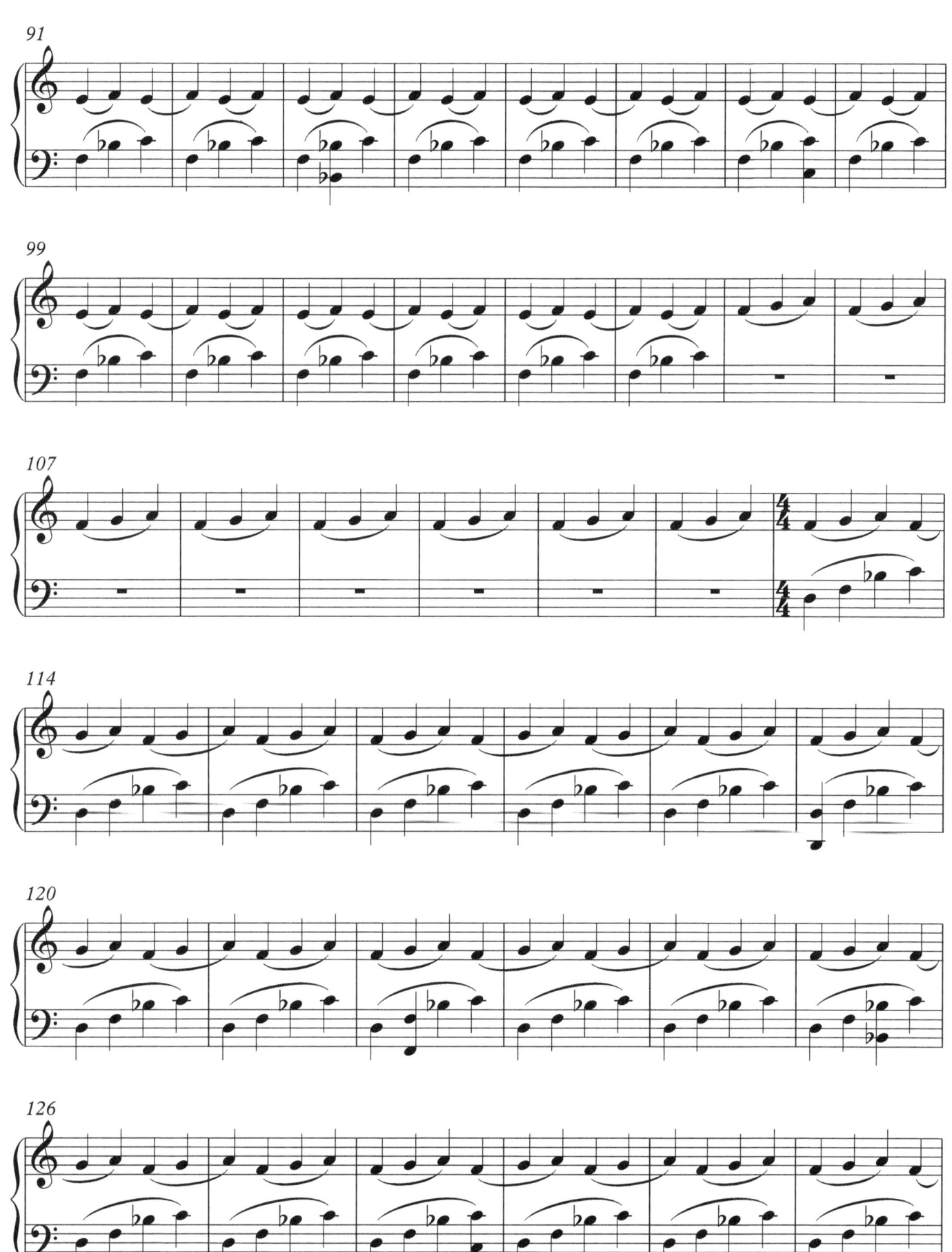

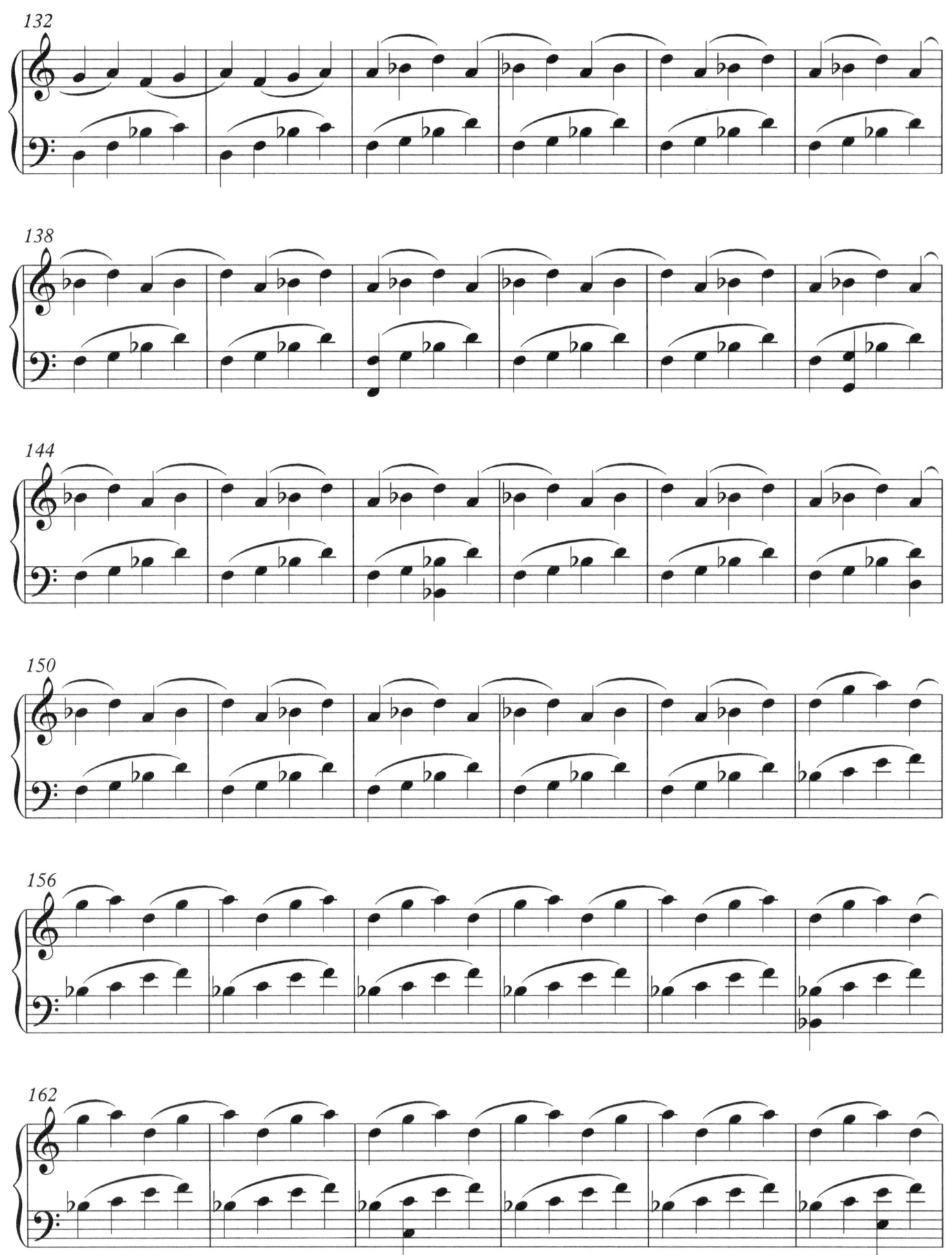

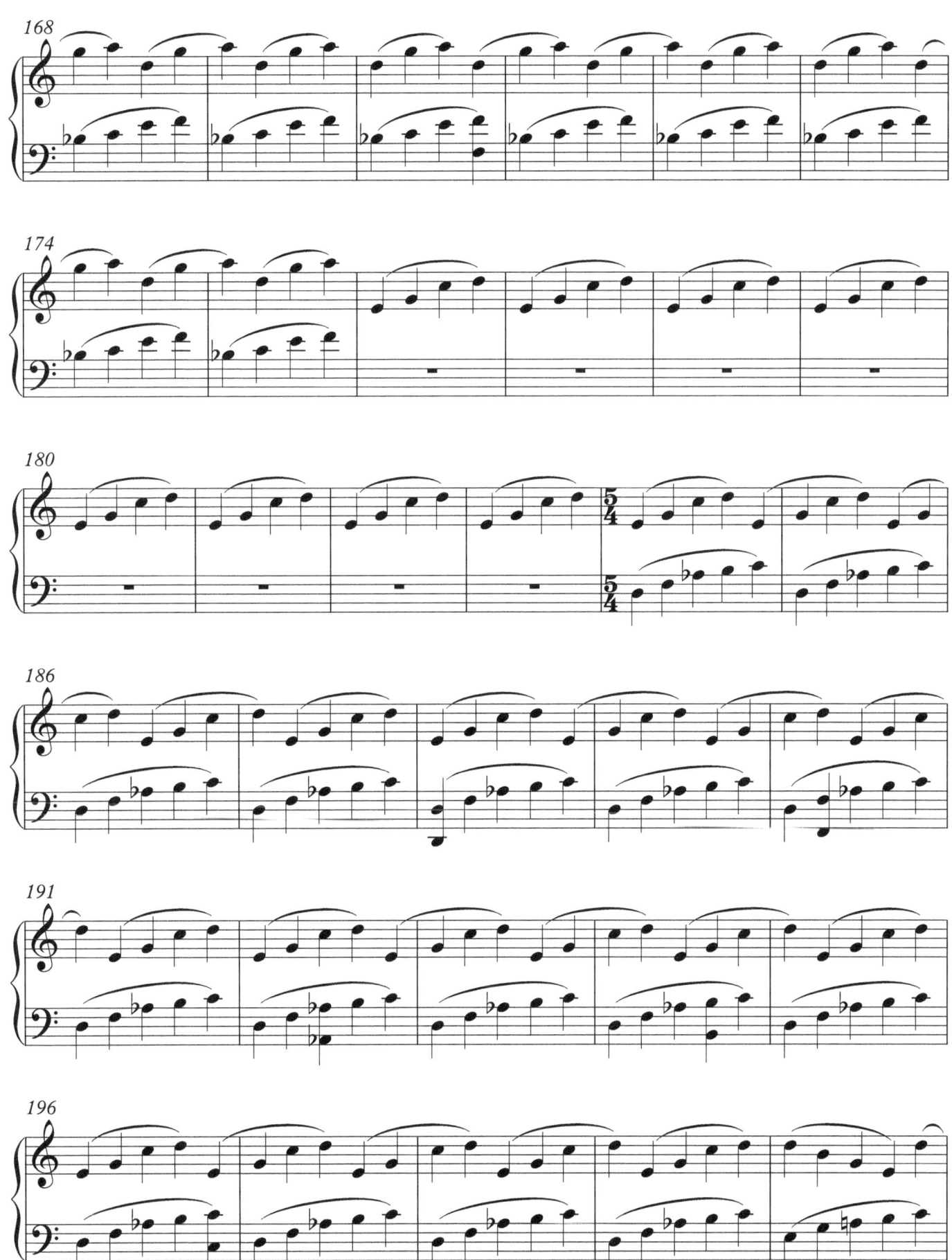

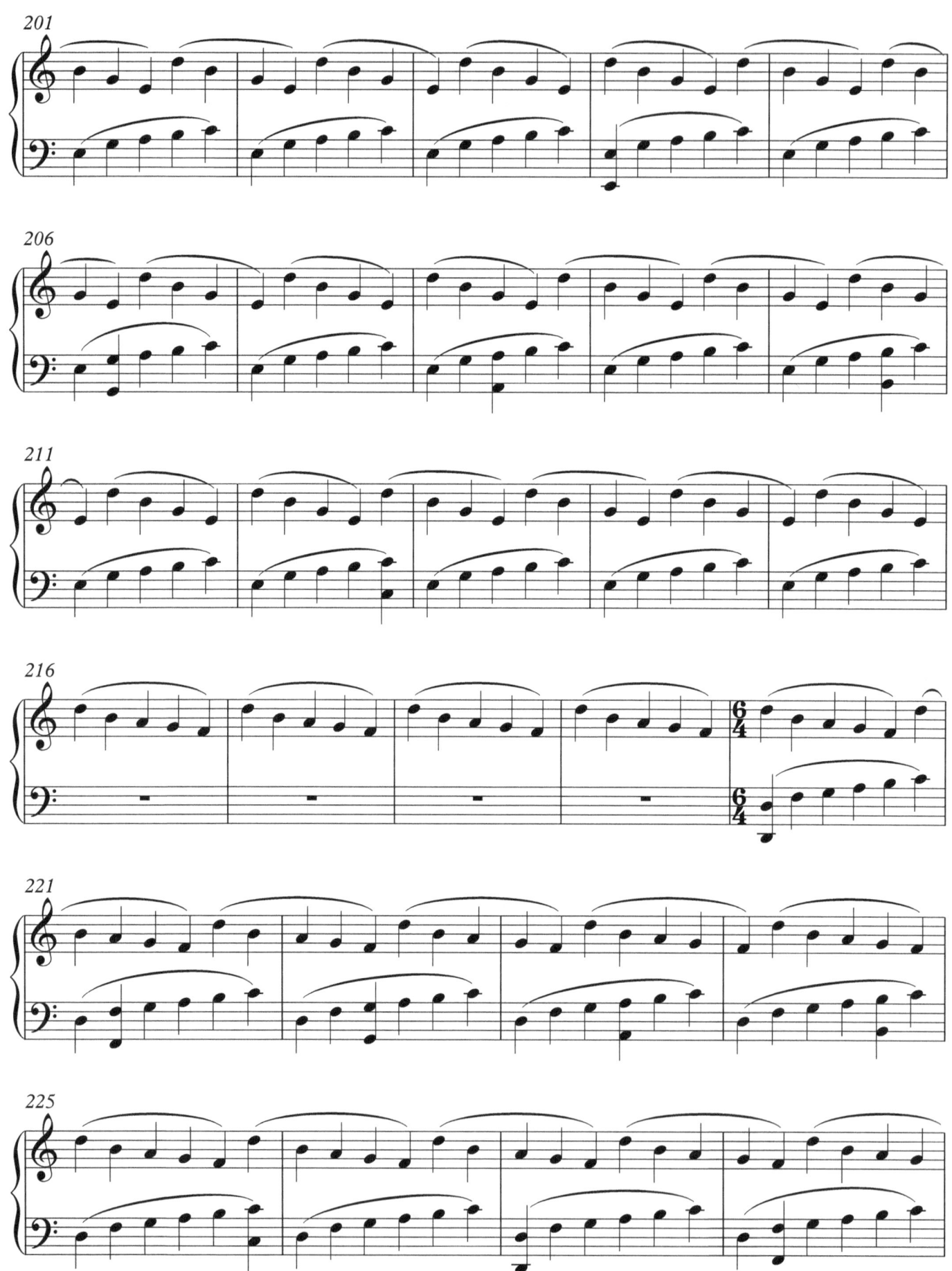

Fun Fact: Comet Fineberg played a couple notes on the Crystal Radio recording "Decategorized Sound" - "Sunrise Comet".

185

Index

A

Arpeggio, 3, 6, 65, 70, 97, 99, 111

Asymmetric,

 Phrases, 80, 99

B

Bach, Johann Sebastian, 1, 101

C

Challenge, 3, 6, 80, 81, 89

 Levels of, 6

Chords, 46, 65, 70, 97, 103, 109-111

Clusters, 46, 103, 110, 112

Combining polymeters and polyrhythms, 67-70

Composition, 107-112

Counterpoint, 5

Cycle 2, 7, 8, 44, 45, 65, 80, 98

F

Free,

 Form Puzzles, 95

 Improvisation, 100

I

Improvisation, 95, 100-111

 Categorization of, 101

 Free, 101

 Structured, 101, 107

Interwoven,

 Pattern 2

 Melody, 111

M

Measure, 7-8, 67, 69, 80

Meters, 1-3, 7, 8, 9, 44, 68, 102, 103, 110, 111

 Relatively prime, 3, 44, 69, 97

 Simultaneous, 1

Motion, 6

Multistable image, 2

Music composition – *see composition*

N

Notation,

 For puzzles, 7

 Polyrhythms, 44-46

Note,

 Sequences, 6, 70, 95, 97, 98

O

Optical illusion 2

P

Patterns, 2-4, 5-6, 31

 Interwoven, 2

Phase,

 Out of, 80-82

 Illustration of, 82-88

Phrase, 67, 68, 81, 84, 100

 Asymmetric 80, 99

 Marks, 67

Pitch, 2-3, 80, 109

 Non, 112

Polychords, 65

Polymeter, 1, 2, 5, 6, 31, 44, 99, 103, 110

 Combining with polyrhythms, 67-70

Polymetric pattern, 2, 3, 31

Polyrhythm, 5, 44
- Combining with polymeters, 67-70
- Executing correctly and accurately, 45-46
- Examples of, 47, 48
- Exercises and Short pieces, 49-64
- Puzzles, 65-66

Polytonality, 39, 65, 70, 110, 169

Prime - *see relatively prime*

Proximity, 6

Puzzle, 1, 3, 4, 6, 8
- Categorization of difficulty, 6
- Custom, steps for building, 97
- Free Form, 95
- Improvisation, 102
- Mash-ups, 99
- Out of phase, 80
- Notation of, 7
- Polyrhythmic, 65
- Variations, 4

R

Relatively prime, 3, 44, 69, 97

S

Scale, 3-4, 6, 65, 70, 95, 97, 99, 100, 103, 109, 111

Sequence, 6, 70, 95-98

Slope, 6

Synch point, 44, 81

T

Transformation, 7, 80, 81

V

Variations, 4-5, 7-8, 31, 66, 69

www.ingramcontent.com/pod-product-compliance
Lightning Source LLC
Chambersburg PA
CBHW080228180526
45158CB00008BA/2064